It's Show Time!

Politics
Media &
Popular Culture

David A. Schultz, *General Editor*

Vol. 2

PETER LANG
New York • Washington, D.C./Baltimore • Boston • Bern
Frankfurt am Main • Berlin • Brussels • Vienna • Oxford

It's Show Time!

Media, Politics, and Popular Culture

Edited by
David A. Schultz

PETER LANG
New York • Washington, D.C./Baltimore • Boston • Bern
Frankfurt am Main • Berlin • Brussels • Vienna • Oxford

Library of Congress Cataloging-in-Publication Data

It's show time!: media, politics,
and popular culture / edited by David A. Schultz.
p. cm. — (Politics, media, and popular culture; vol. 2)
Includes bibliographical references and index.
1. Mass media and culture—United States. 2. Mass media—Political
aspects—United States. 3. United States—Civilization—1970–
I. Schultz, David A. (David Andrew). II. Series.
P94.65.U6 I88 302.23'0973—dc21 99-053016
ISBN 0-8204-4135-X
ISSN 1094-6225

Die Deutsche Bibliothek-CIP-Einheitsaufnahme

It's show time!: media, politics,
and popular culture / ed. by: David A. Schultz.
–New York; Washington, D.C./Baltimore; Boston; Bern;
Frankfurt am Main; Berlin; Brussels; Vienna; Oxford: Lang.
(Politics, media, and popular culture; Vol. 2)
ISBN 0-8204-4135-X

Cover design by Nona Reuter

The paper in this book meets the guidelines for permanence and durability
of the Committee on Production Guidelines for Book Longevity
of the Council of Library Resources.

© 2000 Peter Lang Publishing, Inc., New York

Printed in the United States of America

To Hal and Carol Barger.
Le Bon Temps roulé.

Table of Contents

Acknowledgments

In preparation of this book, thanks go to Hal Barger at Trinity University in San Antonio, Texas. As a former colleague, Hal was instrumental in impressing upon me the new and emerging role of the media and the Internet in politics and why I should take both more seriously than I did. I wish Hal could have contributed to this volume, it would have been a better book because of him.

Conversations with Tracey Gladstone at the University of Wisconsin, Dean Alger, John Shockley at Western Illinois University, and a host of other scholars over the years helped shape the ideas that led to the creation of this book.

Political reporters, journalists, and editors such as Karen Louise Boothe, Kerri Miller, Pat Kessler, Tom Hauser, Steve Kaplan, Laura McCallum, Dane Smith, Jim Ragsdale, Conrad deFiebre, Jim Snyder, Rochelle Olson, Ashley Grant, Doug Tice, Lori Sturdevant, and Veronica McQuillian, among many others whom I have forgotten to name, gave me a better understanding of the ways in which the media and politics work together.

Thanks also go to all the contributors of this volume. I learned more than I could have ever hoped from their chapters and all of them were wonderful to work with.

Also, special acknowledgment goes to Heidi Burns at Peter Lang Publishing who did more than one could ever expect from an editor. Her encouragement and red pen made this a much better book than it originally was.

Finally, my family, including Helene, Tina, and Megan deserve an award for their patience as I edited this book and talked about it incessantly.

Preface
Kenny Meets George Washington
or, "Come on Down, Your 15
Minutes of Fame Are Now!"

David Schultz

"We shocked the world."

So stated former pro wrestler, action film movie actor, and AM radio talk show host Jesse Ventura on November 3, 1998 as the election results revealed that he had been elected governor of Minnesota.

The example of celebrity–turned–politician Jesse Ventura is but one clear indication of how the media, politics, and popular culture are becoming increasingly intertwined in our lives. Here, an individual named James Janos rose to fame as a popular, cult-like, outlandish personality in the televised world of wrestling with the assumed persona Jesse Ventura. From there, he appeared in several films popular with teenagers and college students and then he moved on to be a controversial host of several AM radio talk shows in Minnesota. As host, he was known for his brash, hard talking, "take no prisoners" views that often criticized the political establishment. Jesse carried that persona over into his surprise run for governor, using it as a way to distinguish himself from the political establishment and demonstrate that he would be a different kind of governor if elected.

And elected he was. Using his media image in televised debates and even in commercials that featured "Jesse Ventura action figures," Jesse Ventura did shock the world and since his election he has become an international celebrity, merging his role as governor with that of professional wrestler into a unique figure in American politics. Since taking office, Ventura continued to capitalize on his fame, selling his action figures and other merchandise bearing his name and returning to the wrestling ring to referee a World Wrestling Federation "Summer Slam" event. The media pop culture icon's personality and his role as governor have become indistinguishable.

But in reality, Jesse Ventura is a product of the media and popular culture. He is a politician born and nurtured on television and in the media, and his success as a candidate, his name recognition, his performance as

governor, and the public fascination with him remains simply a product of a media culture that made him possible.

Jesse Ventura is neither the first nor last public figure whose success was a product of the intersection of the media, politics, and popular culture. The fortunes of another former B movie actor Ronald Reagan turned governor and then president were made possible by his career in the movies and throughout his life Reagan was often accused of being unable to separate movies from reality, often quoting lines from the former in speeches he gave while president (Rogin 1987).

Similarly, how John F. Kennedy looked on television in the 1960 debate with Richard Nixon is credited with his presidential victory, and many other politicians including, Sonny Bono, Jack Kemp, Fred Grandy ("Gopher" on the television series *The Love Boat*) and Bill Bradley, drew upon their roles as entertainers or sports heros to push them into elected careers. Even Warren Beatty, flush with his successful role as a rapping senator in *Bulworth*, contemplated a 2000 run for president as a new kind of politician who would be straight talking with the American public.

Yet not only does the world of popular culture seem to be a springboard to politics, but the lines between reality and fiction seem increasingly blurred in the world of politics and popular culture. *Wag the Dog* was a popular 1997 movie that told the tale of a United States president starting a war to distract the public away from a sex scandal in which he was entwined. In 1998, as impeachment was bearing down on President Clinton because of allegations he lied about an affair he had with a White House intern named Monica Lewinsky, he announced that he would begin bombing Iraq. Almost immediately, the public and the press stated this was simply "Wag the dog," using that phrase to describe the real motives Clinton had in this military action. Fiction had perhaps become reality and reality was aping a movie.

As the *Wall Street Journal* proclaimed: "America is reaching the climax of a generation-long trend: the melding of entertainment and politics into a hybrid, all-purpose celebrity culture" where, according to Frank Mankie-wicz, a political consultant, "We're talking about seeing politics as an extension of popular culture" (Seib 1999).

The point with all these examples is that the media and popular culture are an everyday presence in our lives. For many, hours are spent watching television, listening to the radio, going to the movies, or renting tapes for the VCR. We know Big Bird, OJ, and Madonna better than the names of our elected officials. We know the plot lines of *General Hospital* better than who is running for president, and we are more likely to read the *National*

Enquirer than the daily newspaper. Americans, thus, are increasingly nurtured by media messages and their reality is becoming not what they experienced or read but what they say and heard on television, the movies, and the radio. With all the hours spent viewing and listening to the images and messages, one wonders what impact all this has had upon the way the average individual thinks about politics. This is the subject of this book.

In chapters that range from the definition of what news is, coverage of student protests, to images of politicians and women on television and in the news, to movies describing the latest conspiracy theory regarding who assassinated JFK, the various authors in this book seek to inform students and scholars about the diverse ways the media, politics, and popular culture are interconnected. The authors, however, do it in ways often thought as unconventional. Instead of simply looking perhaps to how the media and television undermine social capital and discourage political participation, the focus is broader. It is an effort to describe the numerous and often conflicting images and messages that the media and popular culture project about politics.

Are we cynical about politics because elected officials are depicted as sex-crazed crooks on television and in the movies? Do we root for the baseball players or owners in a strike because the words used to describe them are biased? Do science fiction plot lines "boldly go where no man has gone before" and offer a unique role model on gender relations? Are student campus protests covered in certain ways as to insure that demonstrations depict the protestors as lazy drunken frat boys? Does the Internet, the World Wide Web, and other new forms of media and communication such as C-SPAN have the potential to transform how we think about politics or are they simply another avenue for hate and prejudice? All these are questions asked in the various chapters of the book, with the author offering surprising and often controversial conclusions.

Overall, the hope is that after reading this book, students and perhaps scholars will have a richer and more critical awareness of the diverse ways the media, politics, and popular culture seem connected and how the three together define for many what political reality and news are.

References

Bulworth. 1998. Screenplay by Warren Beatty. Director, Warren Beatty. Producer, Warren Beatty. Performers: Warren Beatty. 20th Century Fox studios.

Rogin, Michael. 1987. *Ronald Reagan, the Movie and Other Episodes in Political Demonology.* Berkeley: University of California Press.

Seib, Gerald F. 1999. "Live From Hollywood, It's American Politics with Warren Beatty." *Wall Street Journal.* September 14. A1.

Wag the Dog. 1997. Screenplay by Hitam Kenkin, David Mamet. Director, Barry Levinson. Producer, Jane Rosenthal, Robert DeNiro, Barry Levinson. Performers: Dustin Hoffman, Robert DeNiro, Anne Heche, Denis Leary. Tribeca Productions; Punch Productions; Baltimore Pictures; New Line.

Chapter 1
American as Baseball and Apple Pie

John M. Bublic

Please read the paragraph below and then stop. Briefly do the requested task before moving on to the rest of the chapter.

I would like you to write an opening lead paragraph—the first paragraph—to a newspaper story about a strike by the National Baseball League players that started after last night's game. Just write a one-or-two sentence lead paragraph to your story as any journalist would. Be concise and to the point. Write your paragraph, and then get ready to read on. So, stop reading now and write the paragraph.

Too often, what is written down in a book like this is taken as it comes without first putting down into words what is initially brought by the reader to a selected reading like this one. This chapter, however, can be best understood if you have written the opening story to the National Baseball League strike. What would you tell readers? What would be the most important aspect of the strike? Whom would you wish to interview?

The first paragraph is key. Indeed, most readers will never read past the first paragraph in a news story. Consequently, the opening paragraph is undoubtedly the most important paragraph in the story. It pulls readers into the story. It summarizes the main points. If readers move on to other stories, they will know, at least, that the baseball players' strike has begun. Furthermore, because many people use television as their primary news source, the first paragraph is doubly important as it is usually all that would be read over the airwaves while pictures were shown to viewers.

We will not be discussing the images on a screen, but the content of the story—the first narrative part of a news story. It comes naturally to most of us. Generally, we have all learned how a news story is written. There have been many scholarly studies showing how uniform journalistic work has become. One famous media theorist, Herbert Gans, wrote in 1983 of the standardized ways of reporting the news, "For a variety of reasons, news organizations, journalistic methods and journalistic behaviors seem to be remarkably uniform whether the news organization is local or national, operates in a print or electronic medium, or serves an elite or popular

audience" (Gans 1983, 177).

It is this uniformity that concerns us here. If there are particular ways to frame a news story, we should ask ourselves, what is being emphasized and what is being de-emphasized or excluded from a story. What words do we choose to write about the story, and how are these word choices biasing the news and conveying specific meanings? Perhaps there is more than one way to write this news story, but generally there truly is not a wide variety of ways to tell it. Maybe no more than two or three. Perhaps there is something consistent about the two or three ways to write a story, which could mean that certain ideas are excluded from them all, and some ideas are included in all of them. This may be the point where students in a classroom should compare their stories. Are there similarities? Differences? Could you distinguish two ways of writing this story? More?

Media Bias

If you have compared stories, see whether conservative students wrote the story differently from liberal students. As mentioned above, there is likely to be a great deal of similarities among stories. Raymond S. Lichter, Stanley Rothman, and Linda S. Lichter (1986) carried out an extensive study about the political leanings of journalists and concluded that most journalists lean toward the values of the Democratic Party. However, the similarities among stories across news organizations, found by Gans and others, underscores other forces shaping the ways in which news stories are written. We will take a look at a "liberal" news organization, *The New York Times*, and see whether their news story about the National Baseball League strike was actually liberal. If not, we will have to ask ourselves why the lead paragraph could be interpreted as conservative. Also, we will take a look at how a conservative bias may come from other, more fundamental, sources.

In the end, you will have to decide how you view the news media, but there are some facts to keep in mind as you read on. More than 80% of the news media are owned by only a handful of multi-conglomerate corporations. News organizations survive on profit, and 80% of the news media's revenue come from advertising, not subscriptions. Thus, the pursuit of objectivity is accomplished within an environment that requires news organizations to make a profit and view the audience as consumers. The way in which journalists create and produce the news has become a taken-for-granted

world, which we can now view as American as Baseball and Apple Pie. The news media business and journalistic professionalism play a fundamental role in the manner in which news is created, and over time, these journalistic values shape the way in which we view our world.

Issue Framing

Life is very complex. Every news event, accordingly, is complex at its core. However, journalists have developed ways of simplifying this complex world by highlighting what they think are the most important aspects of a news story. Consequently, some news must be emphasized and some de-emphasized. Information about any particular story has to be fit neatly into a frame—a news frame surrounding a particular issue. Media scholars sometimes call this issue-framing.

If you and your peers framed this story in a similar way, you have begun to internalize a particular way of viewing the world. What makes stories similar are the assumptions that we make about what is important to a news story and what is not. These assumptions help us understand our world. When we write or assemble a news story we try to give an audience the information they need to understand that particular news story. Even though these assumptions may be commonsensical, they do have implications for us. They affect the way we understand our world and the way in which we should talk about relationships, such as those between players and owners, players and fans, and owners and fans. Over time, we seem to have accepted the way information is organized, assembled, and produced for us to understand our world.

As you can tell, this chapter is not only about news coverage of a baseball strike, but about the general values that we accept as taken-for-granted, ones we rarely question. Accordingly, our assumptions about news reporting are as American as Baseball and Apple Pie. Journalistic values have become accepted as part of our culture, part of the way we make sense of the world around us. We accept baseball as "America's Pastime," and no one really questions that. We can say the same thing about the way we view press coverage of events. There is a set of assumptions about the news that are taken for granted.

You may feel one way or another about the strike, but you probably wrote your story in a very similar way as your classmate or friend next to

you. Even though we may lean toward one side of a story or another, journalists try to be objective. They do not always achieve a purely objective perspective. Indeed, it is impossible. However, there is always an attempt to offer balance in a news story. What do journalists do to achieve this? How does one describe relationships, events, and so forth?

Timeliness

Although you may think there should be more than one or two ways of writing any story, you also should consider the fact that journalists usually work under particular job-related constraints that further limit the ways in which a story can be written. The most important limitation is timeliness. When you pick up a newspaper or watch television news, you do not want to know what happened a month ago, or even last week. You want to know what happened yesterday or today. When you sat down and wrote your lead paragraph, the most important aspect of the story is what happened recently.

However, to truly understand the strike, wouldn't you have to understand what happened last week or even a month ago? Where would this go into your news story? Would anyone ever read about the events that led up to the decision of the players to go out on strike?

The fact that journalists are required to think of the most timely aspects of a news story limits their ability to think about the broader context of any news story. The news becomes ahistorical, only representing what happens the day before, a series of events that are rarely tied together into a whole. It is not the explicit motivation of journalists to report stories a certain way, but it is the necessity to write stories on a daily basis that leads journalists to write certain kinds of stories on a consistent basis.

Authoritative Sources

Would you quote anyone? If you thought that I did not give you enough information to write your lead story, you are right. However, whom would you wish to interview? Journalists almost always choose established authority figures in a particular event. When it comes to a strike, it would be the strike negotiators, whom you would want to interview, or a player or owner of a baseball club. You would try to get both sides of the issue.

Some scholars who have studied the work of everyday journalists, like Mark Fishman (1980) and Gaye Tuchman (1978) have described in detail how the pursuit of objectivity creates a set of rules and behavior that result in a perpetuation of views that originate from established officials. Because the media must produce copy every day, journalists are required to develop specific techniques in order to do their job. They develop sources and continue to go back to them regularly. Consequently, reporters end up needing their sources, just as much as the sources need the reporters to get out information.

This relationship between reporters and sources is symbiotic. This term has its origins in biology to characterize how two animals benefit from each other, indeed the two are dependent upon one another. Likewise, reporters and sources are dependent on each other for survival. Therefore, the nature of a reporter's job creates further constraints on how a reporter can write a story.

Although authoritative figures are highlighted in news reports, there are many others who are tied to this story. For example, there are venders, local businesses, trading card companies, broadcasters, apparel makers, and concessions operators, who were reported as gearing up for the post-strike marketing push to make up for lost ground. Their voices were rarely mentioned in news reports.

This oversight brings up perhaps the most important point, which is that advertisers were left out of this entire story, even though their role is perhaps the most essential. They pay for the television coverage and put up a large percentage of yearly profits for the stadiums themselves and they boost ticket sales through their use of sports stars in their commercials. Yet, advertisers were not part of the labor-management dispute. They were somehow depicted as victims, just like the fans.

Word Choice

When it comes to strikes, timeliness and authoritative sources affect how the news portrays any labor-management dispute. However, if you step back and look at the words that you used in your story or even the words that *The New York Times* used in its stories, you will find some inherent biases. The following lead paragraph was the first story concerning the 1994–1995 National Baseball League strike to appear on the front page of *The New York*

Times, "With the two sides in baseball's labor dispute far apart and rigid in their positions, major league players went on strike after last night's games, shutting down the season with the eighth work stoppage in 23 seasons" (Chass 1994, A1).

Concerning the timeliness of the story, the conflict places two sides against each other. As mentioned before, given the nature of the events that took place that day, it appears commonsensical to view the strike in relation to the two main groups who are at odds with one another. The players indeed wish to get the owners to pay them more money.

In *The New York Times* lead, it is the players who "went on strike" and thus were "shutting down the season." Is that what your story reports? It appears that the players are the ones who caused the strike, rather than the owners playing a major role in shaping the outcome of the labor-management dispute. *The New York Times* at least highlighted that there were two sides to the strike in the story. Did you?

As is often the case, the workers who go out on strike are seen as causing the strike, and therefore the results of a strike, such as a cancellation of the baseball season for the fans, is related to the actions of the workers or the players, not the owners. The owners are usually not even part of the timeliness angle of the news. It is the players who are out on strike, causing the fans to lose their traditional season. The news media seem to be pitting the players against the fans, while leaving the owners out of the story.

The terms *fans, players,* and *owners* portrayed the conflict in an unusual manner, placing the baseball strike into its own peculiar frame. Although the terms seem commonsensical, the press used the most derogatory label perhaps possible for labor. They referred to them as *players.* Being referred to as players had enormous implications for labor not being taken seriously in negotiations. For example, Paul Soloman of the *MacNeil/Lehrer Newshour,* asked a worker: "Would you play for nothing *(MacNeil/Lehrer Newshour* 1994)?" Would the reporter ask the same question of the owners? Probably not, the word *play* implies children's play. Indeed, capitalists were referred to as the *owners,* and consequently given relatively more authority in dealing with the players. This established, at the most basic level, that an uneven relationship between labor and capital existed from the very beginning.

Also, consumers were never referred to as such. They were the fans, characterized as devoted enthusiasts, admirers, spectators—not participants. In this case, though, they are essential participants, without whom the product could not be manufactured and sold for profit. This is not simply a

sport, it is an industry in which capitalists invest, take risks, and make profits, and, in the process, attempt to gain as much surplus value from labor as possible, meaning pay the workers as little as possible, no matter how much profit the workers actually produce. This obfuscation of the longest strike in sports history sets a tremendous precedent for future coverage of strikes. The word *capital* or *capitalism* was completely absent from the news coverage. The mode of production, for example, was not called capital. In fact, it almost never is. Robert Goldman and Arvind Rajagopal conclude, after analyzing CBS's reporting of a strike, "Capitalism—the word—is unspeakable. It is thoroughly taken-for-granted that it need never be spoken (Goldman and Rajagopal 1991, 213)." In the case of the baseball strike, as well, news reports never mentioned capitalism or capital. The owners were not heads of corporations or industry, but clubs. This is not just semantics. It is a way of obscuring the relationship the owners have with their property and their workers. Workers or labor were never referred to as such. In relative terms, calling a few hundred millionaires "labor" is awkward, but the point is that the "players" are workers and that they do produce profits for their employers. They are not only playing.

Some Implications

The way the strike is portrayed obscures the relationship that workers have with capital, so that individuals do not even realize that a strike is sometimes the only recourse workers have against owners of capital. Unless you own capital, or are independently wealthy in some manner, you only have your labor to sell. The baseball players only have their labor to sell. The issue becomes one of how much to pay the worker, rather than the fair percentage of profits that workers should earn. The news media focus on how much the workers are making, de-emphasizing the average income of the owners or the overall profits they make. Although general reports are released concerning a franchise's finances, it is rarely reported how much individual owners make during a particular year. However, the press consistently reports the average income of the workers, which is above the million dollar mark, and their minimum wage, which is $109,000 a year.

It is difficult to sympathize with anyone making hundreds of thousands of dollars and appearing simply to demand more, but the fact that the press even publicizes earned bonuses of players for getting their team to the

playoffs is illustrative of the imbalanced nature of news reporting, and how labor is always more vulnerable than owners in our media. Each Chicago Cub, for example, received $30,000 after taxes in 1989 for getting their team to the playoffs, but the bonuses or profits owners received after signing television contracts and selling tickets were not reported in the mainstream media (Bagnato 1990). The available information that can be found only alludes to the money involved. *The Detroit News*, for instance, reported that major league baseball teams received tens of millions of dollars from television contracts, such as the New York Yankees' contract with cable television for $63 million in 1990. All of this is de-emphasized and leads individuals like Joe Falls of *The Detroit News* to suggest that players wear their salaries on their uniforms (Falls 1991, 2).

Conclusion

The news media offer a complicated variety of information and, thus, generalizations about the information are difficult to come by. Individuals do need to ask themselves, nonetheless, what is being emphasized and what is being de-emphasized in the news to begin to understand what the news media's impact may be. In other words, they need to ask how an issue is framed. As mentioned in the beginning of this chapter, what concerns us most is the uniformity in news coverage. Antonio Gramsci's concept of hegemony is the root concept of much media criticism (Gramsci 1970). Gramsci said that certain ideas are perpetuated through many of society's institutions, such as schools and the mass media, helping perpetuate the status quo. In our case, the news media's coverage of a labor-management dispute helps place a complicated relationship between labor and capital into a particular context. Ultimately, this issue frame is accepted as a taken-for-granted way of viewing a labor-management dispute.

You may believe that the news media do an adequate job playing the watchdog role on our political, economic, and societal system, or you may think they lean toward the right or the left. Beyond this perspective, however, lie fundamental ways of examining labor-management disputes. These also shape the way in which we view ourselves and the distribution of wealth and resources in our society. We see workers negotiating with owners of capital, and the news media represent this relationship in as "objective" a way as possible for us. We begin to view this relationship as natural.

The conflict between the players and the owners began, according to the media and thus our perceptions of it, when the players went out on strike. News routines have established this perspective as common sense. Everything that happened before the players called for a strike is history and because the media are most concerned with timeliness, such as events that occurred yesterday, it is the players who are placed front-and-center and at the top of the news story as the story's main protagonists, leaving out the entire context within which the strike was taking place. This is, again, not due to the explicit motives of journalists, but to time constraints that require journalists to sum up situations with timely and conflict-oriented news angles.

The media's role, consequently, is to report the instability of an otherwise stable world. Where there is instability, the media are there. Accordingly, news conventions determine that the most significant and timely aspect of a strike is disruption of stable working conditions. The media present the various sides to the story, but the assumed goal is a resolution to the conflict and to re-establish order where disorder exists. Thus, the media play a role in helping to reconfirm the status quo.

The most important writing objective also leads journalists to assemble stories reconfirming the status quo, i.e., journalists must keep in mind the fact that they are writing for a particular audience. This audience is looked upon as consumers, and thus the news media tend to frame strikes in terms of how they will affect consumers. This angle, however, connects the strikers with consumers, leaving the owners out of the equation and, thereby, pitting strikers against consumers. A reporter's logical question, for example, becomes: What do the strikers want? This leaves the answer squarely in the hands of labor, who then appear to be the sole cause of the disruption. The owners look passive and, like consumers, want things as they were—orderly and stable. Thus, the public's interests are more in line with the owners' interests. Workers always appear to be demanding something, while others respond to them.

Reports continued to reflect the views of owners and players rather than the underlying incentives each had to negotiate. Even the polls, for example, asked whether the players or the owners were to blame. Interestingly, however, there were polls asking whether it was "greed" that was largely to blame, and most respondents blamed greed, but the source of this greed is assumed to be human nature, and not today's economic system.

The seemingly natural order of baseball-strike coverage highlights the

institutional setting of labor disputes that have come to mean little to consumers except for how it is going to affect them. Labor is not taken seriously and the threat of replacing them was only questioned in relation to whether the replacements are able to work, or in this case play, like the original workers. News conventions perpetuate these distorted beliefs. Taking the strike out of context by reporting daily events rather than giving in-depth background information, relying on information subsidies of established officials, utilizing common terms that distort the relations between actors, and avoiding terms such as capital, leaves the media as little more than a mouthpiece for the existing system. The media's inability to bring the strike to the consumers' personal level of meaning misinforms them and undermines their ability to make knowledgeable opinions about the strike.

However, getting these stadiums built, buying time on television and getting quality workers to bring everyone to the television sets and into the stadium seats is a capitalist product. This product is sanctioned by our government as a legitimate monopoly, which exploits labor and consumers to the hilt, and the media play an intrinsic role in obscuring the underlying relationships that shape what we see, hear, and feel. If the next strike is to unfold differently, the news media may be the first place where change could occur.

The players receive 58% of all games' revenues. Some of the good things that could come out of the baseball strike coverage is more news about the percentages other workers are getting from their industry's revenues. Perhaps, workers in other industries should be getting a fairer percentage of their industry's production.

The coverage of the National Baseball League strike was different in a fundamental way from nearly any other strike. It was covered consistently and thus did include analyses of the strike from various perspectives. The reason why this took place, however, is because there was a team of sports writers who were hired to cover the baseball season and thus needed to cover the strike in lieu of the baseball games. Consequently, what is needed for the adequate coverage of other labor-management disputes is an established team of journalists to cover the ongoing struggle between labor and management. Although the "Business" page covers business and thus does cover labor-management disputes, the diverse requirements of an average reporter means that reporters will cover labor-management disputes as timely, conflict-oriented events, rather than offering consistent analyses of the owners' and workers' positions.

This chapter offers an analysis of the media's coverage of a labor-management dispute and how we accept particular news angles as common-sensical approaches to viewing conflict. These taken-for-granted approaches have ramifications for the way we perceive not only the labor-management dispute in question, but our own relationship with owners of capital and the way the media ought to inform the public about this fundamental artifact of capitalism. Should the media do their job differently? How so? The answers are not easy, especially because of the nature of the news business itself, and its ongoing requirements for timely stories and the nature of the everyday journalist's job. Becoming more critical of the media is essential for each citizen as we are inundated with information every day. By re-examining a single story such as a labor-management dispute, one can look at other issues with a new, more critical perspective that examines even the taken-for-granted nature of reporting the news.

References

Antonen, Mel. 1955 "Survey: Baseball Fans Will Return." *USA Today* 26 January: sec. C, 1.

Bagnato, Andrew. 1980 "Cub Players Get Lift from Playoff Bonus." *Chicago Tribune* 18 March: sec. 3.

Chass, Murray. 1994. "No Runs, No Hits, No Errors: Baseball Goes on Strike: Both Sides Stiffen So Standout Year Is Put on Hold." *New York Times 12* August: A1.

Falls, Joe. 1991. "Owners Can't Give Money Away—Or Can They?" *Detroit News* 11 March: sec. C, 2.

Fishman, Mark. 1980. *Manufacturing the News.* Austin: University of Texas Press.

Gans, Herbert. 1983. "News Media, News Policy and Democracy: Research for the Future. *Journal of Communication* 33: 174–184.

Goldman, Robert and Arvind Rajagopal. 1991. *Mapping Hegemony: Television News Coverage of Industrial Conflict.* Norwood, NJ: Ablex Publishing Company.

Gramsci, Antonio. 1970. *Prison Notebooks.* New York: International Publishers.

Lichter, Raymond S., Stanley Rothman, and Linda S. Lichter. 1986. *The Media Elite.* Bethesda, MD: Adler and Adler.

The MacNeil/Lehrer Newshour. 1994. 12 August. PBS.

Tuchman, Gaye. 1978. *Making News: A Study in the Construction of Reality*. New York: Free Press.

Chapter 2
The Cultural Contradictions
of the American Media

David Schultz

What is news? Perhaps no question is more frequently asked about the media or the news industry than this one. For some, news has been defined as "the unusual, the aberrant, the out of the ordinary," (Salent 1999, 243) as "an objective and trustworthy account of reality," (McQuail 1998, 252) or "an attempt to reconstruct the essential framework" of an event (Schramm 1960, 2).

Yet none of these definitions adequately captures what is shown on the evening television news, what appears in newspapers and magazines, or what is heard on the radio. Instead, to understand what news is in any country, one needs to look to the cultural forces of a society, to the various social values, constraints, or institutions affecting the news production industry.

An adequate understanding and definition of what constitutes news is developed by examining four social imperatives or forces that shape news. These imperatives are:

- the role of the news in a democracy;
- the corporate structure of news production;
- the entertainment imperative of news; and
- the political behavior of news entities in the United States.

These four imperatives, social forces, or constraints are in tension with one another, often dictating conflicting, or contradictory demands upon the news (Gouldner 1980, 169). The result is that what is produced or emerges as "news" in the United States is shaped by, and is the by-product or interplay of the democratic, corporate, entertainment, and political demands that are placed on it.

News as a Social Institution

The production and definition of news does not occur in a vacuum. What

is news and the conditions under which it is defined and reported take place within a social context. Reporters, radio, television, and the entire news gathering and reporting process are embedded within a society. To locate news within a social context means that what is defined as news responds to, and reflects these social assumptions, beliefs, values, and biases.

But to say news is embedded in a social context goes even further than saying that it is reflective of social values. News is not defined under circumstances chosen by the news industry itself, but under specific social, economic, and political conditions. It is these forces of production that to a large extent shape what will air on television or radio or will appear in newspapers. The economic or social forces of production that determine the structure of the ownership of the news gathering industry, or the political values that define the relationship between the media and the government, create a specific set of patterns of behavior that define news.

News is an institution defined by other social institutions in society. By an institution, it exhibits "social patterns of behavior identifiable across the organizations that are generally seen within a society to preside over a particular social sphere" (Cook 1998, 70). Within any society, certain institutions form and these institutions have regularized behavior, norms, and conventions. In the United States, there are political, social, and economic institutions, all of which have their own values and specific patterns of behavior. To borrow from the title of media critic Marshall McLuhan's famous book, not only does the medium determine the message, but many other forces also operate to influence what one reads, hears, or sees in the news. News is a product of the forces of production of other institutions that bear upon the news production industry.

In the United States, four major social institutions or imperatives are especially important in defining and structuring the news production establishment. The first is the democratic imperative, and it refers to the special relationship between the press or news gathering industry and the government. It also describes the role that the press and other media are supposed to play in our democracy.

A second institution refers to the corporate structure of news ownership and production in the United States. The news industry is not owned by the government, it is privately owned and increasingly with a corporate for-profit structure. The third imperative is the increasing entertainment focus on the news, dictated, in part, by its need to compete for audiences against other forms of entertainment. Finally, the political nature of news refers to the participatory role of the news industry in the political process. Here, the

news industry itself competes against citizens and other organizations to lobby and influence the political process to obtain specific political outcomes.

The Democratic Functions of Media

A free press is important to the maintenance of a democratic society because it provides for a forum for political debate, public scrutiny of the government. It provides citizens with the objective information they need to make political judgments. Because of its importance in a free society, the press is the only economic enterprise specifically mentioned in the United States Constitution (Grossman 1995, 69).

The press has long enjoyed a privileged position within the United States. From the earliest colony days of the United States, freedom of the press has been important to the dissemination of political ideas and the criticism of ruling authority. Back in 1735, Peter Zenger was put on trial in colonial America because an article in his paper criticized the local British governor of New York (Levy 1985, 125). Yet a jury acquitted him of libel, stating that the printing of truth was a defense to this charge. The Zenger trial stood for the proposition that the press should be unrestrained in its efforts to report and criticize.

Similarly, the language and ideas of the American revolution were spread through the press, in terms of political pamphlets, handbills, and letters to newspapers (Bailyn 1967, 2; Hyneman and Lutz 1983, xi). Without the freedom of the press, the language of rebellion could not have been spread. The use of the press was critical in 1787, with James Madison, Alexander Hamilton, and John Jay using *The New York Tribune* newspaper as the forum to publish the *Federalist Papers* and urge adoption of the new Constitution. Benjamin Franklin spoke for many when he stated in 1789 that one ought to "leave the liberty of the press untouched, to be exercised in its full extent, force, and vigor" (Franklin 1983, 708). George Washington echoed this sentiment, indicating that the press was important to "facilitating the circulation of political intelligence and information"(Davis 1996, 21). Thomas Jefferson best stated the Framers' views on a free press when he declared: "The basis of our government being the opinion of the people, the very first object should be to keep that right; and were it left to me to decide whether we should have a government without newspapers or newspapers

without a government, I should not hesitate a moment to prefer the latter"
(Jefferson 1984, 880).

Indicative of the importance the Framers placed on freedom of the press
was the eventual adoption in 1791 of the First Amendment that guaranteed
its constitutional protection. Without a constitutional guarantee for the press,
a free society would be impossible. According to Thomas Jefferson: "Our
first object should therefore be, to leave open to him all the avenues of truth.
The most effectual hitherto found, is freedom of the press. It is therefore, the
first shut up by those who fear the investigation of their actions" (Jefferson
1984, 1147).

For Jefferson, a free press was the tool of public criticism. It held public
officials accountable, opening them up to the judgment of people who could
decide whether the government was doing good or whether it had anything
to hide.

In *Democracy in America*, Alexis de Tocqueville underscored the
importance of a free press to a democratic society. For de Tocqueville, the
proliferation and maintenance of voluntary associations is critical to fighting
the tyranny of the majority and fostering a democratic society. Equally as
important to serving these twin tasks is a free press. For de Tocqueville,
there "is a necessary connection between public associations and newspa-
pers: newspapers make associations, and associations make newspapers" (de
Tocqueville 1961, 135). A newspaper brings people together, serves as an
advisor. Because the press was local, with every community possessing
several papers, these papers represented the views of a specific group or
interest, providing a forum for its views and to exchange ideas and engage
in political debate.

A democratic and free society is dependent upon the media to inform. If
a government is to operate on public opinion as the Framers hoped it would,
the public needs to inform its views about government in some way and the
way is through the press because few have direct and immediate access to
what the government is doing. For most, information about politics is
mediated or learned through the press and we look to them to inform us. The
news, such as television, can frame public opinion and how we view issues
(Iyengar 1991, 8). In a democracy, the media operate as agenda setters
(Graber 1993, 307) and they have some effect on elections, perhaps
including turnout in close elections. The media are also important in
interpreting messages, and socializing individuals to democratic norms
(Laswell 1969). More recently, the new media, which include the Internet
and talk radio, have been important in shaping the public agenda (Davis and

Owen 1998, 231–53). Bill Clinton was introduced to America playing the saxophone on the June 3, 1992 airing of the *Arsenio Hall Show*, and radio talk show hosts such as Rush Limbaugh launched the coverage of Monica Lewinsky and the introduction of the term *feminazis* to our political discourse (Davis and Owen 1998, 253).

Overall, as Justice Brennan stated regarding the important role of the press to democracy in *New York Times v. Sullivan*: "The general proposition that freedom of expression upon public questions is secured by the First Amendment has long been settled by our decisions. . . .The maintenance of the opportunity for free political discussion to the end that government may be responsive to the will of the people and that changes may be obtained by lawful means, an opportunity essential to the security of the Republic, is a fundamental principle of our constitutional system" (376 U.S. 254, 269 (1964).

The Corporate Function of the Media

The press and the news may be important to the maintenance of democracy, yet the news does not simply serve the needs of the citizen. The ownership structure of the media dictates that the production of news must be for a profit and, thus, what appears as news is shaped by the needs of making money.

Richard Salent, former head of the news division for CBS, stated the conflict well when he contended that to "give priority to information which the people of a democracy need to know, on the one hand, or to what will interest and titillate them, on the other, is a fundamental and underlying one—both for print and for broadcast" (Salent 1999, 248).

From its colonial origins, American news production has been marked by private ownership. Yet this ownership structure did not always dictate that news was supposed to be simply a for-profit enterprise. The production of news passed from local newspapers by printers to party presses to penny presses. As voices of political parties, the presses promoted political dialogue and as revolutionary rags, they attacked the British (Davis 1996, 24–40). Today the media are market-driven as opposed to the nineteenth century when they were party—driven (Grossman 1995, 85). What are the implications of news being a for profit industry? There are several, but the most important factor is that news is business. For Salent: News is a special kind

of business, but it is a business—a part of the free enterprise system this
nation has chosen. It has to make money in order to spend money. *The New
York Times* boasts "All the News That's Fit to Print," while the former
Aspen *Flier*, a small paper and more modestly—and accurately—announced,
"As Independent as Revenues Permit" (Salent 1999, 140).

News and information are commodities to be bought and sold like
mouthwash, toilet paper, and soda (Lyotard 1979, 5; Wolf 1999, 109).
Industries that produce news wish to maximize revenues and will seek to
present those news items that are most likely to generate readers, viewers,
listeners, and profits. John Welch, chairman of General Electric, the parent
company that owns NBC, requires every division to maintain the same profit
margin as every other division (Grossman 1995, 75). Media services, thus,
must be profitable, and profitable they have been. Media companies are an
attractive corporate investment because for every dollar of revenue, 30 to 35
cents are profit (Parenti 1995,166). As a result of this high profitability, the
media and news industry has become the source of corporate takeovers and
increased concentration in the last twenty to thirty years.

While media concentration is less in America than Europe, the trend
nonetheless has been toward concentration of the media and news production
into fewer and fewer corporate hands (Picard 1998, 201). For example, the
number of controlling firms in the media—daily newspapers, magazines,
radio, television, books, and movies—has shrunk from 50 corporations in
1984 to 26 in 1987 to 23 in 1990 and to less than 10 in 1996. These ten are
Time Warner, Disney, Viacom, News Corporation Limited (Murdoch/Fox),
Sony, Tele-Communications, Inc., Seagram, Westinghouse, Gannett, and
General Electric (Bagdikian 1997, xiii). In 1999 alone, there were talks of
several major mergers, including Viacom and CBS, that would produce even
greater media concentration and power into fewer and fewer hands.

In addition to this concentration, there is the rise of multiple owners in
media where one conglomerate owns several types of media. Presently, there
are fewer than 1,800 daily papers and 1,200 commercial stations in the
United States. In 1995, Gannett owned 93 daily papers, 15 television
stations, and 19 radio stations. Cox Broadcasting owned 11 radio stations,
3 television stations, 4 cable vision systems, and nine newspaper companies.
The New York Times Company owned 35 daily newspapers, 8 weeklies, 2
radio stations, five television stations, and numerous magazines. Capital
Cities/ABC owned 7 television stations, 7 radio networks serving more than
3,000 affiliated radio stations, 18 radio stations, 75 weekly newspapers, and
numerous trade magazines. All this was before Walt Disney Company

bought them in 1995 (Graber 1997, 39; Bagdikian 1997, xxv; Woodward 1997, 28–29). The Telecommunications Act of 1996 lifted many of the ownership restrictions that had been in place so that now one owner can own a total of 8 AM/FM and 12 television stations in one market. Since then, media concentration has accelerated.

Corporate owners such as General Electric use the media they own to support their companies and their other interests, and studies suggest that corporate chains are more likely to pursue profit than traditional editorial policy (Underwood 1995, 119). GE, for example, is a large company with military and consumer products, power distribution systems, computer services, financial services, medical services, and yes, media services. Westinghouse is a major defense contractor and owner of CBS (Parenti 1995, 186). This increased corporate nature of news and media means that the media are not only a profit-making division for GE and Westinghouse, but that the news or media division is also implemented to secure corporate objectives and goals that support the vast holdings of these companies. These news producers are less attached to community than before. As noted above, General Electric required NBC to maintain the same profit margin as every other division. This means that GE is more concerned with profits than with necessarily representing the diverse interests and voices de Tocqueville had in mind.

Overall, the increasingly corporate structure of the media means that news is not simply an objective presentation of political events where the needs of democracy dictate what will be aired or printed. In making decisions regarding what is produced as news, the logic of for-profit journalism means that "rational news departments should compete with each other to offer the least expensive mix of content that protects the interests of the sponsors and investors while garnering the largest audience advertisers will pay to reach" (McManus 1995, 85).

The Entertainment Function of the Media

If news is for profit, it must compete against other sources of entertainment for audience attention. For some, such as former PBS and NBC News President Lawrence Pressman, the result is that the "firewall that separates politics from entertainment has all but disappeared" (Grossman 1995, 108–9). When Bill Moyers quit CBS he indicated that traditional journalism

judgments were being replaced with market demands.

> Managers [at CBS News]. . . yielded to the encroachment of entertainment values
> from within. Not only were those values invited in, they were exalted. . . In
> meeting after meeting, "Entertainment Tonight" was touted as the model—visual
> images containing a highly emotional quotient that are passed on to the viewer
> unfiltered and unexamined. (Grossman 1995, 108-9)

The fact that journalism and media are increasingly "market-driven" means that audiences are seen not as citizens to inform but consumers to attract. The imperative of market needs comes into conflict with democratic needs (McManus 1994, 3), producing news that is less about the government and more focused on attracting audiences, regardless of the content.

Entertainment-focused journalism, however, is not simply a product of the internal drive for profits by mainstream or established news or media services. Instead, the "new media," including talk shows such as *The Jerry Springer Show*, *Oprah Winfrey*, and tabloid style shows such as *Hard Copy* or *Current Affair*, as well as information providers or media services such as *MTV*, the Internet and the World Wide Web, and even magazines such as *People* also serve as competition to the more traditional news services and media outlets (Davis and Owen 1998). These highly profitable shows are in competition for audiences with more traditional news services, thus forcing, as Bill Moyers noted, mainstream news to change its product if it wishes to maintain audiences and revenues.

The new media have the potential to inform, to educate, and facilitate public discourse, yet even the "new media's promise is undercut by the commercial and entertainment imperatives that drive them" (Davis and Owen 1998, 7). It is a profit-making fare that competes against mainstream news, forcing even the latter to change (Davis and Owen 1998, 18). The new media cover politics but only politics as it entertains, in part, because the audience the new media attract is a less politically interested audience than traditional news audiences (Davis and Owen 1998, 18).

One result is that traditional national evening news on ABC, CBS, and NBC now have relatively little "hard news" in a thirty-minute format, with soft and nonnews and commercials occupying the lion's share of the broadcast ("Around the News in 22 Minutes" 1991). One study suggested less than one percent of the news covered is political news (Purdum 1999).

Similarly, recent expansion of news shows on television such as *Date Line* and *20/20* is a result not of corporate news services newfound discovery that people want information about politics and government so much as a

discovery that expanded entertainment-orientated news is profitable. Studies confirm that mainstream news now covers many of the topics previously only found in tabloid shows such as *Hard Copy* (Mifflin 1999). For example, in 1992, the *National Enquirer* broke a story about an alleged affair between Bill Clinton and Gennifer Flowers. Subsequently it was picked up by mainstream media, including a front page *New York Times* story crediting this supermarket tabloid. Apparently, now "All the News That's Fit to Print" includes "What enquiring minds want to know."

The media can deliver news useful to a democracy or useful in selling soap and securing profits. What Edward R. Murrow, one of the early pioneers of journalism, stated about television can easily be generalized to all of the media today when he asserted:

> This instrument can teach, it can illuminate; yes, and it can even inspire. But it can do so only to the extent that humans are determined to use it to those ends. Otherwise it is merely wires and lights in a box. There is a great and perhaps decisive battle to be fought against ignorance, intolerance, and indifference. The weapon of television could be useful. (Sperber 1986, 540)

The Political Role of the Media

The media are not simply important to the maintenance of a democracy but its fourth imperative is as a substantive political actor with its own political interests and impact. In addition to the media serving an important role in setting the political agenda, framing political issues, or perhaps influencing turnout in close elections, the corporate owners and agents involved with the news occupy a significant role in the halls of Congress.

For one, media lobbyists work the corridors of government the same as any other group. In 1988, the Magazine Publishers Association gave $12,000 to Republican candidates for a "Victory 88" fund. From 1985 to 1988, the National Cable Television Association gave $446,000 to federal candidates, and the National Association of Broadcasters gave $308,000 (Bagdikian 1997, 11). In lobbying for changes that resulted in the passage of the Telecommunications Act of 1996, U.S. House of Representatives Republicans met in closed-door meetings with the media industry to discuss changes. In lobbying efforts, $40 million were spent by the telecommunications industry on this bill and $4 million in direct candidate and lawmaker contributions (Bagdikian 1997, xv). The result? Relaxation of telecommunications anti-trust laws that now permit more concentrated media ownership.

The National Association of Broadcasters has a multimillion dollar budget and represents over 6,000 members. It can use this network to mobilize member stations and cover or even ignore issues. For example, in 1979 the federal government proposed major telecommunication law changes that pleased the networks, but that night no news program mentioned it, even though over 200 press people were present at the announcement (Bagdikian 1997, 93).

News organization lobbyists have successfully lobbied to prevent a change in postal rates that would have hurt media interests (Cook 1998, 184). Similarly, Katharine Graham, head of the Washington Post media empire and president of the American Newspaper Publishers Association, lobbied personally to keep AT&T from competing with the papers (Bagdikian 1997, 92).

Most major media corporations, such as Time, Inc., have their own political action committees (Bagdikian 1997, 95). For example, in 1997 almost $4 million were given to the Democratic and Republican Parties and candidates as major media corporations sought to influence debates on the awarding of broadcast rights to high definition television (HDTV) (Common Cause 1997). During that time ABC/Disney contributed $850,000, with Fox ($928,000), NBC/GE ($762,000), and CBS/Westinghouse ($312,000). Other media giants also expended large sums of money for lobbying and direct political contributions.

Overall, the media and the owners of the news industry are not politically neutral and disinterested. They have their own corporate, economic, and political agenda, using their vast wealth and media power to support that agenda.

Cultural Contradictions
of the American Media

The American news industry is caught at the intersection of the democratic, corporate, entertainment, and political imperatives that define its structure and mandates. What does this mean for news and what is defined as news?

First, these four imperatives are not in harmony but often come into conflict with one another. The democratic imperative to provide an objective account of governmental information citizens need to make informed political

decisions, or the demand that the media occupy an adversarial role to check abuses of power, or the need to have competition among news providers to stimulate robust and informed debate that can only come from a diversity of ideas and opinions, is seriously threatened by the corporate, entertainment, and political imperatives of the news media.

For example, concentration in media ownership means a decrease in the diversity of viewpoints expressed. No longer do the media represent the voices of many local interests as de Tocqueville once described; now they represent a handful of corporate speakers able to silence views that hurt corporate objectives. For example, HarperCollins was prepared to print a book written by Chris Patten, the former British governor of Hong Kong, who was critical of the leaders in China. When the parent company of HarperCollins, News Corporation Limited, realized this, publication was halted lest it threaten the telecommunications interests the News Corporation was seeking to protect in China.

In addition, the imperatives of corporate ownership forces more episodic coverage rather than thematic coverage. Thematic coverage places stories in context but episodic does not. Research indicates that episodic coverage frames the way viewers understand events, such that they do not see public officials responsible for issues such as poverty or crime. The result is news does not hold elites responsible for social events. Corporate control of the news is the reason for this type of coverage (Iyengar 1991, 138–39). Corporate ownership biases the content of news in ways that are distinct from merely being "liberal" or "conservative." The bias is structural or institutional rather than individual (Cook 1998, 92). It comes by way of favoring official sources from government or industry (Cook 1998, 92; Herman 1988, 18–26). The result is a corporate bias in favor of the status quo.

The increasing corporatized and centralized control of the media is producing more stories not heard. For example, not one mainstream media service carried a story indicating how much money was spent by the major news industry to lobby for the broadcast rights to HDTV. In 1996, when Bob Dole ran for president, he stated that these broadcast rights, with an estimated value of up to $70 billion, should be auctioned off since they were owned by the public (Alger 1998, 100). The news media gave little attention to this story and gave no attention to the fact they were spending money on candidates and lobbying to receive these broadcast rights for free! Should the public know about this? Yes? Do the media report this? No!

Similarly, it is unlikely that the media will report on its lobbying efforts

in Congress or that NBC will report adverse stories about its parent company GE, including the fact that GE is involved in a major dispute with the government over its alleged pollution of the Hudson River in New York State.

The pressures of corporate ownership also affect what is broadcast on the news. After GE bought RCA/NBC, GE chairman John Welch called NBC News president Lawrence Grossman, former president of NBC news, to express anger about coverage of the stock market collapse in 1987, saying that the reporting further hurt the economy and that using the term "Black Monday" hurt GE stock (Grossman 1995, 83–84). At one point Westinghouse demanded a rewrite of a teleplay on television because it did not like the depiction of the military in it. Westinghouse is a major defense contractor and owner of CBS (Parenti 1991, 186).

Overall, corporate discipline and the imperatives of corporate ownership influence what and how news is covered, often labeling that which challenges the status quo as irresponsible (Herman and Chomsky 1988, 304). News can now be characterized by a chamber of commerce mentality where the line between news and marketing is crossed (Underwood 1995, 139).

Others see additional ways that market-driven journalism affects the content of the news. First, consumers are less likely to learn from news. Second, consumers are misled. Third, news sources become more manipulative, and fourth, audiences become politically apathetic as less information is provided (McManus 1994, 184–96). In addition, there is no investigative coverage of business (Underwood 1995, 131–32). While all newspapers, magazines, and television news have a section devoted to business, there is no comparable "labor" or "workers" section devoted to examining news from the people's point of view.

Finally, there is good evidence that the drive toward a corporatized, for-profit, entertainment focused news industry provides less government news coverage, especially as reporters are pulled from government beats to cover other stories (Underwood 1995, 19; Purdum 1999). Media ownership also influences the choice of story. For example, it is less likely that they will cover crime at a mall and more likely cover crime on the street corner, lest they offend their advertisers (Schwarz 1996, 162–63). Lastly, while tobacco companies cannot advertise on television, these companies own food products, and the media feel tobacco influence through food advertising dollars. For example, *TV Guide* refused an American Heart Association ad in part because it felt pressure from tobacco companies not to accept such an ad critical of smoking (Schwarz 1996, 170–71).

The point here is that the news Americans need to be informed citizens comes into conflict with the news the news industry wants to provide to maintain its profits. What is news, then, is not simply "the unusual, the aberrant, the out of the ordinary, "an objective and trustworthy account of reality," or "an attempt to reconstruct the essential framework" of an event. News is increasingly what will entertain, sustain the status quo, and maximize corporate profits.

Conclusion: The Rise of the Entertainment-Information Complex

In his farewell address to the nation in 1961, outgoing president Dwight Eisenhower warned of the rise of the "military-industrial complex" in America, a complex which was the product of military establishment and the government working together to set public policy at the expense of needs of American democracy. In language ironically reminiscent of Eisenhower's, Walt Disney president Michael Eisner stated:

> It doesn't matter whether it comes in by cable, telephone lines, computer or satellite. Everyone is going to have to deal with Disney . . . The power center of America . . . has moved from its role as military-industrial giant to a new supremacy as the world's entertainment-information superpower. (Bagdikian 1997, x)

If Jefferson was correct that the answer to governmental power is account-ability which means giving voters full information and real choices, who holds the media accountable? With less than a handful of executives making decisions about what constitutes news, our society is losing the range of options and sources of information it needs to function. Power has shifted in the United States away from the people and even the military-industrial complex and toward a media-industrial complex. This shift in power has come at the expense of the traditional role of the media and the news in a free society, posing new threats to democracy.

References

A Current Affair. 1986–present. Fox Television.

Alger, Dean. 1998. *Megamedia: How Giant Corporations Dominate Mass Media, Distort Competition, and Endanger Democracy*. Lanham, MD: Rowman & Littlefield Publishers, Inc.

Around the News in 22 Minutes. 1991. *New York Times*, 7 July, B1.

Arsenio Hall Show. 1989–1994. Fox Television.

Bagdikian, Ben H. 1997. *The Media Monopoly*. 5th ed. Boston: Beacon Press.

Bailyn, Bernard. 1967. *The Ideological Origins of the American Revolution*. Cambridge: Harvard University Press.

Common Cause. 1997. *Return on Investment: The Hidden Story of Soft Money, Corporate Welfare, and the 1997 Budget & Tax Deal*. Washington, D.C.: Common Cause.

Cook, Timothy E. 1998. *Governing with the News: The News Media as a Political Institution*. Chicago: University of Chicago Press.

Dateline. 1992–present. NBC.

Davis, Richard. 1996. *The Press and American Politics: The New Mediator*. 2nd ed. Upper Saddle River, NJ: Prentice Hall.

Davis, Richard, and Diana Owen. 1998. *New Media and American Politics*. New York: Oxford University Press.

de Tocqueville, Alexis. 1961. *Democracy in America*. Vol. 2. Translated by Henry Reeve. New York: Schocken Books.

Franklin, Benjamin. 1983. An Account of the Supremest Court of Judicature in Pennsylvania, viz., The Court of the Press. In *American Political Writing during the Founding Era: 1760-1805*, eds. Charles S. Hyneman and Donald S. Lutz. Vol. 1, 707–11. Indianapolis: Liberty Press.

Gouldner, Alvin W. 1980. *The Two Marxisms: Contradictions and Anomalies in the Development of Theory*. New York: The Seabury Press.

Graber, Doris. 1993. Political Communication: Scope, Progress,Promise. In *Political Science: The State of the Discipline II*, ed. Ada W. Finter, 305–32. Washington, D.C.: American Political Science Association.

Graber, Doris A. 1997. *Mass Media and American Politics*. 5th ed. Washington, D.C.: Congressional Quarterly Press.

Grossman, Lawrence K. 1995. *The Electronic Republic*. New York: Penguin Books.

Hard Copy. 1989–present. Paramount Pictures.

Herman, Edward S., and Noam Chomsky. 1988. *Manufacturing Consent: The Political Economy of the Mass Media*. New York: Pantheon.

Hyneman, Charles S., and Donald S. Lutz. 1983. *American Political Writing during the Founding Era: 1760-1805.* Indianapolis: Liberty Press.

Iyengar, Shanto. 1991. *Is Anyone Responsible? How Television Frames Political Issues.* Chicago: University of Chicago Press.

Jefferson, Thomas. 1984. *Thomas Jefferson: Writings.* Edited by Merrill Peterson. New York: The Library of America.

Jerry Springer Show. 1991–present. Universal City Studios, Inc.

Laswell, Harold D. 1969. The Structure and Function of Communication in Society. In *Mass Communications*, ed. Wilbur Schramm, 117–30. Urbana: University of Illinois Press.

Levy, Leonard W. 1985. *Emergence of a Free Press.* New York: Oxford University Press.

Lyotard, Jean-François. 1979. *The Postmodern Condition: A Report on Knowledge.* Minneapolis: University of Minnesota Press.

McLuhan, Marshall. 1967. *The Medium is the Message.* New York: Bantam Books.

McManus, John H. 1994. *Market-Driven Journalism: Let the Citizen Beware?* Thousand Oaks, CA: Sage Publications.

McQuail, Denis, et al. 1998. Conclusions: Challenges for Public Policy. In *The Politics of News*, ed. Doris Graber, et al. 251–57. Washington, D.C.: Congressional Quarterly Press.

Mifflin, Lawrie. 1999. Big Television Shocker: Tabloid Shows Go Soft The Mainstream Networks ar Co-opting What Was Once Too Lurid for Prime Time. In *New York Times*, 18 January.

Oprah Winfrey Show. 1986–present. King World Productions, Inc.

Parenti, Michael. 1991. *Make-Believe Media: The Politics of Entertainment.* New York: St. Martin's Press.

Parenti, Michael. 1995. *Democracy for the Few.* 6th ed. New York: St. Martin's Press.

Picard, Robert G. 1998. Media Concentration, Economic, and Regulation. In *The Politics of News, The News of Politics*, ed. Doris Graber, et al. 193–217. Washington, D.C.: Congressional Quarterly Press.

Purdum, Todd S. 1999. TV Political News in California Is Shrinking, Study Confirms. In *New York Times*, 13 January, A11.

Salant, Richard S. 1999. *Salant, CBS, and the Battle for the Soul of Broadcast Journalism.* Edited by Susan Buzenberg and Bill Buzenberg. Boulder, CO: Westview Press.

Schwarz, Ted. 1996. *Free Speech and False Profits: Ethics in the Media.*

Cleveland: The Pilgrim Press.

Schramm, Wilbur L., editor. 1960. *Mass Communications*. Urbana: University of Illinois Press.

Sperber, A. M. 1986. *Murrow: His Life and Times*. New York: Freundlic Books.

Underwood, Doug. 1995. *When MBA's Rule the Newsroom*. New York: Columbia University Press.

20/20. 1978–present. ABC.

Wolf, Michael J. 1999. *The Entertainment Economy: How Mega-Media Forces Are Transforming our Lives*. New York: Times Books.

Woodward, Gary C. 1997. *Perspectives on American Political Media*. Boston: Allyn and Bacon.

Chapter 3
The Protest Paradigm and News Coverage of the "Right to Party" Movement

Douglas M. McLeod

"You've got to fight for your right to party!"
—The Beastie Boys

Research on news coverage of social protests reveals that television and newspaper stories often exhibit a number of similarities. These common characteristics constitute a "protest paradigm": a quasi-formula that journalists follow when constructing news stories about social protests (Chan and Lee 1984). Some of the protest paradigm characteristics include: a focus on the appearance and actions of the protesters rather than the issues they raise, news frames that pit the protesters against the police rather than their chosen target, and a heavy reliance on official sources to define the situation. The protest paradigm shapes journalistic decisions about what gets covered, how it gets covered, and what does not get covered (McLeod and Hertog 1999).

Protest Groups and Their Role in Society

Before getting into the discussion of media coverage of protest, there are a couple of important preliminary questions to think about. What is a protest group, and why should we care how they are treated by the media? Most protest groups are loosely organized collections of individuals and subgroups that band together around some issue or set of issues of mutual concern. Groups come together around issues that include international conflicts, economic and social policies, the environment, gender, race, sexuality, labor relations, and many more. They often seek to bring about social change, though some groups organize to prevent change. The value of joining a group can be illustrated by the analogy of sports fans sitting in a stadium. No one can hear the shouts and cheers of a single fan, but when the crowd acts in unison, it can make quite a noise. In other words, the ideas and actions of a group can carry more weight than the group's individual parts.

New communication technologies such as computers, desktop publishing, fax machines, and video equipment have greatly facilitated the actions of organized protest groups by bridging time and space barriers to organization, communication, and action. The internet in particular has brought like-minded people from around the country and indeed from around the world together to share ideas and to organize for action. The participants in the 1989 Tienanmen Square uprising in China used fax machines linked to the United States to coordinate their efforts and send information to the outside world. The global visibility of the Tienanmen Square uprising illustrates how the emergence of international television news media and their ability to use new technological capabilities (e.g., satellite transmission), have increased the potential visibility and impact of protest groups.

Protest groups vary in a number of ways: in size and scope from a small number of like-minded individuals to a massive social movement such as the Civil Rights Movement; in degree of organization and geographic coverage from informal, localized citizen groups to formally organized, international interest groups such as Greenpeace; and in duration from temporary groups like citizens who organize to block the development of a new shopping mall to permanent groups that address ongoing issues such as abortion. Protest groups expand and contract, join other groups to form coalitions, and at times may dissolve entirely.

Two related characteristics of protest groups that affect how they are treated by the media are their degree of "extremism" and "militancy." Extremism refers to the nature of the goals of the group in terms of how much they seek to change the status quo. The goals of most protest groups fall near the middle of an extremism continuum that includes: protection of the status quo, minor policy reform, radical policy change, and even the overthrow of the system itself. Militancy is based on the type of strategies that a group uses in pursuit of goals. Some groups choose to work within the system through generally accepted channels (e.g., lobbying, canvassing, petitioning, and so forth). Other groups choose more overt, system-threatening tactics (e.g., civil disobedience, countercultural displays, inflammatory language, violence, and attacks on cherished symbols). When groups adopt more extreme goals and more militant tactics, media coverage of them tends to be more critical (McLeod and Hertog 1999).

Goal achievement may not be the only criterion by which to judge the success of a protest group. Many groups never realize their primary objectives, but continue to engage in activities and provide fulfilling experiences for their members for decades. The efforts of a protest group

may yield small goals or prevent change that runs counter to the group's interests. Success may simply come in the form of stimulating public awareness and dialogue. Even though a group fails to change systemic policy, it doesn't mean that the group wasn't successful in changing the attitudes and behaviors of citizens. For example, anti-abortion groups might find success in individuals who decide not to exercise their right to an abortion. Protest groups are successful to the extent that they provide avenues of expression for individuals and a collective voice to represent various interests, regardless of whether they bring about obvious change.

When covering stories that involve protest groups, the media often overlook their small accomplishments and important contributions. Moreover, as will be illustrated later, media coverage of protest groups is often very negative. Ultimately, the media contribute to the forces of social control that constrain protest groups and limit their effectiveness. Before we look at the role of the media as a conduit for social control messages, it is important to ask why we should care about protest groups?

Tolerance of protest groups can be a sign of health for a democracy. Their visibility is an indication that the marketplace of ideas is free and diverse. Protest groups play many roles in that marketplace including raising important issues, contributing new ideas, encouraging systemic evaluation, and stimulating reforms. In most cases, social institutions are relatively resistant to change. Protest groups may directly or indirectly provide an impetus for progressive change. At the individual level, protest groups may provide opportunities for people to get involved and may also provide a safety valve for society by allowing individuals to express frustrations. Protest groups provide a venue for bringing like-minded individuals together. For individuals who hold minority viewpoints, protest may be one of the few available avenues of expression (Baker and Ball 1969; Goldenberg 1975).

Social Control and the Protest Paradigm

As important as they are, protest groups are often treated with disdain by authorities, the public, and the media (McLeod and Hertog 1999). Ironically, while protesters in other countries are sometimes treated as valiant heroes (e.g., the Tienanmen Square protesters, the Solidarity movement in Poland, and the protesters that brought down the Berlin wall and other icons of communist rule), this respect is not typically given to domestic protesters.

Many individuals express hostility toward protesters, viewing them as trouble-makers.

One important question for political communication researchers is whether the media play a role in fostering public hostility toward protesters, and thereby serve as forces of social control. Several mass communication theorists have argued that in covering the news (and not just in covering stories about protests), the media serve to protect power and authority of political, business, educational, and religious institutions (Altschull 1984; Donohue, Olien and Tichenor 1995; Paletz and Entman 1981; Tichenor, Donohue and Olien 1973). Researchers have identified a variety of different factors that contribute to status quo support including the personal and professional backgrounds of individual journalists; the routines and practices of the journalistic profession; economic influences such as ownership and advertising; source media relationships; and cultural ideology (Herman and Chomsky 1988; Hertog and McLeod 1995; Shoemaker and Reese 1996).

Media support for the status quo is most evident when individuals or groups (such as protesters) challenge one of the powerful social institutions. When covering such challenges to authority, the media often provide the function of social control. Demonstrating this media function involves examining both media content and its effects.

Several studies have shown that media coverage often treats protesters as deviants (Gitlin 1980; Hertog and McLeod 1995; McLeod and Hertog 1992). Researchers have suggested two propositions that regulate the application of the protest paradigm. First, the more radical the protest group, the more negatively they will be treated in media coverage (Shoemaker 1984). Second, the more radical the protest group, the more closely the media will adhere to the protest paradigm (McLeod and Hertog 1999). Ultimately, the protest paradigm produces stories that perform a social control function. Radical groups are marginalized and the status quo is reinforced.

Effects research shows that exposure to a news story about a protest can make individuals more hostile toward the protesters (McLeod 1995; McLeod and Detenber 1999; Shoemaker 1982). It remains to be demonstrated whether long-term exposure to media messages that are fairly consistent in their cynicism toward protest may lead to greater intolerance of protest groups and ultimately less willingness to participate in them.

Social control messages are inherent in news stories that follow the protest paradigm. Three of the most prominent forms of social control messages that characterize the protest paradigm are: characterizations of the

group, the choice of narrative structures, and representations of public opinion. Before citing examples of each of these forms of social control messages, it is first necessary to provide some background information on the "Right to Party" movement.

The Right to Party Movement

In the late 1990s, college students on at least 30 different college campuses around the country have demonstrated to express objections to alcohol policies imposed by their university, police, or local government. At least seven of these schools have had more than one such protest on alcohol-related issues. The protests ranged in size from a couple of dozen students to mass demonstrations by thousands of students. Some of these protests were peaceful, but many involved clashes with police, leading to numerous arrests. Though some of these conflicts were responses to attempts by police to close down parties in private residences or in public places, most were motivated by a specific policy issue such as alcohol prohibition policies on campus, or restrictions on the size and location of parties. Among the 30 college campuses where alcohol-related protests occurred were:

♦ *Duke University*: In March of 1998, 1000 students organized a protest and set bonfires to protest alcohol restrictions that threatened the school's "work hard, play hard" reputation.

♦ *Michigan State University*: On May 1, 1998, 3000 students rioted to protest a ban on tailgating at football games.

♦ *Ohio University*: On April 5, 1998, hundreds of students demonstrated to protest early bar closing times.

♦ *Washington State University*: On May 2, 1998, a new policy prohibiting alcohol led to a skirmish between 150 and 200 students and police.

♦ *University of Connecticut*: April 24, 1998, 2,000 students rioted to protest a university crackdown on alcohol.

♦ *University of Massachusetts*: On October 20, 1997, 200 students organized a protest against a partial ban on drinking.

♦ *University of Wisconsin*: On May 4, 1996, 10,000 to 15,000 students rioted and set bonfires in clashes with city police at the 26th annual Mifflin Street block party, started in 1969 as a protest against the Vietnam War.

Other protests took place at Bowling Green State University, Colorado State University, Denison University, Indiana University of Pennsylvania, Miami University of Ohio, Ohio State University, Penn State University, Plymouth State College of New Hampshire, Southern Illinois University, Stonehill College, University of Akron, University of Colorado, University

of Dayton, University of Delaware, University of New Hampshire, University of Northern Iowa, University of Tennessee, University of Utah, University of Virginia, University of Wisconsin—Oshkosh, Utah State University, Western Maryland College, and Wright State University.

By most definitions, these Right to Party demonstrations would not really qualify as a social movement. These protests have largely occurred in isolation, without any attempt to organize groups into a larger coalition. The groups themselves were generally not formally organized, and the protest actions were mostly the result of the spontaneous actions of small numbers of individuals that snowballed into a revolt by a larger mass of people. Some people, including many of the reporters who wrote stories on these demonstrations, would go so far as to question whether the Right to Party participants would even constitute a protest group. They might argue that the students were more interested in drinking, carousing, and flouting authority than in contributing to policy debate. However, it is clear that these protests involved a large number of people who were frustrated with the way they were being treated by authority and official policy. Their actions, regardless of whether they were justified or strategically sound, were genuine responses to challenge the status quo.

In the following sections, several prominent characteristics of the protest paradigm will be discussed. They will be illustrated with examples from newspaper coverage of the Right to Party movement. A search of the Lexus-Nexus database turned up a total of 88 stories from 43 different daily newspapers and three wire services.

Characterizations of the Group

One of the most direct ways to convey legitimacy on or withdraw legitimacy from a group is by giving a label to it. Labels provide powerful cues that shape the way audience members organize their thoughts (Becker 1963; Schur 1983). For instance, audience members may construct more hostile attitudes about a group labeled as "agitators" rather than as "concerned citizens." Similarly, the labels describing the protest itself are also important in establishing whether the audience perceives the protest as a legitimate attempt to influence public policy, or as an attempt to cause trouble.

Labels for the Right to Party Protesters. The words used to describe the

student protesters were not very flattering. They included "rioters," "offenders," "hooligans," "thugs," "out of control students," "boozing, mooning campus protesters," "beery-eye students," "beer-swilling, bottle-throwing, pipe-wielding revelers," a "rock-, bottle-, and brick-throwing mob," and an "unruly crowd." An article in the *Wisconsin State Journal* described the Mifflin Street protesters as "violent party-goers" (Filak 1996). The other Madison newspaper, *The Capital Times,* called them "drunken partygoers" in one news article (Schneider 1996) and "hordes of drunken yahoos" in another column (Zaleski 1996). Most articles implied that the protesters were motivated by alcohol rather than larger concerns. For example, the *Wisconsin State Journal* noted that "alcohol played a major role" (Filak 1996). Other articles located the motivation in the characteristics of members of Generation X. A column in *The Capital Times* said that the alcohol-related "catastrophe" was not a surprise "when you consider you're dealing with an entire generation weaned on Beavis and Butthead" (Zaleski 1996).

Labels for the Right to Party Protests. Words used to describe the protests included "full-fledged riot," "drunken chaos," "nightmare," "disaster," "weekend violence," "drunken, destructive brawl," "a violent beer bash," "rampage," "an all-night spree of drunkenness, bottle throwing and street fires," "mob binges," and "alcohol-fueled street melees." Even the extremely common and seemingly benign phrase, "disturbance," implies disruption and inconvenience, and may legitimize the use of force by the police to "restore order." An editorial in the *Cincinnati Enquirer* summarized the purpose of one protest, "The point is that there is no point. The meaning is pure meaninglessness" ("The Beer Riots" 1998). Ultimately, most characterizations of the protesters and their actions lost sight of the fact that in most of these protests, students had legitimate concerns about university or public policy.

Narrative Structures in Media Coverage of Social Protest

News stories are somewhat like fairy tales in that they tend to be organized around predictable, familiar patterns and themes. Researchers have used the term "news frame" to describe how stories are organized (Entman 1993; Gamson 1992; Gitlin 1980; Pan and Kosicki 1993; Tuchman

1978). Common news frames help journalists assemble information into a news story efficiently. These frames are also important in conveying meaning to the audience by shaping the way audience members think about the protesters and the issues raised.

McLeod and Hertog (1999) identify many of the potential patterns/themes that form the underlying narrative structures found in protest stories. These patterns may provide the organizational framework for the entire story, or as the guiding theme of a section of the story. Some of these patterns are more common than others. They also vary in the degree to which they produce negative consequences for the protesters. The most hostile to protesters have been called "marginalizing frames" and include narratives like the "riot," the "crime story," and the "storm warning" (which asserts that the troubles caused by this protest are part of a large "storm" brewing on the horizon). "Mixed frames" are not necessarily positive or negative toward the protesters. The "showdown" narrative describes a confrontation between police and protesters, without necessarily designating the bad guys; however, this type of narrative does work against the protesters by diverting attention away from the underlying issues and toward a confrontation with police.

The "psychoanalysis" narrative analyzes the root causes of the protest. Also in this group are the "association" narrative, which illustrates direct connections between the protest group and some other group (with either a positive or a negative image) and the "comparison" narrative, which highlights the similarities or dissimilarities between the protest group and some other group. Among the "sympathetic frames" (usually found only in alternative media) are the "creative expression," "unjust persecution," "our story," and "we are not alone" narratives. "Balanced frames" attempt to facilitate debate by presenting the positions of each of the relevant parties to the conflict on each of the major issues; these frames are surprisingly rare in the coverage of social protest (McLeod and Hertog 1999).

The Riot Narrative. A vast majority of the newspaper articles were a combination of the riot and crime story narratives. Many stories followed a pattern of leading with a description of the "riot," and then proceeding to provide details of the police efforts to control the riot by making several arrests. These stories stressed the chaos, unrest, and disorder caused by the protest. For example, the *Deseret News* reported that, "The atmosphere was anything but happy-go-lucky as nearly 100 officers from at least five police agencies raced to the University of Utah Thursday night on the call of a riot in progress." The article goes on to give many of the specific details of the

"riot" (Reece 1996).

The descriptions of the Ohio State protest in the *Columbus Dispatch* focused on property damage: "Three cars were flipped and a fourth was smashed. Mattresses, a couch, and other furniture were set afire in the street. Signs were pulled from the ground, and a light pole was pulled down" (LaLonde and Caruso 1996). The *Des Moines Register's* description of conflict at Northern Iowa was much the same: "24 people were arrested. Several people, including two police officers, were injured. Four Cedar Falls patrol cars and an ambulance were damaged. Two other cars were over-turned, and windows in a convenience store were shattered during the melee" (Bullard 1996). These descriptions of protests were commonplace in the newspaper coverage.

The Crime Story Narrative. As is common with many protest stories (McLeod and Hertog 1992), many of the news stories about the Right to Party protests were framed as contests between the students and police. The major elements of these stories centered on the actions of the protesters and the efforts of the police to restore order. One of the main problems with the crime story frame is that the issues being raised by the protesters (as well as the intended target of their protest) are often buried, if not lost entirely.

The Storm Warning Frame. As more and more of these protests took place, subsequent newspaper stories started to identify the threat of an epidemic, similar to what Cohen (1980) described as a "moral panic." Many articles printed lists of the protest to illustrate the extent of the trend.

The Showdown Narrative. This narrative essentially depicts a battle between the protesters and the police. For example, the *Salt Lake Tribune* article on the University of Utah incident describes the protest as a "mace-spraying, baton-waving melee" between the protesters and the police. At various points in the article, both perspectives on the contest were given: "angry" students "say the cops overreacted to their merrymaking and violated their rights. The police, however, say the 75-plus officers who swarmed down on the fraternities were just trying to defend themselves and disperse the noisy, hostile, uncooperative crowd." The article quotes extensively from the official police report and uses several police officers as sources for the story giving disproportionate weight to the "official" version of the events. But the article does quote one student, who was hit with mace: "It's the most excruciating pain I've ever had. [The spraying was] "a complete abuse of power." Shortly thereafter, the article concludes by returning to the official view as articulated by the University Police Chief, "Resistance has to be met with resistance Salt Lake City police handled

themselves very appropriately" (Israelsen 1996).

The Associated Press used the showdown frame for the Michigan State conflict. The coverage began, "A student protest against a ban on alcohol at a favored Michigan State University tailgate party site turned into a confrontation with police in riot gear, and several people were treated for tear-gas-related injuries A crowd estimated at 3,000 people then moved into downtown East Lansing, chanting obscenities at police. Just after midnight, protesters lighted a fire in one of the busiest downtown intersections. Police said they waited about an hour before they fired tear gas into the crowd so firefighters could put out the fire" (Hoffman 1998).

The Psychoanalysis Narrative. Some stories address the underlying causes of the protest and motivations of the protesters. An example of this narrative was found in a guest editorial in the *Capital Times*, which argued that society's chronic lack of parental discipline and prevalence of spoiled children are to blame. "Parents and elders . . . [are] scared of a swat turning into a jail sentence. Kids no longer have to earn things so handouts are expected. No swats, no learning self-control" (Jensen 1996). This sentiment was echoed briefly in a *Boston Globe* article, which noted that "some administrators and specialists theorize that the unrest may be a sign that students are arriving at universities without having learned the respect for authority at home" (Kitteridge 1997).

The Association Narrative. Several articles on the protest at the University of Wisconsin discussed the history of the traditional Mifflin Street block party, which "erupted into a riot" in 1996. The stories point out that the annual party was started in 1969 after the police attempted to shut down a party. The student response turned into a three-day demonstration against the Vietnam War. While the articles did not really imply whether this was a positive or negative association, this comparison represents a powerful cue for audience members who have existing attitudes toward Vietnam War protesters.

The other association that frequently occurred was linking an alcohol-related protest to other recent protests around the country. Numerous articles presented itemized descriptions of other protests, recognizing that these protests are becoming a common occurrence.

The Comparison Narrative. In many of the stories and editorials, the lead used invidious comparisons to more "respectable" protests to set a derisive tone. The Right to Party protesters were compared unfavorably to Vietnam War protesters and to other contemporary protests around the globe. United Press International did a story on the protests at the University

of Wisconsin, the University of Akron, and Southern Illinois University. The lead included the following contrast, "With bonfires, mace and police in riot gear it was reminiscent of campus protests from three decades ago, but police and school officials said it appeared the disturbances were fueled by alcohol" ("Campus Riot Mars Weekend" 1996).

The lead of a *Lewiston (WA) Morning Tribune* column also follows this frame, "It wasn't exactly one of the great social protests of all time. Whereas previous generations of university students took to the streets to demonstrate for racial equality, for the environment, and for peace in our time, a few hundred sudsy souls at Washington State University took to the streets Saturday night to fight for the fundamental American right to drink beer." The column concluded with the statement, "Many veterans of social protest from America's past must be astonished to see what campus activism has come to" (Hall 1998).

The *Boston Globe*'s article on the New Hampshire protest also compared the protesters to groups from the past. "It's not that police here have never faced unruly crowds of students before. Students rose up against the Vietnam War, apartheid in South Africa, and more recently, in anger over campus rapes. But in recent memory, protests here had never turned into violent melees." It goes on to say that the recent rash of "disturbances" around the country have no "discernible purpose" (Kitteridge 1997).

A column in the *Pittsburgh Post-Gazette* on a protest at Indiana University of Pennsylvania states that, "Students used to protest the war. They used to protest human rights violations. Now they're protesting their own right to get drunk." The column concludes with the following statement: "Students wake up. There are children dying in Iraq, racism is out of control and the environment could still use your help. Stand up for something of value for goodness sake. Only then will you truly be standing up for yourselves" (Ryave 1998).

Similar sentiments were expressed by the mayor of East Lansing in the *Detroit News*, "That there were that many people involved in a protest, not over human rights, poverty or racism . . . but because they won't be allowed to get drunk on a specific piece of the MSU campus is pathetic" (Heinlein 1998). A column in the *Arizona Republic* expressed this sentiment with even more sarcasm:

> What was disturbing these bright young minds? Perhaps it was
> America's continued forebearance of human rights violations in China.
> Or failure to once and for all ensure peace in the Middle East. Or the
> administration's reluctance to ban the use of land mines. But when the
> TV pictures came into focus, reality was disheartening Hell, no,
> we won't go without a six-pack Today's students could choose
> from a menu of troubles on which to unleash their power: starvation in
> North Korea, mutilation of women in the Third World, poverty abroad,
> poverty at home, little wars around the globe, toxic waste, the rape of
> the environment, Jerry Springer Civil liberties are less important
> than the right to bear beers. Maybe students have a lot to say—just not
> much to say about making the world a better place. It's more about
> making the world a more festive place. (Yost 1998)

Sympathetic Narratives. It is not surprising that there were no stories written using one of the sympathetic narratives. Mainstream media, guided by the necessity of maintaining objectivity (Tuchman 1972), are hesitant to adopt a narrative that might cause the newspaper to be seen as an advocate for a protest group.

The Debate Narrative. An article in the *Herald-Sun* from Durham, North Carolina, came the closest to representing a debate narrative. This unusually long article (3,000 words as opposed to the typical length of about 700) analyzed varying views on changes to the alcohol policy at Duke University. It presented the ideas of policymakers who are concerned about alcohol-related problems and also the opinions of students who feel that the policy threatens the "work hard, play hard" ethic that is a Duke tradition. While the article articulated viewpoints on both sides, it had a definite pro-policy slant in terms of the relative proportion of arguments (Dickinson 1996).

Representations of Public Opinion in Media Coverage of Social Protest

One of the more interesting ways that social control messages are embedded within news coverage is through characterizations of public opinion. Although the most salient form of public opinion is the reporting of public opinion poll results, it is much more common for protest stories to use other forms of public opinion including generalizations about public opinion, the invocation of social norms and laws, and the use of bystanders as symbols of public opinion (McLeod and Hertog 1992). Research has shown that representations of public opinion in a protest story may affect people's

estimations of public support for the protesters and their issues (McLeod and Detenber 1999). In turn, perceptions of public opinion may be important determinants of people's willingness to speak out on behalf of groups perceived to be in the minority or as losing public support (Noelle-Neumann 1974; Noelle-Neumann 1984). This may constrain the viability and potential growth of a protest movement.

Public Opinion Polls. There were no public opinion polls conducted in any of the coverage of the Right to Party protests. As such, there is no way to gauge how members of the general public, nor members of the student body, felt about any of the protest issues.

Statements About Public Opinion. Though they frequently quoted the hostile reactions of bystanders, journalists generally avoided direct assessments of the larger public reaction to the protests. One example in a *Capital Times* column·read, "But if most people empathized with police and firefighters, there was little sympathy for the thugs responsible for the riot—the general feeling is that they belonged behind bars" (Zaleski 1996).

Norm and Legal Violations. Simply put, norms are widely shared guidelines for acceptable attitudes, beliefs, and behaviors. When there is social consensus that the violation of these norms is sufficiently problematic, norms become codified in the form of a law, with sanctions attached to punish violations. When a group is portrayed by the media as violating a norm or a law, the news story is implicitly pointing out that the group's actions are counter to the public consensus, thus bringing public opinion into the story (McLeod and Hertog 1992).

It was quite common in the coverage of the Right to Party Movement for norm and legal violations to go hand in hand. For example, an article on the Ohio State conflict in the *Columbus Dispatch* noted that police filed charges against 44 protesters "mostly for disorderly conduct and resisting arrest—after parties along E. 12th Avenue ignited fires and threw bottles and rocks at officers and firefighters" ("Way Sought to Stifle" 1995). Describing a similar scene at the University of Wisconsin, the *Wisconsin State Journal* noted that, "Homes in the 400 and 500 blocks of Mifflin Street had broken windows and parts of the porches damaged or missing. The burned-out shell of a car sat in the 500 block People who attempted to stop the vandalism had bottles and other objects flung at them" (Filak 1996). The deviance of the protesters with respect to social norms was pointed out explicitly by the *Capital Times*, when its story used the phrase, "such behavior is so rare in Madison" (Schneider 1996). In the *Salt Lake Tribune*'s characterization of the Utah protest, norm violations included disorderly

conduct, "hostile, obscene epithets," the throwing of beer bottles and cans, and the punching of a police officer (Israelsen 1996). The *Detroit News* noted that the Michigan State students engaged in "bad behavior, such as couch-burning and public urination" (Heinlein 1998).

A column on the Washington State conflict in the *Lewiston Morning Tribune* illustrates how norm violations can be used to isolate protesters from the mainstream. "But it no longer matters that the cause of drinking was advocated Saturday night in a manner so sophomoric and hurtful that any allies the frat brats might have had will now want nothing to do with them or their cause. There aren't a lot of allies for the kind of people who trash a town, set fires, injure peace officers and behave like a British soccer mob" (Hall 1998).

Bystanders. Bystanders, like the chorus in a Greek drama, can serve as a metaphor for the reactions of the larger public (Back 1988). The depiction of reactions of people not involved in the protest is a common occurrence in protest coverage. Journalists use bystanders as symbols for public opinion to show how the protest group is being received by the common person. When it comes to covering protest, the use of bystanders has a built-in bias against the protesters. If bystanders are sympathetic to the protesters, they are likely to be considered part of the protest (McLeod and Hertog 1992).

In a *Columbus Dispatch* article on the Ohio State protest, one student bystander, who was angry because her car was damaged, was quoted as saying, "It's pathetic, the mentality of my age group" (Miller and LaLonde 1995). Another *Dispatch* article described the reaction of a local store owner who "mingled with the [police] officers yesterday and applauded their efforts" (Cadwallader 1995).

The *Detroit News* cited a Michigan State student whose "study for finals was interrupted by a fire that drew a crowd of 500 less than a block from his second-floor apartment. He said he and his roommates stuffed towels around their patio door to try to keep out the tear gas as police tried to break it up" (Heinlein 1998). Another student bystander was quoted by the Associated Press as saying, "To pick alcohol, drugs as a thing to mark your career in college, to say 'I fought for the right to drink,' I find it weak" ("Right to Carouse" 1998). The *Pittsburgh Post-Gazette* reported the comment of a student eyewitness to the Penn State conflict, "I was embarrassed to call myself a Penn State student" (Schackner 1998).

Bystanders are often used to describe the scene. For example, a bystander at the Mifflin St. conflict was quoted in the *Wisconsin State Journal*, "People were throwing bottles at the police and chanting 'F___ the

pigs"! (Filak 1996). The *Capital Times* noted that residents "haven't been shy about expressing their outrage. One bystander was quoted as saying, "I was sitting in my driveway and a guy walked over and smiled and started peeing on a lilac bush right in front of me" (Zaleski 1996).

Bystanders often support the actions of authority figures to control the protest. For instance, the *Capital Times* quoted a bystander as saying that the "police did an admirable job overall but waited too long before taking action" (Zaleski 1996).

It was common to quote public officials who stood by and observed the protests. The *Capital Times* quoted an alderman who said that the Mifflin Street gathering had "no redeeming value. It was just a great big drinking party" (Schneider 1996). An official spokesperson for Miami University of Ohio observed, "What I saw seemed to have no rhyme or reason, no ideological passion, just rebelliousness without a cause" ("Right to Carouse" 1998). The *Detroit News* depicted the reaction of public officials, "Many university leaders and East Lansing residents saw student irresponsibility as the principal cause of the riots" (Shelton 1998).

Newspapers also went to experts for commentary. The *Boston Globe* printed the opinion of a political science professor, "What the hell's going on? . . . This is a bunch of white New Hampshire kids—what are they making a statement about?" (Kitteridge 1997). Another article quoted sociologist Todd Gitlin, an expert on social protest, "I think it's pathetic. . . .There is a certain population who couldn't think of anything more wholesome than fighting for the right to party" (Lizza 1998).

Consequences of Media Coverage

The protest paradigm tends to produce media coverage that is slanted against protesters. To the extent that the protesters challenge authority and the status quo, the coverage tends to be more negative (McLeod and Hertog 1999). As if this wasn't enough cause for concern for a democratic society, research on media effects of protest coverage shows that even subtle differences in the construction of news stories can have a substantial impact on the audience. Even exposure to a single protest story can make audience members more critical of the protesters and more supportive of the police. The audience may come to see the protest as less effective and to make lower estimates of public support for the protest. They may become less supportive

of the protesters' expressive rights and less likely to see the protest as a newsworthy event (McLeod 1995; McLeod and Detenber 1999).

While it is clear that news stories may affect an individual's perceptions of a specific protest group covered in the story, research has not yet demonstrated whether there is a cumulative effect of protest paradigm coverage on attitudes toward protest in general. This raises a question of whether a society that is constantly bombarded by stories that denigrate protesters would create a culture that is less accepting of protesters, and in which individuals are unlikely to participate. If so, this may decrease the effectiveness of the marketplace of ideas and stifle an important impetus for social change.

The protest paradigm also has consequences for protest groups. Hostile media coverage may inhibit the growth of movements, hasten their decline, and hinder their effectiveness. Concern for attracting media attention affects the strategies of protest groups. The Right to Party protest that received by far the most national attention was the Michigan State protest (it was mentioned in at least 39 of the 89 total stories), undoubtedly because it was one of the biggest and most violent protests. By contrast, at the University of Massachusetts, 200 students engaged in a nonviolent protest against a proposed partial alcohol ban. The Lexus-Nexus database search turned up only two short articles on this protest ("Students Fight Ban" 1997; "Mass. Students Protest" 1997). When it comes to protests, media definitions of what is news seem to be based more on the level of violence than on the importance of the underlying issues (McLeod and Hertog 1999). This leads to what Gamson referred to as a "barter arrangement" between the protesters and the media (Gamson 1989). Protesters will get media coverage, but only if they provide exciting video for TV and photographs for newspapers. But this media attention is a double-edged sword. The violence obfuscates the real issues and may create public hostility toward the protesters.

Differences between the student protest of the 1960s and the Right to Party movement raise many questions about the extent to which protest paradigm coverage has contributed to a culture that socializes young people to refrain from active involvement in social issues and politics. By contrast, there is no shortage of advertising messages promoting alcohol consumption. At this point, we can only speculate on the power of mediated culture to shape student perceptions about which kinds of participation are cool and which are uncool. Are the critics of the Right to Party movement right when they say that only alcohol can lubricate apathetic students? Students may lack role models to inspire and mobilize them. The fact is that American

culture does little to teach the skills necessary to organize. An exception that proves the rule may be found in an article on the Right to Party movement in the *Dayton Daily News.* This article contrasted the typical college environment to the protest friendly culture at Antioch College. "The Antioch administration, faculty and students take organized public-protest actions very seriously. Every semester, students organize local protests or round up groups of students to attend many different kinds of protests around the country. Antioch faculty members have held seminars on how to protest nonviolently and effectively" (Felty 1998).

The vast majority of media coverage of the Right to Party movement condemned the student protesters. However, before the actions of the protesters can be written off so completely, it is important to recognize that there are some underlying concerns that are shared by college students around the nation that led to protests on at least 30 campuses. At the heart of many of these protests was a feeling that institutional policymakers routinely ignored the perspectives of students on a variety of civic and educational issues. A contributing factor to why so many of these protests turned to violence is that students are frustrated by a system that seems unresponsive to their needs and unwilling to listen to their messages. Perhaps, if American culture, including the mass media and the public, were more aware of the important functions that organized protest groups serve, they would be more tolerant of groups that challenge the status quo. Moreover, if the media were more receptive to concerned groups that challenge the status quo, protesters would focus on more constructive strategies to air their grievances and influence public policy.

Conclusion

In summary, this chapter introduced the concept of the protest paradigm, a common pattern used by journalists when covering social protests. Characteristics of the protest paradigm were illustrated with examples from newspaper coverage of the Right to Party protests that have taken place on dozens of college campuses around the country over the past few years. Many of these protests were motivated by legitimate concerns on the part of students that university and local government officials were enacting policies that restrict their rights. In general, the media castigated the students and their protests through the use of derogatory labels. Coverage downplayed the

underlying policy issues instead focusing on clashes with police. In addition, stories depicted public opinion as being stacked against the protesters and their issues. Research on media coverage of other protest groups shows that this type of coverage is quite typical. The fact that researchers have begun to demonstrate that such coverage affects the reactions of the media audience raises a serious question for our democratic system. Do the media contribute to a culture that frowns on dissent, thereby suppressing potential sources of social change and narrowing the marketplace of ideas?

References

Altschull, J. Herbert. 1984. *Agents of Power: The Role of the News Media in Human Affairs*. New York: Longman.

Back, Kurt W. 1998. "Metaphors for Public Opinion in Literature." *Public Opinion Quarterly* 52 (fall): 278–88.

Baker, Robert K., and Sandra J. Ball. 1969. *Violence and the Media*. Washington D.C.: Government Printing Office.

Becker, Howard S. 1963. *The Outsiders*. Glencoe, IL: Free Press.

"The Beer Riots, Sobering News on Campus; Come for the Education—Stay for the Drinking." 1998. *The Cincinnati Enquirer*, 13 May, p. A14.

Bullard, Charles. 1996. "Mob's Violence is Condemned; UNI Planning Quick Discipline for Students Involved in Riot." *The Des Moines Register*, 15 October, p. 1.

Cadwallader, Bruce. 1995. "E. 12th Sees Different Sort of Visit." *The Columbus Dispatch*, 7 October, p. 2C.

"Campus Riots Mar Weekend." 1996. *United Press International*, 6 May.

Chan, Joseph M., and Chin-Chuan Lee. 1984. "The Journalistic Paradigm on Civil Protests: A Cast Study of Hong Kong." Pp. 183–202 in *The News Media in National and International Conflict*, eds. A. Arno, and W. Dissanayake. Boulder, CO: Westview.

Cohen, Stanley. 1980. *Folk Devils and Moral Panics: The Creation of the Mods and Rockers*. Oxford: Basil Blackwell.

Dickinson, Blake. 1996. "New Rules on 'Gothic Playground': Trying to Uphold Intellectual Ideals at Hard-working, Hard-drinking Duke." *The Herald-Sun*, 24 September, p. A1.

Donohue, George A., Clarice N. Olien, and Phillip J. Tichenor. 1995. "A

Guard Dog Perspective on the Role of the Media." *Journal of Communication* 45 (Spring): 115–32.

Entman, Robert M. 1993. "Framing: Toward Clarification of a Fractured Paradigm." *Journal of Communication* 43 (Fall): 51–58.

Felty, Dana Clark. 1998. "Antioch Takes Protests Seriously." *Dayton Daily News*, 26 May, p. 6A.

Filak, Vincent. 1996. "Big Mess on Mifflin Street; Rough Crowd Sets Fires and Pelts Police." *Wisconsin State Journal*, 6 May, p. 1A.

Gamson, William A. 1989. "Reflections on the Strategy of Social Protest." *Sociological Forum* 4 (September): 455–67.

Gamson, William A. 1992. *Talking Politics.* Cambridge: Cambridge University Press.

Gitlin, Todd. 1980. *The Whole World Is Watching: Media in the Making and Unmaking of the New Left.* Berkeley: University of California Press.

Goldenberg, Edie N. 1975. *Making the Papers.* Lexington, MA: D.C. Heath.

Hall, Bill. 1998. "Another Great American Cause—Drinking Beer." *Lewiston Morning Tribune*, 5 May, p. 12A.

Heinlein, Gary. 1998. "MSU Firm on Booze Ban: Munn Tailgate Policy Reiterated After Student Protest Turns Ugly." *The Detroit News*, 3 May, p. C1.

Herman, Edward S., and Noam Chomsky. 1988. *Manufacturing Consent: The Political Economy of the Mass Media.* New York: Pantheon Books.

Hertog, James K., and Douglas M. McLeod. 1995. "Anarchists Wreak Havoc in Downtown Minneapolis: A Multi-level Study of Media Coverage of Radical Protest." *Journalism and Mass Communication Monographs* 151 (June): 1–48.

Hoffman, Kathy Barks. 1998. "Michigan State Students Riot Over Alcohol Ban, Set Bonfires, Jeer at Police." *The Record*, 3 May, p. A12.

Israelsen, Brent Israelsen. 1996. "Sorting Out the Row on Fraternity Row; U. of U. Melee Sparks Anger, Questions." *The Salt Lake Tribune*, 11 May, p. D1.

Jensen, Maribeth. 1996. "Mifflin Riot Proves It: Kids Not Taught Well When Young." *The Capital Times*, 14 May, p. 9A.

Kitteridge, Clare. 1997. "UNH Sees Worrying Trend in Campus Unrest; Motive for Assaults on Police Unclear." *The Boston Globe*, 27 September, p. B1.

LaLonde, Brent, and Doug Caruso. 1996. "Police, OSU Are Looking for Answers; Riot Aftermath." *The Columbus Dispatch*, 1 October, p. 1A.

Lizza, Ryan. 1998. "Hell No, We Won't Go (Sober)." *The New Republic* as reported in the *Sacramento Bee,* 12 July, p. FO1.

"Mass. Students Protest Drinking Ban Proposal." 1997. *The Christian Science Monitor,* 27 October, p. 11.

McLeod, Douglas M. 1995. "Communicating Deviance: The Effects of Television News Coverage of Social Protest." *Journal of Broadcasting and Electronic Media* 39 (Winter): 1–16.

McLeod, Douglas M., and Benjamin H. Detenber. 1999. "Framing Effects of Television News Coverage of Social Protest," *Journal of Communication* (forthcoming).

McLeod, Douglas M., and James K. Hertog. 1992. "The Manufacture of Public Opinion by Reporters: Informal Cues for Public Perceptions of Protest Groups." *Discourse and Society* 3 (July): 259-75.

———. 1999. "Social Control, Social Change and the Mass Media's Role in the Regulation of Protest Groups: The Communicative Acts Perspective." Pp. 305–30 in *Mass Media, Social Control, and Social Change: A Macrosocial Perspective,* ed. D. Demers and K. Viswanath. Ames: Iowa State University Press.

Miller, Alan D., and Brent LaLonde. 1995. "OSU, Police to Take Action After Weekend Riot." *The Columbus Dispatch,* 25 April, p. 1A.

Noelle-Neumann, Elisabeth. 1984. *The Spiral of Silence: Public Opinion—Our Social Skin.* Chicago: University of Chicago Press.

———. 1974. "The Spiral of Silence: A Theory of Public Opinion." *Public Opinion Quarterly* 24 (spring): 43–51.

Paletz, David L., and Robert M. Entman. 1981. *Media Power and Politics.* New York: The Free Press.

Pan, Zhongdang, and Gerald M. Kosicki. 1993. "Framing Analysis: An Approach to News Discourse." *Political Communication* 10 (January - March): 55–75.

Reece, Mark L. 1996. "Police Rush to U. to Quell Melee." *The Deseret News,* 10 May, p. 1.

"Right to Carouse in College: A Dividing Issues for Students." 1998. *Associated Press* as reported in *The Chicago Tribune,* 31 May, p. 8.

Ryave, Christine. 1998. "Students, Put Down Your Drinks and Protest a Worthwhile Cause." *Pittsburgh Post-Gazette,* 30 April, p. A-18.

Schackner, Bill. 1998. "Alcohol Fueled State College Riot." *The Pittsburgh Post-Gazette,* 14 July, p. A-7.

Schneider, Pat. 1996. "Cops Defend Mifflin St. Response." *The Capital Times,* 7 May, p. 3A.

Schur, Edwin M. 1983. *Labeling Women Deviant: Gender, Stigma, and Social Control.* Philadelphia: Temple University Press.

Shelton, Shannon. 1998. "MSU Students Should Use Nonviolence to Challenge Perceived Injustices." *The Detroit News,* 8 July, p. S12.

Shoemaker, Pamela J. 1984. "Media Treatment of Deviant Political Groups." *Journalism Quarterly* 61 (spring): 66–75, 82.

———. 1982. "The Perceived Legimacy of Deviant Political Groups." *Communication Research* 9 (April): 249–86.

Shoemaker, Pamela J., and Stephen D. Reese. 1996. *Mediating the Message: Theories of Influences on Mass Media Content.* 2nd ed. New York: Longman.

"Students Fight Ban on Alcohol." 1997. *The Patriot Ledger,* 21 October, p. 6.

Tichenor, Phillip J., George A. Donohue and Clarice N. Olien. 1973. "Mass Communication Research: Evolution of a Structural Model." *Journalism Quarterly* 50 (autumn): 419–25.

Tuchman, Gaye. 1978. *Making News.* New York: The Free Press.

———. 1972. "Objectivity as Strategic Ritual: An Examination of Newsmen's Notions of Objectivity." *American Journal of Sociology* 77 (January): 660–79.

"Way Sought to Stifle OSU-Area Rowdyism; Lashutka Says He's Considering Shutdown of Some Taverns." 1995. *The Columbus Dispatch,* 3 October, p. 1B.

Yost, Barbara. 1998. "Right to Bear Beers: Rally Cry for the 1990s." *The Arizona Republic.* (Republished in *The Chicago Tribune,* 12 May, 1998 p. 13.)

Zaleski, Rob. 1996. "Drugs, Alcohol, Mobs Don't Mix—Anymore." *The Capital Times,* 9 May, p. 1D.

Chapter 4
Mass Media, Citizenship,
and Democracy: Revitalizing Deliberation?

Gregory W. Streich

Since the late 1960s to the early 1970s, voter turnout has declined in the United States while voter distrust of government and cynicism toward politicians have increased. Some argue that the media are at fault for these trends (Putnam 1995; Hart 1984). Others suggest that the media have inherited, rather than created, a passive, cynical, and ill-informed public. Political parties, interest groups, politicians, and citizens are equally responsible for these trends (Bennett 1998; Schudson 1995; Norris 1996). There are indeed other factors involved, but there is strong evidence to show that the media have not just inherited, but have also contributed, to the problems of low voter turnout and high levels of mistrust and cynicism. In short, news coverage—which is increasingly negative in tone, scandal-oriented, emphasizes image over substance, focuses more on gaffes than policy statements, and interprets politics as a strategic game played by elites—reinforces cynicism, mistrust, and apathy. Thus, the media are partly responsible for turning viewers and readers of news into passive, cynical spectators rather than active, informed citizens (Sabato 1991; Patterson 1994; Davis and Owen 1998; Capella and Jamieson 1997).

The task of this chapter is to understand how and why this happened, and to find ways to bring citizen input back into the democratic dialogue. First, we examine the "guardian" and "participatory" strands of democratic theory in the U.S. to develop criteria with which we can evaluate whether the media are serving, or harming, democracy. Second, we examine the political impact of the ownership structure, practices of news framing, and content of news. Finally, we examine proposals to enhance citizen input through the Internet, electronic town meetings, and deliberative polls (Fishkin 1997). Throughout the chapter we evaluate a variety of reforms that are needed to ensure that the media enhance, not undermine, citizenship and democratic deliberation.

Theories of Citizenship
in the United States

In the U.S. there are two main strands of democratic theory: the "guardian" and the "participatory." Theorists within the guardian strand share some important assumptions about citizens. They view citizens as susceptible to wild swings of opinion and being led astray by demagogues who would steer government in potentially radical and inconsistent directions. For them, it is better for educated, wiser elites to govern and discern the "true" public interest. This fear is illustrated by Alexander Hamilton in Federalist Paper #71, when he argues that a republican government "does not require an unqualified complaisance to every sudden breeze of passion, or to every transient impulse which the people may receive from the arts of men, who flatter their prejudices to betray their interests....When occasions present themselves in which the interests of the people are at variance with their inclinations, it is the duty of the persons whom they have appointed to be the guardians of those interests, to withstand the temporary delusion, in order to give them time and opportunity for more cool and sedate reflection" (1982, 363).

For Hamilton, average citizens are easily duped by passionate rhetoric in ways that produce ill-informed judgments. It is better to empower a more elite group of trustees, who stand above the swings of popular opinion, to calmly sift through various opinions, and make decisions based on the public good. Trusting these guardians, for Hamilton, at times "has saved the people from very fatal consequences of their own mistakes" (1982, 363).

This guardian strand carries through to contemporary views on citizenship. This model assumes it is an impossible ideal to expect citizens to be informed on all political issues, so it is best to leave decisions to political elites who have the necessary expertise. For example, Walter Lippmann argues that the political environment is "too big, too complex, and too fleeting for direct acquaintance. We are not equipped to deal with so much subtlety, so much variety....And although we have to act in that environment, we have to reconstruct it on a simpler model before we can manage with it" (1960, 16). For Lippmann, politics is too complex to be left to citizens whom he compares to spectators sitting in the back row of a theater. The media, for Lippmann, should simplify the complex world for a mostly passive citizenry, and ensure that elite decisions have popular support.

The view of citizens as simple-minded, if not downright ignorant, is held by Joseph Schumpeter who claims "the typical citizen drops down to a lower level of mental performance as soon as he enters the political field" so much so that "ignorance will persist in the face of masses of information however complete and correct" ([1950] 1993, 85). The role of citizens is limited to the simple act of voting for competing sets of political elites represented by the Democrat and Republican parties. For Schumpeter, voter choice is similar to how a consumer chooses which brand of a product to purchase. Campaign commercials are like any other commercial trying to persuade people to buy a product by appealing to their emotions and feelings instead of their reason ([1950] 1993, 92). Elections provide the necessary consent and legitimacy in guardian democracy, but after citizens vote in elections they have fulfilled their duty, return to the role of spectator, and let the guardians govern on their behalf.

In contrast, the participatory strand of citizenship reflects a more optimistic view of the capacities of citizens to participate in self-government. This strand is reflected in the thought of Thomas Jefferson who, like Hamilton, feared demagogues would mislead the public to attain political goals contrary to the public good. Rather than entrusting a guardian class of elites to filter through and dampen the swings of public sentiment as Hamilton envisioned, Jefferson places more faith in the people to arrive at sound judgments provided they were adequately informed.

Jefferson had a different vision of "republican" government. The "republic" of the guardian model rests, as Madison argues in Federalist #10, on the indirect participation of citizens via elections that serve as a filtering mechanism to elect the governing elites (Hamilton et al. 1982, 46–47). By contrast, Jefferson believes that a "republic" rests at least partially on a degree of "direct action of the citizens" (Ford 1905 vol. 11, 529) which leads him to warn that "the further the departure from direct and constant control by the citizens, the less has the government of the ingredient of republican-ism" (Ford 1905 vol. 11, 530). Contrary to the guardian strand's assumption that direct action by citizens is dangerous, Jefferson argues that "the people have less regular control over their agents, than their rights and their interests require" (Ford 1905 vol. 11, 532). Thus, political involvement should extend beyond the act of voting. Realizing that members of Hamilton's guardian class might not always be enlightened statesmen and that they might use political power for selfish ends, Jefferson believes "the mass of the citizens is the safest depository of their own rights and especially, that the evils flowing from the duperies of the people, are less injurious than those from

the egoism of their agents" (Ford 1905 vol. 11, 533). Further, Jefferson argues that "I am not among those who fear the people. They, and not the rich, are our dependence for continued freedom" (Ford 1905, vol. 12, 10). Although the "average" citizens Jefferson was defending were property holding white males and Jefferson held African Americans in slavery, his theory of democracy reflects a stronger faith in average citizens than the guardian model.

Jefferson is aware that the masses of citizens can at times make mistakes, especially if they are ill-informed. But this does not mean citizens should be cut out of the governing process. Jefferson warns, "I know of no safe depository of the ultimate powers of society but the people themselves, and if we think them not enlightened enough to exercise their control with a wholesome discretion, the remedy is not to take it from them but to inform their discretion by education" (Ford 1905 vol. 12, 163). This is where the media, public education, and civic participation become important as sources of experience and knowledge that can inform the discretion of citizens.

This participatory strand of citizenship also has contemporary proponents. John Dewey argues against the view that decisions should be made by a governing elite. For Dewey, a "class of experts is inevitably so removed from common interests as to become a class with private interests and private knowledge, which in social matters is not knowledge at all" (1980, 207). If a democracy relies on decisions made by experts and elites, Dewey feared that they would evolve into an aristocratic "specialized class" that is "shut off from knowledge of the needs [of citizens] which they are supposed to serve" (1980, 206). The knowledge of experts is necessary, but, for Dewey, political decisions in a democracy must include the citizenry in "a consultation and discussion which uncover social needs and troubles" (1980, 206). Linking experts and officials with citizens through deliberation is captured in Dewey's folksy insight that the "man who wears the shoe knows best that it pinches and where it pinches, even if the expert shoemaker is the best judge of how the trouble is to be remedied" (1980, 206). Dewey's notion of democracy requires that citizens participate in identifying social problems and policy solutions and not be cut out of public deliberations.

The participatory model, from Jefferson to Dewey, seeks to supplement representative institutions with more citizen input beyond the simple act of voting. This model does not assume that all citizens will possess expert knowledge on all issues, nor does it require everyone to be politically active all the time, but does assume that citizens can make informed judgments about political problems and solutions when given the proper information.

For advocates of both the guardian and participatory models, the quality of news and information provided by the media is connected to the quality of citizenship in the U.S. Our concern is to ensure that the link between the government and citizens via the media is not just a one-way flow of information whereby media pundits and elected officials talk at a passive citizenry, but is a two-way flow of information that allows citizens some input into the dialogue of democracy. We cannot replace representative institutions with direct democracy, but we can ensure that citizens have information and avenues of input to be involved both in the identification of social needs and in the democratic deliberation about the proper policy remedies.

In short, the health of our democracy is connected to the quality of democratic deliberation. Deliberation enables citizens and officials to identify social problems, examine alternative solutions, and arrive at some type of agreement about the proper solutions.

Vibrant political deliberation requires that two general criteria be met. The first is the *range* of deliberation. This criterion focuses our attention on questions of access, such as do the mass media provide a wide or narrow range of ideas and viewpoints? Do the participants in the dialogue represent sociodemographic groups such as women, the elderly, the young, the poor, and racial minorities, or do participants in the dialogue represent a group of "professional communicators" (Page 1996) whose viewpoints and concerns can diverge from those of the general public? If professional communicators do not represent the wide range of views evident in the general public, if some citizens have access to information while others do not, if information is suppressed, and if the potential solutions that are debated are pre-defined for the public, then this criterion of range is violated.

The second criterion is the *quality* of information on which deliberation rests. This criterion focuses our attention on questions, such as do the mass media provide in-depth or shallow analysis? Is the tone of debate critical or cynical? Is there in-depth discussion of policy issues or the trading of rhetorical one-liners or symbolic appeals that oversimplify the issues? If the media do not provide citizens with substantive, in-depth information and analysis, then the criterion of quality is violated.

Given the criteria of range and quality, I argue below that the media do not fulfill their obligations for both the guardian and participatory models of democracy. As Richard Davis and Diana Owen observe, "The traditional media in the United States have set rigid boundaries that have cordoned off the public from political leaders, and thus have restricted the public sphere. Political discourse in the mainstream media is formalized and exclusive. It

has become the bastion of political and media elite. The public has been relegated largely to spectator status" (1998, 45).

Democratic deliberation in the U.S. is increasingly "mediated" through professional communicators (Hallin 1992; Page 1996). Within this mediated deliberation, citizen input is increasingly minimized as they are turned into spectators of political debate among professional communicators. To understand how citizens have been transformed into spectators, and what reforms are needed to bring citizens back into the democratic dialogue as participants in a broader public debate, we turn to an analysis of the mass media.

The Marketplace of Ideas
Versus the Media Monopoly

Mass media in the U.S., except for outlets like PBS and NPR, which are partially subsidized by public funds, are privately owned. Private ownership and the First Amendment are shields that prevent government from controlling or censoring news and information. In an ideal market system, competition between media outlets stimulates more variety and better quality of information and entertainment. In this "marketplace of ideas," citizens have access to a wide range of competing ideas which, in turn, helps them become informed citizens. Justice Hugo Black captured the importance of the marketplace of ideas when he wrote, "The First Amendment rests on the assumption that the widest possible dissemination of information from diverse and antagonistic sources is essential to the welfare of the public" (Alger 1998, 20). However, there is a growing concern that corporate ownership of mass media is undermining the marketplace of ideas, resulting in news which is neither diverse nor produced by antagonistic sources.

In recent years there has been the rise of the "media monopoly" (Bagdikian 1992) and "megamedia" corporations (Alger 1998) which own most of the media outlets in the U.S. Ben Bagdikian observed in 1992 that "despite more than 25,000 outlets in the United States, twenty-three corporations control most of the business in daily newspapers, magazines, television, books, and motion pictures" (4). The number of megamedia giants shrank from 50 to 23 in the decade prior to 1992, and since 1992 has shrunk to the "dominant dozen" (Alger 1998). Three-fourths of daily newspapers in the U.S. are owned by conglomerates such as the Hearst and Gannett corporations. ABC, NBC, and CBS are owned by Disney, General Electric (GE),

and Westinghouse, respectively. These corporations, whose primary interests are in financial, manufacturing, and entertainment products, are responsible for replacing an emphasis on public interest and substantive political news with "infotainment" which brings ratings and profits (Bennett 1996). Indeed, local television stations typically earn 20% to 50% profit margins, while newspapers earn 12% to 35% profit margins (Alger 1998).

This corporate control of mass media creates conflicts between journalistic ethics and profit-seeking. A Marquette University poll of newspaper editors found that 93% of them felt that advertisers tried to influence the content of news coverage, and 37% admitted they succumbed to this pressure (Alger 1998, 163–164). Advertisers can also influence news content, such as when a St. Louis radio program was pressured by the Monsanto corporation, a major local employer, to drop a guest who was critical of the corporation (Davis and Owen 1998).

Corporate owners, in addition to advertisers, can subtly influence news content. As public funding for PBS shrinks, corporate sponsors fill the gap, which raises fears that the news programming of PBS will reflect the interests of corporations such as Archer Daniels Midland that underwrite the programs (Croteau and Hoynes 1994). NBC's *Today* show, in a story on consumer boycotts, did not mention that GE was targeted, and in another story they "cut out a reporter's reference to the fact that some faulty bolts used in airplanes and missile silos were made by GE" (Alger 1998, 172). These examples illustrate that contemporary censorship is not due to government regulation but often the result of market pressures that lead journalists to avoid stories that might offend advertisers or the corporate parent.

Critics of the media monopoly argue that megamedia corporations have sacrificed in-depth political news and information to the desire for unlimited profits, ratings, and reaching target audiences to whom advertisers want to sell products (Alger 1998; Bagdikian 1992; Bennett 1996). As former NBC reporter Linda Ellerbee notes, "In television the product is not the program, the product is the audience and the consumer of that product is the advertiser. The advertiser does not "buy" a news program. He buys an audience. The manufacturer (network) that gets the highest price for its product is the one that produces the most product (audience)....The best news program, therefore, is the one watched by the greatest number of people . . .Altruists do not own television networks, nor do they run them. Businessmen own and run them. Journalists get fired and canceled by businessmen. That is how it is" (Bennett 1996, 18).

The drive for larger audiences has led many news programs to shift away

from serious political news and toward human interest, entertaining, and scandalous stories which bring higher ratings. Richard Cohen, former senior editor of the *CBS Evening News*, warns that editors and journalists have been pressured by the corporations that own media outlets to replace news values (where reporters and editors decide what is important for citizens to know) with entertainment values (where reporters and editors give the people what they want, even if it is trivial). The result is "market-driven news" that is heavy on life style, scandal, and celebrity stories and light on political information (Cohen 1998).

Studies back up these concerns. The Project for Excellence in Journalism found that from 1977 to 1997, news coverage in the mainstream media, such as CBS, *Newsweek* magazine, and *The Washington Post*, shifted away from the coverage of government and toward the coverage of celebrity and scandal. For example, traditional news and straight news, which are largely straightforward stories analyzing political events, comprised 85% of stories in 1977 but decreased to 59% of stories by 1997. What has filled in the rest? Feature news, such as coverage of Hollywood personalities, human interest stories, and the bizarre, which comprised just 15% of stories in 1997 but increased to 44% of stories in 1997 (Project for Excellence 1998). With news coverage shifting away from politics toward entertainment and infotainment, viewers and readers of news are increasingly treated as consumers who want to be entertained rather than citizens who want to be informed.

Is there any way to combat the effects of megamedia corporations on news and information? Yes. Existing anti-trust laws could be enforced by the Justice Department to prevent further monopolization (Brinkley et al. 1997; Alger 1998). Congress and the Federal Communications Commission (FCC) could put pressure onto broadcasters when it comes time to renew broadcasting licenses to live up to public service obligations and provide viewers with more in-depth coverage of important political issues. The FCC could reinstate the Fairness Doctrine, which was dropped in 1987, to prompt television and radio outlets to devote more time to substantive political discussions. Additionally, Congress and the FCC could develop creative mechanisms such as a 1% tax on television and boombox sales to help fund public and alternative media outlets (Alger 1998). Congress could even fund two PBS networks: one liberal and the other conservative (Bennett 1996). At present, however, Congress is unwilling to engage in these reforms. Indeed, in the Telecommunications Act of 1996, Congress eliminated the limits on the number of media outlets that a single corporation could own in a single market and weakened the public service obligations of megamedia corpo-

rations that use the public airwaves (Alger 1998).

Some argue that Congressional and FCC action is unnecessary because the media monopoly is already being counteracted by alternative media outlets. For example, there is PBS and NPR, but also newspapers serving minority communities such as Latinos and African Americans that are alternative sources of information as well as advocates for certain issues of importance to these communities. Indeed, the Ethnic News Watch is now available on-line at www.softlineweb.com. Further, there has been a flourishing of conservative news magazines and radio talk shows, the growth of cable television, and a seemingly endless number of web sites on the Internet. Even corporations like Time-Warner, which owns CNN, realize there is an audience, and thus a market to be reached by advertisers, for diverse political perspectives. Thus, CNN broadcasts *Both Sides with Jesse Jackson* to supplement their more mainstream offerings.

However, this more populist programming is outnumbered by shows dominated by pundits who represent more elite and status quo opinions (Page 1996; Croteau and Hoynes 1994). Cable television and the Internet have allowed the media monopoly to re-package the same news and entertainment into new products which reinforces their influence over what we see, hear, and read (Bennett 1996). The growth of cable television and the Internet has not produced a wider range of ideological viewpoints or broadened the range of issues examined, but instead has reinforced the homogeneity of news coverage as all media outlets follow the tendencies of pack journalism and intensely cover the same issues (Davis and Owen 1998, 205). The professional communicators who discuss politics through media outlets typically represent a range of opinion "indexed" to reflect the Democratic and Republican Party positions (Page 1996). Further, while "new" media outlets such as the Internet and talk radio provide a little more ideological diversity, they are largely controlled by the existing media monopolies and give established interest groups and think tanks more ability to shape public debate (Davis and Owen 1998, 248).

Media monopolies clearly violate our criteria of range and quality because citizens are not provided with a range of viewpoints from antagonistic sources, they are not provided in-depth coverage of politics, and they are relegated to spectator status. The existence of media monopolies thus raises serious questions about how profit-seeking negatively affects the range and quality of information on which our democratic deliberation rests.

The Visual Packaging
and Framing of News

Some scholars argue that the increasing reliance on television for news and entertainment creates an illusion of participation, but actually reinforces a more passive, inactive, and detached citizenry since television watching is itself a passive, solitary activity (Hart 1994). Further, the visual imagery that frames news stories and political commercials on television reinforces the spectator status of citizens.

In the early 1980s, Lesley Stahl, a reporter for CBS news, ran a story critical of President Reagan. In the report, Stahl showed footage of President Reagan attending the opening ceremonies of the Special Olympics and housing for the elderly, but in her voice-over narration she told viewers how President Reagan had cut the budgets for programs benefitting the elderly and disabled. Stahl's piece called attention to the gap between the President's image and his actual policies. After the report was aired, a senior White House official called Stahl to thank her for the piece. Stahl was stunned, and asked if they realized that she was critical of the President in the piece. In her recollection of the conversation, the official responded, "Lesley, when you're showing four and a half minutes of great pictures of Ronald Reagan, no one listens to what you say. Don't you know that the pictures are overriding your message because they conflict with your message? The public sees those pictures and they block your message. They didn't even hear what you said. So, in our minds, it was a four-and-a-half-minute ad for the Ronald Reagan campaign for reelection" (Bennett 1996, 98).

Stahl failed to understand in time what Michael Deaver, President Reagan's media advisor, realized. For Deaver, when there is a conflict between the eye and the ear, the eye always wins (Hertzgaard 1988, 25). This lends support to those who argue that television is turning citizens into spectators of politics rather than participants. Prior to the television age, John Dewey observed that "[v]ision is a spectator; hearing is a participator" (219). Dewey promotes citizen input in political deliberation, but this is undercut in current times by the power of symbols and images on television which reinforce the spectator role of citizens.

In addition to the power of visual symbolism, there is also the power of "framing." How a news story is framed influences whom viewers hold responsible for causing a problem and providing a solution (Iyengar 1991). In particular, the way television frames an issue such as unemployment,

homelessness, or poverty influences viewers' perceptions of political responsibility. An "episodic" frame that focuses on individuals and portrays isolated examples of poverty elicits sympathy from viewers, but little support for government programs to solve the problem (Iyengar 1991). On the other hand, a "thematic" frame that focuses on the broader social, economic, and political context that are beyond the control of individuals who are living in poverty elicits more viewer support for government programs. In short, episodic framing encourages viewers to hold individuals responsible for problems such as homelessness and poverty, while thematic framing encourages viewers to hold social and political institutions responsible (Iyengar 1991).

Given that the episodic frame dominates television news (particularly local news that focuses on crime and car crashes), framing can unintentionally divert attention away from potential government solutions to ongoing social problems. Further, politics is portrayed largely as a disconnected series of isolated events that focuses on the personal, dramatic side of the story but does not frame it in a thematic context that helps viewers connect seemingly isolated events to a broader understanding of political trends (Iyengar 1991; Bennett 1996).

Adopting a "thematic" approach would give citizens more in-depth information. Instead of an event being covered as an isolated episode, events can be covered and analyzed as part of a more complex social problem. In other words, providing viewers, listeners, and readers with more context, background, and historical information about events and issues will help them make informed judgments. Rather than presenting simplified coverage of complex issues, in-depth coverage could help make citizens, and politicians, aware of the complex solutions required for many of our political problems (Bennett 1996). However, megamedia corporations have cut budgets and staffs in ways that make intensive investigative reporting more difficult, thus making it less likely that the media will adopt a more thematic approach that provides more context (Alger 1998). Shows like *The News Hour* with Jim Lehrer on PBS provide more in-depth coverage, but this is the exception to the rule.

If the media were to employ thematic framing and provide viewers with more historical background and context, would citizens tune in? Perhaps not everyone. One recent study shows that young people between 18 and 30 are focusing more on sports and entertainment than on political news (S. Bennett 1998). This lends support to Michael Schudson's observation that simply watching news does not automatically lead to political activity. Even "better"

news will not stimulate citizen interest and participation unless political parties re-connect with, and mobilize, potential voters (Schudson 1995).

A more proactive approach to journalism might eventually win back the trust of viewers and readers. Some have urged the media to return to its traditional "watchdog" role in which it serves as the advocate of the public interest even if the public is tuning out (Schudson 1995). Others argue that the media should ease off on the excessive focus on scandal and the personal lives of politicians that has turned the healthy skepticism of democracy into a corrosive cynicism that reinforces low levels of trust and participation (Sabato 1991). These efforts, many hope, would enhance the credibility of the media in the eyes of citizens which, in turn, may revive their interest in politics.

Sound Bites and Strategy
versus Policy Analysis

Campaign coverage also reinforces the spectator status of citizens. To paraphrase political scientist V.O. Key, voters may not be fools, but without adequate information they may make foolish choices. The way television covers campaigns has elicited a variety of criticisms, such as: there is an excessive focus on image and symbolism over substance; reporters are increasingly critical of candidates; reporters spend more time on gaffes than on policy proposals; eight second "sound bites" do not provide voters with enough information about candidates or issues; and campaigns are covered as "horse races" in which viewers are only told who is ahead in the polls but are not given any in-depth analysis of their policy agendas (Patterson 1994; Hallin 1992; Davis and Owen 1998). For Davis and Owen, "the constant barrage of bad news gives citizens the impression that political leaders are dishonest, government institutions are dysfunctional, and elections are a charade" (202).

Further, modern campaign strategies use (or misuse) television and radio to air "attack" ads against opponents. Attack ads are more prevalent than comparative or advocacy ads. These attack ads are not intended to inform voters but simply divide and polarize the electorate, which leads many voters to stay at home since the ads inform us whom to vote *against* but offer us nothing to vote *for* (West 1997). Attack ads reinforce citizens' distrust of political leaders and cynicism about politics in general (West 1997).

Moreover, attack ads are often covered by the media as "stories," which then gives them "free" air time on national news programs.

While voters often see through and reject these attack ads, many attack ads are able to sway voters on the basis of fears, misinformation, and symbolic manipulation (West 1997). Attack ads used in recent campaigns, such as George Bush's "Willie Horton" ad in 1988 and Jesse Helms' anti-affirmative action ad in 1990, often are not only false but have not-so-subtle messages about crime, race, and other gut-level issues that invite voters to react in very emotional ways.

To counteract these attack ads, many have suggested that the FCC should find creative ways to urge the major networks to provide candidates with free air time on the condition that they do not engage in mudslinging. Others have argued that the media should serve as a "fact checker" for the claims made in campaign ads. Many news programs and newspapers have adopted Ad Watches where they highlight misleading and dishonest claims. Citizens who read or see such Ad Watches report that they are very helpful in clarifying the issues (West 1997, 105). Although there is a risk that the media might be seen as too critical of politicians by serving as fact checkers, thereby creating an anti-media backlash, this is worth the risk (West 1997).

Television news has also tried to move away from "horse-race" coverage in recent years and offer viewers longer "sound bites" which have shrunk from an average of 43 seconds in 1968 to less than 10 seconds in 1988 (Hallin 1992). To move away from 10 second sound bites, CBS has a segment where they show lengthier segments of candidates speaking so viewers can see and hear them "in their own words." Politicians, however, have adjusted their speeches to include many sound bites which makes it hard for networks to provide viewers anything but a collection of sound bites sprinkled throughout a candidate's speech. The average sound bite has shrunk to eight seconds in length through the 1992 and 1996 election cycles (Davis and Owen 1998).

Despite these efforts to improve campaign coverage, the news media still analyze politics as a strategic game played by political elites. Thomas Patterson (1994) argues that instead of focusing on substantive policy issues, the media largely interpret politics as a strategic game. Patterson notes that everyone employs "schemas" to help understand new and complex informa-tion. However, voters use "governing" schemas that help them interpret new information and relate it to questions of how a candidate would perform once in office, while the media increasingly use "game" schemas that interpret politics and campaigning as a strategic game of maneuvering to win an

election. When the media use game schema to cover campaigns, "A campaign promise may invoke a schema that presumes the candidate is trying to gain favor with a particular interest; a change in media strategy may be seen as an attempt by the candidate to project a more favorable image; the results of a primary election may be viewed as altering the competitive balance between the contending sides; and so on (Patterson 1994, 57).

Understanding the strategy of campaigns is important, but analysis of substantive policies is increasingly minimized. Since the early 1960s, news coverage of campaigns focuses more on the game strategy of politicians than on the substance of the policies and issues: in 1960 news coverage was split roughly 55% policy orientation to 45% game orientation, but by 1992 news coverage was 15% policy orientation to 85% game orientation (Patterson 1994). The dominance of the game schema is prevalent among media pundits on cable television and Sunday morning news programming. For example, during the health care debate in the early 1990s, roughly 90% of news stories focused on the strategy and motives of groups that purchased advertisements while only 10% of stories focused on the complex, substantive policy issues being debated (Delli Carpini and Keeter 1996). The game schema leads political issues to be portrayed as dramatic contests between political leaders (e.g., "Newt versus Bill"), but citizens are given little information about the policies that are being debated.

Even some journalists worry that media coverage of politics is too game oriented. James Fallows, former editor of *U.S. News & World Report*, writes, "A relentless emphasis on the cynical game of politics threatens public life itself, by implying day after day that the political sphere is nothing more than an arena in which ambitious politicians struggle for dominance, rather than a structure in which citizens can deal with worrisome collective problems" (1996, 55). It is this type of political coverage that feeds citizens' cynicism, mistrust, and disconnection from politics. As Davis and Owen suggest, "in the current situation, surrogates—political elites, media elites, pundits, pollsters, and a small active segment of the population—speak most often for the general public in political affairs" (27). Some suggest that the "star" journalists covering politics in Washington, D.C. are too close to the politicians they cover and their salaries and honoraria allow them to live a life style much different from that of average citizens (Page 1996; Fallows 1996).

Citizens are not given a rich debate that they can be a part of, but instead are offered debates among pundits which often resembles a shouting match.

Further, the pundits often do not have expertise on policy issues they are commenting on, resulting in shallow policy analysis and more emphasis on the strategy of politics (Patterson 1994). As Margaret Carlson, a columnist for *Time* who appears on CNN as a commentator because both are owned by Time-Warner, admits, "What I write in *Time* magazine are things I've thought through, I've studied, I've gotten every point of view....What's good tv and what's thoughtful analysis are two different things. That's been conceded by most producers and most bookers. They' re not looking for the most learned person; they' re looking for the person who can sound learned without confusing the matter with too much knowledge. I'm one of the people without too much knowledge. I'm perfect" (Davis and Owen 1998, 193).

Thus, television emphasizes one-liners, sound bites, and strategic analysis of politics, with in-depth analysis of policy being pushed aside in the search for ratings. While pundits engage in shallow debate about political strategy, citizens are treated as Lippmann's spectators in the back row rather than Dewey's concerned citizens.

Reviving Citizen Input and Deliberation: Imperfect Possibilities

Instead of debate among professional communicators that focuses on the strategy of politics, thus turning citizens into spectators of a game, we need a richer political deliberation about issues that includes some form of citizen input.

Many citizens do yearn for better information and for more discussion of policy rather than politics as a strategic game. Studies show that when the media use the governing schema rather than the game schema to analyze politics, this results in less cynicism among viewers and readers of news (Capella and Jamieson 1997). Additionally, voters are more apt to ask policy related questions while reporters are more likely to ask questions related to political strategy (Patterson 1994). For example, during the 1996 campaign, Tim Russert of NBC's *Meet the Press* quizzed Steve Forbes about whether his candidacy was a mid-life crisis and how he personally would gain from his flat-tax proposal. In contrast, citizens who called into shows like Larry King Live asked substantive questions about NAFTA and what his flat-tax proposal would do to the budget deficit (Smith 1996). The different questions in this example illustrate the journalists' focus on scandal and strategy while

the listeners who called in focused on substantive policy issues. Further, when pundits commented on President Clinton's State of the Union speech in 1995, they overwhelmingly focused on its length and gave little attention to his policy proposals. In contrast, polls showed that citizens did not care about the speech's length. Instead, they were more concerned with the substance of the speech and felt more informed about the President's agenda and accomplishments (Smith 1996).

With reporters trying to trip-up candidates, or focusing on details of little concern to voters, rather than dig into substantive issues, it is easy to see why average citizens increasingly view reporters and media pundits as part of the Washington elite rather than watchdogs for the public interest. Indeed, a *Washington Post* survey conducted during the 1996 campaign found that "77 percent of citizens would rather see candidates themselves giving their positions on the issues, while only 16 percent preferred to see more of the news devoted to reporters explaining where candidates stand" (Davis and Owen 1998, 216). Such poll results illustrate first a desire among citizens for unmediated access to candidates, and second, that many citizens want to interpret candidates' positions for themselves rather than rely on journalists to shape their perceptions.

This desire for unmediated access to political leaders and candidates has led many citizens and scholars to argue in favor of new political forums, such as electronic town meetings, where citizens meet and discuss politics directly with political leaders. Telecommunications innovations such as the Internet, satellite television connections, and e-mail are looked at as possibly creating avenues for direct citizen input and cutting back on the political power of the pundits. If citizens have access to vast stores of information from a variety of news outlets and the Internet, why not allow for more direct participation by citizens?

Some argue that the Internet has been developed enough that citizens can and should be able to vote directly on some political issues (Grossman 1995). Using the Internet to create avenues of direct participation and influence on the part of citizens reflects the participatory strand of democratic theory and a growing desire of people to have more say in political decisions. However, Internet direct democracy is not without potential problems that might negatively affect the quality of democratic deliberation. For example, immediate and direct voting may not allow for enough reflection, face-to-face discussion, or examination of alternatives, which might limit the opportunity to find alternatives or compromises (Brinkley et al. 1997). While the Internet can be another source of political information for citizens, many worry that

the immediacy of Internet democracy might lead citizens to make decisions on the basis of gut-level emotions rather than reasoned reflection (Brinkley et al. 1997). Further, the anonymity of the Internet and e-mail has been linked with the rise of "uncivil" dialogue which may turn our democracy into a shouting match between increasingly splintered groups (Brinkley et al., 1997; Davis and Owen 1998).

Moreover, direct Internet democracy may violate our criterion of range if it does not ensure equal access on the part of all citizens. Scholars warn that educated, wealthier, and male voters would have disproportionate political influence because the poor, less educated, women, and minorities have less access to computers and the Internet (Davis and Owen 1998). If we are to experiment with direct Internet democracy, we *must* prevent the emerging digital divide and guarantee access for all citizens to the information and avenues of participation provided over the Internet. Further, we must make sure that Internet direct democracy would allow for the consideration of alternatives and room for compromise.

A second reform for creating direct input is to hold electronic town meetings where citizens could meet candidates face-to-face. Electronic town hall meetings were employed during the 1992 and 1996 elections, and many citizens who directly attended or viewed them on television were satisfied with the quality of information they received (Davis and Owens 1998). While only a small percentage of citizens are motivated enough to attend or watch electronic town meetings, surveys have found that they would draw people from all economic classes. This would help address the problem of unequal participation along lines of income, and improve the range of deliberation by enabling lower income citizens to voice their concerns (Davis and Owen 1998, 150).

A third reform is James Fishkin's idea of "deliberative polling" (1997). Fishkin argues that if about 600 citizens who represent a cross-section of the American public were given in-depth information on a variety of issues like foreign policy, crime, and so forth, and then allowed to discuss alternative solutions before their opinions were polled, that the results would reflect an informed public judgment. If elected political leaders were to look at deliberative polls, rather than traditional polls that reflect a snap-shot view of reactions to questions that offer respondents pre-determined answers to choose from, Fishkin argues that we can improve the deliberations within our representative democracy. Deliberative polls are an attempt to ensure that the polls relied on by the media and elected leaders represent the opinions of a thoughtful, reasoned, and informed public. However, Fishkin's critics have

argued that deliberative polls only offer participants pre-selected topics, information, and choices that reflect the interests of political elites that guide the deliberation (Ornstein and Schenkenberg 1996). If this is the case, deliberative polls also fail to satisfy our criterion of range by only giving participants pre-determined issues and options to choose from and not allowing citizens to place issues that concern them onto the public agenda.

In short, direct Internet democracy, electronic town meetings, and deliberative polling may not be perfect remedies for bringing citizen input back into democratic deliberation. Although promising in their potential to expand the range and quality of democratic deliberation, they each risk reinforcing the problems of unequal access and participation.

Conclusion

The emphasis of this chapter has been on moving away from the guardian strand of democracy that views citizens as uninformed, passive spectators of politics toward the participatory strand of democracy that views citizens as participants in political deliberation that identify social troubles and potential solutions. A vibrant democracy requires political deliberation; and political deliberation requires information and news that is both wide in range and high in quality. Narrow, simplified, and shallow political information will lead to narrow, simplified, and shallow political deliberation. Citizens need the media to provide a broader range of view-points, an awareness of the complexity of politics, and a richer contextual understanding of politics. To revitalize democratic deliberation, we don' t need to institutionalize direct democracy, but we need to open up avenues of citizen input so our representative institutions are more responsive to public concerns.

At the very least, the media can revive its public watchdog role, institutionalize Ad Watches, focus more on substance than strategy, and can provide more context in news reports. However, since the search for profits undermines in-depth news, the government must enforce anti-trust laws, pass campaign finance reform, prompt megamedia corporations to live up to their public service obligations, and reinstate the fairness doctrine. Since the government has been unwilling to pursue many of these reforms, citizens must learn to critically engage the media, turn off the television every once in a while and pick up some newspapers and newsmagazines, and seek out

alternative information outlets outside of the mainstream. If we want to redirect the current trend of passivity and cynicism among citizens, and if we want to reconnect citizens with their elected leaders so we can tell them "where the shoe pinches," the issues and reforms discussed in this chapter are of the utmost importance.

References

Alger, Dean. 1998. *Megamedia: How Giant Corporations Dominate Mass Media, Distort Competition, and Endanger Democracy*. Lanham, MD: Rowman & Littlefield.

Bagdikian, Ben. 1992. *The Media Monopoly*. 4th ed. Boston: Beacon Press.

Bennett, W. Lance. 1996. *News: The Politics of Illusion*. 3rd ed. White Plains, NY: Longman.

————. 1998. "The Uncivic Culture: Communication, Identity, and the Rise of Lifestyle Politics." *PS: Political Science and Politics* 31 (December): 741–61.

Bennett, Stephen Earl. 1998. "Young Americans' Indifference to Media Coverage of Public Affairs." *PS: Political Science and Politics* 31 (December): 535–41.

Brinkley, Alan, Nelson W. Polsby, and Kathleen M. Sullivan. 1997. *The New Federalist Papers*. New York: W.W. Norton.

Cappella, Joseph N., and Kathleen Hall Jamieson. 1997. *Spiral of Cynicism: The Press and the Public Good*. New York: Oxford University Press.

Cohen, Richard. 1997. "The Corporate Takeover of News: Blunting the Sword." In *Conglomerates and The Media* ed. Erik Barnouw, et al. New York: The New Press.

Croteau, David, and William Hoynes. 1994. *By Invitation Only: How the Media Limit Political Debate*. Monroe, ME: Common Courage Press.

Davis, Richard, and Diana Owen. 1998. *New Media and American Politics*. New York: Oxford University Press.

Delli Carpini, Michael X., and Scott Keeter. 1996. *What Americans Know About Politics and Why It Matters*. New Haven: Yale University Press.

Dewey, John. [1927] 1980. *The Public and Its Problems*. Athens, OH: Swallow Press.

Fallows, James. 1996. "Why Americans Hate the Media." *Atlantic Monthly* (February): 45–64.

Fishkin, James S. 1997. *The Voice of the People: Public Opinion and Democracy.* Updated ed. New Haven: Yale University Press.

Ford, Paul L., ed. 1905. *The Works of Thomas Jefferson.* Vols. 11 & 12. New York: The Knickerbocker Press.

Green, Philip, ed. 1993. *Democracy.* Atlantic Highlands, NJ: Humanities Press.

Grossman, Lawrence. 1995. *The Electronic Republic: Reshaping Democracy in the Information Age.* New York: Viking.

Hallin, Daniel C. 1992. "Sound Bite News: Television Coverage of Elections, 1968–1988." *Journal of Communication* 42 (spring): 5–24.

Hamilton, Alexander, James Madison, and John Jay. [1787–88] 1982. *The Federalist Papers.* New York: Bantam.

Hart, Roderick. 1994. *Seducing America: How Television Charms the Modern Voter.* New York: Oxford University Press.

Hertzgaard, Mark. 1988. *On Bended Knee: The Press and the Reagan Presidency.* New York: Farrar, Straus & Giroux.

Iyengar, Shanto. 1991. *Is Anyone Responsible?* Chicago: University of Chicago Press.

Lippmann, Walter. [1922] 1960. *Public Opinion.* New York: Macmillan.

Norris, Pippa. 1996. "Does Television Erode Social Capital? A Reply to Putnam." *PS: Political Science & Politics* 29 (September): 474–480.

Ornstein, Norman, and Amy Schenkenberg. 1996. "The Promise & Perils of Cyberdemocracy." *American Enterprise* (March/April): 53–54.

Page, Benjamin I. 1996. *Who Deliberates?* Chicago: University of Chicago Press.

Patterson, Thomas E. 1994. *Out of Order.* New York: Vintage.

Project for Excellence in Journalism. 1998. *Changing Definitions of News: A Look at the Mainstream Press Over 20 Years.* Washington, DC: Project for Excellence in Journalism.

Putnam, Robert. 1995. "Tuning In, Tuning Out: The Strange Disappearance of Social Capital in America." *PS: Political Science and Politics* 28 (December): 664–83.

Sabato, Larry. 1991. *Feeding Frenzy: How Attack Journalism Has Transformed American Politics.* New York: The Free Press.

Schudson, Michael. 1995. *The Power of News.* Cambridge: Harvard University Press.

Schumpeter, Joseph. [1950] 1993. "Capitalism, Socialism and Democracy." In *Democracy.* Ed. Philip Green. Atlantic Highlands, NJ: Humanities Press.

Smith, Hedrick. 1996. *The Unelected: Lobbies and The Media*. 157 min. PBS Video. Videocassette.

West, Darrell M. 1997. *Air Wars: Television Advertising in Election Campaigns, 1952–1996*. 2nd ed. Washington, D.C.: Congressional Quarterly, Inc.

Chapter 5
Mirror, Mirror?
The Politics of Television Science Fiction

Rex Brynen

"Get a life, will you, people! I mean for crying out loud, it's just a T.V. show!"
—William Shatner ("Captain Kirk"), *Saturday Night Live*

The study of television, and of popular culture more generally, has a peculiar history within mainstream political science. Some aspects—in particular, the role of political advertising in electoral campaigns, and the impact of TV news—have been extensively studied. There has also been substantial work done on broadcasting policy, particularly in those countries where the state assumes a major regulatory role or where (as in Canada and many European countries) the state itself owns a major broadcast network. Paradoxically, the primary *content* of television—namely, popular entertainment—has received much less attention from political scientists. Instead, this field of analysis has largely been left to scholars of communication/media studies, cultural analysis, comparative literature, and anthropology.

Television science fiction (sf TV) too has received little academic attention. Part of the reason stems from its status as "low" culture, presumably unworthy of serious attention. The *Encyclopedia of Science Fiction*, for example, notes that:

> . . . televised sf, in a history spanning over 40 years, has never approached the intellectual excitement of the best written sf, or indeed the best sf in the cinema. Because televised sf cleaves to the expected, we are seldom surprised by it; we seldom feel any sense of wonder or even stimulation. . . . Televised sf is a cultural scandal. . . (Nicholls and Clute 1993, 1208; Disch 1998, 97)

Be this as it may, there are good reasons to undertake serious political analysis of popular entertainment in general, and sf TV in particular.

First, the entertainment industry has often been intimately bound up with political debates and sociopolitical change. It is also clear that popular entertainment is an important vehicle for the transmission of political ideas and values. Take, for example, the political rebelliousness associated with many strands and eras of popular music: the American counter-culture,

anti-war ethos of the 1960s, the under-class underpinnings of British punk rock in the 1970s, the connection between some aspects of skinhead music and the neo-Nazi movement in Europe, the very political content of much reggae music, or the inner-city origins and reflections of rap—all of these illustrate the point. In the case of television, the two most popular American television shows of all time (*TV Guide* 1998), *All in the Family* and *M*A*S*H*, were filled with social commentary on bigotry and war, respectively. During the Bush administration, both *The Simpsons* and *Murphy Brown* came under political attack for the life-styles they portrayed—and both shows mounted on-air responses. Subsequently, Bill Clinton fought his successful 1992 and 1996 presidential election campaigns in part through innovative on-air appearances on *MTV, Larry King Live,* and the *Arsenio Hall Show*. At that time, surveys suggested that a quarter of Americans had gained information on the campaign through watching talk show hosts like Jay Leno and David Letterman, and 13 percent cited *MTV* as a source of political information (Kurtz 1999).

Moreover, in the broader context of TV entertainment, there are good reasons to focus special attention on TV science fiction. First, it has often been a very successful genre. *Star Trek,* for example, is widely considered to be the most successful franchise in the history of television, broadcast in up to one hundred countries, and viewed by more people per day than science fiction literature is read in five years (Spinrad 1990, 79). The original series (ST:TOS) gave eventual birth to *Star Trek: The Next Generation* (ST:TNG), *Star Trek: Deep Space Nine* (ST:DS9), *Star Trek: Voyager* (ST:VOY), an animated series, scores of best-selling books, and nine successful feature-length movies. Its language ("warp speed," "beam me up," "to boldly go") entered popular idiom, and its fans ("trekkies" or "trekkers") became the only such group to merit an entry in the *Oxford English Dictionary*. As Greenwald notes, "the exploits of Kirk and Picard are at least as famous as the labors of Hercules . . . the *Enterprise* itself may be the most famous vehicle ever created" (1998, 4–5).

Second, television science fiction, like science fiction in general, is by its very nature speculative. As such, it is open to imagining a range of possible futures, and has often had politics as a central focus. The very successful drama show *The X-Files*, for example, played upon growing interest in genetic manipulation, the possibility of alien intelligence, and a host of other scientific themes. It was also said to reflect—and perhaps contribute to—widespread 1990s cynicism about politics, the media, and the role of government. In other cases, writers have used the medium to explore or

expound particular social and political visions. Both *Star Trek* creator Gene Roddenberry and the creator of the highly-regarded *Babylon 5* series, J. Michael Straczynski, for example, were explicit about the extent to which they used their shows to treat a range of contemporary—and future—social issues.

To Boldly Go: Analytical Perspectives

In studying TV sf—or, for that matter, any other aspect of popular culture—a variety of approaches can be adopted.

One approach is to emphasize the degree to which *politics shapes culture*. Cultural output is thus seen as a mirror of social and political inputs—a reflection of sorts of the fears, dreams, and preoccupations of society. As will be shown later, TV sf (and indeed, the genre more generally) is replete with these sorts of connections. Many plots are inspired by contemporary events, or represent veiled (or not so veiled) social commentary. Gene Roddenberry once noted that his inspiration came from "concentrat[ing] on something about our world that annoys me—so that I get sufficiently moved, so that I want to write about how, in the *Star Trek* world, it's done differently" (Fern 1996, 86). Similarly, prolific *Star Trek* scriptwriter Brannon Braga suggests that the typical episode "tells an exciting adventure, while at the same time serving as a metaphor for contemporary humanity" (Greenwald 1998, 199). Conversely, the societal attitudes can also *constrain* what is possible in the cultural sphere. Roddenberry complained, "I can't replicate my world on television, because there are too many other considerations involved. It has to make money. It has to comply with current society's standards of decency—of today's values" (Fern 1996, 115).

A second approach to the study of popular culture reverses the causal connection, and examines the extent to which *culture shapes politics*. From this perspective, the entertainment industry is one of many agents of political socialization, acting to transmit political attitudes. As Roddenberry once noted:

> . . . a producer or writer cannot help [but] make a statement of one type or another which influences his audience. Or, by trying to make no statement, a creator is actually committing a sin of omission and actually stating to the audience that there are no problems or issues which ought to concern the audience. This is perhaps the greatest evil which commercial television

perpetuates upon our nation. . . . I have some nagging doubts about what happens
to the medium if we all leave it to those who don't worry about its impact on
people. (Alexander 1995, 387)

What is this impact? Research on science fiction suggests that those who
frequently read or watch the genre are much more likely to be dissatisfied
with the present state of society, much less likely to be religious, more likely
to be liberal in their political views (albeit with a conservative subgroup of
fans also evident), and much more likely to support public spending in
support of space exploration. This has led some to conclude that exposure
to sf encourages intellectual independence, a "subculture of free thinkers"
that is "prepared to consider many radical alternatives in culture and social
organization" (Bainbridge 1986, 170–171). Moreover, the demographics of
television science fiction tend to be biased towards higher levels of
socio-economic status and education, suggesting that its impact is strongest
in segments that are typically considered social opinion leaders.

A third approach highlights the operational realities of cultural
production. One overriding aspect of this has been the *commercial
imperative* for television sf to attract viewers and advertisers, and hence
survive in the fiercely competitive world of broadcasting. Television content
is also constrained by the *technical aspects* of the medium: the costs of
actors, sets and special effects; rapid production schedules; the imperative
to fit stories within thirty or sixty minutes (minus commercials), and the
desirability of building the show around these required interruptions; the need
for humor, conflict, or engaging personalities to underpin the story line. TV
sf aliens are so often humanoid, for example, in large part because of the
costs and complexities of makeup, costuming, and special effects, as well as
the need to create characters to whom viewers can relate. Thus, these
constraints may clash with another important factor: the *creative impulses*
of writers and directors. For some analysts—even those that accept that the
"third generation" of genre science fiction has been dominated by television
rather than literature—the result is necessarily formulaic (Stableford 1996).
Yet, while the cultural quality of television may be derided by critics, there
remains much art in balancing the commercial imperatives, technical
constraints and the professional desire to produce interesting work.

The approach taken in this chapter integrates all three of these
perspectives, highlighting how politics shapes culture, how culture shapes
politics, and how commercial, technical and creative factors shape both. As
John Street argues (1997, 9, 22), "Popular culture makes us feel things,

allows us to experience sensations, that are both familiar and novel. It does not simply echo a state of mind, it moves us." This, he notes: "This process takes place within a wider context in which political interests and values shape popular culture, just as the political economy of popular culture determines the political possibilities within that culture."

At the same time, some analytical caveats are in order. One is the problem of demonstrating causal relationships. Does sf really contribute to critical free-thinking, or are critical free thinkers more likely to be attracted to the genre? The cloudiness of the historical record can also cause analytical problems. In the case of *Star Trek*, for example, some reports of the show's battles with gender and racial discrimination may contain a degree of after-the-fact embellishment. Finally, it is not always self-evident whether science fiction writers are really commenting on critical social issues, or whether analysts are imposing their own preoccupations onto content that is really rather less meaningful than they claim. J. Michael Straczynski, commenting (positively) on an academic book on *Babylon 5*, wryly highlighted the problem: "I found in reading it that I was smarter, stupider, more liberal, more conservative, more progressive, more reactionary, than I had previously imagined" (Straczynski 1998, commenting on James and Mendelsohn 1998). Or, as a holographic Sigmund Freud commented in one *ST:TNG* episode ("Phantasms")—"sometimes a cigar is just a cigar."

A Brief History of Science Fiction Television

Before TV there was film. Cinematic science fiction, although almost as old as the medium itself, had its first burgeoning in the 1930s in the form of adventure serials. With the advent of television, many of the earliest shows copied this pattern: *Captain Video* (1949–55), *Buck Rogers* (1950–51), *Tom Corbett: Space Cadet* (1950–52), *Space Patrol* (1950–55), among others (Disch 1998, 98).

A second wave of cinematic sf in the 1950s produced more innovative work, often reflecting both accelerating technological change and growing Cold War fears. A decade later, this second wave of science fiction also began to find its echo on the small screen. Anthology shows such as the *Twilight Zone* (1959–64) and the *Outer Limits* (1963–65) were early examples. A host of TV series (and movies) from Irwin Allen also appeared:

Voyage to the Bottom of the Sea (1964–68), *Lost in Space* (1965–68), *Time Tunnel* (1966–67), and *Land of the Giants* (1967–69). *My Favorite Martian* (1963–66) played alien visitation as light comedy; *The Invaders* (1967–68) portrayed it as dark threat.

Today, however, it is *Star Trek* (1966–69) that is considered to have a seminal place in this history. Certainly, it seemed to articulate a vision of the future that was different from the *Leave It to Beaver* ethos of *Lost in Space*. *ST: TOS* also addressed, as discussed later, many of the most controversial political issues of its time. Its influence was hardly evident, however, in its mediocre ratings and eventual cancellation. An animated series (1973–74) briefly followed.

Indeed, in the US few second-generation shows lasted more than three seasons. In the UK, matters were different, in large part because of a different competitive environment. The quirky BBC series *Dr. Who* sustained what would become the longest run of any sf or fantasy series, from 1963 until 1989. *Blake's Seven* (1977–81) also survived for an extended period, as did the satirical *Red Dwarf* (1987–). The miniseries *Hitchhiker's Guide to the Galaxy* (1981) was a critical success, and frequently rebroadcast.

The third wave of sf TV was, once again, partly spurred by the cinema. The 1970s and 1980s saw a host of science fiction box office successes, including three *Star Wars* movies, *Close Encounters, Alien, Aliens, ET, Terminator,* the various *Star Trek* movies, and many others. Such success led network and studio executives to look for similar results in the television universe. Some of the resulting shows were linked to cinematic versions: *Planet of the Apes* (1974), *Battlestar Galactica* (1978–80), and *Alien Nation* (1989–90, plus TV movies). All of these had short and largely uninspiring runs. *Space 1999* (1975–77) was another effort at "hard" (technological) television science fiction.

In September 1987, however, *Star Trek* once more returned to television. The crew of *Star Trek: The Next Generation* (1987–94) was new, but the initial Roddenberry vision was still very much in evidence. Later, two additional series—*Star Trek: Deep Space Nine* (1993–99) and *Star Trek: Voyager* (1995–)—were also produced. By the end of 1998, the various Star Trek television incarnations had broadcast a remarkable total of 543 episodes.

In addition to Star Trek, this period saw the emergence of a number of other "hard" sf shows. Many utilized the same "exploratory" theme. *Seaquest DSV* (1993–96) transferred it to an underwater setting. *Quantum Leap* (1988–93) was premised on a sort of time travel, while *Sliders* (1995–)

explored a series of alternative Earths, each with differing social, political, and environmental conditions, and *Stargate SG-1* (1997–) saw the protagonists explore distant worlds via alien technology. Still others emphasized a grittier representation of galactic conflict than the *Star Trek* universe. *Space: Above and Beyond* (1996–97) enjoyed only a short-lived run, but combined its space combat theme with well-written commentary on racism and other issues. *Babylon 5* (1994–98) won acclaim for its intricate multi-year story arc, as well its depiction of the political, economic and cultural complexities of interstellar relations. Earth invasion themes—a genre stretching back to the 1950s—remained well represented, in shows such as *War of the Worlds*, *Third Wave*, *V* (1984–85) and *Earth: Final Conflict* (1997–). Both *The Twilight Zone* (1985–88) and *Outer Limits* (1994–) returned with new anthology series. Finally, *Max Headroom* (1987–1988) was notable not for its duration—it ran less than a full season—but both for its sharp-edged social commentary on the mass media, and for the extent to which it grew from, and became, a pop icon. Originally conceived as a hypothetical host for (UK) Channel 4 music videos, Max went on to become a spokes(person?) for Coca-Cola, and was used by satirical cartoonist Gary Trudeau to depict the public relations skills of the Reagan administration.

And then there was *The X-Files* (1993–)—a very different kind of show, predicated on a mix of paranormal phenomena, alien invasion, and sinister government conspiracy, and sustained by outstanding writing and cinematography. Watched by an estimated 10 million American households each week, and millions more in syndication, it was among the top twenty US television shows through much of its run. It also spawned a number of imitators, including *Dark Skies* (1996–97), *Psi-Factor* (1996–), and *Strange World* (1999-).

To the extent that sf TV enjoyed a rebirth, much of the reason lay with the changing technology and political economy of the broadcast industry. In the US, the oligopoly of the big three broadcasters (ABC, CBS, NBC) gave way to a more diverse context, characterized by greater viewer accessibility, satellite broadcasting, the rise of other smaller networks and speciality channels, and the growing importance of domestic and international syndication. Similar media diversification was underway in Europe and elsewhere. This, and especially the establishment of science fiction speciality channels in the US (the *Science Fiction Channel*) and Canada (*Space: The Imagination Station*) made it easier for producers to find development funding, target their product at a niche audience, and sell their final product. The diversification of media outlets also made it possible for some science

fiction shows (such as *Lexx*, 1997–) to be much more provocative than would have been possible twenty years earlier, when they had been forced to rely on major broadcasters and sponsors, larger audiences, and broader demographics. As the station manager for *Space: The Imagination Station* noted, "In the cable world, we have a bit more leeway with our audiences, not needing the huge numbers that the networks demand, that lead to cancellations after two shows" (McGrath 1998).

Changing technology also affected the production of sf TV in another way. The growth of the internet not only linked fan communities in new and powerful ways, but also provided a direct and immediate channel for feedback from consumers to producers. *The X-Files* is often said to be the first television show to have acquired cult status through its internet fan base of X-philes. The large *Star Trek* community also adapted quickly to the new technology. *Babylon 5* creator Straczynski could often be found in online discussion groups, where he and fans could directly explore plots and story arcs. Inevitably, such online discourse helped shape the future evolution of all of these shows—a level of social interactivity previously unknown in the medium.

sfTV and Contemporary Social Issues

As noted earlier, sf TV has offered an unusually strong focus on political and social themes. There is much that could be discussed in this regard. An entire volume, for example, has been written on the metaphysics of *Star Trek*, and its reflections on life, sentience, science, identity, reason, and religion (Hanley 1997). For reasons of limited space, three sets of social and political issues will be explored below: geopolitics, multiculturalism, and gender and sexual orientation.

Geopolitics

From the 1960s to the late 1980s, most sf TV shows were archetypically American, in which the future reflected contemporary American values, expressed with an American accent. Indeed, "foreign" accents were almost always used to denote a certain alien quality, especially of the threatening variety. Cold War fears found frequent representation in sinister plots by

aliens or humans that threatened freedom, democracy, or other cherished ideals of Western civilization.

Perhaps the first shows to offer more varied reflections on US foreign policy were the anthologies (Worland 1996). *The Twilight Zone* raised the possibility of US troops dying in Vietnam in 1963, a year before the Tonkin Gulf Resolution formalized US entry into the war as an acknowledged combatant. *The Outer Limits* too offered stories that dealt with the situation in southeast Asia. Both dealt with other Cold War reflections, too—sometimes critically, sometimes repeating established cliches. However, if the anthology shows periodically pushed the edges of the creative and political envelope, they were also shaped by the limited tolerance of controversial material by networks and sponsors. *Twilight Zone* creator Rod Serling once characterized himself not as "a meek conformist," but rather "a tired non-conformist." He noted, "I'm not writing any material that lies in the danger zone. . . . It no longer behooves us to bite the hand that feeds us" (Boddy 1984, 106).

A few years later, *Star Trek* also offered a mixed portrayal of contemporary political realities through the lens of sf. Many aspects of *ST:TOS* reproduced rather than challenged conventional images. Treatments of indigenous cultures, for example, generally cleaved to one or other of two entrenched stereotypes: the dangerous barbarian, or the noble savage. Other episodes seemed to recreate the tensions of the Cold War. The Klingons of *ST:TOS* often seemed little more than futuristic Soviets—untrustworthy, expansionist, and locked in an inevitable bipolar struggle with the benevolent Federation for control of the galaxy. The more "inscrutable" Romulans later provided a possible analogy for Communist China in quasi-Roman garb. The mission of the Enterprise often seemed to combine liberal utopianism with a sort of benevolent imperialism: colonizing areas of space, bringing knowledge and democracy to backward planets, and protecting them from Klingon or other threats (Goulding 1985). As Lagon (1993, 262) argues, "The original Star Trek series overtly examines the compulsion of American foreign policy makers to feel that they owe it to other countries to interfere in their affairs. In revealing this American penchant, the series is so metaphorically suggestive that it yields lessons beyond the context existing when it aired."

In other respects, however, *Star Trek,* challenged some established assumptions. Despite conflict with the Klingons, the general Roddenberry vision was of a more cooperative future, and manifest in the form of *Star Trek*'s "United Federation of Planets." The "Prime Directive"—although

often violated—forbade intervention in the affairs of less advanced civilizations, distinguishing Federation policy from the sort of destructive expansionism that had historically characterized European and American contact with indigenous populations in the Americas, Africa, and Asia. In *ST:TOS*, a number of episodes can be seen as offering commentary on both the Cold War and the ongoing war in Vietnam (Franklin 1994; Gross and Altman,1995, 60, 71). "City on the Edge of Forever" (Kirk must allow a 1930s pacifist to die so as to assure US entry into World War II) seemed to suggest the dangers of the anti-war movement . However, "A Private Little War"—explicitly intended as commentary on Vietnam—offered a more complex moral challenge: when the Klingons arm a group of villagers on a neutral planet, Kirk intervenes to maintain a military balance, despite complaints from Dr. McCoy that this condemns the locals to years of continuing conflict. In "Day of the Dove," the Enterprise crew and the Klingons must cooperate to deal with a common foe that feeds off violent conflict. "The Enterprise Incident" was an episode directly inspired by capture earlier that same year of the US spy ship *Pueblo* by North Korea, although the *Star Trek* version generally seems to avoid much discussion of the illegality of such espionage (Worland 1988).

It could be argued that the depiction of conflict, and the tendency to cast it as a struggle between good and evil, arises not only from the geopolitical ethos of the time, but also from the requirements of dramatic television. Indeed, *ST:TNG* attempted to break away from the stereotypes by introducing a new type of foe: the Ferengis, driven by motives of trading interests and financial profit rather than conquest or power politics. Yet early depictions of the Ferengi were far from an unqualified dramatic success. Consequently, the Ferengi "personality" was substantially modified over time, and more classically militaristic threats were (re)invented in order to provide greater dramatic tension. The Romulans reappeared. A new cybernetic enemy—the Borg—were invented. In *ST:DS9*, the expansionist Dominion and its Cardassian allies would become an increasingly important component of the show—once again, in a deliberate effort to provide greater dramatic tension.

The Borg would prove to be one of the most popular of all *Star Trek* enemies. Perhaps this was because they captured end-of-millennial social angst regarding the dehumanizing effects of technological progress, the complexities of postmodern identity, or reflected the emergence of new forms of social control (Hastie 1996; Gray and Mentor 1995). Their collective cybernetic consciousness certainly embodied the fundamental antithesis of

liberal individualism—a point underscored by the distinct identities of the few reformed, "good" Borg such as "Hugh" (*ST:TNG*) and "Seven-of-Nine" (*ST:VOY*). Or perhaps it was simply because the Borg were such great villains. Certainly, with the introduction of Seven-of-Nine and the Borg "Queen" (*ST:VOY*, and movie *Star Trek VIII: First Contact*) the show managed to successfully combine the entertainment staples of sex and violence.

Still, as Clyde Wilcox has argued (1992), it is very clear that "cultural change has altered the mission of the *Enterprise* and the interactions of its characters." In later versions of *Star Trek*, the undesirability of war and the value of cooperation were much more frequently underscored than they had been in *ST:TOS*. Captains Picard (*TNG*), Sisko (*DS9*) and Janeway (*VOY*) often eschewed available force, and relied on diplomacy—in sharp contrast to the more action-oriented Captain Kirk. Despite Roddenberry's concerns about a slide toward greater militarism, *The Next Generation* exhibited less violence than its predecessor: in the first three seasons, the Enterprise fired on a crewed ship on only three occasions, and in each case under unusual circumstances (Wilcox 1992, 93). In *ST:DS9*, the military struggle with the Dominion was depicted as costly, brutal, depressing, dehumanizing, and fundamentally unsatisfying. Of course, not all of old Starfleet was gone. The Federation remained interventionist—albeit with the best of intentions, and in a way more suggestive of post-Cold War international politics.

Perhaps most interesting was the political transformation of the Klingons. The movie *Star Trek VI: The Undiscovered Country* (1991) was an obvious allegory for the end of the Cold War, in which hawks on both sides plot to prevent a peace agreement between the Federation and the Klingon Empire. It was also a movie in which Captain Kirk is forced to reexamine his previous prejudices. In the *ST:TNG* episode "A Matter of Honor," Commander William Riker served aboard a Klingon warship on an exchange program, acquiring a new appreciation for Klingon society in the process. The Klingon mythic/historical figure of Kahless—depicted as an exemplar of evil in *ST:TOS* ("The Savage Curtain")—was depicted in the later series as a model of honor and virtue. Overall, *ST:TNG* and *ST:DS9* painted an increasingly complex picture of Klingons and their society, often through the medium of Worf, a Federation officer of Klingon origin.

Thus, in *Star Trek*, this more nuanced treatment of conflict evolved over time, slowly shaped by contemporary attitudes, by concurrent events (Vietnam, detente, the end of the Cold War), by the vision of its creator and writers, and by the requirements of successful dramatic television.

In some other cases, however, commentary on the nature of peace and conflict was more deeply embedded into story arcs from the outset. *Space: Above and Beyond* initially seemed to have a rather militaristic space-marines-combat-alien-menace theme. Even the name given the alien foe—"Chigs"—was a conscious echo of the demeaning language often used by soldiers to refer to the enemy. However, clues throughout its single season slowly revealed that humans (and corporate greed) were in large part responsible for the outbreak of war.

More important still was the treatment of alien races in *Babylon 5*. The Narn were brutal, reptilian, militaristic, humorless, almost barbarian, and clearly not to be trusted. The Centauri were humanoid, humorous, gregarious, and outgoing. Over the first three seasons, however, it was revealed that the Narn had previously suffered genocide at the hands of a brutal Centauri occupation, and that parts of the Centauri leadership were committed to reestablishing their empire through treachery and aggression. The powerful, wise Vorlons were revealed as less benevolent and less powerful than early episodes suggested. Meanwhile, Earth's previous foe, the Minbari, turned out to be its greatest ally—their previous war a tragic mistake, and their past and future closely linked. These carefully-crafted twists were very effective commentary on the blinkers of ethnocentrism, the dangers of stereotypes, and the scope for cultural misunderstanding—in short, the complexities of interstellar (or international) politics.

The Politics of Multiculturalism

As noted previously, early *Star Trek* often seemed to be an idealized projection of contemporary American society. The composition of the first Enterprise crew reflected this projection: despite being a multispecies, multicultural Federation, it featured only one significant (semi-)alien, the Vulcan/human science officer Spock. One African (Lt. Uhura) and one Asian (Lt. Sulu) crew member were also regulars, but speaking flawless American English. Compared to the later polyglot spacestations of *ST:DS9* or *Babylon 5*, the generally human, white and Anglo-Saxon face of the Federation was unmistakable.

Yet *ST:TOS* was broadcast in the 1960s, not the 1990s, and it would be inappropriate to judge it by contemporary expectations. At the time, network executives were very unhappy that Kirk's second in command should be an

apparently demonic-eared alien of mixed parentage, and the producers had to fight hard to retain the character. Roddenberry also proved sensitive to the view that the diversity of the crew should be increased. When the Soviet communist party newspaper *Pravda* reportedly criticized *Star Trek* for its lack of a Russian character, a new Russian bridge officer (Lt. Pavel Chekov, modeled on the *Beatles* and *Monkees*, and intended to increase teen appeal) was added to the crew (Solow and Justman 1996, 343-45).

Perhaps even more striking evidence of *Star Trek's* innovation was provided by African-American actress Nichelle Nichols (Lt. Uhura). Annoyed by petty racism and only a limited screen presence, she initially decided to leave the show at the end of the first season. When she mentioned this to civil rights activist Dr. Martin Luther King during a chance meeting:

> "You *cannot*," he replied firmly, "and you *must* not. Don't you realize how important your presence, your character is?" he went on. "Don't you realize this gift this man has given the world? Men and women of all races going forth in peaceful exploration, living as equals. You listen to me: Don't you see? This is not a Black role, and this is not a female role. You have the first nonstereotypical role on television, male or female. You have broken ground . . .

> "You must not leave. You have opened a door that must not be allowed to close . . . you have changed the face of television forever. You have created a character of dignity and grace and beauty and intelligence. Don't you see that you're not just a role model for little Black children? You're more important for people who *don't* look like us. For the first time, the world sees as we should be seen, as equals, as intelligent people—as we *should* be seen." (Nichols 1994, 164–165).

Because of this, Nichols subsequently decided to stay with the show. King's view that her role might be ground-breaking was confirmed: the third season episode "Plato's Stepchildren" contained the first interracial kiss in American television history. While the kiss was involuntary—the plot had the characters forced into the act by aliens with telekinetic powers—it nonetheless caused anxiety among network executives. They feared that southern affiliates would refuse to broadcast the show, and therefore wanted to cut the scene (Shatner and Kreski 1993, 282-286; Nichols 1994, 193–196—although Alexander 1995, 320 suggests less network angst).

The episode "Let That Be Your Last Battlefield" dealt with racism even more directly, in a deliberate effort by the writers to demonstrate "the stupidity of prejudice" and that "color is only skin deep" (in Gross and Altman 1996, 74). In the story, one alien (half white and half black) hunts another (half black and half white, in a mirror-image reversal) over millennia—only to discover that such racial conflict has destroyed their

homeworld. In the view of actor George Takei (Lt. Sulu), "*Star Trek* is, and has always been, the antithesis of racism" (Wagner and Lundeen 1998, 165).

Subsequent versions of *Star Trek* further increased the sympathetic roles available to visible minorities (for example, Geordi LaForge and Guinen in *ST:TNG*; Captain Benjamin Sisko, Jake Sisko, Kasidy Yates, Julian Bashir, and Keiko O'Brien in *DS9*; Chakotay in *ST:VOY*), for the first time reflecting their approximate share of the US (but not global) population. They also continued to deal with issues of ethnic conflict, although increasingly in futuristic terms. In one *DS9* episode ("Beyond the Stars"), Benjamin Sisko dreams the life of black science fiction writer living amid the racism of the 1950s. In another episode, ("Badda-Bing, Badda-Bang") Sisko expresses his discomfort with holodeck recreations (and, by extension, fictional accounts and contemporary recollections) of American history that gloss over the racism of the past.

Issues of racism—that is, genetic and cultural intolerance—also arise in sf TV in more futuristic ways. *Alien Nation* explored the social difficulty of integrating alien newcomers into American society. In *Space: Above and Beyond*, some of the main characters are clones—"in vitros," pejoratively referred to by others as "tanks" or "nipple-necks." Their struggle for social equality, affirmative action, and uneasy integration in the military were central themes in the show. In *Babylon 5*, similar issues arose in the often conflictual relations between "mundanes" (normal humans) and "teeps" (telepaths), and between "Earth-born" and "Mars-born" citizens. Some of these sf treatments may prove prophetic, as current scientific breakthroughs in cloning and genetic manipulation stimulate political debate on the role that government should play in regulating genetic experimentation.

In the case of *Star Trek*, the later series expanded the array of non-human characters (Worf in *TNG*; Odo, Quark, and Garak in *DS9*; Neelex, Tuvok, the Doctor, and B'Elanna Torres in *VOY*, among others), for the first time offering a vision of a truly pluralistic Federation. In many ways this raised a similar set of issues, but at a different level of complexity. How do communities identify themselves as such? How can multicultural polities operate? What are the challenges of dealing with new societies? What is sentience? Is it necessarily biological? Here too TV pushed the frontiers of popular social discourse, exploring issues—such as artificial intelligence—that will undoubtedly emerge on public agendas in the decades to come.

Yet, in dealing with the notion of alien intelligence, sf writers face a challenge. To what extent should different species act in different ways, and

what subtext might this suggest about the genetic (and hence racial) basis of behavior and personality? In other words, are all Klingons warlike? Are all Ferengi mercenary? Certainly *Star Trek* generated characters that seem to lie outside their racial stereotypes. Quark's brother, Rom, was one example—a Ferengi interested more in engineering than profit-making. Worf's non-martial Klingon son, Alexander, was another case. These, however, were the exceptions rather than the rule. Indeed, characters of mixed ancestry often seemed to experience internal conflicts driven by their mixed genetic heritage: Spock struggled to keep human emotion buried beneath Vulcan logic, while both Torres and Worf's first mate K'Ehleyer were both torn between (Klingon) violence and (human) good humor. As Hurd (1997, 33) observes:

> Star Trek tries to have a liberal and positive outlook. In many ways, its depictions of conventional ethnic groups are very encouraging for the future of race relations. After all, how many other current shows have Asians, Native Americans, African-Americans, Arabs and other ethnic groups represented by lead characters all living together harmoniously? . . . But the show tries to have its racial equality cake and eat it too. By constantly returning to the "tragic mulatto" stereotype to define different species, the Trek world only perpetuates the idea that character is biologically essential, race is immutable, and peoples of different colors are really different species. *Trek* preaches tolerance for others and for that it is justly praised, but it does so by being oddly intolerant for which it should be watched carefully (1997, 33).

Gender and Sexual Orientation

Over the past half century, the social roles of women have undergone a remarkable transformation. The same transformation is evident in sf. Traditionally, most science fiction fans (perhaps 80% to 90% in the 1940s and 1950s) were male. In the earliest sf TV shows, women were generally damsels in distress, exotic alien queens—or, in the case of *Lost in Space*, a space-faring mother and housewife, with futuristic responsibility for cleaning, childcare, and meal preparation. Only a spunky female journalist (or spunky daughter of respected scientist) occasionally varied the mix.

In the conventional lore of *Star Trek*, the series was ahead of its time in its depiction of gender roles. The original pilot for the show cast a woman as first officer of the *Enterprise*. Preview audiences (and especially women) reportedly proved unwilling to accept the notion of a woman in such a senior command position, and the character was subsequently dropped at the insistence of network executives (Shatner and Kreski 1993, 92. Other

accounts cast doubt on this version of events.) The show did, however, place sympathetic female characters in scientific and dangerous settings at a time when few women in the real world occupied such roles. The show also attracted a significant female viewership: one 1979 survey of American undergraduate students found that 42.2% of women (and 60.2% of men) reported a liking for *Star Trek*, although only 6.8% of women (compared to 35.6% of men) had a preference for science fiction novels (Bainbridge 1986, 178).

The social impact of this is difficult to measure, of course, although it is possible that it encouraged women to think about challenging new frontiers. Certainly NASA thought so. In 1977 it asked former *Star Trek* actress Nichelle Nichols (Lt. Uhura) to assist in its efforts to recruit female (and minority) astronauts. Shortly thereafter, the number of female applicants to the space program soared from 14 to 387 per month (Nichols 1994, 225).

Yet, despite *Star Trek*'s (often deliberately cultivated) image as a social trailblazer, a deeper reading suggests a generally conservative depiction of gender. The three recurrent female characters in *ST:TOS* all performed tasks that were accepted "women's work" in the mid-1960s. Communications officer Lt. Uhura was essentially a futuristic telephone operator whose dialogue was often restricted to "hailing frequencies open, Captain." Characters Christine Chapel and Janice Rand were a space-travelling nurse and secretary, respectively. All were were young, attractive, and dressed in very short skirts, as were most of the other women to appear in the show. Storylines involving Captain Kirk's irresistible masculine allure, and his conquest and subordination of women, were commonplace. Even the show's slogan—"to boldly go where no *man* has gone before"—signaled its reflection of, rather than challenge to, established gender stereotypes.

Two decades later, *ST:TNG* updated the *Enterprise*'s mission ("to go where no *one* has gone before"), but was slower to challenge gender roles. A female security chief (Lt. Natasha Yar) was introduced then killed in the first season. While all of the other primary female characters were smart and independently minded, none was cast in unorthodox gender roles: ship's counselor Deanna Troi, kind-hearted bartender/advisor Guinan, and doctors Beverly Crusher and Katherine Pulaski. Of this situation, actress Marina Sirtis (Troi) complained "I don't think we've addressed feminism . . . the women on the show were very non-threatening . . . I don't think it's realistic in the 20th century, so it's definitely not realistic in the 24th century" (Gross and Altman 1996, 202). Producer Jeri Taylor agreed that "Gene [Roddenber-

ry] gave the women on *TNG* very traditional roles . . . and it was difficult to break them out of that mold" (Poe 1998, 213). Although one episode early in the first season ("Angel One," which envisaged a planet characterized by female dominance and sexual apartheid) was explicitly designed to provide "political" commentary on sexism, the show's weak execution was later admitted by the producers to be "absurd," undercutting the intended message (Gross and Altman 1996, 162–63).

Changes in the production staff and pressure from fans and actors alike led to some changes. A strong-willed female ensign, Ro Laren, was added to the crew in an explicit effort to provide a more varied mix of female character types. Counselor Troi was ordered to replace her plunging necklines with a standard Starfleet uniform. Dr. Crusher qualified as a bridge officer, even piloting the *Enterprise* into combat. *ST:DS9* took this progression still further, introducing a female second in command (former resistance fighter Kira Nerys) and science officer (Lt. Jadzia Dax). Finally, with *ST:VOY*, the franchise received a female lead character, in the form of Captain Katherine Janeway.

Coming in the mid-1990s, the idea of a female commander was hardly a daring social leap. Prior to the start of *ST:VOY*, studio research showed that around half of the response groups were strongly supportive of the idea, although around a quarter remained opposed (Poe, 213–14). More surprising is that *Star Trek* should take almost twenty years to fully depict sexual equality in space—all the more so given the show's intentionally and self-consciously progressivist flavor. The legacies of the original series, the predominately male demographics of the show, and the predominance of male writers and production staff may account for part of this. At the same time, the show's evolution paralleled very real debates within the US over the Equal Rights Amendment, the role of women in the military, and other issues. While the first Soviet female cosmonaut had flown in space in 1963, it was not until 1983 that NASA put a woman in space. By 1999, around one-third of the major crewpersons in *ST:DS9* and *ST:VOY* were women, as were around a quarter of real-life NASA astronauts in training (Prigg 1999).

Equally interesting is the apparent need of so many *Star Trek* fans to claim the show offered a progressive depiction of gender, often despite evidence to the contrary. This represents a clear effort to invent a history for the show that matches its mythology. Methodological, it poses a challenge to any analysis of popular culture, reminding us that the cultural past may be "remembered" in light of the political present.

Elsewhere, other TV sf in the 1990s offered a more consistent portrayal

of women as equals, capable of brain and brawn as well as caring and compassion. *Space: Above and Beyond* was noteworthy in this regard: leadership and combat roles were equally assigned between male and female characters, and little (if any) gender differentiation was evident.

A more commercially successful example of changes in gender roles can be seen in *The X-Files*, where FBI Special Agent Dana Scully provides a strong, independent, rationalist counterpart to her unorthodox male partner, Fox Mulder. Indeed, in many ways *X-Files* reversed the stereotypical depiction of gender roles of earlier decades: it was the male rather than female character that was inclined to emotionalism and instinct, and the female character that offered technical knowledge and sober second thought. Indeed, when cast into "traditional roles" in the episode "Arcadia"—in which the two go undercover as a married couple in a suburban community—the incongruity provided for comic relief.

But is this politics? Not self-consciously so—unlike *Star Trek* or *Babylon 5*, the writers of *X-Files* have never really set themselves the task of purveying social messages. Much the same might be said of horror-fantasy shows, like *Xena* or *Buffy: Vampire Slayer*, featuring strong female leads. However, broadcast in a real world—a world in which role models can have real effect on attitudes and expectations—the broader social impact of such portrayals can be significant nonetheless.

If sf TV's portrayal of gender has undergone substantial change since the 1960s, its treatment of sexual orientation has been slower to change. Here too, a complex and changing interrelationship is evident between cultural values and political discourse.

Until relatively recently, sexual orientation was a taboo topic on television. To the extent that apparently (but never explicitly) homosexual characters appeared in popular entertainment, they tended to be cast in morally dubious roles. Like other shows, *Star Trek* steered away from the topic altogether, despite the diversity and tolerance it claimed for its vision of the future.

Only in the late 1980s did the issue begin to arise. Part of the reason for this was growing gay and lesbian political activism, coupled with more tolerant social attitudes. Gay and lesbian science fiction fans also began to organize themselves, and to press for the inclusion of such characters in sf TV. In 1986 the Gaylaxian Science Fiction Society was formed, later to become the nucleus of a larger network. In 1988, the first gay, lesbian, and bisexual science fiction convention took place in the US (Gaylaxians 1999).

In the *Star Trek* universe, therefore, the issue of sexual orientation arose

as the Enterprise was starting a new phase of its continuing voyage in *The Next Generation*. Early on, Roddenberry —although rejecting at least one script for its "homosexual content," and expressing concern about "defying present average conventions"—stressed the need to deal with the issue (Solow and Justman 1996, 334; Fern 1996, 168–69). The producers were barraged by letters from fans suggesting the same. The difficulty in doing so was evident, however, in the fact that the first episode to do so, "The Outcast," didn't appear until *TNG*'s fifth season.

The episode—in which Commander Riker falls in love with a member of an androgynous alien race—was deliberately written to deal with the issue of intolerance and sexual orientation. It also proved highly controversial. Some fans protested the non-heterosexual storyline as an assault on traditional values, and some conservative Christian groups complained that *TNG* was characterized by "full nudity, both male and female, and homosexual kissing with a plethora of other items of unacceptable nature" (CAP 1996). Many others complained that the show had dealt with the issue too obliquely, and that *Star Trek* had still failed to create mainstream homosexual characters. Certainly, the episode hardly confronted the issue head on, given that the "genderless" alien was clearly played by a female actress. Jonathan Frakes (Riker) later complained: "I didn't think that they were gutsy enough to take this where they should have. Soren should have been more evidently male. We've gotten a lot of mail on this episode, but I'm not sure it was as good as it could have been" (Gross and Altman 1996, 240–41).

The issue of homosexuality was again alluded to in the fourth season of *DS9*. In "Rejoined," symbiotic Trill science officer Jadzia Dax encounters the wife of her former host, only to wrestle with a Trill taboo against resuming such relationships. The same-sex kiss between the two—the first in the *Star Trek* universe—again generated some criticism from a minority of conservative fans. Then, in the seventh season (1998–99) of DS9—more than 22 years after *ST:TOS* had first aired—viewers were finally shown a homosexual character whose sexual orientation was largely incidental to the plot: a lesbian, mercenary version of Lt. Ezri Dax from a parallel universe ("The Emperor's New Cloak").

By this time, however, social reality had undergone even greater change. In 1999, the Supreme Court of Canada expanded the legal definition of spouse to include same-sex couples. Similar reforms were underway in a number of other Western jurisdictions. Furthermore, in mainstream television itself, gay and lesbian characters had become increasingly common, with the

Gay and Lesbian Alliance Against Defamation reporting more than 25 in network shows during the 1998–99 season (Shister 1999).

Yet resistance also continued. In 1999, the conservative Christian Action Network called for "HC" warning ratings to be attached to television episodes with "homosexual content." That same year, conservative televangelist Jerry Falwell identified "Tinky Winky" (the purple, handbag-carrying character from the British children's show *Teletubbies*) as a gay role model corrupting American youth. Clearly, television was part of a broader cultural and political battleground.

Star Trek wasn't the only sf TV show to address the issue. So too did *Babylon 5*, which subtly hinted at (and ultimately confirmed in "Ceremonies of Light and Dark") a lesbian attraction between Commander Susan Ivanova and telepath Talia Winters. Later, in the episode "Racing Mars," two male characters (Stephen Franklin and Marcus Cole) went undercover on Mars as honeymooners. The plot device was played for laughs, but—aired amid conservative efforts to restrict the equality rights of homosexuals, as well as growing political debate over same-sex marriage and the spousal rights of gay couples—it also intentionally suggested a future that differed from the present.

Interestingly, little or no fuss was raised about these *B5* episodes, although the show's understated treatment had ultimately been more radical than *Star Trek*'s efforts. Part of the reason, of course, was *B5*'s much smaller viewership. However it also reflected *Star Trek*'s continuing status as a cultural icon, and hence the value of influencing its content. In the social and political struggles that are embedded in popular culture, some terrain is more important (and influential) than others.

Conclusion

The end of the twentieth century was a time when science fiction melded with science fact. The frontiers of science—for example, the (real life) announcement by NASA that possible evidence for life on Mars could be found in Antarctic meteors—stimulated popular imaginations and popular fears. It was also a time when, despite the scientific progress of the past century, the boundaries between fact and fantasy were sometimes rather blurred. According to one 1990 Gallup poll, 46% of Americans believed in extrasensory perception, 35% believed in ghosts, and 22% believed that

aliens had visited earth. By 1996, the proportion who believed that UFOs had visited earth had risen to 45% (Shermer 1997, 26; Nacomm 1997). The darker aspects of technological change also combined with end-of-millennium concerns about what the future might hold (Kingwell 1996). The over-hyped "Y2K" crisis (the concern that computers, unable to deal with the final two digits of the year 2000, would malfunction, causing social chaos) encapsulated this perfectly. Surveys found that 59% of Americans were somewhat or very concerned about the advent of the year 2000, 38% feared riots on the streets or other social unrest, and 13% would consider arming themselves in preparation ("End of the World" 1999, 38).

In this context, it was hardly surprising that *The X-Files* should become the most successful television science fiction show of the 1990s—indeed, in terms of ratings, one of the most successful ever. Yet the success of *The X-Files* was founded not only on these elements, but also on its successful interweaving of them with political paranoia and dark hints of government conspiracy. All of these had become increasingly common subtexts of the post-Watergate, post-Iran-Contra, post-Lewinsky era, as the American public grew increasingly cynical about politics. Indeed, Gallup polls note that three-quarters of Americans believe that President Kennedy's assassination was the result of a conspiracy; one-quarter believe that the US Navy (rather than mechanical malfunction) downed TWA Flight 800 in 1996; over half believe that the president would lie "if he could get away with it"; and 71% believe that the government is not revealing all that it knows about UFOs (Gallup 1997, 1999). A CNN poll similarly found that two-thirds of Americans believed that aliens had crashed in Roswell, New Mexico in 1947, while 80% felt that the government was covering up evidence regarding alien life (CNN 1997). With American voter turnout among the lowest of any Western democracy, the number of Americans who believe in UFOs outnumbers those who voted for Ronald Reagan, George Bush, or Bill Clinton (NACOMM 1998).

Thus science fiction television once more reflects, and perhaps contributes to, political trends. The "strange new worlds" motto of *Star Trek* spoke political language of 1960s idealism: a world for bold exploration, filled with liberal optimism and faith in the American dream. Fox Mulder's "trust no one," by contrast, may be a watchword for a more jaded and suspicious political world, a world in which obfuscation and deceit are believed to be the norm.

References

Alexander, David. 1995. *Star Trek Creator: The Authorized Biography of Gene Roddenberry.* New York: Roc.

Alien. 1979. Screenplay by Dan O'Bannon. Dir. Ridley Scott. Prod. Gordon Carroll, David Giler, and Walter Hill. Perf. Tom Skerritt, Sigourney Weaver, Veronica Cartwright. Fox/Brandywine-Ronald Shusett Productions.

Alien Nation (TV series). 1989–90. Fox.

Aliens. 1986. Screnplay and directed by James Cameron. Prod. Gale Ann Hurd. Perf. Sigourney Weaver, Michael Biehn, Bill Paxton. Fox.

Babylon 5. 1994–98. Syndicated/PTEN.

Battlestar Galactica (TV series). 1978–80. ABC.

Blake's Seven. 1977–81. BBC.

Boddy, William. 1984. "Entering the Twilight Zone." *Screen* 25 4–5: 98–108.

Brahm, Gabriel, Jr., and Mark Driscoll, eds. 1995. *Prosthetic Territories: Politics and Hypertechnologies.* Boulder: Westview.

Buck Rogers. 1950–51. ABC.

Buck Rogers in the 25th Century. 1979–81. NBC.

Cable News Network (CNN). 1997. "Poll: U.S. Hiding Knowledge of Aliens." http://cnn.com/US/9706/15/ufo.poll/index.html.

Captain Video and His Video Rangers. 1949–55. DuMont/syndicated.

ChildCare Action Project (CAP). 1996. *Entertainment Media Analysis Report 0059* http://www.startext.net/homes/chldcare/capreports/ on 12 March 1999.

Close Encounters of the Third Kind. 1977. Screenplay and directed by Steven Speilberg. Prod. Julia Philips and Michael Philips. Perf. Richard Dreyfuss, François Truffault, Teri Garr. Columbia/EMI.

Dark Skies. 1996–97. NBC.

Disch, Thomas. 1998. *The Dreams Our Stuff Is Made Of: How Science Fiction Conquered the World.* New York: Free Press.

Dr. Who. 1963–89. BBC.

Earth: Final Conflict. 1997– . Syndicated.

"The End of the World as We Know It ?" 1999. *Time.* (18 January)(Canadian edition).

ET: The Extra Terrestrial. 1982. Screenplay by Melissa Mathison. Dir. Steven Spielberg. Prod. Steven Spielberg and Kathleen Kennedy. Perf.

Henry Thomas, Dee Wallace, Peter Coyote. Universal.

Fern, Yvonne. 1996. *Gene Roddenberry: The Last Conversation*. New York: Pocket Books.

Franklin, H. Bruce. 1994. "Star Trek in the Vietnam Era." *Science Fiction Studies* 21 (March): 24–34.

Gallup News Service. 1997. "Cause of TWA Flight 800 Crash Not Settled In Americans' Minds." 29 May. Accessed at http://www.gallup.com/.

Gallup News Service. 1999. "Initial Reaction to Friday's Senate Vote." 15 February. Accessed at http://www.gallup.com/.

Gaylaxians. 1999. "Gaylaxian History." Accessed at http://www.gaylaxians.org on 30 January 1999.

Gray, Chris Hables, and Steven Mentor. 1995. "The Cyborg Body Politic and the New World Order." In *Prosthetic Territories: Politics and Hypertechnologies*. Ed. Gabriel Brahm and Mark Driscoll. Boulder: Westview Press.

Greenwald, Jeff. 1998. *Future Perfect: How Star Trek Conquered Planet Earth*. New York: Viking.

Gross, Edward and Mark A. Altman. 1996. *Captain's Logs: Supplemental*. Boston: Little, Brown & Company.

Hanley, Richard. 1997. *The Metaphysics of Star Trek*. New York: Basic Books.

Harrison, Taylor, Sarah Projansky, Kent Ono, and Elce Rae Helford. 1996. *Enterprise Zones: Critical Positions on Star Trek*. Boulder: Westview Press.

Hastie, Amelie. 1996. "A Fabricated Space: Assimilating the Individual on Star Trek: The Next Generation." In Harrison et al. 1996.

Hitchhiker's Guide to the Galaxy. 1981. BBC.

Hurd, Denise Alessandria. 1997. "The Monster Inside: 19th Century Constructs in the 24th Century Mythos of Star Trek." *Journal of Popular Culture* 31 1: 23–35.

The Invaders. 1967–68. ABC.

James, Edward, and Farah Mendelsohn, eds. 1998. *Parliament of Dreams: Conferring on Babylon 5*. London: The Science Fiction Foundation.

Kingwell, Mark. 1996. *Dreams of Millennium: Report from a Culture on the Brink*. Toronto: Viking.

Kurtz, Howard. 1999. "Americans Wait for the Punch Line on Impeachment," *Washington Post* (26 January).

Lagon, Mark P. 1993. "We Owe It to Them to Interfere: Star Trek and US Statecraft in the 1960s and 1980s." *Extrapolation* 34 3: 251–77.

Land of the Giants. 1967–69. ABC.

Lexx. 1997–. Syndicated.

Lost in Space. 1965–68. CBS.

Max Headroom. 1987–88. ABC.

McGrath, Denis. 1998. Comments Posted to "Speakers Corner." http://i-chat.chumcity.com/eshare/server?action=150&board=14&article=9 on 29 July 1998.

My Favorite Martian. 1963–66.

NACOMM. 1997. "Poll Shows Strong Belief That Life Is Out There." Accessed at http://www.nacomm.org/news/1997/qtr2/gallup.htm on 22 March 1999.

NACOMM 1998. "CNN/Time Poll" Accessed at http://www.nacomm.-org/news/1998/ qtr2/cnntime.htm on 22 March 1999.

Nichols, Nichelle. 1994. *Beyond Uhura: Star Trek and Other Memories.* New York: G.P. Putnam's Sons.

Nicholls, Peter, and John Clute, eds. 1993. *The Encyclopedia of Science Fiction.* New York: St. Martin's Press.

The Outer Limits. 1963–65. ABC.

The Outer Limits. 1994–. Syndicated.

Planet of the Apes (TV series). 1974. CBS.

Prigg, Mark. 1999. "The First Human on Mars Might Just Be a Woman: NASA." *The Montreal Gazette* (12 March).

Psi Factor. 1996–. CBS.

Quantum Leap. 1988–93. NBC.

Red Dwarf. 1987–. BBC.

Seaquest DSV. 1993–96. NBC.

Shatner, William, and Chris Kreski. 1993. *Star Trek Memories.* New York: Harper.

Shermer, Michael. 1997. *Why People Believe Weird Things: Pseudo-science, Superstition, and Other Confusions of Our Time.* New York: W. H. Freeman and Company.

Shister, Gail. 1999. "Television Gay Watch?" *The Montreal Gazette,* 12 March.

Sliders. 1995–. Fox.

Solow, Herbert and Robert Justman. 1996. *Inside Star Trek: The Real Story.* New York: Pocket Books.

Space 1999. 1975–77. Syndicated.

Space: Above and Beyond. 1996–97.

Space Patrol. 1951–52. ABC.

Spinrad, Norman. 1990. *Science Fiction in the Real World.* Carbondale: Southern Illinois University Press.

Stableford, Brian. 1996. "The Third Generation of Genre Science Fiction." *Science-Fiction Studies* 23 3: 321–330.

Stargate SG-1. 1997–. Syndicated.

Star Trek. 1966–69. NBC.

Star Trek (animated series). 1973–75. NBC.

Star Trek: The Next Generation. 1987–94. Syndicated.

Star Trek: Deep Space Nine. 1993–99. Syndicated.

Star Trek: Voyager. 1995–. UPN.

Star Trek: The Motion Picture. 1979. Screenplay by Harold Livingstone. Dir. Robert Wise. Prod. Gene Roddenberry. Perf. William Shatner, Leonard Nimoy, DeForest Kelley. Paramount.

Star Trek II: The Wrath of Khan. 1982. Screenplay by Jack B. Sowards. Dir. Nicholas Meyer. Prod. Robert Sallin. Perf. William Shatner, Leonard Nimoy, Ricardo Montalban. Paramount.

Star Trek III: The Search for Spock. 1984. Screenplay by John Hickridge. Dir. Leonard Nimoy. Prod. Harve Bennett. Perf. Leonard Nimoy, William Shatner, DeForest Kelley. Paramount/Cinema Group Venture.

Star Trek IV: The Voyage Home. 1986. Screenplay by Harve Bennett, Steve Meerson, Peter Krikes, Nicholas Meyer. Dir. Leonard Nimoy. Prod. Harve Bennett. Perf. William Shatner, Leonard Nimoy, DeForest Kelley. Paramount.

Star Trek V: The Final Frontier. 1989. Screenplay by David Loughery. Dir. William Shatner. Prod. Harve Bennett. Perf. William Shatner, Leonard Nimoy, DeForest Kelley. Paramount.

Star Trek VI: The Undiscovered Country. 1991. Screenplay by Nicholas Meyer and Danny Martin Flinn. Dir. Nicholas Meyer. Prod. Ralph Winter and Steven Charles Jaffe. Perf. William Shatner, Leonard Nimoy, DeForest Kelley. Paramount.

Star Trek: Generations. 1994. Screenplay by Ronald D. Moore and Brannon Braga. Dir. David Carson. Prod. Rick Berman. Perf. Patrick Stewart, William Shatner, Jonathan Frakes. Paramount.

Star Trek: First Contact. 1996. Screenplay by Brannon Braga and Ronald D. Moore. Dir. Jonathan Frakes. Prod. Rick Berman. Perf. Patrick Stewart, Jonathan Frakes, Brent Spiner. Paramount.

Star Trek: Insurrection. 1998. Screenplay by Michael Piller. Dir. Jonathan Frakes. Prod. Rick Berman. Perf. Patrick Stewart, Jonatahn Frakes, Brent Spiner. Paramount.

Star Wars: A New Hope. 1977. Screenplay and directed by George Lucas. Prod. Gary Kurtz. Perf. Mark Hamill, Harrison Ford, Carrie Fisher. Lucasfilm/Fox.

Star Wars: The Empire Strikes Back. 1980. Screenplay by Leigh Brackett and Lawrence Kasdan. Dir. Irvin Kershner. Prod. Gary Kurtz. Perf. Mark Hamill, Harrison Ford, Carrie Fisher. Lucasfilm/Fox.

Star Wars: The Return of the Jedi. 1983. Screenplay by Lawrence Kasdan and George Lucas. Dir. Richard Marquand. Prod. Howard Kazanjian. Perf. Mark Hamill, Harrison Ford, Carrie Fisher. Lucasfilm.

Strange World. 1999. ABC.

Street, John. 1997. *Politics and Popular Culture.* Cambridge: Polity Press.

Straczynski, J. Michael. 1998. "J. Michael Straczynski Speaks," *The Zocalo* 168 (30 November).

"Survey Says.... All-Time Favorite TV Show." 1998. *TV Guide.* 30 May. Accessed at http://www.tvguidelive.com/survey-says/results- May30.-html on 30 January 1999.

The Terminator. 1984. Screenplay by James Cameron and Gale Ann Hurd. Dir. James Cameron. Prod. Gale Ann Hurd. Perf. Arnold Schwartzenegger, Michael Biehn, Linda Hamilton. Cinema 84/Pacific Western Productions.

Tom Corbett: Space Cadet. 1950–52. CBS, ABC, NBC.

Twilight Zone. 1959–64. CBS.

Twilight Zone. 1985–88. Syndicated/CBS.

V. 1984–85. NBC.

Voyage to the Bottom of the Sea. 1964–68. ABC.

Wagner, Jon, and Jan Lundeed. 1998. *Deep Space and Sacred Time: Star Trek in the American Mythos.* New York: Praeger.

War of the Worlds (TV series). 1988-90. Syndicated.

Wilcox, Clyde. 1992. "To Boldy Go Where Others Have Gone Before: Cultural Change and the Old and New Star Treks." *Extrapolation* 33 1: 88–100.

Worland, Rick. 1988. "Captain Kirk: Cold Warrior." *Journal of Popular Film and Television* 16 3: 109–17.

Worland, Rick. 1996. "Sign-Posts up Ahead: The Twilight Zone, The Outer Limits, and TV Political Fantasy, 1959-1965." *Science Fiction Studies* 23 1: 103-22.

The X-Files. 1993–. Fox.

Selected Internet Resources

Exopolitics. http://www.arts.mcgill.ca/meppp/exofile/exopol.html.
Internet Movie Database. http://www.imdb.com
Science Fiction Channel. http://www.scifi.com/indexreal.html
Space: The Imagination Station. http://www.spacecast.com/
TV Sci-Fi and Fantasy Database. http://www.pazsaz.com/scifan.html
Ultimate Science Fiction Web Guide. http://magicdragon.com/UltimateSF

Chapter 6
Political Cynicism and Its Contradictions in the Public, News, and Entertainment

Stephanie Greco Larson

In the movie *Wag the Dog*, the president authorizes a fake war with Albania to distract people from his sex scandal. In *Air Force One*, the president single-handedly saves a plane full of passengers from terrorists. News coverage of politicians trumpets their infidelities, financial follies, and obfuscation while using politicians as the primary sources to define and interpret problems and propose solutions. Polls show that trust in government institutions is low, but that people are satisfied with the direction in which the country is going. What are we to make of these contradictory observations? Are we a nation of cynics bombarded with negative political news and entertained by demeaning images of politicians? Or do our attitudes toward politics and their manifestations tell a different story?

In this chapter, I will evaluate the academic literature on political cynicism in the public, news coverage, and movies to show that cynicism has been exaggerated and evidence of its contradictions overlooked. Rather than a disdain for politics, I believe, we share an ambivalence toward it which is both reflected in and promoted by our news and entertainment. In fact, skepticism coexists with optimism, criticism of politics with a commitment to government and a celebration of American values. This complex mix of messages is not always obvious because social scientists tend to "boil down" public opinion and media content in order to understand it. This chapter is an effort to try and recapture some of what has "evaporated."

Mixed messages have been identified in scholarship about media representations of women (Douglas 1994; Farrell 1998; Larson 1991). In her examination of the contradictory messages about women in American culture, Susan J. Douglas argues that "the war that has been raging in the media is not a simplistic war against women but a complex struggle between feminism and antifeminism that has reflected, reinforced, and exaggerated our culture's ambivalence about women's roles for over thirty-five years" (1994, 12-13). An example of these mixed messages is when explicit dialogue and plot lines, such as those that proclaim that rape is wrong, coincide with more subtle cues in scenes, as when a romantic lead treats a

woman's "no" to his sexual advance as if it means "yes" (Larson 1991).

Mixed messages are not simply confined to gender. The non-monolithic mass media also produce contradictory political communication. Not only are various media and outlets appealing to different audience preferences, but individual stories can contain contradictions between the verbal and visual elements as well as differences between the reporter's spin and the anchorperson's introduction or segue. Similarly, the public rarely shares one voice or mind on a matter. Intense minority opinion registered on individual questions creates a conflicting message regarding what "The Public" thinks. Answers to different questions on one public opinion poll can contradict each other, and results from one poll can contradict other polls (or other non-poll indicators of public opinion). Movies too can reflect or contradict "reality," or our hopes and fears about it.

Political Cynicism and Its
Contradictions in the Public: Examining Polls

A 1997 survey done by the Pew Research Center for The People & The Press found that less than 40% of the public said they trusted government in Washington "always" or "most of the time" (Pew Research Center 1997). Given the consensus that trust in government has generally been declining since the early 1960s, public opinion scholars would not be surprised by these numbers. Distrust practically tripled from 1964 to 1980, and despite a small increase in trust in 1984 and 1988, it has continued to go down (Luttbeg and Gant 1995). Confidence in Congress and the Executive Branch has also been declining for decades (Bennett 1998). These and other poll numbers paint a picture of an increasingly cynical American public, however, this conclusion is too simple. It overlooks the theoretical complexity of the concept of "cynicism" and evidence that the public is sophisticated, realistic, and politically engaged.

First of all, not all measures of political alienation point to the same changes over time. For example, more people thought that there were crooks in government after 1968 than before, but suspicion has fluctuated erratically since then (Luttbeg and Gant 1995). Despite the evidence that the public holds Congress in low esteem, people continue to express trust in their own representatives (Asher and Barr 1994). In addition, those who are "distrusting" generally act no differently politically from those who trust government;

therefore, voicing distrust might simply be "fashionable" (Citrin 1974). Changes in alienation over time do not consistently correspond to changes in political participation (Luttbeg and Gant 1995). Some forms of civic engagement remain high, for example, interest in politics, satisfaction with communities, and volunteerism (Bennett 1998).

What does it mean to have low trust? W. Lance Bennett questions whether decreases in trust reflect detachment or if they show "a public realistically engaged with the political performance of its governing institutions" (1998, 743). After all, it is not always the same groups or necessarily the least educated who voice feelings of alienation (Luttbeg and Gant 1995). Therefore, as the politics of the day change, winners and losers change, and who is dissatisfied, changes. Wouldn't a "true cynic" remain disillusioned regardless of the politics of the day? (Jack Citrin 1974, 974, 987) compares the public's distrust with government to sports fans who boo their losing home team, but continue their allegiance since it is still the *home* team. Support for our system of government remains high as "most Americans agree that the federal government is basically sound and needs only some reform" (Pew Research Group 1997, 8). In contrast to Europeans, Americans have higher trust in political leaders (Pew Research Center 1997). Patriotism, regard for the law, and support for government services are unaffected by levels of trust in government (Pew Research Center 1997). Clearly not all polls present a pessimistic view of the public's attitudes toward government.

Political Cynicism and Its Contradictions in the Public: Beyond Polls

Are public opinion polls the best way to measure political cynicism? Although statistically representative and numerically precise, polls can only superficially measure public opinion. To find out what people really mean when they say they do not trust government, we need to use other techniques which allow people to talk in their own words and address concerns that are important to them. Therefore, focus groups, in-depth interviews, and events like the National Issues Convention should be studied to understand public cynicism. By listening to the voices of Americans, polls can be put into perspective.

One recent study exhaustively examines the "dynamic interactions of

citizens, candidates, and news media" during the 1992 presidential campaign (Just et al. 1996, 43). Four in-depth interviews were done with 48 individuals from four different regions of the country. Researchers also talked to sixteen focus groups ranging in size from 10 to 12 members. The public mood revealed in this study was concern for policy issues (especially the economy) and disinterest in negative campaigning. It was when scandals and mud slinging were discussed that the voters voiced the most skepticism and disinterest. However, people's disgust toward certain campaign tactics and the media's attention to them did not discourage them from engaging in the campaign. In fact, this dislike for negative campaigning informed their candidate preferences by hurting Bush's evaluations because of his advertising choices (Just et al. 1996). Overall, the electorate studied here was knowledgeable, discerning, interested, and substantive in their considerations of the candidates. The authors concluded that "Even if the institutions are lacking for people to deliberate collectively, individual citizens can and do deliberate over the evidence and its implications when it comes time to vote and select a president" (Just et al. 1996, 230).

Interest and enthusiasm for politics and policy solutions were also reflected at the National Issues Convention held on February 19, 1996, which brought together 459 Americans in Austin, Texas to deliberate about public policy and then to express their opinions in a "deliberate poll" (Hart and Jarvis 1998). These discussions revealed that the public's considerations of policies are complex when "unconstrained by Likert categories"—a survey question format (Hart and Jarvis 1998, 12). It also showed that "the American people are resilient, a nation of problem-solvers" (Hart and Jarvis 1998, 14) and that "the participants viewed themselves as being in control of their destinies" (Hart and Jarvis 1998, 10) as they discussed solutions and affirmed policy proposals.

In conclusion, not all evidence points to a cynical public. Poll results are open to various interpretations. Low trust, especially in light of the declining trust in other non-political institutions, might be evidence of skepticism (a curious dubiousness) rather than cynicism (an unquestioned hopelessness). However we choose to characterize this distrust, we should recognize that it has not seemed to interfere with the public's understanding or engagement in politics. In fact, in some cases it informs their decisions and helps them discern.

Political Cynicism in the News

Trying to decipher factors contributing to the public's decline in trust has led scholars to examine the content and impact of television news. As W. Lance Bennett explains: "scholars have attributed various ills of democracy, if not to the sheer presence of television, to specific political uses of the ubiquitous electronic medium" (1998, 743). Early empirical evidence of this relationship was demonstrated by Michael Robinson (1968), who found the greatest level of "political malaise" among those who used television as their primary or only news source. Robinson suspected that this was due to television news' "inadvertent audience" being ill-equipped to deal with negative images. Roderick P. Hart argues that the intimacy of this medium and politicians' use of it encourages emotional responses "with television, politics becomes melodrama and cycles set in. Charm begets adoration begets disappointment begets cynicism" (1994, 30).

A preference for the kind of news that is seen as leading to a cynical public may be rooted in the commercial motivations and the professional goals of actors in news organizations. "Commercial motivation" refers to the need for television news shows to compete for an audience to "sell" to the advertisers. Network news is now expected to make money for the industry that produces it (Fallows 1996). Trying to appeal to an audience who has so many choices supposedly pushes the news toward certain types of stories and ways to cover these stories. Stories with conflict and scandal, thought to have audience appeal, get frequent coverage (Graber 1997). Reporters accentuate the negative to enhance conflict (Fallows 1996). These choices result, in part, from the journalists' "watchdog" role orientation—their perceived professional obligation to inform the public of governmental wrongdoing since the public does not have the time or access to what is "really" going on (Ranney 1983, 61). This adversarial role toward government is reinforced by reporters' expertise in political strategy rather than public policy (Fallows 1996), their frustration over being at the mercy of politicians for access and guidance (Fallows 1996), and their own negative attitudes toward politicians (Ranney 1983).

A negative attitude about politicians and the responsibility to both entertain and reveal the "truth" to viewers pushes reporters toward strategy coverage (sometimes called "game" coverage). This type of news slant is well-documented as the dominant way that elections are covered (Patterson 1993; Cappella and Jamieson 1997). Strategy coverage focuses primarily on

who is ahead and who is behind and what the candidates are doing about the race. In this coverage, polls, war/sports analogies, and references to political acts as "performance" are common (Jamieson 1992). Joseph Cappella and Kathleen Hall Jamieson explain how this coverage inherently undermines a politician's legitimacy and promotes cynicism: "When actions are placed in this (strategic) interpretive frame, the motivation for action (of any sort, whether a policy or personal choice) is reduced to a single, simple human motivation—the desire to win and to take power that elected office provides. In such an interpretive frame, all actions are tainted" (1997, 34). Their experiments provide some limited evidence of a relationship between strategic news and public cynicism (Cappella and Jamieson 1997).

Contradicting Political Cynicism in the News

The criticism that the news creates a cynical public should be taken with a grain of salt once the mixed messages in the news and the public's ability to see beyond the strategic frame is recognized. Ultimately "television, while an important political force, has been put in the wrong place in 'declinist' causal schemes of society and democratic politics" (Bennett 1998, 758). Although public opinion coverage on television news during the 1996 election does demonstrate reporters' preferences for accentuating public dissatisfaction (Larson 1999), the reporters' spin was only part of the stories told. There were also trusting and hopeful voices of "people-on-the-street" who said things like, "we're in good shape" and "if it's not broke, don't fix it." Campaign news also included voters' policy solutions (shared on NBC's "Fixing America" segments) and candidate speeches (on CBS's *In Their Own Words*) (Larson 1999). Despite the focus on the horse race, "there is plenty of information in the news about where the candidates stand" (Just et al. 1996, 240). In addition to the evening news, television carries debates, interview programs, talk shows, convention speeches, and specials.

Not only are substantive and analytical features like ABC's "American Agenda" present on the news, but studies show that they resonate highly with viewers (Just et al. 1996). Specials like NBC's "To Your Health" about health care reform actually increase public cynicism (Cappella and Jamieson 1997, 158). Since the public is well aware of and concerned with television news' proclivity toward negativity, they are skeptical of much of the information they hear, seek information from other sources, and use their

own experiences in their political deliberations (Just et al. 1996). Members of focus groups studied during the 1996 campaign "commonly ignored or transformed rather than followed the meaning of messages to which they were exposed" (Just et al. 1996, 236).

Overall, television news reinforces dominant cultural ideologies and the institutions that promote them (Gans 1973) and legitimates the status quo (Bird and Dardenne 1988). Negative coverage of government is present, but it is "normalized" by placing blame on aberrant individuals rather than the system and allowing authorities to give the reassuring last word (Bennett 1996). As a result, "the news takes us on a daily tour of the world-as-it-ought-to-be: a world filled with mainstream American values and comforting images of authority and security" (Bennett 1996, 71). Thereby even bad news ultimately promotes the conclusion that "the system works" (Bennett 1996).

Cynical Representations of Politics and Their Contradictions in Entertainment

The media also represent politics through entertainment. Rather than simply being seen as "stories," communication scholars remind us that movies (and television shows for that matter) reflect common cultural themes, dreams, and myths (Nimmo and Combs 1990, 108). Since "movies tell us about ourselves in relation to our politics" (Nimmo and Combs 1990, 110) and provide an accessible forum for members of a society to work through problems and solutions (Miles 1996), it is important to see what they are telling us. Are they presenting cynical messages that say: "politicians are inherently untrustworthy"? Once again, the answer seems to be "sometimes." As in the cases of public opinion and news, we are offered mixed messages in our entertainment.

Phillip L. Gianos (1998, 169) introduces this idea eloquently: "It is not that we love politicians or hate them; it is that we love them *and* hate them. Political life embodies, simultaneously, great aspirations and great disillusionment, and this mix of aspiration and disillusionment is simultaneously individual and collective Films, like other media, tend to exaggerate and simplify these tensions." Although Gianos argues that politicians on film are heroes, villains, or both, he emphasizes the negative, calling *Citizen Kane* "profoundly negative" (184), *Nixon* "deeply pessimistic" (188), and *All the King's Men* "tragic" (192). Even *The Candidate,* which he claims is

ambivalent (192) and shows a more "gentle" political journey (195) is said to demonstrate political life as "skeptical" and "ironic" (194). Gianos' analysis of *Mr. Smith Goes to Washington* includes the contradictory conclusions that it views politics as "deeply pessimistic" (103) and "celebratory" (192). Both are probably true depending upon which character, scene, image, dialogue, or theme is being examined.

Claims that the images of politics in entertainment are mostly negative are common, but not especially persuasive because they lack evidence or focus on only part of the film ignoring contradictory scenes and dialogue. For example, Austin Ranney (1983) argues that there is an "antipolitician bias" against fictional politicians but offers no systematic evidence. Dan Nimmo (1993, 285) claims that "political media consultant Pete St. John teaches what winning *Power* (1986) is all about in the television age: 'My job is to get you in. Then you can do whatever your conscience tells you to do.'" However, this statement, made early in the movie, is negated by the same character who is transformed in both attitude and action by the end of the film when St. John tells *Power's* version of Mr. Smith that consultants are irrelevant and that he should "Go out there and say exactly what you think . . . maybe even what you feel."

Terry Christiansen's conflicting conclusions about the negativity of political films reveal the mixed messages. On the one hand, he claims that "the cinematic portrait of politics and politicians is almost wholly negative . . . They are frequently corrupt, greedy, self-serving, and ruthlessly ambitious" (1987, 8). On the other hand, Christiansen acknowledges that these films usually "tell us that bad people can mess up the system and good ones can set it right" (1987, 8). His characterization of political films as "dramas of reassurance" which "reinforce the status quo, telling us that all is well in America and that any little problems can be worked out, usually with the help of a heroic leader" (Christiansen 1987, 8) acknowledges their ultimate optimism, much like "normalized news" mitigates the negative press coverage of politicians (Bennett 1997). Even the critique that the "popular formulas" show government as flawed and requiring individual outsiders to bring about justice (Cawelti 1993, 43), ignores that these institutions are ultimately shown as responsive to a "Mr. Smith" or a "Dave" and that recent blockbusters portray the hero as coming from inside of government (such as the presidents in *Air Force One*, *Independence Day*, and *The American President*).

Of course not all images of the president in contemporary films are heroic; there are negative images as well. Today's films contain both positive

and negative images of fictional politicians just as they always have. Although fictional politicians can be seen as sleazeballs, simpletons, and saviors, individual films and even specific political characters exhibit a mix of these types. Other characters, like the president in *Deep Impact*, a "good guy" unable to save people from death by an asteroid, seem not to fit in these three groups. The mixed political messages in entertainment can be illustrated by seeing how sleazeballs, simpletons, and saviors co-exist, and even overlap, in political films and television.

Sleazeballs. Sleazeballs are the politicians portrayed in entertainment as financially corrupt, sexually deviant, or evil. These portrayals reflect our fears that "power corrupts and absolute power corrupts absolutely" or that there is something inherently wrong with people who seek governmental leadership positions. Examples of the first scenario—that it is the power that does the corrupting—are found in *All the King's Men,* where a teetotaling monogamous common man becomes a rich philandering law-breaking demagogue. "Power seduces him, dominates him, and finally kills him and virtually everyone around him" (Gianos 1998, 191). Examples of financially corrupt sleazeballs include many senators in *Mr. Smith Goes to Washington,* both candidates in *Speechless*, the current president in *My Fellow Americans*, and an Ohio senatorial candidate backed by foreign oil interests in *Power.*

As in *All the King's Men,* sexual mischief can be just one of the symbols of corruption used to show the transformation of someone from "good guy" to morally bankrupt "politician" (like in *The Seduction of Joe Tynan* and *The Candidate*). For other films, sexual indiscretion is used as a catalyst to move the story along, as in *Wag the Dog* and *Dave.* In these movies the presidents are largely off-screen, but their sexual mischief marks them as sleazeballs and sets up plot lines revolving around what happens when unelected people take over the reigns of power. For those films, the degree of sleaziness varies with those shown trying to resist their own moral decay as less offensive (and more sad), than those who have already succumbed.

A more complex sleazeball appears in *Primary Colors.* The presidential candidate's affairs are introduced too early to symbolize a "fall" and the first sexual indiscretion coincides with images of him being a compassionate listener. The fact that the affair is with an awkward admiring middle-aged teacher, is off-camera, and is treated in a comical way diminishes its power to stigmatize the character. The sexual misconduct is almost seen as a "natural" weakness in a "regular guy," much like his overeating. In the 1990s, it might take more than "ordinary" affairs to mark a politician as a

sleazeball. Perhaps this is why this candidate is eventually implied to have impregnated a teenager and fakes a blood test to cover it up. Similarly, the president in *Wag the Dog* does not simply cheat on his wife, he does so with the fictional equivalent of a girl scout.

A few sleazeballs are downright evil. This is the case in *Bob Roberts*, *The Manchurian Candidate*, and on ABC's *One Life to Live* soap opera. Senator Graham (on *One Life to Live*) blackmails a police commissioner, destroys criminal evidence, and orders drive-by shootings (one resulting in murder) to cover up his daughter's crimes. Although the murder of an investigative reporter is not ordered by Pennsylvania Senatorial Candidate, *Bob Roberts*, the blame is put at his feet by the narrator of the film and the audience. In addition to financial scandals, this candidate orchestrates a fake assassination attempt in order to help himself win the election. In *The Manchurian Candidate* the man running for president is a communist stooge complicit in the brainwashing of his step-son and several murders.

Simpletons. Simpleton politicians are characters who are often not central to the story, but serve to show politicians as out-of-touch and/or influenced by people behind the scenes. In the scene where John Doe (in *Meet John Doe*) is convinced by a small-town crowd to continue his crusade on behalf of the common people, a little fat mayor serves as comic relief. He asks in a silly high-pitched voice why he was the only one not invited to join the "John Doe Club" and nods in agreement when the answer denigrates politicians. Few television series use political settings, but two of the longest running have simpletons in the official positions of authority. The mayor in *Spin City* and the Governor in *Benson* are both sympathetic scatterbrains. These simpleton politicians are often vacuous front men used to show who is "really" in control. In *Benson* and *Spin City* it is the quirky and often wise staff who get things done. In *Power* a gubernatorial candidate in New Mexico is shown bumbling and foolish to initially demonstrate the consultant's power to transform images. In addition to being a sleazeball, *The Manchurian Candidate* is shown as an idiot and treated like one by his communist-operative wife.

Saviors. Saviors are either idealized fantasies of politicians or men who are transformed into heroes during the course of the film. This transformation usually reinforces already positive characterizations, but shows the politician overcoming uncertainty (caused by other politicians, staff, or reporters) or their own flaws to become ideal. Sometimes their personal relationships lead them to brave and/or moral choices. One example of this is *The American President* who is generally shown as a loving, forgiving,

informed, and decisive leader. However, his pragmatic attitude ("we've got to fight the fights we can win") is transformed into a more noble one ("fight the fights that need fighting") by the advice of his chief of staff (and friend) and his love for a lobbyist. In the end, he reverses a broken promise and a timid campaign style to elegantly defend his fiancée, the ACLU, gun control, and environmentalism. The Democratic presidential frontrunner in *Running Mates* has a similar transformation. At the end of this film, he stands up to reporters (and his staff) to defend his fiancée and her First Amendment right to appear topless in a film. In *Independence Day* a world-threatening crisis and his martyred wife inspire an uninspiring president to become a bold leader who heroically fights aliens from an F-16.

Other saviors are citizen heroes who are not personally reformed, but have the potential to reform politics. For example, Mr. Smith is the "good guy" who becomes a politician who will stand up to corruption. The final scenes of *Speechless* and *Dave* reintroduce the movies' protagonists as candidates to suggest that there is room for moral leadership in politics. This optimism is also shown at the end of *Power* when it is implied that the principled independent college professor will run for office again.

The most idealistic version of a savior politician is one who is neither reformed nor an outsider. He is the ultimate fantasy president in *Air Force One*. From the beginning of the film to the end, Harrison Ford portrays this president as a paragon husband, father, friend, patriot, and fighter. He exhibits intelligence, bravery, and compassion. This image is of the president as an adventure hero.

The characters in *My Fellow Americans* illustrate nicely the combination of these types. The vice president is shown as both a simpleton (mispronouncing words, reading the lyric to "Muskrat Love" at a funeral, and hospitalizing a spectator at a golf tournament) and an evil sleaze (orchestrating kidnapings and murders to become president). The main characters, two ex-presidents, are also mixed types. Their goals and their role in the eventual plot outcome put them into the savior description—they risk their lives to reveal a scandal and as one puts it "do what I promised—to preserve, protect, and defend." However, they are portrayed as petty, sneaky, crass, cheap, nasty, whiny, and selfish. They are buffoons who look more like simpletons than saviors. Despite their underlying good intentions, they are primarily presented in an unpresidential light (like refilling a hotel mini-bar's vodka bottles with water to save money). Little wonder that a staff member refers to them as "idiots" and they ultimately need someone else to save their lives.

Conclusion

Michael Parenti (1992) argues that movies and television not only send political messages that support the status quo, but these are messages we believe despite our conscious knowledge that political entertainment is fiction. Research on "cultivation" effects supports this interpretation. Results show that heavy television viewing leads people to make certain assumptions about reality—heavy viewers of police shows, for example, believe that crime is more prevalent than it really is (Gerbner et al. 1980). Of course the direction of causality need not be simply one way (the movies influencing public opinion); films can reflect cultural attitudes as well. "These fables of power either affirm or subvert inherited and current feelings about power" (Nimmo and Combs 1990, 110)—feelings, which I believe, are ambivalent.

If movies can affect viewers, what might that impact be, given the conflicting messages of the films discussed in this chapter? We should not assume that it will necessarily be negative for real-life politicians. A negative image (like a sleazeball) might remind us of our own corrupt or sexually deviant politicians or it might put in perspective the extent of their transgressions. In other words, the Gennifer Flowers-like story in *Primary Colors* reminds us of Clinton's affair (probably putting Clinton in a bad light), but the other candidate in the movie is a reformed coke addict who traded sex for drugs (probably putting Clinton in a better light since his own affairs do not seem as bad in comparison). On the other hand, a similar case could have been made for the possible impact of *Wag the Dog* on cynicism toward President Clinton: the "sleeping with a young girl" scandal in the movie reminds us of Clinton and Monica Lewinsky; however, the fake war with Albania puts that affair in perspective. But what about the bombing of Iraq and the references made to it by the press and public? Rather than put "real" corruption in perspective, the movie was elicited to question the motivations of president. Similarly, might the idealized image of the president as savior have the "halo effect" of improving evaluations of politicians? Or do the savior images serve as unrealistic comparisons for politicians? After all, our leaders do not throw terrorists out of planes or kill aliens.

The bottom line is that we do not actually know what effect these images have on the public, so we should not assume that negative representations result in cynicism or that positive ones create optimism. Not only will viewers bring their own attitudes and experiences to their understanding of these messages, but the fact that these messages are so mixed is more likely

to reinforce our own mixed feelings about politics and leaders rather than resolve our ambivalence.

References

Air Force One. 1997. Screenplay by Andrew W. Marlow. Director, Wolgang Peterson. Producer, Armyan Bernstein, John Shestack, Wolfgang Petersen, Gail Katz. Performers, Harrison Ford, Gary Oldman, Glenn Close. Beacon Communications; Radiant Productions.

All the King's Men. 1949. Screenplay by Robert Rossen. Director, Robert Rossen. Producer, Robert Rossen. Performers, Broderick Crawford, Joanne Dru, John Ireland, Mercedes McCambridge. Columbia.

The American President. 1995. Screenplay by Aaron Sorkin. Director, Rob Reiner. Producer, Rob Reiner. Performers, Michael Douglass, Annette Bening, Martin Sheen, Michael J. Fox. Columbia/CastleRock/Wildwood.

Asher, Herb, and Mike Barr. 1994. "Popular Support for Congress and Its Members." In *Congress, the Press, and the Public*, ed. T. E. Mann, and N. J. Ornstein. Washington, D.C.: The American Enterprise Institute.

Bennett, W. Lance. 1996. *News: The Politics of Illusion*. 3rd ed. New York: Longman Publishers.

Bennett, W. Lance. 1998. "The UnCivic Culture: Communication, Identity, and the Rise of Lifestyle Politics." Political Science 31 (4): 741–61.

Benson. 1979-1986. New York: ABC.

Bird, Elizabeth, and Robert W. Dardenne. 1988. "Myth, Chronicle, and Story: Exploring the Narrative Qualities of News." In *Media, Myths, and Narratives: Television and the Press*, ed James W. Carey. New York: Sage Publications.

Bob Roberts. 1992. Screenplay by Tim Robbins. Director, Tim Robbins. Producer, Forrest Murray. Performers: Tim Robbins, Alan Rickman, Giancarlo Esposito, Gore Vidal. Rank/Polygram/Working Title/Line Entertainment.

The Candidate. 1972. Screenplay by Jeremy Larner. Director, Michael Ritchie. Producer, Walter Coblenz. Performers: Robert Redford, Peter Boyle, Don Porter, Allen Garfield. Warner/Redford-Ritchie.

Cappella, Joseph A., and Kathleen Hall Jamieson. 1997. *Spiral of Cynicism: The Press and the Public Good*. New York: Oxford University Press.

Cawelti, John G. 1993. "'Who's Running This Show? Ideology, Formula and Hegemony' in American Film and Television." In *Movies and Politics: The Dynamic Relationship*, ed. J. Combs. New York: Garland Publishing, Inc.

Christiansen, Terry. 1987. *Reel Politics: American Political Movies from "Birth of a Nation" to "Platoon."* New York: Basil Blackwell, Inc.

Citizen Kane. 1941. Screenplay by Orson Welles and Herman J. Mankiewicz. Director, Orson Welles. Producer, Orson Welles. Performers: Orson Welles, Joseph Cotten, Everett Sloane, Agnes Moorehead. RKO.

Citrin, Jack. 1974. "Comment: The Political Relevance of Trust in Government." *American Political Science Review* 68: 973–88.

Dave. 1993. Screenplay by Gary Ross. Director, Ivan Reitman. Producer, Lauren Schuler-Donner and Ivan Reitman. Performers: Kevin Kline, Sigourney Weaver, Frank Langella, Kevin Dunn. Warner.

Deep Impact. 1998. Screenplay by Michael Tolkin, Bruce Joel Rubin. Director, Mimi Leder. Producer, David Brown, Richard P. Zanick. Performers: Robert Duvall, Morgan Freeman, Eliah Wood. Zanuck/-Brown Productions, Dream Works SKG, Paramount Pictures.

Douglas, Susan J. 1994. *Where the Girls Are: Growing up Female with the Mass Media*. New York: Times Books.

Fallows, James. 1996. *Breaking the News: How the Media Undermine American Democracy*. New York: Vintage Books.

Farrell, Amy Erdman. 1998. *Yours in Sisterhood? Ms. Magazine and the Promise of Popular Feminism*. Chapel Hill, NC: University of North Carolina Press.

Gans, Herbert. 1973. *Deciding What's News: A Study of CBS Evening News, NBC Evening News, Newsweek, and Time*. New York: St. Martin's Press.

Gerbner, George, Larry Gross, Michael Morgan, and Nancy Signorielli. 1980. "The Mainstreaming of America: Violence Profile No. 11." *Journal of Communication* 30: 37–47.

Gianos, Phillip L. 1998. *Politics and Politicians in American Film*. Westport, CT: Praeger.

Graber, Doris A. 1997. *Mass Media and American Politics*. 5th ed. Washington, DC: Congressional Quarterly Press.

Hart, Roderick P. 1994. *Seducing America: How Television Charms the Modern Voter*. New York: Oxford University Press.

Hart, Roderick P., and Sharon E. Jarvis. 1998. "Collective Language at the National Issue Convention." Presented at the American Political Science

Association Meetings, Boston.

Independence Day. 1996. Screenplay by Dean Devlin and Roland Emmerick. Director, Roland Emmerick.. Producer, Dean Devlin. Performers: Will Smith, Jeff Goldblum, Bill Phullman, Margaret Colin. TCF/Centropolis.

Jamieson, Kathleen Hall. 1992. *Dirty Politics.* New York: Oxford University Press.

Just, Marion R., Ann N. Crigler, Dean E. Alger, Timothy E. Cook, Montague Kern, and Darrell M. West. 1996. *Crosstalk: Citizens, Candidates, and the Media in a Presidential Campaign.* Chicago: University of Chicago Press.

Larson, Stephanie Greco. 1999. "Beyond Polls: Public Opinion on Television Election News." *Political Communication* 16: 133-145.

Larson, Stephanie Greco. 1991. "Television's Mixed Messages: Sexual Content of "All My Children." *Communication Quarterly* 39: 156–63.

Luttbeg, Norman R., and Michael M. Gant. 1995. *American Electoral Behavior 1952-1992.* 2d ed. Itasca, IL: F. E. Peacock Publishers, Inc.

The Manchurian Candidate. 1962. Screenplay by George Axelrod. Director, John Frankenheimer. Producer, Howard W. Koch. Performers: Frank Sinatra, Lawrence Henry, Janet Leigh, Angela Lansbury. VA/MC.

Meet John Doe. 1941. Screenplay by Robert Riskin. Director, Frank Capra. Producer, Frank Capra. Performers: Gary Cooper, Barbara Stanwyck, Walter Brennan, Spring Byington. Liberty Films.

Miles, Margaret R. 1996. *Seeing and Believing: Religion and Values in the Movies.* Boston: Beacon Press.

Mr. Smith Goes to Washington. 1939. Screenplay by Sidney Buchman. Director, Frank Capra. Producer, Frank Capra. Performers: James Stewart, Jean Arthur, Claude Rains. Columbia.

My Fellow Americans. 1996. Screenplay by E. Jack Kaplan, Richard Chapman and Peter Tolan. Director, Peter Segal. Producer, John Peters. Performers: Jack Lemmon, James Garner, Dan Aykroyd, Lauren Bacall. Peters Entertainment; Storyline Productions; Warner Brothers.

Nimmo, Dan. 1993. "Political Propaganda in the Movies: A Typology." In American Film and Television." In *Movies and Politics: The Dynamic Relationship,* ed. J. Combs. New York: Garland Publishing Inc.

Nimmo, Dan, and James E. Combs. 1990. *Mediated Political Realities.* 2d ed. New York: Longman Publishers.

Nixon. 1995. Screenplay by Stephen J. Riveley, Christopher Wilkinson and Oliver Stone. Director, Oliver Stone. Producer, Clayton Townsend,

Oliver Stone, and Andrew G. Vajna. Performers: Anthony Hopkins, Joan Allen, James Woods, Powers Boothe. Entertainment/Illusion/Gnergi.

One Life to Live. 1968-present. ABC.

Parenti, Michael. 1992. *Make-Believe Media: The Politics of Entertainment*. New York: St. Martin's Press, Inc.

Patterson, Thomas. 1993. *Out of Order*. New York: Knopf.

Pew Research Center for The People and The Press. 1997. "Deconstructing Distrust: How Americans View Government." (http://www.people-press.org/trustrpt.htm).

Power. 1986. Screenplay by David Himmelstein. Director, Signey Lumet. Producer, Reene Schisgal, Mark Tarlow. Performers: Richard Gere, Julie Christie, Gene Hackman, Kate Capshaw. TCF/Lorimar/Polar.

Primary Colors. 1998. Screenplay by Elaine May. Director, Mike Nichols. Producer, Mike Nichols. Performers: John Travolta, Emma Thompson, Billy Bob Thorton. Universal Studios/ Mutual Film Co.

Ranney, Austin. 1983. *Channels of Power: The Impact of Television on American Politics*. Washington, DC: American Enterprise Institute.

Robinson, Michael J. 1976. "Public Affairs Television and the Growth of Political Malaise." *American Political Science Review* 70: 409–32.

Running Mates. 1992. Screenplay by A. L. Appling. Director, Michael Lindsay-Hogg. Producer, James D. Brubaker, Marvin Worth. Performers: Diane Keaton, Ed Harris, Ed Begley, Jr., Ben Masters. HBO.

The Seduction of Joe Tynan. 1979. Screenplay by Alan Alda. Director, Jerry Schatzberg. Producer, Martin Bregman. Performers: Alan Alda, Barbara Harris, Meryl Streep, Rip Torn. Universal.

Speechless. 1994. Screenplay by Robert King. Director, Ron Underwood. Producer, Renny Harlin and Geena Davis. Performers: Michael Keaton, Geena Davis, Bonnie Bedelia, Ernie Hudson. Metro-Goldwyn-Mayer.

Spin City. 1996-present. ABC.

Wag the Dog. 1997. Screenplay by Hitam Kenkin, David Mamet. Director, Barry Levinson. Producer, Jane Rosenthal, Robert DeNiro, Barry Levinson.. Performers: Dustin Hoffman, Robert DeNiro, Anne Heche, Denis Leary. Tribeca Productions; Punch Productions; Baltimore Pictures; New Line.

Chapter 7
Criminals and Buffoons:
The Portrayal of Elected Officials
on Entertainment Television

Tracey L. Gladstone-Sovell

It is the fall of 1998 and all members of the U.S. House of Representatives and one-third of the senators are up for election. In Pennsylvania, Congressman Graham has decided to run for the senate seat. During the course of the election, his daughter, Barbara, confesses that she has accidentally killed a police officer. The officer happens to have been the son of the former, much admired, Police Commissioner of a suburban Philadelphia community. (She was really trying to murder her married ex-lover with whom she has had an adulterous affair, but that's another story.) In addition to killing the officer, she seriously wounds the wife of her ex-lover, leaving the woman paralyzed and confined to a wheelchair. The Congressman puts pressure on the new Police Commissioner (Sykes), (whom Congressman Graham has placed in office through clearly nefarious means,) to pursue other individuals—people Graham knows are innocent—as suspects in the murder.

The congressman wins the election in November and becomes the state's senator-elect. Commissioner Sykes knows that the now "Senator" Graham's daughter is a primary suspect in the murder, but keeps quiet because of the political pressure he is under. In December he finally tells the former commissioner about his suspicions and the pressure. Together they arrest the daughter for murder and, eventually, Senator Graham for obstruction of justice. The corrupt commissioner resigns, the former commissioner is reinstated and one presumes that the "senator-elect" will never take the oath of office and will be convicted of the crime in due course.

As scandalous as this story may seem, it never made the front-page of the Philadelphia *Inquirer*. It did however, get full coverage in the two competing Llanview papers, the *Banner* and the *Sun*. Regular viewers of the ABC soap opera *One Life to Live* will be familiar with all the details of the crime and cover-up, and they will recognize the characters involved in the story (ABC.com, ABC TV's *One Life to Live*, 2/16/99).

It is my contention that this story line is representative of one of the two

dominant patterns through which entertainment television portrays fictional elected officials: the elected official as criminally corrupt, sometimes caught, more times not. The other pattern is the elected official as inept bumbler, pleasant perhaps, often engaging or amusing, but basically an idiot. The best known example of this portrayal is probably Governor Gatling on the 1980s sitcom *Benson*, the most recent example, New York City Mayor Winston as depicted on the 1990s sitcom *Spin City*. Elected officials are rarely shown in a positive or realistic light.

The term "elected official" was carefully chosen for this analysis. The more common term would be "politician." However, the term *politician* has become a "loaded" term, carrying with it connotations of corruption, dishonesty and manipulation. "Politician" is also indiscriminately used to apply to individuals elected to office, to those appointed and to those hired to serve elected officials. Political consultants, party bosses, "spin doctors," and other aides have been lumped together with mayors, legislators, governors, and others under this label. Consequently, I prefer the term "elected official" since it tends not to carry the same negative connotation that the term "politician" does and because it refers only to those elected to office.

The depiction of elected officials on entertainment television has not received any serious scholarly or public attention. Political scientists whose interests lie in the area of political communication tend to focus most of their attention on the influence of the news media in determining political attitudes and behaviors. These analyses have often criticized television news for contributing to the high levels of public cynicism and distrust that currently characterize the political landscape (Bennet 1996). Such critiques are usually well grounded and telling, but their focus is firmly directed toward "the news." However, television viewing is lowest during the hours of the day when "the news" is traditionally broadcast and highest during the time periods when entertainment programming dominates the airwaves (World Almanac 1998, p. 260.) In other words, people spend more time watching entertainment television than they do watching the news.

Scholars and critics who examine the political ramifications of popular culture look at entertainment television have usually sought to expose the underlying political assumptions that pervade television (Nimmo and Combs 1990; McBride and Roburen 1996). Cultural critics have spent time analyzing and critiquing the influence of negative and/or stereotypical television characterizations of African-Americans (*Color Adjustment* 1991) and of women (Faludi 1991, 140–69). Scholars have documented the effects

of unrealistic television treatments of lawyers and physicians (Pfau, Mullen, and Deidrich 1995; Pfau, Mullen and Garrow 1995). Both academics and political figures too numerous to cite have debated the influence of violent programming on children.

The list could continue. The assumption behind both the scholarly analysis and the public and cultural debates that mirror the scholarship is that what we watch on television matters. Fictional portrayals of different types of people, of various professions and of the way in which conflict is resolved, influence our day-to-day perceptions of people and how we act on those perceptions. While there are legitimate debates over the extent to which television influences our understandings of the world around us, it is hard to believe that all these scholars, as well as all the political actors who express similar concerns, are wrong. If they are all mistaken, it would mean that, collectively, we are always able to successfully distinguish between fiction and reality, between television and "real life." Events such as the infamous incident where Vice President Dan Quayle entered into a debate with the fictional lead character from the sitcom *Murphy Brown* over the merits of single parenthood provide evidence that suggests that, for a good number of people at least, there is, at worst, no distinction between TV and reality and, at best, a blurring of the lines. Television has merged into "real life," it is part and parcel of our reality, especially our political reality. To use Nimmo and Combs' terminology, we inhabit a mediated political reality (Nimmo and Combs 1990).

If we accept that scholars and public figures are justified in expressing concern about the content and messages of television programming, why would the portrayal of elected officials on television be exempt from this larger trend? If African-Americans and women are affected by negative stereotypes, if lawyers and physicians are unfairly and/or unrealistically portrayed, why would the treatment of elected officials be any different? It is my contention that there is no difference. In a study of the impact of television on American politics, Austin Ranney tried to sort through existing research on the question of political bias in news coverage. His conclusion was that rather than a left or a right wing bias, there was a bias ". . . against *all* politicians, and especially against those most identified with electoral politics."

He went on to observe that while he knew of no "systematic study of the matter," he believed that "entertainment television also has a distinct antipolitician bias. Most of the live politicians that appear in situation comedies and dramas are portrayed as pompous, windy, hypocritical, and

self-seeking buffoons" (Ranney 1983, 58–59).

Ranney's suspicion has always seemed to me to be justified. What follows is an attempt to substantiate his belief through an interpretive analysis of the depiction of elected officials on television. While, I make no claims that this analysis is comprehensive, it is based on a lifetime of watching *way* too much television. The interpretation is informed by various students of the medium who have taught me to watch TV not just as a casual viewer and a fan, but also with a critical eye. To substantiate and confirm my own conclusions, I have picked the collective brains of colleagues, friends, family, and students over the years for additional examples, illustrations, and reactions to the portrayal of elected officials who appear on TV. I have consulted the little written material available on the subject. Having done all this, I have found a good deal of evidence to support my argument that elected officials on television are either criminals or buffoons, I have found only scattered evidence of officials portrayed in a positive or a realistic light.

The Elected Official as Buffoon

The elected official portrayed as a buffoon appears to have a rather long history on TV. *The People's Choice* (1955–58) featured a "naturalist" (played by Jackie Cooper) who somehow found himself elected to the city council. A job he was clearly not ready for, so his actions were often well intentioned, but usually comically inept. The "hook" of the show was that the most intelligent character in it appeared to be "Cleo," a talking basset hound. In terms of what follows, the most remarkable aspect of this program was that the main character in the show was an elected official. Over the years, the clownish, inept elected officials tend to be secondary characters, the starring roles being reserved for individuals not elected to office (McNeil 1996, 650).

One of the best known illustrations of the inept elected official is Governor Gatling on *Benson*. The popular 1980s sitcom's title character was Benson Dubois who had appeared previously as a minor character in the 1970s sitcom *Soap*. Benson joined the governor's staff as the household manager, i.e., he was the butler. He was clearly the only sane, intelligent, and responsible member of the governor's staff. Over the years Benson became a valuable advisor to the governor. He was appointed the state's budget

director in 1981. The governor was, to put it kindly, an "airhead," not terribly in touch with reality. He was good-hearted and endearing, but bumbling. He needed his staff, both political and household, to keep him out of trouble. He was, in short, an archetypal television elected official—the fool. One of the more interesting aspects of this program, however, was that Benson himself was elected lieutenant governor in the later years of the show. He eventually challenged his former employer in the gubernatorial election during the final year of the show. But viewers never got to find out who won the election. The last episode ended with the two men watching the election returns, the results were never made known, and the show went off the air. This is not really surprising, if Benson had been elected, the standard television approach to elected officials would have had to change. Benson was clearly an intelligent, responsible, dedicated, and hard working elected official—a character type rarely appearing on entertainment television (McNeil 1996, 86).

The 1990s version of the elected official as a fool is Mayor Randall Winston on the ABC sitcom *Spin City*. *Spin City* is a rarity on television: a successful situation comedy set in a political environment. When the show first aired, there were a number of articles, especially in New York media outlets, analyzing the "reality" of the show. Some authors noted that the visual setting was fairly accurate, if a bit larger and cleaner than the real thing. However, there seemed to be a consensus that the characterization of the mayor was way off base. Clyde Haberman described the mayor as a "basically good-hearted man but often a clueless 25-watt bulb." He went on to observe that New Yorkers have tolerated many things in their mayor who "can be vain and tyrannical, nasty and foulmouthed. But not dim. Certainly not the hapless pawn of an all-knowing deputy whose main talent seems to lie not in getting things done but in "spinning" reality so that it looks as though he is getting things done" (Haberman, 1996). Gail Collins expressed similar views. She described the Mayor as a "handsome, dimwitted presence with a Reaganesque out-to-lunch charm, who lets his staff really run the city." She goes on to note, somewhat disparagingly, that "Politicians whose main attributes are a good head of hair and a smart staff can do very well in the United States Senate. But they cannot be mayor of New York City. Being mayor of New York is a hands-on job, practiced in full view of the voters. A mayor here can get away with being bad-tempered, egotistical, vindictive, peculiar, whiney, a cross-comber or dogmatic, but not dumb" (Collins 1996).

New York Magazine interviewed a number of New York City political figures to get their reaction to the show. Their assessments echoed those of

the journalists. Mark Green did not think the public would "buy a mayor who was a turkey." Green was obviously mistaken since the show is running strong in its third season. Ruth Messinger's verdict on the show was that "It's probably exactly what the world thinks politics is like" (Hawkin 1996). Unfortunately she is likely correct as shows such as *Spin City* help perpetuate the simpleton image of elected officials. This view is exacerbated when the picture drawn is also that of a political leader who is really a puppet controlled by behind-the-scene handlers more interested in image than substance, politics than policy.

As *Spin City* has evolved since its initial airing, it has become less about politics and is now primarily an office sitcom. Anita Gates sees it as one of a number of contemporary programs that focus on "the dysfunctional office family" (Gates 1998). At the time of the writing of this essay, the main story lines involve various inter-office romances including one between the mayor and his administrative assistant. Since the mayor is recently divorced, he is not engaging in anything improper, however in the post-Monica Lewinsky era, romantic relationships, no matter how consensual, between superiors and subordinates are highly suspect, if not clearly inappropriate. While it will be interesting to see how this story plays itself out, the mayor is still the likeable dimwit he was when the show first aired. Still, it is noteworthy that *Spin City* has managed to remain popular, and therefore on the air, longer than any other politically oriented situation comedy since *Benson.*

There have been a few other sitcoms located in a political setting but they have not been able to successfully remain on the air. *Hearts Afire, The Powers That Be* and *Women of the House* were all programs set in Washington D.C. and featuring members of Congress that had short lives on network television. Like *Spin City*, *Hearts Afire* centered on political staff, in this instance the staff of an "addled" southern senator. The Washington DC setting was quickly scrapped and the staff, minus the senator, relocated to a small southern town in the second season to run the local newspaper. (McNeil 1996, 368–69). *The Powers That Be* featured a "dimwitted United States Senator" and his dysfunctional family. As is often the case on television, the Senator's chief administrative assistant, was also his mistress. This show intermittently aired for just a single season. (McNeil 1996, 669–70). *Women of the House* did not even make it that long, remaining on the air less than a single season. In it Delta Burke reprised her *Designing Women* role as southern belle, Suzanne Sugarbaker, who takes over the Georgia congressional seat of her late, fifth husband. She played the same flighty, shallow character as she did on the previous show, demonstrating

that the dimwitted elected official is not an exclusively male phenomenon (McNeil 1996, 922).

The Elected Official as Criminally Corrupt

As the opening paragraphs of this essay illustrate, soap operas are particularly good at promoting the image of elected official as criminal. *One Life to Live's* congressman Graham may be emblematic of soap portrayal, but he was an admittedly minor character and was written out of the show in the course of a few months. The same cannot be said for Grant Harrison, a long term "villain" on the NBC soap, *Another World*. Harrison arrived in Bay City (the fictional location of *AW*) in 1990 to seek medical treatment, at the time he was a U.S. Congressman serving as Chairman of the House Committee on Crime and Racketeering (a wonderful irony knowing the rest of his career). He won a senate seat in 1991, which of course is impossible since senators are only elected in even numbered years, and spent years planning a presidential race by creating the perfect image for himself. The effort came to a halt when he had to resign from the senate after he was discovered to have framed his ex-wife for attempted murder. He then went on to shoot his brother Ryan to stop him from interfering with Grant's life. He was imprisoned for his various crimes, but was released rather quickly. In 1997 he was elected mayor of Bay City. Since his election he has planted a bomb to try to kill his ex-wife and caused a fire that burned down the home of the police commissioner, generally carrying on his criminal pursuits while serving as mayor. Grant was murdered shortly before the program was cancelled in the late spring of 1999 (Grant Harrison 1999). Grant Harrison is unusual in terms of criminal elected officials in that he remained with the show a long time despite his criminal record. What is particularly telling is his political rejuvenation, that he could be elected mayor after having served time for murder, does more than strain credibility, it insults the voting public, both real and fictional as well as all conscientious, hard-working mayors throughout the country.

Perhaps the best, and certainly the most outrageous, example of the criminal official appearing on a daytime soap occurred on *Days of Our Lives* in the late 1980s. In 1987 a new, major character appeared in Salem, the fictional location of *Days*, U.S. Senator Harper Devereaux. A wealthy and powerful man, the senator was involved in a number of dishonorable

activities including poisoning and kidnapping his daughter-in-law. Regular viewers of the show knew fairly quickly that Harper was one of the "bad guys," what they didn't know for some time was exactly how bad. They found out in 1988 during the period when the senator became a presidential candidate.

To all but the most ardent viewer, it would have been obvious that Senator Devereaux would not be able to win the election, even soap writers know they can only go so far in getting the audience to "suspend disbelief," but there were numerous scenarios that could have been used to explain his loss in the election. The show's explanation, however, would shock even the most scandal jaded citizen. It seems that Salem had a problem that year with a serial murderer. The "Salem Slasher" was somewhat indiscriminately running around town attacking, and sometimes murdering, a number of the city's desirable young women. Well, it turned out that Senator Devereaux *was* the "Salem Slasher"—certainly not the most gracious or admirable, not to mention, realistic, way to exit a presidential campaign. To make matters even worse, after being arrested and imprisoned for his various criminal acts, the senator orchestrated an escape, returned to town and took his daughter-in-law hostage again before finally exiting the show permanently.

Daytime dramas are not the only shows that regularly present viewers with elected officials who are criminal or corrupt. *Knott's Landing*, a popular nighttime drama on the air from 1979 to 1993 featured Gregory Sumner, another U.S. senator with a questionable background and highly suspect methods of operating. He joined the program in 1983. He had a number of extra-marital affairs and traded sex for political favors. This illustrates that the pattern of adulterous elected officials seems to appear regardless of whether the official is corrupt or a buffoon. Sumner was involved in a questionable land deal, had a clear relationship with organized crime, and, when pressured, abused his power in order to protect the crime interests. All of this was just in the first season of his appearance on the show. Eventually he left politics in order to become CEO of a large, rather mysterious, corporate empire. To the show's credit Sumner was just as corrupt in his corporate practices as he was while an elected official (McNeil 1996, 454–55; Laurie's Knots Landing Web Site, 2/25/99).

The corrupt elected official appears much less frequently as a series than does the bumbling idiot. But every once in a while, we come across a figure who actually combines the character traits of both depictions. The case in point is *The Dukes of Hazzard*'s Boss Hogg, a county commissioner who

was always trying to enrich himself at the expense of the people—clearly a corrupt official. He was also clearly incompetent since his plans often backfired and was usually undone by the "good ole boys" who were the stars of the show. It is also true that the "evil" elected official appears more often in dramas rather than situation comedies. One can speculate that, other than in the soap opera format where long-term villains are a standard fare, it is fairly difficult to sustain long term interest in a disreputable figure.

If one adds to the mix elected officials who appear irregularly, in only one or two or even a handful of episodes, the overwhelming impression remaining is that of the elected official as either a fool or a criminal, in either case most likely carrying on an adulterous or inappropriate sexual relationship. It is no wonder that the public expressed minimal outrage at the revelation of the Clinton-Lewinsky relationship, the elected officials they see on television are "doing it" all the time.

The Exceptions That Prove the Rule

There are some exceptions to the general pattern described above, but they are few and hard to identify. In *Mayberry R.F.D.*, the successor to the highly popular *Andy Griffith Show*, Ken Berry played Sam Jones, a town councilman. He took on the Andy Griffith role as the only sane character surrounded by a familiar cast of misfits, incompetents, and other generally comic figures. The show aired for three seasons in the pre-Watergate era, from 1969 to 1971 and, given its television ancestor, was a reflection of the nostalgic and romantic vision of small-town life exemplified by *The Andy Griffith Show* (McNeil 1996). In 1989, at the end of the Reagan era, a dramatic series entitled *Top of the Hill* made it on the air for three months. It featured an "idealistic" congressman who took over the seat of his ill father. The congressman was a "good guy" and clearly intelligent; however, he spent most of his time solving mysteries. While this was an example of a positive representation of an elected official, very little of the show actually emphasized his role as a congressman and it lasted barely half a season (McNeil 1996). On *Northern Exposure,* Holling Vincoeur was a main figure in the drama. He ran the local bar/restaurant which also served as the town center. After a few seasons, it was revealed that Holling was the mayor. Later in the show another major character, Maggie O'Connell became mayor. While the elected official story line was highlighted only a few times,

both figures fulfilled their obligations in an admirable manner, and neither became corrupt nor did they display signs of weakened intelligence as a consequence of serving. (McNeil 1996; Kimiye's Home Page *(Northern Exposure)*.

The Ambiguous Cases

Then there is the somewhat ambiguous case of *Picket Fences*. Rome, Wisconsin, the setting for the show, went through at least five mayors during the four years the program aired. During its first season there was a contested race for mayor. The incumbent was not entirely "clean" but seemed to be something of a comic figure. The election was filled with various revelations regarding the candidates and eventually the mayor was reelected, but at the beginning of the second season, he was convicted of murder for killing a car-jacker. His conviction was overturned on appeal, but just as he was being told of his good fortune, he died via "spontaneous combustion." (Strange occurrences were fairly common in Rome, Wisconsin during the show's run.) The new mayor runs the local lingerie store. She makes a number of questionable decisions, has a somewhat shady past revealed, is forced to leave office, and is replaced by a new mayor who suffers from Alzheimer's. After a few episodes the demented mayor is shot by his son. During the third season, the shows main female star and a very sympathetic character overall, Dr. Jill Brock, becomes mayor. She is arrested for denying a federal court order, undergoes a trial for murder and eventually is replaced by a new mayor. The new mayor has a child fathered by her gay brother's lover. While the various mayors of Rome do not seem to fit neatly into either the criminal or the buffoon pattern, they are all exceedingly strange (*Picket Fences* Rome Pages, 3/3/99).

A Lost Opportunity

An interesting opportunity for presenting an alternative picture of politics and elected officials occurred during the February 1999 sweeps period. The sitcom *Dharma and Greg*, pursued a story line that had the potential of taking a new approach to elected officials when Dharma decided to run for San Francisco city supervisor. For those not familiar with the

program, ABC describes Dharma as "the free-spirited daughter of hippies" who marries Greg "the conservative son of blue-bloods." She is off-beat and eccentric, but she is intelligent and honest, i.e., she is neither corrupt nor stupid. The story line began when Dharma engaged in a "random act of kindness"—putting quarters into parking meters about to expire. It seems this is against the law in San Francisco and, after an encounter with a rather unpleasant meter reader, Dharma receives several tickets for her act. She then proceeds to "fight city hall" in an effort to right an obvious injustice. In a very funny episode she experiences an inordinate amount of bureaucratic red tape in her quest.

Dharma ends up deciding to run for a newly open seat on the board of supervisors. Consistent with her character, she mounts a decidedly off beat campaign, assigning jobs by pulling names out of a hat, a style that her husband, a lawyer and former congressional candidate, tells her will be her downfall. At first she remains true to her character, honestly putting forth her views and ideas about improving life in the city. It seems like she might have a chance to win the election until a former state assemblywoman decides to enter the race. Dharma's opponent is a "typical politician," (the term is used intentionally) a slick manipulative woman. She destroys Dharma in a debate by misrepresenting Dharma's views and past. The debate causes Dharma to change her tactics and run her campaign as a "traditional" politician would. Consequently she lies, misrepresents herself, tells various audiences what they want to hear, and generally panders to the voters. These actions are so out of character that her body rebels and she becomes sick. She looks terrible.

In a pivotal scene where she is doing a live TV interview with her opponent, Dharma "listens to her body" and tells the world she has been lying and that she just can't do it any longer. The general conclusion is that this means she will loose the election. But, as the returns come in, it appears that the election is too close to call. However, after staying up all night, in the end, Dharma finds out that she has lost the election (ABC-TV *Dharma and Greg* Episode Guide, 3/3/99). This would have been a wonderful opportunity to counter the dominant trend in entertainment programming when it comes to elected officials. The writers on the show had demonstrated that they could pursue a political story line that was very funny (it would be unrealistic to even suggest that a sitcom not strive for comedy), but that also could have a lead character be an elected official with integrity. Unfortunately, it was an opportunity that was lost when the show decided to follow the general pattern on entertainment television in depicting politics as "dirty"

and people running for office as manipulative and deceitful.

An Alternative Possibility

A role model does exist for an alternative picture of elected officials. Programs that are set in law enforcement settings have been intentionally omitted from this analysis. One reason for the omission is that officials on such programs tend to be depicted in a more complex manner, they are presented more realistically and more sympathetically. Another, more important, reason is that while district attorneys and sheriffs are very likely to be elected to their positions, most people do not seem to place law enforcement officials into the same category as they do mayors, governors and representatives, i.e., one rarely hears a D. A. being described as a "politician."

An alternative depiction of an elected official can be seen in the character of District Attorney Adam Schiff on the NBC program *Law and Order*. Schiff is the New York County (Manhattan) District Attorney, an elected position. As such, Schiff rarely appears in the courtroom, his job is setting the policy, direction, and tone for how the office is run. While he is not the central figure on the program, he is an integral part of an ensemble cast, and his character often has a pivotal role in the plot lines. In "real life" the Manhattan D.A. can often find him/herself at the center of political controversies. Such has regularly been the case on *Law and Order*. Ultimately Schiff makes decisions regarding the prosecution of cases, but he usually defers to his assistant district attorneys. He does, however, step in when high profile cases are involved. Schiff has, at times, put his job on the line for a cause he believes in. He has, at other times, been more prudent or pragmatic, making decisions that his staff disagrees with. He fully acknowledges the "politics" of his job. He has had to struggle to retain his office after angering a major political power broker with a decision. Adam Schiff is an intelligent man with personal and professional integrity. He exercises his authority carefully and responsibly. Adam Schiff comes closer to the reality of most elected officials than any other fictional elected official currently on television. He is hardworking, dedicated to his job, willing to make difficult decisions, and hence is not always the most popular guy in town. He is neither stupid nor is he corrupt nor does he appear to have any inclination to get involved in any inappropriate romantic entanglements. There is no reason

why other television dramas could not have characters that resemble Adam Schiff (*Law and Order* Episode Guide, 3/5/99).

Conclusion

The question that remains open is why? Why is the negative portrayal of elected officials so persistent on entertainment television? This is probably too complex a question for there to be a definitive answer. In order to get a complete understanding, one would have to interview various writers and producers to discover their intentions. Are the patterns conscious decisions on the part of the writers, or are they the only portrayals that come to mind? It is easier to think and write within the confines of stereotypes than it is to develop complex and realistic characters. It is possible that the writers are simply choosing the easy path. Exploring the writers' intentions would present an interesting research project, but it is beyond the scope of this chapter.

Even if we could know the writers' intent, this would still beg the question. There is the always troubling issue of causation. Does the negative picture of elected officials mirror, or does it contribute to, an overall public perception? Adding to the complexity are, of course, the events themselves. From Vietnam to Watergate, through Iran-Contra and the Clinton scandals, recent history has given the public ample reason to be suspicious, even cynical regarding the integrity of public officials. What does seem clear is that our collective perception of our elected leaders is that they are not very admirable. The best conclusion may well be that there is a complex interaction between television and the public atmosphere in which it is situated. Television does not "cause" negative perceptions of elected officials, but it certainly contributes to the perpetuation of the stereotypes.

This analysis has not been premised on an idealistic understanding of elected officials. There are elected officials who are corrupt, there may even be some who are not overly bright, although this is a less plausible scenario given what it takes to achieve office these days. However, elected officials are arguably neither more nor less corrupt and stupid than the rest of the population. Certainly those who exercise corporate power are as prone to abuse it as those who exercise political power. The significant difference lies in the fact that voters ultimately can remove their representatives by not returning them to office, there is no similar accountability system in place for

the business world. The truth about elected officials lies somewhere between the criminal and the idiotic. Most elected officials are reasonably intelligent, hardworking dedicated individuals trying to do their jobs the best they can. The jobs themselves are not easy because officials are often placed in positions of having to make difficult choices. They have to respond to and resolve various situations involving social conflict. There is as much inherent drama in political settings as there is in courtrooms, medical offices, and police stations. Political settings are also not without their humor. The lost opportunity of *Dharma and Greg* demonstrates that we could have had an engaging character as an elected official even within the constraints of a situation comedy. In the Fall of 1999 NBC introduced a new drama entitled *The West Wing*. The program is set in the west wing of the White House and it offers the possibility of a more complex and sympathetic portrayal of elected officials, although the staff and not the president appear to be the primary characters. We will have to wait to pass judgement regarding *The West Wing*, but it does seem unlikely that we will see any overall change in television's long established patterns of portraying elected officials any time soon. The best that we might hope for is that viewers watch television with more caution. If we can be made aware of other negative stereotypes, we can also cast a critical eye at the depiction of elected officials.

Note

I would like to thank all those individuals who shared their knowledge of television with me. It would have been impossible to come up with all the illustrations included in this essay without the help of other people. In addition to the family, friends, colleagues, and students who have pointed me to many of the examples of elected officials on television, I also want to thank all the fans who have posted synopsis and character biographies on the internet, without their help my task would have been much more difficult.

References

ABC-TV Dharma and Greg Episode Guide, 3/3/99.<http://abc.go.com/-primetime/dharma_and_greg/episode_guide/index.html>
ABC.com, ABC TV's *One Life to Live*, 2/16/99 <http://abc.go-.com/soaps/-onelifetolive/the_past/index.html>

The Andy Griffith Show. 1960–1968. CBS.

Another World. 1964–1999. NBC.

Bennet, W. Lance. 1996 *The Governing Crisis: Media, Money and Marketing in American Election*. New York: St. Martin's Press.

Benson. 1979–1986. ABC.

Collins, Gail. 1996. "The Spin on 'Spin City'." *The New York Times*, 20 September, p. A30.

Dharma and Greg. 1997–present. ABC.

Days of Our Lives. 1965–present. NBC.

Designing Women. 1986–1993. CBS.

The Devereaux Family, 2/27/99 <http:/-members.aol.com-/rcushman/-days/devereaux.html#harper>

The Dukes of Hazzard. 1979–1985. CBS.

Faludi, Susan. 1991. *Backlash: The Undeclared War Against American Women*. New York: Crown Publishers.

Gates, Anita. 1998. "Home Sweet Workplace, Nest of Neuroses." *The New York Times,* 17 May, p. 39.

Grant Harrison, 2/25/99 <http://www.intranet.ca/~awhp/granth.html

Habeman, Clyde. 1996. "Dramatic License in City Hall's Halls." *The New York Times*, 1 December, p. 48.

Hawkins, Lucy. 1996. "Spinning 'Spin City.'" *New York Magazine* 29 (September 9): 72.

Hearts Afire. 1992–1995. CBS.

Kimiye's Home Page (Northern Exposure) 3/3/99 <http://www.-gate.net/~kimi/>

Knott's Landing. 1979–1993. CBS.

Laurie's Knots Landing Web Site, 2/25/99 <http://www.geocities.-com/Hollywood/Hills/4489/index.html>

Law and Order. 1990–present. NBC.

Law and Order Episode Guide, 3/5/99 <http://www.dickinson.edu/-~buchan/docs/lo/completelist.html>

Long, Rob. 1995 "That's Entertainment?" *National Review* 47 (July 31): 65-66.

Mayberry R.F.D. 1968-1971. CBS.

McBride, Allan, and Robert K. Roburen. 1996. "Deep Structures: Polpop Culture on Primetime Television." *Journal of Popular Culture* 29 (spring): 181–200.

McNeil, Alex. 1996. *Total Television: The Comprehensive Guide to Programming From 1948 to the Present* 4th ed. New York: Penguin

Books.

Murphy Brown. 1988–1997. CBS.

Nimmo, Dan and James E. Combs. 1990. *Mediated Political Realities* 2nd ed. New York: Longman.

Northern Exposure. 1990–1995. CBS.

One Life to Live. 1968–present. ABC.

The People's Choice. 1955–58. NBC.

Pfau, Michael, Lawrence J. Mullen, and Tracy Deidrich. 1995. "Television Viewing and Public Perceptions of Attorneys." *Human Communication Research* 21 (March): 307–30.

Pfau, Michael, Lawrence J. Mullen, and Kirsten Garrow. 1995. "The Influence of Television Viewing on Public Perceptions of Physicians." *Journal of Broadcasting and Electronic Media* 39 (fall): 441–58.

Picket Fences. 1992–1996. CBS.

Picket Fences Rome Pages, 3/3/99 <http://wwwgeocities.com/-TelevisionCity/Set/9182/>

The Powers that Be. 1992–1993. NBC.

Ranney, Austin. 1983. *Channels of Power: The Impact of Television on American Politics*. New York: Basic Books, Inc.

Riggs, Marlon. 1991. *Color Adjustment*, California Newsreel.

Soap. 1977–1981. ABC.

Spin City. 1996–present. ABC.

Top of the Hill. 1989. CBS.

Women of the House. 1995. CBS.

The World Almanac and Book of Facts. 1998. Mahwah, N.J.: World Almanac Books.

Chapter 8
"As Brave as Stallone, as Beautiful as Brooke Shields" POW Rathbun-Nealy and American Military Women in the Gulf War

Martha F. Lee
Cynthia Nantais

"Good men respect and defend women."
—Commissioner, Presidential Commission 1992

This statement expresses well the traditional cultural foundation of the American military.

Notwithstanding the presence of women in each American war, the link between men and war remains powerful and distinct. Lethal force on the battlefield is intimately linked to masculinity. The warmth and normalcy of the homefront are linked to femininity. These entrenched cultural images frustrate the efforts of women to achieve cultural recognition as full and equal participants in military service.

States require vast human resources to engage in modern warfare. As a result, wars create opportunities for women. They fill roles normally set aside for men, both on the homefront and the battlefront. This participation does not, however, produce more opportunities for them after hostilities cease. In fact, following conflicts, both society and the military tend to seek a "return to normalcy," that is, the way things were before the war (Segal 1995, 761). A kind of "cultural amnesia" takes place, whereby women's expanded contributions are forgotten. This process allows the traditional cultural images of the male as protector and the female as protected, to remain intact.

The United States sent an unprecedented number of women to the Persian Gulf. Of its over 500,000 combined forces, more than 36,000 were female (United States Department of Defense 1992, Appendix R).[1] At the time of the 1991 Gulf War, women were integral to the functioning of the military, serving in a number of non-combat capacities. The Gulf War demonstrated that the line between combat and support was blurring and that the distinction was less meaningful and more arbitrary as two women were

taken as POWs. Both women survived and arguably endured their experience well. Women's achievements in the Gulf therefore led many scholars and activists to conclude that American women's participation in the military would continue to increase, and that their full and equal participation in combat roles was inevitable (see, for example, Holm 1992; Shroeder 1992; and Muir 1992).

This chapter argues that this outcome is a possibility, but it is not an immediate certainty. It does so by analyzing the media images of military women during the Persian Gulf War, particularly the United States' first female Prisoner of War (POW), Melissa Rathbun-Nealy.[2] As will be seen, the pattern of "cultural amnesia" is reflected in the media's treatment of American military women in general and Rathbun-Nealy in particular. Her experience and the media's portrayal of it, suggest much about women's roles in the American military, both during and after the Gulf War.[3]

Cultural Images, Gender, and the Military

Weedon argues that culture is comprised of "structures and practices that uphold a particular order by legitimizing certain values, expectations, meanings and patterns of behavior" (quoted in Wood 1994, 26). Every culture produces images, or "shorthand representations of reality" that endorse and maintain a particular view of reality; these images are significant because they govern behavior (Boulding 1956, 6). Communication and the media perpetuate, interpret, and amplify these cultural images.

Cultural images, like myths, "[transform] history into nature." They create a reality that is vital to a society's self-understanding. For this reason, they are fundamentally resistant to change; a society's members tend to ignore or discredit deviations from the norm (Boulding, 1956, 8). Indeed, MacDonald argues that cultural images are vulnerable only to challenges that confront "the whole understanding of the way things are" (MacDonald 1987, 3). Gender images present a particularly good example of entrenched cultural images.

Sex is the biological division of organisms between male and female, and genetically determined. Gender is "the constellation of meanings that a given culture assigns to sex differences" (Cooke 1993, 223). It is learned. Gender is typically expressed as masculinity and femininity, each of which prescribes assumptions and expectations based upon a cultural ideal.

Although there has been some relaxation of each definition as the role of women in society has evolved, their essence remains the same. Masculinity is strength, ambition, success, rationality, and control. Femininity is beauty, deference, passivity, emotion, empathy, and the capacity to nurture (Wood 1994, 21). The ideas that constitute gender are expressed in many facets of culture and they act to shape perception and prescribe action in these realms.

Men dominate state militaries, and in most countries, the military's defining activity — combat — is the sole responsibility of men. Images of masculinity therefore pervade military culture, to the extent that Morris describes it as a "hyper masculine" culture (Morris 1996, 710). Indeed, David Marlow, Chief of Military Psychiatry at the Walter Reed Army Institute of Research has written that for combat soldiers, ". . . masculinity is an essential measure of capability . . . the maleness of an act is the measure of its worth and thus a measure of one's ability" (Morris 1996, 708). Young recruits, for example, are subject to coercion that exploits their anxiety about sexual identity. Name-calling, such as "ladies" and "girls" is utilized as a means of motivating them to prove their manhood on the battlefield (Stiehm 1983, 371; see also Morris 1996, 716–17). These expectations form part of the "baggage of expectations and myth" that surrounds military combat (Grossman 1998, 33).

Judith Hicks Stiehm analyzes one aspect of this culture and its images in her "protector/protected" model. She argues that our culture links masculinity and the military's function of protection in such a way that the act of protecting is associated with men, and that the position of being protected is associated with women and femininity (Stiehm 1983, 368). As protectors, men are responsible for protecting women. This helps to explain why, during times of war, women are typically perceived as "symbols, victims or dependents . . . 'women and children rolls so easily off network tongues because . . . women are family members rather than independent actors" (Enloe 1992, 102). In such a culture, the role of women soldiers is ambiguous. They are trained to be protector-warriors, but our culture's image of their sex assigns them to the class of protected dependents. Military policy, which prohibits women from undertaking full combat roles, reinforces this ambiguity.

The "hyper masculinity" that surrounds our image of the protector demands much of men: self-reliance, toughness, and dominance. It also includes several assumptions regarding virility and sexual needs (Morris 1996, 710–16). These images are also linked to the protector/protected dichotomy. Part of the reason a protector is willing to risk his life on the

battlefield is because he believes he is protecting those who depend on him; by their very existence, the protected justify the battle. A successful protector may therefore feel entitled to draw his reward from those whom he protects. This helps to explain how cultural images contribute to certain patterns of sexual behavior within the military.

As early as World War II, servicewomen reported varying degrees of harassment. Major General Jeanne Holm, for example, cites one soldier who commented that "You [could not] even go into the chow hall without running the gauntlet" (Holm 1992, 70). The 1992 Tailhook Convention, where women were again forced to navigate "the gauntlet," echoed her story. In 1988, 64% of active-duty women reported experiencing one or more instances of sexual harassment in the previous 12 months (Bastian, Lancaster, and Reyst 1996). This figure is noticeably higher than the civilian average of 30% to 40% (Muir 1992, 158). In November 1996, these problems were further evidenced at Maryland's Aberdeen Proving Ground, where women soldiers filed allegations of sexual harassment against three male officers responsible for training new recruits, and seventeen more officers were investigated for similar charges. Immediately following these revelations, the Army received 3,930 calls reporting similar incidents (Ehrenreich 1996, 80). Morris finds that the rate of rape within the military is also comparatively higher than civilian rates, and suggests that the sexual norms of military culture help to explain this fact (Morris 1996, 761–62). As Stiehm points out, protection has a cost (Stiehm 1983, 373). It could be argued that this type of behavior indicates that a soldier has "confused his fellow soldier with the foe," and therefore committed treason (Ehrenreich 1996, 80), but these types of actions are consistent with the protector/protected relationship.

No male protector would, however, accept such treatment of his own dependents by the enemy. His responsibility for them, by definition, creates "both a burden and an expanded vulnerability" (Stiehm 1982, 372). A successful attack by the enemy on these dependents is evidence of his failure. In this context, rape is a blatant message that the men responsible are not able to protect "their" women (Seifert 1992, 59).

The prewar campaign by the United States to justify military intervention in the Gulf utilized images of rape. The Iraqi invasion became known as "the rape of Kuwait." Media coverage depicted the "looting, torture and rape" of Kuwait as an "assault on the soul of [the] nation," and suggested that "the concepts of sovereignty and violation in the international arena were linked to sexual counterparts of integrity and rape" (Farmanfarmaian 1992, 113).

The capture of Army Specialist Melissa Rathbun-Nealy played on these fears. One American official was quoted as saying that "a woman POW is the ultimate nightmare." This statement reflects media-exploited fears that if the Iraqis treated their own and Kuwaiti women appallingly, there was a strong possibility that they would abuse or rape Rathbun-Nealy (Wheelwright 1994, 124). It also reflects longstanding military belief that female POWs would be particularly unacceptable because of their "natural" vulnerability to sexual assault.

American Military Women in the Persian Gulf War

The conflict between the image of women as protected and protectors is evidenced in both society and the military. Its impact is felt most particularly by those women who serve within the military structure and who must attempt to reconcile these conflicting roles and images. On the one hand, the military claims to use women as professionals. On the other hand, media images of them are often those of a society's protected citizens. In the Gulf War, this conflict was further intensified through the image of the female Prisoner of War, Melissa Rathbun-Nealy.

Cynthia Enloe writes that the prevalent image of American military women to emerge from the Gulf War was that of the professional soldier (Enloe 1992, 98). An examination of media reports, however, reveals a persistent preoccupation with stereotypical conceptions of femininity and masculinity. The media consistently raised questions and offered opinions about femininity and the nature of women with respect to war. Elshtain makes reference to one article, for example, that highlighted the special utility of having women in the Gulf. In addition to completing essential military support tasks, they were "also useful in the war effort because they provided a 'shoulder to cry on' for the men" (Elshtain 1991, 15). A *Time* article featuring women serving in the Gulf described the activities of Lt. Lynn Bifora and her commitment to equal opportunity. The article also suggested, however, that Bifora "admits that it would be nice to put on a dress again, and clings to what femininity she can" (Gibbs 1991, 37). This final impression undermines her presence as a soldier. She is a woman —the protected—first.

The media also highlighted the perceived nature of masculinity by

referring to the sexual needs of male soldiers. Consequently, they also addressed the implications for the women serving with those men. Knight-Ridder Newspapers, for example, circulated a story entitled "Female Troops Feel the Stress of New Roles." In the article, female soldiers were described as fearing being around men who were in the desert for extended periods of time. One enlisted woman commented that "When men are living in the desert, their loins start tingling. They see a female and their heads aren't clear. They want to go into combat with a clear head" (Copeland 1991, 6F). This attitude stereotypes both men and women. It assumes male soldiers are by nature sexual predators, and that female soldiers are not fellow combatants, but sexual objects.

Following this, media reports also exaggerated problems of fraternization and pregnancy, and often constructed incidents as exclusively the responsibility of women. The Navy Destroyer *Acadia*, for example, was portrayed as indicative of a 'baby boom.' It became known as the "Love Boat" after thirty-six female crew members became pregnant (Hackworth 1991, 26). The media gave the impression that pregnancy was a widespread problem (see, for example, Horowitz 1992, 62), but more men were incapacitated due to sports injuries than women due to pregnancy. The Department of Defense stated that while detailed figures were not meaningful, the overall early return rates were approximately 2% for men and 2 ½% for women (Presidential Commission 1992, C-48).

In *Women, Men and Media*, a study of gender and media coverage during the Gulf War, M. Junior Bridge found that newspaper reports in February of 1991 were predominantly focused on "men, their jobs, their weaponry, their opinions" (Bridge 1991).[4] What coverage there was of women focused on the "Mommy War," stories of young mothers and their prolonged separation from their children. These reports tended to question the acceptability of using mothers as soldiers. While there was demonstrated concern over mothers leaving their children, "there was not one article or editorial on the impact of a father leaving his children" (Bridge 1991). In the words of Kate Muir, it was "the mothers who took all the flak" (Muir 1992, 115). An example of this type of perspective can be found in a syndicated editorial by Elaine Donnelly, who wrote: "The sight of a male soldier leaving his baby behind has always tugged at the heart, but there is an extra dimension of profound uneasiness when a young mother is involved. In all of our nation's wars, we have never asked so much of the children left behind" (Donnelly 1991, 3B).[5]

Human interest stories also reflected gendered assumptions about men

and women. An example of such coverage were the stories that focused on personal items men and women took with them to the front to remind them of home. Material concerning men focused on such items as female undergarments, while that featuring women portrayed them as carrying pictures of loved ones. Clearly these stories reflected reality, but they also reinforced the traditional gender constructions of masculinity and femininity. One of the most popular and widely reproduced photographs of a woman soldier during the Gulf War was that of Captain Jo-Ann Conley, shown with a photograph of her daughter pinned to her helmet (Bridge 1991). Even at war, female soldiers were both protectors and the protected. The conflicts inherent in these roles are nowhere better evidenced than in the experience of POW Melissa Rathbun-Nealy.

POW Melissa Rathbun-Nealy

Those who oppose women in combat often use the possibility of a female POW to justify their case (see for example, Wheelwright 1994, 124; Testimony of E. Donnelly to the Presidential Commission 1992, 103; Binkin 1991; and Hackworth 1991, 24–29). They argue that any such capture would undermine public support for a war. Accordingly the case of Rathbun-Nealy is interesting.[6] It offers insight not only into public and media perception, but indirectly into government and military expectations. Rathbun-Nealy was a female soldier presumed protected by military policy. She was, however, subject to a consequence generally reserved for male protectors. Her capture highlighted the internal contradiction in the image of the female soldier. As a result, her experience had the potential to challenge the traditional protector/protected dichotomy.

Melissa Rathbun-Nealy was born March 9, 1970 in Grand Rapids Michigan. She joined the military in 1988, and completed her basic training at Fort Dix, New Jersey, and her advanced individual training at Fort Lennox, Missouri. There, she trained as a truck driver and earned the rank of Specialist. Rathbun-Nealy was sent to the Persian Gulf on October 16, 1990, and was stationed in Dhahran. The Iraqis captured her on January 31, 1991, and the military initially classified her as "missing in duty." The Iraqis held her for thirty-three days, but it was only a week before her release that the American military changed her status to Prisoner of War. She was released to the Red Cross on March 4, 1991.

Rathbun-Nealy illustrates well the ambiguities experienced by female soldiers in the U.S. military during the Gulf War. While she advocates a strong role for women in the military, she nevertheless characterizes much of her role in the Gulf as consistent with the role and image of the protected. Most clearly, Rathbun-Nealy illustrates that masculinity remains part of the foundation of military culture. While she believes that women can be good soldiers, she does not think that "any place in the army is a place for women at all" and that men "like to keep it all men and they allow us [women] because they have to."

Rathbun-Nealy's experience with sexual harassment in the military was consistent with the events at the Aberdeen Proving Ground. She claimed that it was not usually her fellow enlisted soldiers who were guilty of sexual harassment, but her male superiors. Rathbun-Nealy reported that she was first the target of this type of behavior during her basic training, and that it continued throughout her time in the Army. As evidence, she offered several anecdotal accounts, explaining that she did not make any official complaints regarding this harassment. She intimated that her reluctance to do so was related to the explicit discrimination that she believed was experienced by her fellow servicewomen. Although fraternization was against military policy, she recounted that male sergeants often became involved with lower ranking, enlisted women who occasionally became pregnant. According to Rathbun-Nealy, the men often denied responsibility and received no reprimands, while the women's careers were effectively over.

When a woman becomes pregnant in the American armed services, she has the option of leaving the military. Rathbun-Nealy was childless at the time of the Gulf War, but she held clear opinions on the issue of "mothers going to war," a topic given significant attention by the media and manipulated by those opposing the use of women in war. She acknowledged that any change in policy would add a further obstacle for women in the military,

> "[women want to be admitted into] this men's world and be treated as an equal in this man's world, but we want to have these little double standards set aside where if we don't feel like we want to do it, then we shouldn't have to do it. But the men have to do it whether they want to or not." This explanation suggests that although military women might find such "double standards" useful, they will not enjoy full equality until the military eliminates barriers such as the combat and draft exclusions. The military "mommy track" reinforces the image of women as protected soldiers.

Rathbun-Nealy argued that this policy of protection was problematic for her. Although modern warfare blurs the lines between combat and non-

combat roles, military leadership still enforced these rigid boundaries. She believed that this policy led to a situation where the military undervalued her talents and those of other military women. Despite her demonstrated ability in truck driving, for example, she received few assignments in the Gulf that required that skill. Like many women in her unit, she was usually confined to kitchen and guard duty. This policy reinforced a traditional gendered division of labor, and affected the image of the servicewoman in the eyes of her fellow soldiers, as evidenced in Rathbun-Nealy's own experience.

Rathbun-Nealy recounted that she was on her first mission the day the Iraqis captured her, and the only woman in a convoy with three men. Once they were unsure of their exact location (they later learned they had missed a detour), they met to discuss their course. When Rathbun-Nealy saw the Persian Gulf, she knew they had gone too far, and argued that they should turn back. The men dismissed her explanation, and one of them reminded her that she had no mission experience. They continued onwards, despite her objections, and the Iraqis captured her and her partner David Lockett. She concluded that in this event she was a "victim of male chauvinism." Because women were technically classified as support — despite their proximity to the front lines — Rathbun-Nealy lacked practical war experience. This fact compromised her stature and credibility relative to her fellow servicemen and, it could be argued, contributed to their capture.

Rathbun-Nealy attributed this military policy to social pressure, but polls suggest that American society after the Gulf War would likely accommodate a greater presence of women at the front. A *Newsweek* poll released August 5, 1991, found that 53% of Americans surveyed would support combat assignments for women, but only if they wanted them. Support fell to 26% when the assignment was involuntary (Kantrowitt, Clift, and Barry 1991, 23). A Roper Organization poll in July 1992 found that 71% of respondents wanted to "maintain or increase the proportion of women in the military." This support diminishes, however, in cases of direct, ground, hand-to-hand combat where only 38% of those surveyed advocated assignment (The Roper Organization 1992). One possible interpretation of these figures is that the public is unwilling to relinquish the image of the female soldier as somehow different from the male soldier, and still in need of some measure of protection.

Rathbun-Nealy also addressed the question of whether she believed the presence of women undermined camaraderie in a unit, a criticism often made by those opposing the integration of women into military combat units. Interestingly, the role she described for herself and her fellow servicewomen

in this dynamic is consistent with that of the protected in the protector-protected relationship. She thought that women helped cohesion in her unit because "even if there wasn't a lot of sexual activity going on, at least the men had that availability to flirt so a lot of that tension was relieved from them just to be able to flirt and see pretty women." From this perspective, servicewomen in the Gulf satisfied the same needs that pin-ups and prostitutes did in earlier conflicts. Rathbun-Nealy commented that some men could relieve their sexual tension and therefore go on to do their jobs with a clear head. She likened their presence to that of "all those beautiful women coming out and hugging the GIs during USO tours in Vietnam."

Rathbun-Nealy's attitude reflects military culture's ambiguous attitude toward women soldiers. On the one hand, she advocates full equality and participation for women, including combat assignments (and resents the military's under-use of her talents), but at the same time, she views women as serving in ways consistent with the reward and justification function of the protector-protected relationship.

Media Coverage of Melissa Rathbun-Nealy

Media coverage of Rathbun-Nealy's experience reflected the traditional gender images of masculinity and femininity. Shortly after her capture, *USA Today* published an article typical of the media coverage she received. In it, Army Sergeant Leisa Frederick was quoted as not being able to keep from thinking the worst: "I shudder to think what they might to do her." In addition, men in her unit had "become more watchful"; they refused to let women go anywhere alone (Keen 1991, 2A).

The link between sexuality and war was clearly present in the coverage of Rathbun-Nealy, both during her imprisonment and after her release. Despite her many public statements to the contrary, public perception of her incarceration forced on the suspicion that she had been raped. *People* magazine summed up popular fears during her captivity in the following way: "if she were alive, [had] she been the victim of rape or torture like so many Kuwaiti women?" (Freeman, Weinstein, and Greenwalt 1991, 46). In fact, Rathbun-Nealy was not raped and, after her release, stated this to the press on several occasions. Media coverage, however, focused on speculation that her Iraqi captors had sexually assaulted her. These stories appeared most frequently in popular accounts of the conflict. According to Rathbun-

Nealy, the *Globe* tabloid printed a story claiming that the Iraqis had assaulted her. (She later settled a lawsuit against the tabloid out of court.) Media suggestions concerning this issue continued as recently as April 1995, when *20/20* aired a story on the Survival, Evasion, Resistance, and Escape (SERE) training program. Rathbun-Nealy believed that this story, which used her image, implied that she had been raped. *20/20* denied that there was any such implication. She recounted that after it aired, she was again forced to deny to her family and friends that she had been raped.

As noted above, the rape of the protected during war demands that the "failed protector" reassert his manhood. This connection was explicitly played out during Rathbun-Nealy's incarceration. Following her release, several fellow soldiers told her that their commanders had called them to order and claimed she had been raped, and/or found "slit from [her] crotch to [her] neck, [her] head was cut off, [her] arms were cut off and this or that was cut off." These stories, which are consistent with the tactic of using the protected as motivation to "pump up" soldiers before combat, circulated throughout the military.

Interestingly, Rathbun-Nealy felt that several of her Iraqi captors had, in her words, "protected" her. They treated her much differently from the men whom they had captured in that she was well fed, given exercise, and allowed some measure of freedom. Upon her return the media were quick to use her statement that the Iraqis had described her as "brave as Stallone and as beautiful as Brooke Shields" (Walsh 1991, 23).

In August 1991 Congressional testimony, a Bush Administration official stated that both Rathbun-Nealy and fellow female POW Rhonda Cornum were "subjected to sexual threats and one was fondled by her captors" (Healy 1991, 1A). He did not qualify this statement, however, and its ambiguity resulted in many interpretations. Cornum's later disclosure that she was sexually assaulted further complicated this problem. The fates of the two women were linked by their POW status, an anomaly in the realm of the protected, and Cornum's statement thus had implications for the public's perception of Rathbun-Nealy.

Popular weekly magazine reports framed coverage in more gendered terms than did newspapers (Nantais 1995, 125–28). Symbolic of this tendency was a *Newsweek* story that questioned how the public would "react to seeing women held captive and possibly tortured." The author concluded that: "For women in the military, attaining equality may carry a terrible price" ("Women in the Military" 1991, 20). This was, however, a price the public and media seemed to accept for male soldiers.

Magazine coverage often focused on Rathbun-Nealy's character. Family and friends were characterized as emphasizing that she possessed exceptional personal strengths, implying that regardless of whether women as a group could survive captivity, Rathbun-Nealy as an individual could. Her seventh-grade teacher, for example, stated: "If anyone has her, they're going to be in for a fight. She's a fighter that one" (Arias, Alexander, and Weinstein 1991, 43). This type of distinction was reflected in post-war assessments of the female POW experience. It was acknowledged that there was a relatively positive outcome for Rathbun-Nealy, but there was a demonstrated reluctance to derive lessons for all women soldiers.

Despite the apparent widespread interest in Rathbun-Nealy's fate, there was little attention paid to the full story of her capture. This may be in part explained by the fact that her narrative, which painted a humane picture of the Iraqis, and contained no accounts of rape or torture, was interpreted as having little news value. Regardless of the reasons for it, however, the effect was that her relatively positive experience was not widely publicized.

After Rathbun-Nealy's release, media coverage could be interpreted as consistent in its depiction of her as the protected. *USA Today*, for example, reported that Rathbun-Nealy descended the steps from the airplane to "graciously" greet her military superiors. She then "fell into her mother's arms" with "tears streaming down her face." This description contrasts markedly with the article's depiction of Army Staff Sergeant Daniel Stamaris, who after sitting upon his gurney to greet the receiving line, saw his family members rush over and "shower him with kisses." A quotation from a local spectator, Lorraine Dwyer, concluded the article: "All the Americans that went over there are my *sons* [emphasis added]" (Hall and Howlett 1991, 1A). Rathbun-Nealy and the other women soldiers who served as protectors, were already fading from public memory.

The Post–Gulf War Environment

The political repercussions of these gendered images were made clear in the 1992 Presidential Commission on the Assignment of Women in the Military, where the increased risk of women POWs was used frequently to justify the continued exclusion of women from combat roles. The decisive vote was cast in favor of reinstating the statutory exclusion due to the "POW factor" (Presidential Commission 1992, 82). This decision was made despite

evidence in testimony that the combat exclusion did not eliminate the risk of capture, and despite the experiences of Rathbun-Nealy and Cornum, who had proven that their capture was not a "greater threat to national security than the capture of the men who were with them" (Presidential Commission 1992, 83).

This perception of the POW factor is largely rooted in the understanding of women as protected, and their consequent vulnerability. Those representing the Survival, Evasion, Resistance, and Escape (SERE) training program testified that there were no gender-based performance differences in enduring captivity, but instructors observed that men, because of cultural norms, felt "a need to do something . . . to stop it or . . . to protect" (Presidential Commission 1992, C45). There was a concern that the mistreatment of female POWs would have a negative impact on fellow male captives, exposing a greater vulnerability to the enemy. Further, a Joint Services SERE Agency survey found that students thought that "females would be more likely to be sexually exploited than males." SERE leadership explained that this attitude resulted from a lack of attention to the sexual exploitation of male POWs. The survey also determined that despite this widespread anxiety, women were less concerned with being sexually exploited than were their male counterparts (Testimony of Colonel J. Graham to the Presidential Commission 1992, 212). As Rhonda Cornum testified to the Commission, "[Rape] is an occupational hazard of going to war and you make the decision whether or not you are going to take that risk when you join the military" (Testimony of R. Cornum to the Presidential Commission 1992, 14).

Despite women's awareness and apparent acceptance of this risk, the issue of women POWs played an important role in the Presidential Commission debate. This was particularly true of the Commission's published "Alternative View" sections. This perspective argued that women POWs, no matter what the treatment they received, would have a "far more demoralizing effect on the American Public than similar treatment of male prisoners" (Presidential Commission 1992, 70).

The fear of women as POWs appears to reside less in their ability to withstand the ordeal than in the negative impact of the image of the captured on military effectiveness and public support. Evidence given in testimony to the Presidential Commission on the Assignment of Women in the Military supports this argument. The post-war evaluation of the role of women in the military discounted the revolutionary value of her experience and relied instead on the traditional perception of women as the protected.

Conclusion

The women who served during the Gulf War performed their duties well. In several cases, including that of Melissa Rathbun-Nealy, their service was exceptional. Circumstances allowed them to step beyond the limits of American military policy and demonstrate that their abilities were equal to those of their male colleagues. The success of these women, however, did not lead to a permanent expansion of women's roles. After the Gulf War, the military did not choose, and society did not demand a fundamental reorganization of women's roles.

This chapter argued that one of the reasons for this lack of integration lies in the power of traditional cultural images. Despite women's advancement in many spheres of social and political life, we still tend to view men as society's protectors, and women as those who should be protected. Both during and after the Gulf War, the media reinforced these cultural stereotypes. Coverage of American servicewomen was framed in terms of the traditional protector/protected relationship, even in the case of Melissa Rathbun-Nealy.

The longevity of the protected/protector stereotypes and their prevalence throughout all levels of society—including the media—suggest that full and equal integration of women into the military will be a long and difficult process. The power of our traditional values seems to indicate that real change, if it is to occur, must come from within society, as well as the military. Not only must women soldiers be able to do what "real" soldiers do, which is to kill and die in battle for society, but society must be able to believe that they can do it.[7]

Notes

1. Of this number, 26,000 women served with the Army, and were assigned to forward support units in numerous specialties, including transport, military police, air defense artillery, and intelligence. The Navy sent 3,700 women, who served on hospital, supply, and repair ships, and as Naval pilots. Women also served in the Marine Corps, Air Force, and Coast Guard, in similar positions of responsibility. This level of participation, although the largest in American history, was significantly less than women's 11% participation in the regular forces.

2. Following the Persian Gulf War, Rathbun-Nealy remarried. Her name is now Melissa Coleman. For clarity and consistency, this article identifies her by her surname at the time of the War.

3. The research presented in this paper was originally published in a separate article in the *Journal of Gender Studies*, 1999.

4. Women, Men, and Media, conducted by M. Junior Bridge, was conducted in February 1991, and sponsored by the University of Southern California's Women, Men, and Media Project. The study examined content in ten major newspapers and eleven smaller markets (a circulation of 20,000–50,000) newspapers. It examined front page and op-ed (or equivalent) pages for content and bylines to assess the frequency and character of coverage of and by women.

5. The public was clearly concerned about this issue. An Associated Press poll published on February 21, 1991, demonstrated that two of every three Americans felt that "sending women with young children to a war zone was unacceptable" (Binkin 1991, 12). A *Newsweek* poll published August 5, 1991, found that 54% of Americans questioned thought mothers on active duty should be able to refuse assignments (Women in the Military 1991, 27).

6. The information that follows was obtained through interviews with Melissa Rathbun-Nealy in May of 1995 in Grand Rapids, Michigan.

7. In his testimony to the Presidential Commission, Edwin Dorn argued that there were "instructive similarities" between the effective integration of African Americans and the incomplete integration of women into the American military (Dorn 1992b, 21). The integration of African-Americans after President Truman's 1948 Executive Order 9981, which called for "equality of treatment and opportunity for all persons in the armed forces regardless of race" (Dorn 1992a, 5), was not immediately successful. Ignorance and racial stereotypes were difficult to eliminate. In the case of African-Americans, Dorn argues, the military undertook a sustained human relations campaign to eliminate racial prejudice. As well, African-American men were subject to the same risks as their colleagues. Dorn argues that for women to be fully integrated, the military must eliminate its combat exclusion policy.

References

Arias, Ron, Benita Alexander, and Fannie Weinstein. 1991. "As the War Claims Its First Female MIA, Melissa Rathbun-Nealy's Pals Recall One Tough, Spirited Kid." *People* (February): 43.

Bastian, Lisa D., Anita R. Lancaster, and Heidi E. Reyst. 1996. *1995 Sexual Harassment Survey.* (Report No. 96-014). Arlington, VA: Defense Manpower Data Center.

Binkin, Martin. 1991. "The New Face of the American Military: The Volunteer Force and the Persian Gulf War." *The Brookings Review* (Summer): 10.

Boulding, Kenneth. 1956. *The Image.* Ann Arbor: University of Michigan Press.

Bridge, M. Junior. 1991. "Women, Men and Media Study: As the Gulf War Raged, the Gulf Between News Coverage of Women and Men Continued." Press Release. 8 April.

Cohn, Carol. 1993. "Wars, Wimps, and Women: Talking Gender and Thinking War." In *Gendering War Talk*, ed. Miriam Cooke and Angela Woollacott. Princeton, NJ: Princeton University Press.

Copeland, Larry. 1991. "Female Troops Feel the Stress of New Roles." *Detroit Free Press* (17 February): 6F.

Donnelly, Elaine. 1991. "Children Suffer When Mommy Goes to War." *Detroit Free Press* (17 February): 3B.

Dorn, Edwin. 1992a. "Integrating Women into the Military." *The Brookings Review* (Fall): 5.

Dorn, Edwin. 1992b. Statement before the Military Personnel and Compensation Subcommittee and the Defense Policy Panel of the Committee on Armed Services, House of Representatives. *Gender Discrimination in the Military.* (29 and 30 July): 21.

Ehrenreich, Barbara. 1992. "Wartime in the Barracks." *Time* (International Edition) (2 December): 80.

Elshtain, Jean Bethke. 1991. "Feminism and War." *The Progressive.* (September): 15.

Enloe, Cynthia. 1992. "The Gendered Gulf." In *Collateral Damage: The New World Order at Home and Abroad,* ed. C. Peters. Boston: South End Press.

Farmanfarmaian, A. 1992. "Did You Measure Up?" In *Collateral Damage:*

The New World Order at Home and Abroad, ed. C. Peters. Boston: South End Press.

Freeman, Pat, Fannie Weinstein, and Julie Greenwalt. 1991. "Survivor of 32 Too Many Arabian Nights, Melissa Rathbun Nealy Heads Home from Baghdad." *People* (March): 46.

Gibbs, Nancy. 1991. "Life on the Line." *Time* (25 February): 36–38.

Hackworth, David. 1991. "War and the Second Sex." *Newsweek* (5 August): 24–29.

Hall, Mimi and Debbie Howlett 1991. "USA 'Opening Its Arms to You': 'Someday' Finally Came for Ex-POWs." *USA Today* (11 March): 1A.

Healy, Melissa. 1991. "Pentagon Details Abuse of American POWs in Iraq." *Washington Post* (2 August): 1A.

Holm, Maj. Gen. Jeanne. 1992. *Women in the Military: An Unfinished Revolution.* Novato, CA: Presidio Press.

Horowitz, David. 1992. "The Feminist Assault on the Military." *The National Review* (5 October): 46-49.

Kantrowitt, Barbara with Eleanor Clift and John Barry. 1991. "The Right to Fight." *Newsweek* (5 August): 22–23.

Keen, Judy. 1991. "Women in the Gulf Know Risk," *USA Today* (4 February): 2A.

MacDonald, Sharon. 1987. "Drawing the lines — Gender, Peace, and War, An Introduction." In *Images of Women in Peace and War: Cross-Cultural and Historical Perspectives,* ed. Sharon MacDonald, Pat Holden, and Shirley Ardener. London: Macmillan Education Ltd.

Morris, Madeline. 1996. "By Force of Arms: Rape, War, and Military Culture." *Duke Law Journal.* 45.4: 652-781.

Muir, Kate. 1992. *Arms and the Woman.* London: Sinclair-Stevenson Ltd.

Nantais, Cynthia. 1995. *"Images of American Women in War."* Master's Thesis, University of Windsor.

Presidential Commission on the Assignment of Women in the Armed Forces. 1992. *Report to the President.* Washington, D.C.: GPO.

Rathbun-Nealy, Melissa. 1995. Interviews with Cynthia Nantais. Grand Rapids, Michigan, May.

The Roper Organization. 1992. *Attitudes Regarding the Assignment of Women in the Armed Forces.* August.

Schroeder, Patricia. 1992. Testimony before the Military Personnel and Compensation Subcommittee and the Defense Policy Panel of the Committee on Armed Services, House of Representatives. *Gender Discrimination in the Military.* July 29-30.

Segal, Mady Wechsler. 1995. "Women's Military Roles Cross—Nationally, Past, Present, and Future." *Gender and Society* 9.6,: 757–775.

Seifert, Ruth. 1992. "War and Rape: A Preliminary Analysis." In *Mass Rape: The War Against Women in Bosnia-Herzegovina,* ed. Alexandra Stiglmayer. Lincoln: University of Nebraska Press.

Stiehm, Judith Hicks. 1983. "The Protected, The Protector, The Defender." In *Women and Men's Wars*, ed. Judith Hicks Stiehm. Oxford: Paragon.

United States Department of Defense. 1992. *Conduct of the Persian Gulf War, Final Report to Congress.* April.

Walsh, Edward. 1991. "As Brave as Stallone . . . Beautiful as Brooke Shields." *Washington Post* (6 March): 23A.

Wheelwright, Julie. 1994. "'It Was Exactly Like the Movies!' The Media's Use of the Feminine During the Gulf War." In *Women Soldiers: Images and Realities,* ed. Elisabetta Addis, Valeria E. Russo, and Lorraine Sebesta. New York: St. Martin's Press.

"Women in the Military: The First POW." 1991. *Newsweek* (11 February): 20.

Wood, Julia T. 1994. *Gendered Lives.* Belmont, CA: Wadsworth Publishing Company.

Chapter 9
"Mr. Smith Tells Congress to Go to Hell": Celebrity and Performance in the Iran-Contra Affair

Amy Fried

For *Mr. Smith* a replica of the U.S. Senate chamber was built in the studio and many scenes were photographed against Washington backgrounds—*a novelty in 1939.* . . . *Every detail was as authentic as movie magic and Hollywood magic could make it*
—Richard Griffith on the making of *Mr. Smith Goes to Washington*

We delegated to the Architect of the Capitol the problem of how to accommodate twenty-six members of the Committee in the Russell Senate Office Building's majestic Caucus Room *The answer was obvious: construct a two-tiered dias, a simple matter of marshaling lumber, carpenters, and money* *What none of us noticed was that we had transformed the hearing room into a mini-coliseum and that we appeared as the equivalent of Russian potentates turning thumbs up or down on the stoic Christians who would be dragged before us to give testimony.*
—Senators Cohen and Mitchell on the preparations for the Iran-Contra hearings

Question: Why do you think Oliver North provoked the public reaction he received?
Answer: It was "Mr. Smith tells Congress to go to hell." He came across as an honest man in a military uniform facing a bunch of "all talk, no action" politicians.
—Staff member for Iran-Contra investigating committee

With the film *Mr. Smith Goes to Washington*, director Frank Capra created an indelible image of political heroism. In this film "an honest and relatively inexperienced man is taken from a small-town environment into a more complex environment that tests and nearly shatters his world view [and where he is] threatened by men of power and wealth" (Maland 1998, 110).[1] Mr. Smith, played by actor Jimmy Stewart, was down home, independent, sincere, and steadfast against those who threaten ordinary citizens. Like George Bailey in the Capra Christmas classic *It's a Wonderful Life* (a part also played by Stewart), Mr. Smith found corruption and greed in the powers that be. Yet the aptly-named Jefferson Smith remained a champion of

American political values, and ultimately triumphed.[2]

But what does this movie from 1939 have to do with modern politics? As this essay will show, *Mr. Smith* provided one metaphor that was to depict unfolding political events during the congressional investigation of a major presidential scandal. In the Iran-Contra hearings of 1987, the media turned to popular culture to explain and describe the proceedings. In recounting events, reporters did not use purely objective terms, but drew from evocative symbols and created compelling narratives. By using pre-existing imagery and developing new story lines, journalists made their news stories more interesting. Witnesses were presented as characters in a drama, as celebrities whose performances and audience appeal deserved review. While the story of *Mr. Smith Goes to Washington* had virtually nothing in common with the foreign policy endeavors investigated by Congress, the media used key elements of the script—especially certain plot elements and protagonists—to frame unfolding events. At the same time, this approach led the media to leave out consequential elements of the real story.

During the hearings, Oliver North's appearance before the Committee marked the high point of the media's allusions to popular culture. Journalists' discussions of North's statements, the comments directed toward him, and public reaction were all framed in this way. Thus North's supporters, some of whom had earlier planned to demonstrate against Congress, were interpreted as ordinary citizens who were upholding Mr. Smith's principle that the little guy can challenge entrenched elites. At the same time North proclaimed he had previously lied to Congress, North presented himself as a man of integrity who, like Jefferson Smith, would tell the truth even in the face of scorn and disdain. Furthermore, members of Congress believed North's stance influenced the general public, although, in fact, the evidence for this was not strong. In a political culture oriented toward celebrity and performance, some senators (as we see in some of the opening quotations) blamed their poor staging decisions for the audience response they feared.

After outlining the particulars of the Iran-Contra Affair, this chapter discusses the ways Oliver North presented himself dramatically. After that, the essay analyzes how the media reacted to Mr. North, with special attention to the media and cultural tendencies that stimulated journalists to emphasize performance, celebrity, and scripts. Because the media focused on performance, numerous reports focused on how the audience was reacting; at the same time, reporters' interest in style and image led them to do a poor job in understanding public response. Finally, this chapter examines the impact of these dynamics on the congressional investigation and on the new public

career of Oliver North.

The Circumstances, the
Setting, and the Man at the Center

Following a series of troubling revelations in November 1986, the Iran-Contra hearings were held to investigate and clarify a complex series of events. In fact, the Iran-Contra Affair involved three separate but entangled secret policies.[3] The first was the sale of U.S. weapons to certain elements in the government of Iran, a plan intended to speed the release of American hostages. Private citizens were used as intermediaries, and they earned profits from the sales. When this situation was first revealed, President Reagan denied that this had been a straight arms for hostages trade. However, most commentators and most of the public believed it had been such a swap and President Reagan soon announced an end to the endeavor. This sort of exchange was seen as wrong because the U.S. policy was to never reward hostage takers since such deals would lead to more hostages being taken. These arms sales were also especially controversial because the U.S. State Department had labeled the Iranian government a terrorist nation and had urged other nations not to sell them arms. Furthermore, many Americans had very negative views of Iran because the nation had previously held U.S. embassy staff hostage for 444 days. Before they were released in January 1981, these Americans were periodically marched out of the embassy blindfolded while American flags were burned and the hostage takers chanted "Death to America."

In the second part of the Iran-Contra scandal, the Reagan Administration was found to have secretly supported a group called the contras. This group fought against the government of Nicaragua. Following a revolution in 1979, the government in this central American nation was first fairly moderate and President Carter secured it economic assistance. However, more radical forces emerged in Nicaragua and President Reagan changed policies. Reagan concluded that the Nicaraguan government was a security threat, and he wished to support armed rebels termed the contras. President Reagan asked Congress for money for the contras and some years these were granted. However, when members of Congress learned about certain covert actions (such as the mining of Nicaraguan harbors, an act in violation of international law), they were angered and cut off funds. A 1984 provision

barred the U.S. government from acting for "the purpose or which would have the effect of supporting, directly or indirectly, military or paramilitary operations in Nicaragua by any nation, group, organization, movement, or individual" (Kornbluh and Byrne 1993, 385). As the Iran-Contra Affair developed, it was discovered that individuals in the White House had raised private money for the contras and had otherwise assisted their effort.

The third part of the affair involved a connection between the first and second parts. Investigators discovered that some of the profits from arms sales to Iran were funneled to the contras. Both ways of raising money for the contras dismayed many, even some who thought the contras deserved U.S. support. This was because money spent to support U.S. policies is supposed to be granted in laws passed by Congress and signed by the president. Congress had debated aid to the contras and had sometimes voted against them. Yet the Reagan Administration found a back-door way to fund the contras. As for all three parts of the scandal, many were bothered because the executive branch had done all of this without telling anyone in Congress, since there are laws which require that a small number of members of Congress be informed of secret foreign policy actions.

Congressional leaders created a special committee to investigate the affair.[4] The Iran-Contra Committee included members of the Senate and the House of Representatives and it held hearings from May to August 1987. Clearly its most watched witness was Lt. Colonel Oliver North, a Vietnam veteran and marine. During the events of Iran-Contra, North had helped organize many of the scrutinized activities. North did this as a staff member for the National Security Council (NSC). The NSC is part of the executive branch and its head, the National Security Advisor, is supposed to coordinate information and policy options coming from the Departments of Defense and State and to advise the president. By doing such things as raising money for the contras and arranging arms sales, the NSC (headed by National Security Advisors Robert McFarlane and John Poindexter) went beyond its lawful mission.

By the time North came to Capitol Hill in July 1987, media interest was intense. Previous witnesses had given information about events, but none was as involved in as many parts as North. In addition, President Reagan fired North in November 1986 because, the president said, North and others had done things without his permission. North had also shredded documents about the affair after it was first made public and before he was fired. North's centrality in the case and his destruction of documents meant that he might know things—including whether the president knew more than he

admitted—which had not been revealed. People in the White House gave mixed messages about North before his appearance, with President Reagan calling him a hero at one point and spokespeople claiming that he was a "loose cannon" who had acted on his own. This ambivalence was marked in media reports as well, as the broadcast networks previewed North's visit to Capitol Hill. Although ABC and NBC aired short pieces (40 seconds and 20 seconds) showing largely negative views toward North in the general public, ABC and CBS broadcast fairly lengthy (5 minutes and 6 minutes and fifty seconds) news pieces about his hometown and military career, which prominently featured positive remarks by his wife, friends, and teachers. Although some voiced misgivings about North's actions, he was portrayed as a committed, hardworking, and courageous individual.

The Dramatic Oliver North

While North's place in the scandal's events made him a key witness, the combination of his persona and certain media tendencies made his appearance the most dramatic and most watched part of the hearing. North was able to use the emotionally powerful symbols of the U.S. military. He arrived at Capitol Hill in full military dress, even though, in his assignment to the White House, he had always dressed in a suit. The picture of North standing in uniform, with its various ribbons of merit, as he took his oath to tell the truth, was to become one of the most memorable and widely circulated. In addition, North frequently referred to himself as "this marine" and "this lieutenant colonel" and President Reagan he termed the "commander-in-chief." But North's military bearing was not joined to deference toward the elected legislature. Instead, North frequently challenged members of Congress and the committee's attorneys.

North's demeanor was both a product of his own forceful personality and the advice of his counsel. Before appearing on the Hill, his attorney had successfully negotiated a grant of immunity. This meant that nothing North said in his congressional testimony could be used against him in a prosecution. This legal protection enabled North to dramatically proclaim that he would "tell the truth – the good, the bad, and the ugly" and to admit that he had previously lied to and misled Congress. In addition, most other witnesses were questioned privately by committee staff before their public appearances, thus giving the committee lines of inquiry for further develop-

ment. However, Brendan Sullivan, North's attorney, had not agreed to this. Sullivan also tried to gain strategic advantage in other ways. For instance, Sullivan told committee lawyers that they should not give him copies of memos and other documents (about which they would question North) until soon before North's appearance. Then, after the documents were delivered to Sullivan, he had them arranged into a tower of paper next to which North stood and asked photographers to shoot the scene. Sullivan produced the picture during the hearings as they were being carried on national television and then complained that the committee was unfair to give them the papers so late. The visual image and attorney Sullivan's criticisms promoted the idea that North was a little guy harassed by Washington power brokers.

North had ample opportunity to burnish his persona, for he carefully practiced beforehand in his lawyer's office, planning what he would say to probable questions. Such practice sessions were clearly designed with public relations in mind. For example, it was learned that one of the individuals who had profited from the arms sales had paid for an elaborate security system for Oliver North's home, and documents relating to this were falsified. (Later North would be convicted for "accepting an illegal gratuity;" i.e., this system.) In pre-testimony negotiations, attorney Sullivan asked that public questioning begin with this matter. When North was asked about this in public, he proclaimed in a fifteen-minute response that he had felt threatened by the terrorist Abu Nidal. Furthermore, while he was prepared to "go man to man" with Abu Nidal, he had to think of his family. North then referred to a photo of an American girl named Natasha Simpson who was shot in a terrorist incident in Rome and said, "Gentlemen, I have an eleven year old daughter, not perhaps a whole lot different from Natasha Simpson." North's answer suggested that the committee was petty, and that the questioners' character was far below that of the protective and brave Oliver North. Looking back, two senators noted, "It was now clear why Sullivan had tried to get the public questioning to begin with the subject of the fence. North's response had sealed his triumph" (Cohen and Mitchell 1989, 156).

Cultural Tendencies and
Media Responses to Oliver North

In speaking to the committee, North and those who readied him for his testimony took account of the culture in how they crafted his heroic

character. As any television or movie producer would agree, figuring out how to create a memorable and effective image is not a task with predictable results (Schudson 1989), but North's handlers prepared him well. North also benefitted from the ways the media approach political news, particularly with the media's focus on celebrity and performance.

Journalists have always been storytellers to some degree (Broder 1987) simply because they must explain who did what and when. However, the line between commercial entertainment and journalism has blurred increasingly, and the news media have tended to heighten the intensity and dramatic sensibility of their reports. One consequence is greater attention to conflict and strategy, rather than substantive matters (Patterson 1994). Scripts that include a great deal of contention and disagreement provide ready templates the media may adopt as they tell their tales. Another result is that the media judge public figures the way a critic would judge an actor, that is, in terms of performance on a stage. As one scholar explains, "The performance criteria ask not what you are but how you seem or appear (Jamieson 1992, 171)."[5]

Oliver North's testimony to Congress was assessed in terms of his performance. Reporters devoted a lot of time to describing how well North presented himself, so much that one concluded afterward that, "The Iran-Contra hearings last week may have had more to do with theater and symbolism than with great constitutional questions" (Morrow 1987, 12). Indeed, this same journalist sounded like a drama critic himself when he wrote in *Time* magazine

> North is a natural actor and conjurer of illusion. His face is an instrument that he plays with an almost unconscious genius His voice was low and passionate. It cracked in the affecting way that Jimmy Stewart's does, although sometimes with a force of anger behind it, the voice sounded like Kirk Douglas in a manic moment. (1987, 12)

North's seeming ability to put over a performance was noted with dismay by some. For example, a piece in *U.S. News & World Report* concluded (McLoughlin 1987, 18), "Virtually overnight, the putative villain of the piece became a freshly minted hero, even though—by his own testimony—North had lied to Congress and shredded documents in directing the Iran-Contra operation."

Furthermore, North was also treated like a celebrity, a person who has become famous and can be identified with particular qualities. Daniel Boorstin noticed the trend toward celebrity worship in the U.S. some years

ago.

> Celebrity-worship and hero-worship should not be confused. Yet we confuse
> them every day, and by doing so we come dangerously close to depriving
> ourselves of all real models. We lose sight of the men and women who do not
> simply seem great because they are famous but who are famous because they are
> great. We come closer and closer to degrading all fame into notoriety. ([1961]
> 1987, 48)

Part of what makes people celebrities is their concern with managing their
own fame and reputation. Journalists, in examining North, took just that
approach. According to a correspondent looking back at Iran-Contra,
"[R]eporters concentrated on who was scoring more public relations points
on any given day—the witnesses or the committee members and their
counsel" (Armstrong 1990, 31). In examining North's image as a new
celebrity, he was regularly compared to stock characters and other well-
known role players. For R.W. Apple, for instance, North epitomized the
"underdog, true believer, one man against the crowd: there was a lot of Gary
Cooper in him, the lonesome cowboy, a lot of Jimmy Stewart, too, the honest
man facing down the politicians, and quite a bit of Huck Finn" (1987, 1).

In their reporting, the media's attention to celebrity and performance
intermixed, especially as the media became assessors of the audience.
Journalists frequently behaved like culture critics who predict whether people
will like a play in production or who record the boos or applause as an
audience is seated. In making these judgments, reporters made determinations
about how the staging of the hearings and the other "characters" had or
would come across. For example, before North's appearance, "A TV
Viewer's Guide" in *Newsweek* proclaimed, "If it all works out, the show will
be a hit spinoff: Watergate with a new cast and fresh plotThat may
seem like a lot of characters to keep track of, and there are 11 more besides.
Too many to make it a hit series? Size never seems to hurt 'General
Hospital.' If the plot works, the fans will follow" (Alter and Clift 1987).
Then, following North's visit to the Hill, *Newsweek* concluded that Oliver
North had entranced his public. According to Alter and Clift's cover story

> Lt. Colonel Oliver L. North charged up Capitol Hill last week as the Rambo of
> diplomacy But he captured the Hill as Ollie: a new national folk hero who
> somehow embodied Jimmy Stewart, Gary Cooper, and John Wayne in one
> bemedaled uniform. He touched off a tidal wave of telegrams, flowers and
> letters; "Give 'em hell, Ollie," bumper stickers, T-shirts and banners blossomed
> across the country."[6]

But had North's performance really been so effective? In addition, even if it had, why did North's putative celebrity and performative abilities dominate news coverage? Most importantly, did the media's approach to the hearings have any significant influence on policy or the investigation?

How Did the Media Matter?

One impact of the media's emphasis on celebrity and performance was simply that it gave less time and attention to the facts and the constitutional issues. The Iran-Contra Affair raised important questions about the proper role of Congress, the president, and the public in foreign policy (Koh 1990; Draper 1991). Steps taken by the Reagan Administration were meant to sidestep Congress, thus undermining the institutional system of checks and balances. Whether or not the administration's actions were justified, given its view of international threats, was a question worthy of careful analysis. Yet these aspects of what many consider to be the most significant presidential scandal were largely overlooked. Before the story broke, the national press had largely ignored early reports of help to the contras and Iranian contacts (Bonafede 1987; Randolf 1987). Once it became a public story, the Watergate analogy was frequently used in the media, but this was a blurred lens (Cornfield and Yalof 1988). Then during the hearings, the fundamental issues were again given short shrift.

In their role as audience assessors and theater critics, the media also missed key features of public opinion. This is especially ironic since the media frequently approached the hearings in precisely this way, regularly making claims about the public's reaction to North. Yet they did not get the story right. To be fair, determining what the public thinks is not an easy process. If one goes by polls, one must be sure that they were done correctly; the sample size and specific questions should be examined. When different questions are asked by different organizations, small changes in wording can lead to very divergent responses. At the same time, interpreting polls is rarely a purely rational process. After elections, for instance, the media look at exit polls and voting trends and converge on particular explanations. Yet these "constructed explanations" (Hershey 1992) are not the only reasonable interpretations of the public voice. Even understanding what the public thinks of a president is not always certain because one can look at various questions

and can decipher the findings in various ways. For example, the press regularly proclaimed that President Reagan (before Iran-Contra) was unusually popular, yet his job approval ratings were consistent with historical trends (King and Schudson 1995).

Furthermore, in evaluating Americans' responses to North, the media were not limited to information from opinion polls. Instead, there were frequent reports on the number of citizen contacts to members of Congress, demonstrations, and cultural expressions (such as songs, haircuts, and sandwiches dedicated to Oliver North). Based on these responses, the media proclaimed that "Olliemania" had swept the nation and that Americans strongly supported Colonel North. This coverage and the responses the media chronicled affected members of Congress and the progress of their investigation. However, there were serious flaws in the conclusion that North's strategy of presenting himself as the star of "Mr. Smith Tells Congress to Go to Hell" led to widespread admiration of North.

Clearly the American people were watching and responding to North's testimony. According to historian David Thelen, "The half-million letters, telegrams, and phone calls that Americans sent to the committeemen over three months in the summer of 1987 together represented perhaps the largest spontaneous popular response to a congressional activity in American legislative history" (1996, 19). However, Americans who called or wrote to members of Congress (and to newspapers) were by no means united in their praise for North. Calls to the Senate side of the Iran-Contra Committee started out pro-North, but then switched to anti-North. Letters to Representative Lee Hamilton (D-Indiana), studied by Thelen, were fairly mixed but more anti-North. Furthermore, the letter writers used their missives to go beyond the concerns raised in the media, addressing issues as varied as the rule of law, the role of the U.S. in international affairs, and the meaning of patriotism and heroism.

The media also overlooked the extent to which telegrams (photogenically stacked by North's lawyer next to him at the witness table), letters, and other responses were mobilized and orchestrated. Groups that had supported contra aid and the Reagan Administration planned to mount an effort before North's testimony began. The Conservative Caucus sent its direct mail list the following message:

> Our Mailgrams are timed for the North-Poindexter testimony when the media spotlight is at its height Perhaps you've watched Senator Inouye on TV or read about his committee in your new newspaper . . . and you've observed how this liberal-led committee is ruthlessly trying to lynch those patriots, military

leaders and Reagan advisors who tried to aid the anti-Communist freedom fighters in Nicaragua. Well, our Mailgram asks Senator Inouye to stop. (qtd. in Fried 1997, 140)

The media also cited public demonstrations as evidence for North's popularity. Held just after the testimony began, two of the broadcast networks aired footage of the demonstration, and pictures of these were included in later television and print stories. However, these activities were also arranged before North testified and were not spontaneous reactions. In explaining to the conservative *Washington Times* why he planned a series of demonstrations across the nation, organizer and North friend H. Keith Haines II said, "I hope Ollie will see the amount of support he has on a grass-roots basis, and more specifically I hope Congress sees the amount of public support out there and maybe then they will change their game and tactics" (McCaslin 1987, A3).

The fascinating range of cultural responses to North like the haircuts and the Ollie B. Goode song were regularly mentioned elements in the media's portrait of the audience. While they were indeed colorful and undoubtedly reflected some individuals' sincere appreciation of North, they were not good indicators of overall public response. In some cases, they reflected a desire to get public attention or attract customers. One person's removal of the "H" in the hillside 'HOLLYWOOD' sign (so that it instead read "Ollywood") gained him mentions on two broadcast networks. Reports about North merchandise surely did not demonstrate public regard for the marine, especially since entrepreneurs who hoped to gain a quick buck frequently lost money. Only 200 copies of a foot-high North doll were sold and videos and other merchandise also fell far short of projections (Thelen 1996, 40).

Overall, the media's analysis of audience response to North's performance and celebrity gave too much attention to unreliable indicators of public opinion. Mobilized groups and individuals with intense views often do not represent the general public and, in this case, they did not. Polls using national random samples to survey opinion on North were available, yet they received only 10% of the total time the network news programs devoted to analyzing public opinion (Fried 1997, 119). Attention to sources other than polls gave a very different picture from the poll numbers did. An ABC poll on July 11 and 12, 1987, for instance, found that 19% of the public agreed that North was a hero, while 64% said he was a victim, and 8% a villain. When the CBS/*New York Times* poll asked "Do you think Oliver North is a national hero?," 74% said no on July 9 and 68% on July 16. In a *Time*

magazine poll, 39% agreed that North was "someone we need in govern-
ment." Granted, North himself received strong personal approval ratings,
ranging from 56% to 67% in July 1987. Yet, while the majority of Ameri-
cans appeared to admire the man's work ethic and love for his country, they
did not herald him and instead disapproved of his actions.

Why did the media misread public opinion? First, interpretations were
faulty because the indicators of public opinion which received the most
attention were visually interesting. Producers of television news programs
want to find pictures that will grab and keep an audience and polls, quite
simply, provide boring pictures. On the other hand, candlelight marches, the
"Ollywood" sign, piles of letters, and North dolls, are much more appealing
to the eye—and they suggested a positive public reaction to Mr. North.
While radio and print journalism need not have been affected by this
tendency, these outlets often follow television's lead in how stories are to be
framed. Furthermore, as the media turned to cover Oliver North as a
celebrity and to present his life as a sort of human interest story, the
emphasis on public acclaim was a natural dynamic, particularly as there was
some evidence that he was loved by some of the people. Third, the media's
commitment to a particular script, with a plot and character type, also
encouraged them to emphasize positive audience responses. Fourth, as
Herbst (1998) shows, journalists often rely on their "news sense," their
intuition, and not rigorous examinations of evidence, to interpret public
opinion. When it came to the North testimony, a careful analysis of letters
and opinion polls would have provided a very different picture of public
opinion from that presented by the media. Reporters would have been forced
to conclude that opinion was complex and sometimes ambivalent, with
different publics having quite divergent views. Finally, the quickly develop-
ing events simply made public opinion hard to decipher thoroughly.

But did reporters' skewed presentation of North—as a great performer
and a celebrity skilled at public relations—influence members of Congress?
While the hearings were going on, members and their staffs were extremely
busy reading documents and preparing for questioning, and they also took
the time to monitor news reports and tally incoming messages. Although
members of Congress are skilled at the political art of understanding public
opinion, they rarely face the intensity and magnitude of media and public
concentration that developed during North's appearance on Capitol Hill. In
the rush of events, news coverage was often used as a proxy for citizen
response. For example, Senators Cohen and Mitchell wrote, "North also
gained public attention and support. The July 9 edition of the *Washington*

Post contained twenty-three pictures of North. Twenty-three pictures of one person in a single edition of a daily newspaper!" (1989, 157). Indeed, it appears that many members of Congress concluded that North had become a new American hero. Yet this judgment led to different reactions.

Some members of Congress, particularly conservative Republicans who had been strong supporters of contra aid, began to rally toward North. Representative Bill McCollum of Florida, for instance, criticized North in late June 1987 for "deceiving and lying," saying that, "I think that that in itself may well be a crime. If it is not a crime, it is certainly one of the highest acts of insubordination and one of the most treacherous things that has ever occurred to a President" (Cohen and Mitchell 1989, 158). However, after North testified and conservative citizens supported the Lt. Colonel, McCollum on July 14 called North a "dedicated, patriotic soldier" for whom the nation and he were "grateful." Republican Senator Orrin Hatch referred to North's standing with the American public when close to the end of the testimony, he told North, "I don't want you prosecuted. I don't. I don't think many people in America do. And I think there's going to be one lot of hell raised if you are" (Bradlee 1988, 528).

Other members of Congress seemed to mute their criticisms. CBS news reported on July 10, 1987 that one Senate staffer had said that the Senator "thinks North is out of line, but won't say anything critical, since he fears the reaction of constituents supporting North." According to another staff member (personal communication), "Some committee members lost their lust for wanting to be on stage with the bright lights. Instead of a career enhancer it was beginning to look like a liability." One evaluation of the hearings concluded that committee members did not ask some tough questions which committee staff had drafted because they felt intimidated by public support for North (Engelberg and Rosenbaum 1987).

However, what many committee members believed was a wave of support for North caused others to challenge their witness. Representative Ed Jenkins (D-GA) asked North about North's accountability to elected officials, chosen by the people. Many members chose to deliver short speeches to North rather than ask him questions because North frequently dodged specific questions. Another staff member reported (personal communication), "We decided that we were going to get our view across . . .[Committee members] felt the need to counter the interpretation that was getting out there." Thus a group of committee members, including Senators Rudman (R-NH), Cohen (R-ME), and Mitchell (D-ME) criticized North's words and deeds in the context of ardent and pointed statements about the

meaning of democracy and patriotism.

It is not clear if North's performance, as reviewed and celebrated by the media, changed what the committee uncovered. Journalist Seymour Hersh claimed that the committee's view of public opinion led it to abandon leads that could have led to President Reagan's impeachment (Hersh 1990). One group of committee members and staff members (Fried 1997) gave conflicting views on this matter. Some thought the investigation had been truncated, while others argued Congress had been quite complete.

Ultimately Oliver North, helped by the media's raves about his performative skills and newfound celebrity, became an entertainer in his own right. Following a period in which he gave well-received speeches to conservative groups and fought legal problems, North tried for political office himself in Virginia. In 1994, the year of the historic Republican sweep of Congress, North ran for Senate under the Republican banner and lost. While some Virginians acclaimed North, his appeal was limited to a niche in the citizenry. During the election, North's Iran-Contra activities remained controversial. Nancy Reagan, the wife of President Reagan, criticized North and he was forced into a three-way race with incumbent Democratic Senator Charles Robb and an independent candidate, Republican Marshall Coleman.

Mr. North now works as a radio talk show host. North, in words reminiscent of the every-man tradition of Capra's *Mr. Smith,* proclaims that he "brings common sense to the radio and the internet."[7] In his first great step on the public stage, and in a setting the Capitol Architect designed, he proved he could carry himself with aplomb. Dubbed a fine performer by the media, today Oliver North speaks to millions of Americans and sells t-shirts, bumper-stickers, and coffee mugs from his web site. With his own fan merchandise and intermittent visits on CNN's *Larry King Live*, his celebrity status could not be more complete. As one who gained from popular culture's imagery, as he employed it and the media adopted it, North is now part of the media.

Conclusion

As this chapter has shown, the media focused on performance, celebrity, and elements in well-known scripts to guide their coverage of the Iran-Contra hearings. Because the news media are influenced by the culture and by an interest in attracting an audience, reports emphasized entertaining elements

and interesting visuals. The gripping story lines and details led reporters astray, for news reports portrayed North as more the hero than he actually was. Unfortunately, these media and cultural tendencies are well-entrenched and thus can stimulate the media to misinterpret complex situations.

Notes

1. *Mr. Smith Goes to Washington* begins with reports of a senator's death and discussions about who the governor will appoint to fill his seat. Various conversations quickly reveal that the state's political matters are essentially run by a party boss. The remaining Senator (Joseph Paine) and the boss want to make sure that a corrupt land deal will not be revealed by the new appointee. If their plan is adopted, the federal government will build an unnecessary dam on land the corrupt officials have purchased surreptitiously. Jefferson Smith, who heads the state's Boy Rangers, gets the nod to fill out the remaining part of the senatorial term. He is naive and idealistic, and the politicians believe he will be easily manipulated. After Smith takes an emotional visit to Washington landmarks, he finds his office and meets his canny and somewhat cynical secretary. In his first legislative effort, Smith begins to draft a bill for a boys' camp in his state. However, he unwittingly includes land which was to be used for the unneeded dam. When supporters of the dam learn about this conflict, they try to discourage Smith from proceeding. Smith, with the help of his secretary, realizes that the politicians are involved in a corrupt scheme. When Smith won't back down, the senior Senator of his state accuses him on the Senate floor of trying to gain personal profit from the boys' camp plan. False documents and evidence are used to try to establish Smith's wrongdoing and efforts are begun to expel Smith from his Senate seat. Media in his state are controlled by the party boss and spread misinformation about Smith. In the film's most dramatic section, Smith carries out a one-person filibuster of 23 hours in which he reads from the Declaration of Independence and proclaims that government should serve the people. As Smith nears collapse, Senator Paine, who is filled with remorse, runs from the Senate chamber, is prevented from shooting himself, and calls out that Smith had told the truth. Onlookers celebrate Smith's vindication.

2. The film *Mr. Smith Goes to Washington*, while heralded by the American Film Institute in 1998 as one of the top 100 American films (and ranked as number 29), has not been without controversy. When the film was first released, some elected officials and commentators deemed it unpatriotic for suggesting that corruption was prevalent in the U.S. Senate (Wolfe 1998, 196-198). Wolfe (1998, 218) also notes that, "A shifting ground of interpretation is also suggested by reports that *Mr. Smith* roused audiences to their feet as an anti-fascist work in Marseilles and Toulouse, France, just before the Vichy ban on American films in 1942, but also was received as an attack on American politics when shown (perhaps with an altered ending) in Moscow in 1950."

3. For more information on events involved in the Iran-Contra Affair, see Draper (1991) for a comprehensive account and Kornbluh and Byrne (1993) for a collection of relevant documents.

4. Other investigations were carried out by a special board called the Tower Commission and by an Independent Counsel. The Tower Commission issued its report in late February 1987, and concluded that correct processes were not followed, leading to poor policy. Independent Counsel Lawrence Walsh was named in mid-December 1986. Ultimately, twelve individuals were convicted of crimes. North was found guilty of three felonies in May 1989, but these decisions were dismissed by an appeals court because it could not be proven that his testimony to Congress (given under a grant of immunity) had not influenced the verdict. The final report of the Office of the Independent Counsel was issued in 1993.

5. The importance of performance was recognized by President Reagan, who had the moniker "the Teflon President." At the end of his presidency, Reagan told a journalist that he believed that being an actor helped one to be a good president (Cannon 1991, 51).

6. "Ollie Takes the Hill: The Fall Guy Becomes a Folk Hero," *Newsweek*, 20 July 1987, 12.

7. See the Oliver North home page at www.northamerican.com.

References

Alter, Jonathan, and Eleanor Clift. 1987. "A TV Viewer's Guide." *Newsweek* (11 May): 23.

Apple Jr., R.W. 1987. "The Colonel Stands His Ground." *New York Times* (12 July) 4: 1.

Armstrong, Scott. 1990. "Iran-Contra: Was the Press Any Match for All the President's Men?" *Columbia Journalism Review* (May-June): 27–35.

Bonafede, Dom. 1987. Scandal Time. *National Journal* (24 January): 199–207.

Boorstin, Daniel J. [1961] 1987. *The Image: A Guide to Pseudo-Events in America*. New York: Atheneum.

Bourdieu, Pierre. 1990. *The Logic of Practice*. Translated by Richard Nice. Stanford: Stanford University Press.

Bradlee, Jr., Ben. 1988. *Guts and Glory: The Rise and Fall of Oliver North*. New York: Donald I. Fine, Inc.

Broder, David S. 1987. *Behind the Front Page*. New York: Simon & Schuster.

Cannon, Lou. 1991. *President Reagan: The Role of a Lifetime*. New York: Simon & Schuster.

Cohen, William S., and George J. Mitchell.1989. *Men of Zeal: A Candid Inside Story of the Iran-Contra Hearings*. New York: Penguin Books.

Cornfield, Michael, and David Yalof. 1988. "Innocent by Reason of Analogy: How the Watergate Analogy Served Both Reagan and the Press during the Iran Contra Affair." *Corruption and Reform* 3: 185–206.

Draper, Theodore. 1991. *A Very Thin Line: The Iran-Contra Affairs*. New York: Hill & Wang.

Edelman, Murray. 1964. *The Symbolic Use of Politics*. Urbana: University of Illinois Press.

Engelberg, Stephen, and David E. Rosenbaum. 1987. "What the Iran-Contra Committees Wish They Had Done Differently." *New York Times* (20 November): A1.

Fried, Amy. 1993. "Is Political Action Heroic? Heroism and American Political Culture." *American Politics Quarterly* 21: 490–517.

Fried, Amy. 1997. *Muffled Echoes: Oliver North and the Politics of Public Opinion*. New York: Columbia University Press.

Griffith, Richard. 1984. *Frank Capra*. London: The British Film Institute.

Herbst, Susan. 1998. *Reading Public Opinion: How Political Actors View the Democratic Process*. Chicago: University of Chicago Press.

Hersh, Seymour M. 1990. The Iran-Contra Committees: Did They Protect Reagan? *New York Times* (29 April) 6: 47+.

Hershey, Marjorie Randon. 1992. "The Constructed Explanation: Interpreting Election Results in the 1984 Presidential Race." *Journal of Politics* 54: 943–76.

It's a Wonderful Life. 1946. Screenplay by Frank Capra. Dir. Frank Capra. Prod. Frank Capra. Perf. James Stewart, Donna Reed. RKO/Liberty Films.

Jamieson, Kathleen Hall. 1992. *Dirty Politics: Deception, Distraction, and Democracy*. New York: Oxford University Press.

King, Elliot, and Michael Schudson. 1995. "The Press and the Illusion of Public Opinion: The Strange Case of Ronald Reagan's 'Popularity.'" In *Public Opinion and the Communication of Consent*. New York: Guildford Press.

Koh, Harold Hongju. 1990. *The National Security Constitution: Sharing Power after the Iran-Contra Affair*. New Haven: Yale University Press.

Kornbluh, Peter, and Malcolm Byrne, eds. 1993. *The Iran-Contra Scandal: The Declassified History*. New York: New Press.

Maland, Charles J. 1998. "Capra and the Abyss: Self-Interest versus the Common Good in Depression America." In *Frank Capra: Authorship and the Studio System*, ed., Robert Sklar and Vito Zagarrio. Philadelphia: Temple University Press.

McCaslin, John. 1987. "North Classmate Plans Rallies in His Support." *Washington Times* (6 July): A3.

McLoughlin, Merrill. 1987. "Television's Blinding Power." *U.S. News & World Report* (July 27): 18.

Morrow, Lance. 1987. "Charging up Capitol Hill: How Oliver North Captured the Imagination of America." *Time* (20 July): 12.

Mr. Smith Goes to Washington. 1939. Screenplay by Sidney Buchman. Director, Frank Capra. Producer, Frank Capra. Performers: James Stewart, Jean Arthur, Claude Rains. Columbia.

Patterson, Thomas E. 1994. *Out of Order*. New York: Vintage Books.

Randolf, Eleanor. 1987. "How the Newshounds Blew the Iran-Contra Story." *Washington Post* (13 November): C1.

Schudson, Michael. 1989. "How Culture Works: Perspectives from Media Studies on the Efficacy of Symbols." *Theory and Society* 18: 153–80.

Thelen, David. 1996. *Becoming Citizens in the Age of Television: How*

Americans Challenged the Media and Seized Political Initiative During the Iran-Contra Debate. Chicago: University of Chicago Press.

Tomasulo, Frank P. 1989. "Colonel North Goes to Washington: Observations on the Intertextual Re-presentation of History." *Journal of Popular Film and Television* 17: 82–88.

U.S. House and U.S. Senate. 1987. *Report of the Congressional Committee Investigating the Iran-Contra Affair. With Supplemental, Minority, and Additional Views*. Washington, D.C.: U.S. Government Printing Office.

Wolfe, Charles. 1998. *Mr. Smith Goes to Washington*: Democratic Forums and Representational Forms. In *Frank Capra: Authorship and the Studio System*, ed. Robert Sklar and Vito Zagarrio. Philadelphia: Temple University Press.

Chapter 10
Synthetic History and Subjective Reality:
The Impact of Oliver Stone's Film, *JFK*

Jim Kelly
Bill Elliott

Members of the media establishment get upset when art gets political, especially when they disagree with the politics and fear the viewpoint. When this priesthood is challenged as the sole or privileged interpreters of our history, they bludgeon newcomers, wielding heavy clubs like 'objectivity' and charging high crimes like "rewriting history." The real issue is trusting the people with their real history.
—Oliver Stone

President John F. Kennedy was assassinated in November 1963. It and the events that followed had a profound impact on those who would later be known as the "60s generation." This study examines the impact of the assassination on a generation born long after President Kennedy's death, a generation whose knowledge of the events came from history texts, talks with parents and grandparents, and Oliver Stone's film, *JFK*.

JFK was no ordinary movie. It retold and reanalyzed the assassination stressing a national conspiracy and the existence of a powerful and sinister shadow government.

While *JFK* drew considerable critical acclaim, including an Academy Award nomination for the best picture of 1991, it also generated a vituperate response on the press's news pages by some of its most senior reporters—highly unusual given that *JFK* was "just a movie." Coverage in *The New York Times* began nine months before the film's premier ("Oliver Stone Faces," 1991 and "Oliver Stone Gets," 1991). *LIFE, Newsweek,* and *Esquire* published cover stories about *JFK* to coincide with the theatrical release of the movie, and virtually all news magazines and newspapers printed *JFK* stories in addition to movie reviews.

Most reports discussed the variety of conflicting facts and descriptions surrounding the assassination itself. But *Newsweek* (Auchincloss 1991) directly attacked Stone and the movie by labeling it "propaganda" and "twisted history." As was true of many of the reports, *Newsweek* found fault with the credibility of Stone's sources and his facts, but the major complaint

was with the docudrama genre and its probable effect on young audiences. While it is true that any recreation of an event ultimately distorts the event, *Newsweek* saw even greater danger in *JFK* because of the skill with which it was done.

The press approached *JFK* as it had often approached film (Lowery and DeFleur 1988), as a propagandistic attempt to lead the audience to a particular point of view. The press thought that *JFK* would be able to convince its audience that its *interpretation* of the history of the assassination was *the* history of the assassination.

Tom Wicker, who was a *New York Times* reporter in Dallas the day of the assassination, was concerned about *JFK*'s influence on youthful moviegoers. He (1991) worried that, "among the many Americans likely to see it, ... particularly those too young to remember Nov. 22, 1963, 'J.F.K.' is all too likely to be taken as the final, unquestioned explanation."

Is that true? Can a well-crafted film convince an audience that a movie accurately portrays reality? Would an audience believe that the "facts" dramatized in *JFK* were the "facts" about the assassination? To answer these questions, we applied theoretical models about how "social reality" is created and used a quasi-experimental design to help us test the theory we developed.

Literature Review

Our literature review is in four sections. First, we investigate past research on the influence of motion pictures, television mini-series, and docudramas on audiences' political and social attitudes and orientations toward political institutions. Second, we review the research on the development of perceptions of "reality" and the psychological mechanisms that influence this reality development. Third, we present our model, along with its assumptions and rationale. Finally, we present our hypotheses.

Film Influences

Film has long been seen as a possible influence on our image of the world. Research on film's influence on racial attitudes and stereotypes began with work done by Peterson and Thurstone (reviewed in Austin 1989) as part of the Payne Fund Studies of the 20s. They found that attitudes toward

minorities could be influenced by film exposure and later research showed that attitudes toward Jews could also be influenced by a single exposure to the 1947 picture *Gentleman's Agreement* (Austin 1989).

There have been fewer studies of film as an influence on people's orientations toward institutions, however. The ones available have shown inconsistent results. Film was shown to be effective in changing attitudes toward socialism and toward the Works Progress Administration (WPA) in 1938, but other studies have failed to document changes from propaganda films designed to influence similar attitudes (Austin 1989).

More recent studies have focused on the influence of television mini-series and docudramas. Studies done on *Roots*, *Shogun*, and *Holocaust* produced mixed results on the effects of these mini-series on attitudes (Walker 1989). Research on *The Day After* (Adams and Webber 1984) indicated that viewers of the 1983 docudrama believed more in the possibility of a nuclear attack, were less likely to want the president to get tougher with Russia, and wanted more money spent for protection from nuclear attack. Similar studies were conducted around ABC's 1985 mini-series *Amerika*. Seeing *Amerika*, was related to increased concern about a communist threat and to support for a stronger military defense (Walker 1989). Perhaps the only recent film having a potential impact similar to that feared for *JFK* was the 1976 film, *All the President's Men*. Elliott and Schenck-Hamlin (1979) found that seeing *All the President's Men* was associated with increased political alienation.

While studies done regarding the influence of film, mini-series, and docudrama have tended to be atheoretical, they have provided a basis for some tentative conclusions regarding possible film impact. First, movies, docudrama, and mini-series can influence people's knowledge about the subject of the film in consistent ways. Second, attitudes can be influenced by exposure to a film, but the mechanism for such influence is unclear. Third, most motion pictures are entertainment oriented and are not designed to send a "message." This has undoubtedly reduced the willingness of researchers to study film and television as serious elements in the creation of political attitudes and knowledge. We think this is an oversight.

Reality Construction

Although studies of film and related messages provide little theoretical

insight into film influence, a significant body of research links media images to personal images of reality. Walter Lippmann (1922) raised the issue early. He suggested a three-part model between the scene of an event, the report of the event, and the response to the event. Reports of news events generate the "pictures in our heads" that serve as the basis for our actions. To the degree that such reports are inaccurate, then the possibility of serious errors in action increase.

Kenneth Boulding (1956) analyzed how messages change or fail to change the "images" people have of the world. "Images" are people's store of subjective knowledge about an event, person, or experience. It is our overall image that determines our behavior. Boulding pointed out that any message has meaning to the extent that it can change our image. Entertainment messages often have a limited impact because they are interpreted as irrelevant guides to behavior. Other messages can change our image in predictable ways through confirmation and by adding detail. Messages can also change our image in revolutionary ways. We discover new facts, encounter new ideas about why an event happened, and have our convictions about a past "truth" weakened. The possibility of such revolutionary change in our image about the assassination of President John F. Kennedy in 1963 worried many in the press.

Adoni and Mane (1984) saw the media's potential impact as part of their role in another three-element model. Media images are part of *symbolic reality*, abstractions of experience that are created by individuals and groups as a way of storing information. Two other "realities," objective and subjective, form a triangular "reality" concept. *Objective reality* refers to the raw material of direct experience, the objects, things, events, and happenings that human beings experience by sight, smell, hearing, and taste. *Subjective reality* is the image of the world constructed by the individual based on the inputs from objective and symbolic realities. It is subjective reality that guides our behaviors, structures our cognitions, and influences our attitudes. We can only act on what we think. To the degree that subjective reality is based on symbolic reality (including the type of reality possible through motion pictures), the media assume a central role in the construction of subjective realities. Subjective reality parallels Boulding's (1956) image.

Most research has looked at the influence of symbolic reality on individual perceptions of reality, often termed "perceived reality" (Potter 1988). Potter has summarized research within this area and has put forward several generalizations. First, a number of variables have been found to influence reality perceptions. True-life experience reduces our likelihood of

accepting media images as real. Ability and knowledge also act to reduce the acceptance of media portrayals. Second, Potter has found that reality perceptions can be experimentally manipulated to show short-term influences on attitudes and behavioral change in the direction advocated in the message. Other scholars have made attempts to develop explanations that demonstrate the mechanisms by which symbolic reality becomes part of the individual's image of reality. Perse (1990) suggested that reality formation is triggered by involvement (a sense of importance attached to an object, person, or issue) and must be judged as "real" before it becomes the basis for additions or modifications of an individual's perception of social reality. Once involvement is triggered, attention ("allocating cognitive effort to process the information"), recognition ("categorizing the information as familiar or unfamiliar"), and elaboration ("relating the information to prior knowledge") can follow.

Shapiro and Lang (1991) concentrated on the process by which reality perceptions are created. They suggested that a process called "reality monitoring" uses contextual information associated with event memory to make reality decisions. Basically, all stimuli are treated as "real" from the person's standpoint. Higher order judgments are necessary to determine whether or not an orienting response or another type of response (startle or defensive) should be invoked or maintained. Reality verification processes become the basis for possible perceived reality and social reality effects.

Synthetic experience (Funkhouser and Shaw 1990) is a recent addition to the language of symbolic reality. Technology has made it possible for symbolic reality to exhibit characteristics impossible in real life. Activities can be speeded up (fast-forward), slowed down (slow motion), or replayed (instant replay). Perspectives can be changed from distant to close (zoom). Shifts can take place in time (past, present, or future) or space. "Synthetic experience" now shares time with real experience, even in news presentations, and can be presented in ways that are more exciting, stimulating, and thought provoking than "real experience." Our perceptions of reality are being shaped by synthetic experience, our ideas of history are being more and more based on a "synthetic history" made up of "synthetic facts" in support of this history.

In the case of *JFK*, where Oliver Stone makes the film capture the feel of the time and place of the assassination and where we can identify with a central film character, is it possible that movie scenes can become accepted as actual events? Given film's ability to create its own "reality" and to charge that reality with emotional content, the probability that our ideas

about events are shaped by film images is great.

In *JFK*, where information was often presented in a court setting with "evidence" countering existing (Warren Commission) explanations, the chance for deep and extensive thinking about the assassination is maximized. This process, known as "elaboration (Petty and Cacioppo 1986), can have long-term effects on attitudes, knowledge, and behavior.

Our Model

First, we advanced a series of assumptions based on the reviewed literature.

1. People construct "subjective reality" based on information they receive from "objective" and "symbolic" sources. This subjective reality contains affective as well as factual components. Affective components strengthen memory, making it more likely to be recalled as information on the event, real or mediated. For a significant percentage of our reality "images," the only source of information comes from symbolic sources. For anyone born during the 1960s or later, the assassination of President Kennedy is known only through symbolic reality, many times removed from the actual event.

2. The mechanisms for constructing subjective reality are complex but understandable. These mechanisms include:

a. *Comparing new information with existing information.* To the degree that new information adds to the existing store, it adds to that store. Repetition may add to the perception of information as "real."

b. *Evaluating the information in terms of its perceived reality.* To the degree that a message is perceived as real, then it is more likely to be stored within a "real" memory grouping or, later in time, to be confused with "real" events. To the degree that a message creates a "synthetic experience" in making its point, it may become as or more effective than the experience of the actual event.

c. *Messages and parts of messages are evaluated by the individual.* Messages have no "meaning" aside from their influence on the person using them. While a message may be fictional, elements of that message may be interpreted as "real" or "realistic." Fictional events, particularly film events, are often explicit attempts to make what is fantastical appear as "real," increasing audience response to the message.

d. *Messages that generate thought by the audience, that force the audience to elaborate about the message, even to discuss it with other people, are most likely to be associated with changes in images.* This elaboration can be increased if:

 1) The audience is interested in and pays attention to the message. Most entertainment media count on audience attention and interest to attract an audience;

 2) Information in a message is presented in a way requiring audience evaluation and participation in a reasoning process (in *JFK* the use of logical argument and point-counterpoint presentation in a movie trial scene where previous explanations of the assassination are carefully compared with new interpretations);

 3) The message is perceived as relevant. The stronger the relationship between the message and a person's life, the more likely the person is to weigh possible consequences of the message (Roser 1990).

 3. Multiple exposure to a message is not required for influence. This is particularly true in the case of messages on novel topics and messages dealing with topics that have not been well defined.

The model we have developed is presented in Figure 1. It is composed of three elements. There is an *objective reality*, which we define as an event occurring in real time and space. In this case, the event of interest is the assassination of President John F. Kennedy in 1963. Following the Adoni and Mane model (1984), there is also a *symbolic reality*. Symbolic reality is defined as the stored messages regarding an event.

We have broken the symbolic reality of President Kennedy's assassination into three components: unsanctioned symbolic reality, sanctioned symbolic reality, and synthetic experience. We define *unsanctioned symbolic reality* as those stored messages running counter to accounts published by official sources (major mass media, government, mainstream academics). *Sanctioned symbolic reality* is defined as the official accounts of an event. In the case of the assassination of President Kennedy, it refers to the *Warren Commission Report*, the reports of the House and Senate investigating committees and the general reports by the establishment news media in this country.

Synthetic experience refers to stored images that are enhanced through technology. Many of the news accounts of the assassination used technology to enhance news presentations. Instant replay, slow motion, close-ups, etc., became an accepted (and unnoticed) part of the assassination coverage. In *JFK*, Oliver Stone used film technology to recreate many of the assassination

events, to intermix archival film footage of the assassination with his own black and white "newsreel" footage, and to show "flashbacks" to the assassination and related events.

Finally, there is *subjective reality*, the stored image held by the individual regarding the event and influences that might be associated with the event (such as attitudes toward government, etc.). It is subjective reality that guides future beliefs, attitudes, and behaviors. For each of us, this subjective reality, in this case our subjective reality about the Kennedy assassination, represents part of our image of the world. This "reality" results from our experiences with unsanctioned and sanctioned reports as well as attendance at Oliver Stone's 1991 film, *JFK*. Our interests are on the possibility that a single message such as *JFK* could impact our subjective reality of the assassination.

Hypothesis

H1: Exposure to a synthetic experience will influence an individual's subjective reality in the direction suggested in the synthetic experience. Exposure to a synthetically created experience, such as *JFK*, will alter the following:

1. Beliefs about the basic "facts" of the Kennedy assassination. We have developed two sets of facts.

a. *Sanctioned knowledge*. We have defined "sanctioned knowledge" as information that is undisputed. In the case of knowledge regarding President Kennedy's assassination, it would include knowledge of when the assassination took place, individuals involved with the assassination and its investigation, etc.

b. *Unsanctioned knowledge*. "Unsanctioned knowledge" refers to that information whose source is based almost entirely (does not tie to either sanctioned reality or to objective reality) on synthetic experience. In this case, symbolic reality is composed of the probability of certain events such as the existence of at least three assassination teams, Lee Harvey Oswald working for the CIA, etc., which were stressed in *JFK*.

2. Generalizations from the "facts" to attitudes toward and beliefs about more general processes. Not only will exposure to *JFK* result in changes in the "facts" surrounding the assassination, but it will also change feelings people have about political institutions and the general principles of govern-

The Model of Social Reality Construction

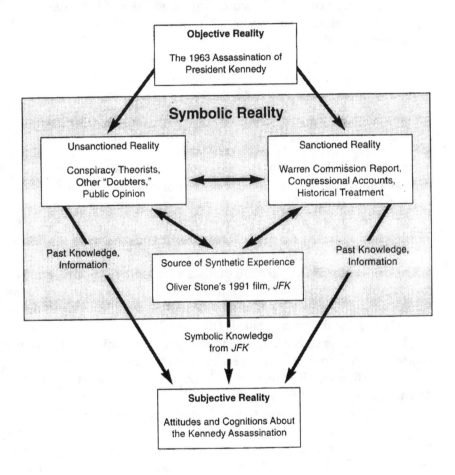

ment. We measured two sets of attitudes and beliefs.

a. *Political mistrust*. Political mistrust refers to the individual's failure to believe that the government is willing to help individuals or that the individual can influence government.

b. *Belief in the existence of a "shadow government."* A "shadow government" is a secret and powerful group of people who actually run the United States, a group whose existence was suggested in *JFK*. It is this latter variable, the existence of a "shadow government," that is most closely tied to the content of *JFK*.

Method

Design

Students enrolled in introductory Journalism laboratory sections were used as subjects in this quasi-experiment (Campbell and Stanley 1963). Instead of a pretest-posttest design, ours is a posttest and post/posttest design. Three laboratory classes were assigned to each of four conditions. The experimental group was measured at two time points—immediately after they attended a free screening of the movie *JFK* in February and again three weeks later in March. A total of 56 students attended the free screening and saw the film for the first time. Twenty-nine of them were interviewed immediately after seeing the film (E1) and all 59 were interviewed three weeks later using the same questions (E1 and E2).

The control encompassed 37 subjects who had not seen the film. Nineteen of these students were interviewed at the same time as the 29 (C1) who saw the film and all 37 were interviewed three weeks later (C1 and C2). The design is presented in Figure 2.

Use of this design allowed us to test short- and longer-term effects and to test for instrument sensitization (subjects responding to questions only because they had been asked the same question previously). Because of the small Ns in several of our analyses, we will present findings for probability levels of .10 or less. That means there is roughly a 10 percent chance that what we found is due to error rather than the film.

Quasi-Experimental Design

Experimental Group

Attend *JFK* E1: Measure E1: Measure 3
Feb. 6-12 after attendance weeks after attendance
(N=56) Feb. 13-14 March 4-9
 (N=29) (N=29)

 E2: Measure 3
 weeks after attendance
 March 4-9
 (N=27)

Control Group

Did not see *JFK* C1: Measure C1: Measure 3
(N=37) Feb. 13-14 weeks later
 (N=19) March 4-9
 (N=19)

 C2: Measure 3
 weeks later
 March 4-9
 (N=18)

Variables

Independent variables. Our primary independent variable was *exposure to JFK.*

Covariates. Several variables were likely to influence a number of our measures, particularly the questions about factual knowledge. To hold the influence of these variables constant, we used multiple classification analysis[1] which allowed us to determine the influence of the independent variables on the dependent variables after statistically neutralizing the influence of the covariates.

The covariates were political interest, media use and past information seeking behavior regarding the Kennedy assassination. *Political interest* was measured by a single question that asked, "How interested would you say you are in politics *in general?*" We covaried for four measures of media use—*Magazine use, Newspaper use, Television news use,* and *Television talk show use.* We asked several questions about their general use of these media—many of which had recently done stories about the assassination. *Past information seeking about the assassination* was formed by summing positive responses to questions asking if respondents had ever read a book, written a paper, or gone to the library to look up information about the Kennedy assassination.

Dependent variables. Our dependent variables fell into two groups. The first group included the "facts" about the assassination (symbolic reality). Our second set of dependent variables used measures of attitudes and beliefs, political mistrust and belief in a shadow government (subjective reality). These two measures represent generalizations from the "facts" to more global perceptions and processes.

We looked at two sets of "facts." *Sanctioned knowledge* was measured by summing the correct answers of each respondent to six questions about facts supported by official sources. Five of the questions were in multiple choice format. They asked where the only conspiracy trial for the assassination of President Kennedy took place (New Orleans), the year of the assassination (1963), the name of the member of the Warren Commission whom Kennedy had fired as Director of the CIA (Allen Dulles), the name of the district attorney prosecuting the only person charged with conspiracy to assassinate President Kennedy (Jim Garrison), and the crime Lee Harvey Oswald was charged with when he was arrested (shooting a police officer). The final sanctioned knowledge question asked respondents to indicate

whether it was probably false, probably true, or they weren't sure whether or not the presidential motorcade had slowed down just before the first shot (probably true was the correct answer). The range for sanctioned symbolic knowledge was from 0 to 6. The mean for the February administration was 3.28 with a standard deviation of 1.89. For the March administration the mean was 3.30 and the standard deviation was 1.69.

Our second set of "facts" was labeled *unsanctioned knowledge*. Unsanctioned knowledge referenced the disputed assertions in *JFK*, those suggestions that have not been supported by official sources. Respondents were asked for probabilistic responses (probably false, not sure, probably true) to five statements clearly stressed as true in the film: that President Kennedy was planning to withdraw all military advisors from Vietnam, that most telephone lines in Washington, D.C., were out of order just after the assassination, that President Kennedy had planned to normalize relations with Cuba, that Lee Harvey Oswald had worked for the CIA, and that President Kennedy was killed in a cross-fire involving at least three assassination teams. A sixth statement, that Lee Harvey Oswald had acted alone in carrying out the assassination, was presented in *JFK* as false. This was added to the unsanctioned knowledge measure. The final item was based on subjects' responses to the question, "How many shots were fired during the Kennedy assassination?" The Warren Commission indicated only three shots were fired. The range for unsanctioned symbolic knowledge was from 0 to 7. The mean for the February administration was 4.53 with a standard deviation of 1.75. For March the mean was 4.32 with a standard deviation of 1.72.

We used two measures of attitudes and beliefs to represent subjective reality in our model. We labeled our first political orientation variable "political mistrust." Political mistrust—a lack of belief in the government's ability to serve the needs of the public—was adapted from the political cynicism scale reproduced in Robinson, Rusk, and Head (1968). They defined political cynicism as "the extent to which one is contemptuously distrustful of politicians and the political process" (479). Our measure also includes some of the political cynicism items originally developed by Agger, Goldstein, and Pearl (1961) and some items of our own invention. Four Likert type items[2] were summed to form the mistrust scale.

Our second measure was belief in a "shadow government," a secret and powerful group of people who actually run the United States. Operationally, belief in a shadow government was constructed by summing four Likert type items[3] into a single score.

Results

The tests of our hypothesis, which stated that synthetically recreated experience will result in changes in subjective reality (facts and attitudes and beliefs) matching the synthetic experience, found consistent support for our "fact" measures. The results of our multiple classification analysis are presented in a series of four graphs. The means reported in these graphs are the adjusted means after controlling for the influence of the covariates. In all cases, the models were run after eliminating non-significant covariates.

The results for exposure to *JFK* and sanctioned knowledge are presented in Graph 1. Exposure to *JFK* was a consistently strong predictor. Of the respondents interviewed in February, those who had seen *JFK* had a higher adjusted mean sanctioned knowledge score (mean = 4.51) than the control (mean = 1.53). Of the covariates, political interest was significant, accounting for approximately 15.0% of the variation. The full model accounted for 69.5% of the total variation in sanctioned knowledge with exposure to *JFK* emerging as the strongest contributor (b = .77).

The pattern was the same for respondents interviewed in March. The highest mean sanctioned knowledge scores (mean = 4.15) were for the subjects who had seen the film. The control group, who had not seen the film, had an adjusted sanctioned knowledge mean score of 1.83. This time, magazine reading accounted for 3.6% of the variation in objective knowledge and past assassination information accounted for an additional 2.4%. The total model accounted for 56.1% of the variation in sanctioned knowledge in March, again with *JFK* exposure explaining the greatest portion of the variation (b = .71).

This pattern, for exposure to *JFK* to emerge as the dominant influence on knowledge, was repeated for unsanctioned knowledge and is shown in Graph 2. When measured in February, the adjusted unsanctioned knowledge mean score for subjects who had seen the film was 5.56. For the controls, the adjusted mean was 3.51. The full model accounted for 43.7% of the variation in the February measure of unsanctioned knowledge. The covariate political interest accounted for 7.7% of the total variation with past assassination information accounting for an additional 5.0%. Again, exposure to *JFK* was the strongest influence (b = .59).

Though not quite as strong, the same pattern of relationships was observed in March. Those who had seen *JFK* had higher adjusted mean scores (mean = 4.96) than those who had not seen the movie (mean = 3.58).

For the covariates, magazine use explained 3.1% of the total variation while past assassination information accounted for an additional 5.8%. The full model accounted for 29.4% of the total variation with exposure to *JFK* accounting for the largest portion (b=.42).

The pattern of *JFK*'s influence is clear. Exposure to the film increased sanctioned knowledge about the assassination of President Kennedy and it increased the likelihood that viewers would accept Oliver Stone's presentation of events associated with the assassination as possible (unsanctioned knowledge). This held for the interviews conducted in February and in March. As a source of information, sanctioned and unsanctioned, *JFK* functioned very well.

The results of our multiple classification analysis of the influence of exposure to *JFK* on political mistrust are presented in Graph 3. This pattern is not as neat as for factual knowledge but is still understandable. The influence of *JFK* was noted only for one of our political orientations, belief in a shadow government. Only a minor influence of *JFK* exposure was noted for political mistrust.

People who saw *JFK* were not statistically more mistrustful of politics than control subjects when interviewed in February. The mean scores, 13.62 for the experimental group and 12.79 for the control, were similar. The dominant influence on political mistrust in February came from the covariates political interest and television news exposure. The full model accounted for 17.1% of the variation in political mistrust.

The picture was modified only slightly in March, most likely because of the large N (86 in March compared to 48 in February). Here the experimental mean, 13.37, was significantly higher (p < .10) than the control group mean, 12.43. This time, the significant covariates were magazine reading and past assassination information. The full model accounted for 13.1% of the total variation in political mistrust.

The results of exposure to JFK on our final dependent variable, belief in a shadow government, are presented in Graph 4. Belief in a shadow government was significantly influenced by *JFK* attendance in the February and March interview periods. In February, the mean score for those who had seen *JFK* was 15.37; for those who had not seen the film it was 13.03. Two covariates, newspaper reading and past assassination information, were significantly related to belief in a shadow government. The total model accounted for 21.0% of the total variation in belief in a shadow government with *JFK* exposure having the greatest impact (b = .40).

In March, the difference between the experimental (mean =14.61) and

control (mean = 13.14) was still statistically significant, although the magnitude of the difference had decreased. No covariate was statistically significant. The total model accounted for 8.6% of the total variation in belief in a shadow government.

While generalizing from these observations is more complicated than generalizing from the results for factual knowledge, a pattern does appear and it does make sense. First, well-established attitudes dealing with very general beliefs, such as political mistrust, are not easily influenced, even by a film as powerful as *JFK*. The differences between those who saw the film and those who did not were slight, although there was a statistically significant difference (p < .10) in March. The type of belief represented by political mistrust is resistant to short-term change.

However, for a set of beliefs in the formative stages, such as a belief in the existence of a shadow government, there is a *JFK* influence. This influence is strongest when measures are taken near the time of exposure, February in this case. The difference between the experimental and control group was less in March but it was still considerable. The belief in the existence of a shadow government, as influenced by the film, was still there four weeks after seeing *JFK*.

Discussion

Our results provide encouraging support for the model outlined in Figure 1. Exposure to the film *JFK*, as a source of synthetic experience, had a significant immediate and delayed effect on students' beliefs. Seeing *JFK* resulted in more sanctioned and unsanctioned knowledge about the assassination of President John F. Kennedy. Just as the *Why We Fight* propaganda films of the 40s had shown (Lowery & DeFleur 1988), film is an excellent way to transmit knowledge. This confirmation of much of "sanctioned reality" should be comforting to those concerned about the possible negative influence of *JFK*.

However, *JFK* was also an excellent source for information likely to

Graph 1
Exposure to *JFK*:
Sanctioned Knowledge

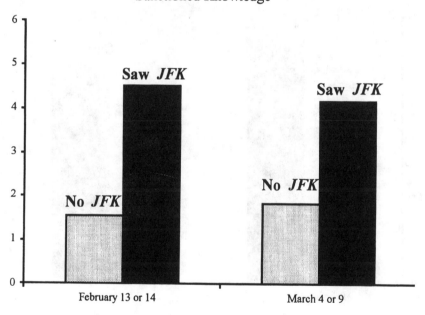

Graph 2
Exposure to *JFK*:
Factual Information

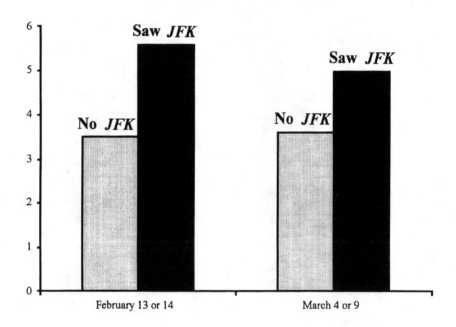

Graph 3
Exposure to *JFK*:
Political Mistrust

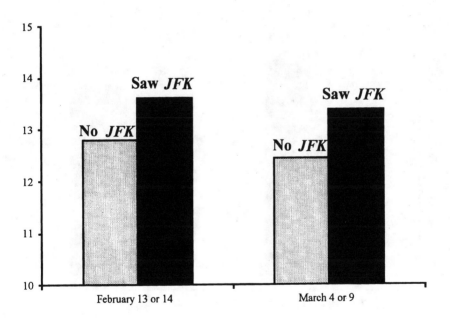

Graph 4
Exposure to *JFK*:
Full Model

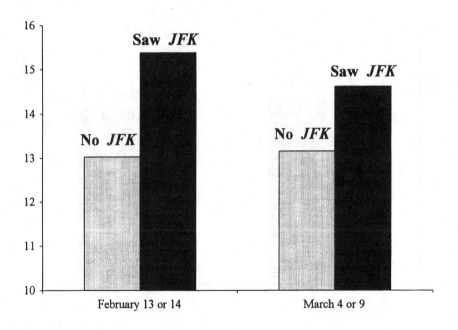

come from unsanctioned sources, mainly the ideas of the main character, prosecutor Jim Garrison (1988) and the film's director, Oliver Stone. When a presentation as carefully done as *JFK*, on a subject as interesting and important as the assassination of President Kennedy is presented to an audience as removed in time from the actual event as these students (the oldest was 33, the mean age was 21.5), there is a likelihood that symbolic realities about the assassination, both sanctioned and unsanctioned, will become a part of the person's subjective reality. A skillfully made film, and *JFK* was definitely that, can integrate its message with existing messages and create a reality for its audience where the difference between "sanctioned" and "unsanctioned" explanations of an event becomes lost. Oliver Stone was able to create a set of "synthetic facts," dramatic reconstructions of the events associated with the Kennedy assassination, that were accepted as part of the symbolic reality of many in our student audience.

It needs to be noted that *JFK* had only slight impact on our political mistrust measure. Political mistrust represents a stable set of beliefs about government, a set of beliefs resistant to change because of *JFK*. The film suggested high level corruption: not average people rallying behind honest politicians to change things. This was no *Mr. Smith Goes to Washington*. Seeing *JFK* only minimally made our students less trusting of the political system.

But where Stone suggested the existence of subversive groups determined to maintain control at all costs and when he implied that a group composed of leaders of industry, the military, and the government (including a suggestion that Vice President Lyndon B. Johnson might have been involved in the conspiracy), *JFK* had a more measurable impact. Students who had seen the film believed more in the existence of a "shadow government," a group of individuals who would do anything (even assassinating our leaders) to maintain control. This influence was statistically significant in February and March, although the strength of the influence was reduced by the second measurement. *JFK* strengthened a belief among the members of our youthful audience that powerful negative forces control our government. For many, that is a lesson that is not wanted.

Conclusion

JFK had an impact on the students who saw the film as part of the

experimental group. *JFK* also had an impact on the nation.

For the students, *JFK* had a profound influence on the "facts" they associated with the assassination of President Kennedy. Facts "sanctioned" by the national media and governmental establishment were learned by the audience. More than their non-attending counterparts, film viewers learned the official account of the assassination. They also learned the "unsanctioned facts," the speculation about the assassination generated by Jim Garrison and *JFK*'s director, Oliver Stone. They learned that Lee Harvey Oswald, Kennedy's officially sanctioned assassin, was part of a larger national conspiracy. They learned that the assassination involved numerous individuals including three assassination teams.

The students learned more than just the sanctioned and unsanctioned facts. Students seeing the film were more likely to believe that a "shadow government" exists in the United States. This shadow government stops at nothing, even the assassination of our national leaders, to maintain control. By extension, such a shadow government was portrayed as being involved in the assassination of President Kennedy.

For the nation, *JFK* raised the salience of the assassination of President Kennedy as a national issue. People began to talk and to rethink about what really happened in 1963. *JFK* drew the press into the discussion, generating new levels of interest in and speculation about the assassination. The establishment press attacked the film on the grounds that its "unsanctioned" facts were less worthy than the "sanctioned" facts from the Warren Commission and numerous independent investigations. The press also questioned some of the findings of the Warren Commission. Politically, the U.S. House of Representatives voted to open the assassination files, files that were scheduled to remain sealed until 2029.

Aesthetically, *JFK* was nominated for the best picture Oscar in 1991. For just one motion picture, *JFK* accomplished quite a bit.

Our theoretical model found solid support in the *JFK* experiment. This film, as an example of a synthetic experience, demonstrated that subjective reality, the set of beliefs held by the individual regarding an event, can be shaped and ordered by a synthetic experience. While other communication behaviors (television news, newspaper reading, magazine reading, past information seeking about the assassination) also had an influence on subjective reality, the synthetic experience of *JFK* dominated as a source of information and influence for all of our measures except political mistrust. The implication is that synthetic experience can play a more important role in subjective reality formation than traditional sanctioned or unsanctioned

sources, at least for this audience of relatively young students.

Media messages can change our images of the world. *JFK* was able to integrate sanctioned and unsanctioned reality messages to synthesize more than just a new message. Oliver Stone manufactured an experience, a synthetic experience, that not only recreated the assassination of President Kennedy but that recreated it in a new mode, a mode that forced the audience to weigh one piece of information (sanctioned) with another (unsanctioned) and encouraged them to believe differently about their government. It worked. It changed people's beliefs.

This study represents a continuation of the basic models suggested by Lippmann (1922) and Boulding (1956). In a future world where individual program selectivity will remove message consistency as a factor in media use (Gilder 1990), how individual messages influence the audience will necessarily be a central area for theory development. We have offered a model that can help organize our future investigations.

Notes

1. The four items used were "Money is the most important thing that influences how politicians make up their minds." "Most of our leaders are devoted to the service and good of this country" (reverse coded). "In order to get elected, candidates make promises they don't intend to keep." "It seems to me that government fails to take necessary steps on important issues, even when most people favor such action."

2. Each respondent indicated whether they strongly disagreed, disagreed, were neutral, agreed, or strongly agreed with each of the following: "The truth is that a small group of very powerful men really run this country." "Powerful people in government are willing to violate the Constitution in order to serve the interests of big business and the military." "There is a small group of people in this country who have the power to do almost anything, even to assassinate our own leaders." "The CIA, FBI, and the military use covert methods to stop politicians who are trying to change things."

3. Multiple classification is a statistical analysis procedure that allowed us to inspect the adjusted mean scores (averages) for various exposure groups

after controlling for alternative influences (political interest, magazine use, newspaper use, television news use, television talk show use, past information seeking about the assassination), thereby eliminating some likely alternative explanations. The number of times the respondents had been interviewed allowed us to determine if sensitization had been a problem and it allowed us to make some judgments about changing influence over time.

References

Adams, R. C., and Gail M. Webber. 1984. "The Audience for, and Male vs. Female Reaction to *The Day After.*" *Journalism Quarterly* 61:812–816.

Adoni, Hanna, and Sherrill Mane. 1984. "Media and the Social Construction of Reality." *Communication Research* 11: 323–40.

Agger, R. E., M. N. Goldstein, and S. A. Pearl. 1961. "Political Cynicism: Measurement and Meaning." *Journal of Politics* 23: 477–506.

Auchincloss, Kenneth. 1991. "Twisted History." *Newsweek*, 23 December, 46–49.

Austin, Bruce A. 1989. *Immediate Seating: A Look at Movie Audiences.* Belmont: Wadsworth.

Boulding, Kenneth E. 1956. *The Image: Knowledge in Life and Society.* Ann Arbor: The University of Michigan Press.

Campbell, Donald T., and Julian. C. Stanley. 1963. *Experimental and Quasi-Experimental Designs for Research.* Chicago: Rand McNally.

Elliott, William R., and William. J. Schenck-Hamlin. 1979. "Film, Politics, and the Press: The Influence of *All the President's Men.*" *Journalism Quarterly* 56: 546–53.

Funkhouser, G. Ray, and Eugene F. Shaw. 1990. "How Synthetic Experience Shapes Social Reality." *Journal of Communication* 40: 75–87.

Garrison, James. 1988. *On the Trail of the Assassins: My Investigation and Prosecution of the Murder of President Kennedy.* New York: Sheridan Press.

Gilder, George. 1990. *Life after Television.* Knoxville: Whittle Direct Books.

JFK. 1991. Screenplay by Jim Mars, Oliver Stone, Zachary Sklar. Dir. Oliver Stone. Perf. Sally Kirkland, Gary Taggart. Warner Bros.

Lippman, Walter. 1922. *Public Opinion.* New York: The Free Press.

Lowery, Shearson A., and Melvin L. DeFleur. 1988. *Milestones in Mass Communication Research* . 2d ed. New York: Longman.

"Oliver Stone Faces Snarls over Texas Shoot." 1991. *New York Times*, 4 March.

"Oliver Stone Gets His Window." 1991. *The New York Times*, 18 April.

Perse, Elizabeth M. 1990. "Cultivation and Involvement with Local Television News." In *Cultivation Analysis: New Directions in Media Effects Research*, ed. N. Signorielli, and M. Morgan. Newbury Park: Sage.

Petty, Richard E., and John T. Cacioppo. 1986. *Communication and Persuasion: Central and Peripheral Routes to Attitude Change*. New York: Springer-Verlag.

Potter, W. James. 1988. Perceived reality in television affects research. *Journal of Broadcasting & Electronic Media* 32: 23–41.

Robinson, John P., Jerrold G. Rusk, and Kendra B. Head. 1968. *Measures of Political Attitudes*. Ann Arbor: Institute for Social Research.

Roser, C. 1990. "Involvement, Attention, and Perceptions of Message Relevance in the Response to Persuasive Appeals." *Communication Research* 17: 571–600.

Shapiro, M. A., and A. Lang. 1991. "Making Television Reality: Unconscious Processes in the Construction of Social Reality." *Communication Research* 18: 685–705.

Stone, Oliver. 1991. "Who Is Rewriting History?" *The New York Times*, 20 December.

Walker, James R. 1989. "The Impact of a Mini-series: A Quasi-experimental Study of Amerika." *Journalism Quarterly* 66: 897–901.

Wicker, Tom. 1991. "Does 'J.F.K.' Conspire Against Reason." *New York Times*, 15 December.

Chapter 11
C-SPAN: A Window on the Political Process

Stephen E. Frantzich

Today millions of Americans can turn on their televisions and watch government in action uninterrupted by analysis or interpretation. For public affairs junkies, sound bites, and talking head journalists can be augmented by gavel-to-gavel coverage. Congress in session, congressional committees, full-length speeches by state and national officials, cinema verite´ coverage of public officials going about their daily routines, and average citizens communicating to a national audience about what they are seeing and hearing. Two decades ago such a window on the political process was unheard of.

The Vision

Most revolutions begin with a simple idea and an individual who believes in it. To some degree, the simpler the idea, the more revolutionary. Brian Lamb's idea was very simple. Let the American people see what their government is doing, and let them see it undiluted. Just when we begin to believe that modern and complex American society leaves little room for an individual entrepreneur with a revolutionary idea, we discover an idealist with a vision, who capitalized on a responsive environment.

Lambs vision emerged from frustration. Years in Washington, D.C., as a Navy public affairs officer, press secretary to a politician, White House policy aide, and journalist allowed him to see the media from a number of different perspectives, all leading him to the conclusion that there "had to be a better way to cover public affairs" (author's interviews).[1] Lamb recognized that network television was not showing the public what was really happening in national politics. The battle for viewer "eyeballs" as measured by audience ratings forced commercial television toward more of an entertainment format, while common assumptions about audiences led the networks to become more and more alike in what they chose to cover and their coverage techniques. Lamb's "gut instinct . . . was that if I'm interested enough to want to know more of what's going on behind the scenes, there's

got to be more people who feel the same way" (quoted in Duff, 1994, p. 5).

The network Lamb dreamed of flew in the face of contemporary media practice. Existing programming accepted the role of the media as an "interMEDIAry," standing *between* the audience and the actual event, choosing what portion to show and how to show it. With short attention spans and busy lives it was felt that viewers would simply ignore public affairs events that were not edited, interpreted, and made more exciting through sophisticated video production techniques. Conventional wisdom was clearly borne out in a number of political realms. The average network sound bite of presidential candidates speaking on their own behalf declined from 43 seconds in 1968 to 8 seconds in 1992 (Carmody, 1992). Most stories used journalists talking about the "horse race" aspects of who was ahead and who was behind in the campaign. Only a small percentage of members of Congress ever appeared on national television as the networks gravitated toward a few well-known members. With television news stories of ninety seconds or less, it took too much time to introduce a broad range of congressional participants in such a way that viewers could interpret their comments. Congress became represented by short and exciting clips of extraordinary conflict between a few unrepresentative, but well-known, spokespersons.

Political coverage looked more like sports with a talking-head color commentator telling the viewer what they were about to see, or had just seen. The event itself became almost irrelevant, except as a news hook justifying the story itself. While each editorial choice and enhancement distorted reality, the networks justified their decisions by arguing it was better to engage the public in "a little bit of something," when it came to public affairs, rather than to turn them off with "a lot of nothing." Lamb bet that the networks were dead wrong. He believed there was both something to cover and a relevant audience to receive it.

A Responsive Environment

In order to better inform the American public, Lamb needed both a message to broadcast and a medium to deliver it. Fortuitous timing readily suggested the medium. A group of frustrated Washington insiders provided potential access to the message.

An Economic Motivation

Cable television, developed largely to provide programming to areas with poor reception from broadcast signals, was itching to expand its audience base. They needed unique programming to convince viewers to pay for programming the viewers were accustomed to getting free. In the mid-1970s, cable was seen as stealing broadcast signals, offering morally questionable programming and providing little public service (Ely, 1985). Above and beyond programming, the cable industry needed legitimacy in the minds of members of Congress responsible for the regulatory environment in which cable would thrive or wither. By promoting his ideas of public affairs programming as a demonstrable public service with positive public relations payoffs, Lamb persuaded cable owners to listen and put up the money for a network that in itself would never be a commercial vehicle underwritten by advertising.

Political Pragmatism

Over a decade after television had become the primary source of political news for most Americans, Congress remained wary of its impact, but afraid to ignore its potency. The earliest discussions occurred in the House of Representatives. Behind the rhetoric about expanding the public gallery and opening the "people's House" to the people, lay a more practical reason for televising House proceedings. As one member put it, "A Congress unable to project its voice much beyond the banks of the Potomac . . . can be neither representative nor responsive. A Congress able only to whisper, no matter how intelligently, cannot check and balance the power of the Executive or safeguard the liberty of individual citizens" (Metcalf, 1974). Many House members saw television coverage of their chamber as gaining their body visibility relative to the Senate and circumventing the mainline television news programming which covered Congress via short—and often very negative—sound bites. The major sticking point in the House was not so much accepting or rejecting television, but rather who would control the cameras and how the signal would be distributed. Lamb's newly christened C-SPAN (Cable Satellite Public Affairs Network), with its commitment to national distribution of full gavel-to-gavel coverage according to Congress's own policies appealed to the House on both political and economic grounds.

By limiting camera shots to the official proceedings, Congress could avoid embarrassing scenes of sleeping members or an empty chamber. With C-SPAN handling the distribution through the growing cable audience at no cost to the Congress, except for installing and operating the cameras, the price tag was right. C-SPAN coverage of House proceedings went on the air in March of 1979.

Institutional mission statements are often not worth the paper they are written on. C-SPAN breaks this rule, using its mission statement as a benchmark against which to measure its procedures. New employees are heavily encouraged to "check their political agendas at the door and memorize the mission statement." The mission statement reads:

> To provide C-SPAN's audience access to the live gavel-to-gavel proceedings of the U.S. House of Representatives and the U.S. Senate and to other forums where public policy is discussed, debated and decided—all without editing, commentary, or analysis and with a balanced presentation of points of view;
>
> To provide elected and appointed officials and others who would influence public policy a direct conduit to the audience without filtering or otherwise distorting their points of view;
>
> To provide the audience, through call-in programs, direct access to elected officials, other decision-makers, and journalists on a frequent and open basis;
>
> To employ production values that accurately convey the business of government rather than distract from it.

Able to broadcast 24 hours a day covering a Congress which is in session only part of that time, C-SPAN soon began adding programming such as committee hearings, National Press Club speeches, and the first ever television viewer call-in programs. The format remained the same; coverage of entire events using neutral camera techniques and a minimum of commentary and analysis. With main line television gravitating toward fancy graphics, excitement-building camera techniques and an entertainment model, C-SPAN's attempt to get their cameras into the room and then get out of the way became more distinctive.

C-SPAN entered the national political consciousness in 1984 when members of the Conservative Opportunity Society—a group of conservative insurgents within the Republican party under the leadership of Newt Gingrich (R-GA)—began using C-SPAN's coverage of "special order" speeches at the end of each day's House session to promote their message. Their goal was to bypass the traditional media which largely ignored their

messages about wasteful government programs and the decline of the American family and make contact directly with the public. Democratic Speaker Tip O'Neill attempted to embarrass them by revising the coverage rules to show they were speaking to an empty chamber. In the end the brouhaha led to wider recognition of C-SPAN, greater exposure of Gingrich and his colleagues, and public chastisement of the Speaker.

While the House accommodated to C-SPAN coverage, the Senate hung back, concerned about upsetting its traditions and unique role. The momentum to allow Senate controlled cameras into their chamber with C-SPAN distribution rested both on a practical and a philosophical thread. The practical perspective asserted that televising Senate proceedings was an idea whose time had come and that the Senate would look foolish and/or irrelevant if they failed to accommodate television's power in society. As Senator Howard Baker (R-TN) saw it, "If we don't open up the Senate to radio and television, I predict that in a few years . . . in the public mind at least, the House will be the dominant branch" (quoted in Shales, 1981). From a philosophical perspective it was asserted that television would improve relations between the Senate and the public, thus strengthening representative democracy. Again according to Senator Baker, "a democracy thrives on public support, and public support thrives on open government" (quoted in U.S. Congress, Senate, 1981). With a touch of humor, Baker took his argument to *TV Guide*, a vehicle for informing television viewers, and asserted, "Otto von Bismarck, the 'iron Chancellor' of Germany is supposed to have said, 'if you like laws and sausages, you should never watch either one being made.' I say, 'Baloney'" (Baker, 1984). Opponents were forced to face the criticism that they stood in the way of progress and/or that the Senate had something to hide.

What the Window Reveals

Flipping through channels, C-SPAN coverage retains a unique look. With access to the TV signal from the Senate floor, C-SPAN added a second channel (C-SPAN2). House and Senate proceedings trump all other programming options and are covered live in their entirety. The focus of House and Senate cameras is almost always on the official proceedings with no cutaway reaction shots or commentary. C-SPAN sends its own camera crews to cover congressional committees, presidential press conferences,

public speeches by state and national officials, and public policy forums in the same neutral manner. Like all media C-SPAN must make choices. It would be impossible to cover all national public affairs events. C-SPAN's programming department takes great pains to maintain ideological, partisan, and issue-area balance. C-SPAN's view of balance and objectivity does not rely on a slavish attempt to balance each idea on a one-on-one basis, but rather *over time* to expose its audience to the widest range of relevant views possible.

In its attempt to cover entire events in long form, C-SPAN hopes to insert the viewer into the event like a fly on the wall. With no commercials or commentary, the viewers are largely on their own to understand and interpret an event. For audiences accustomed to fancy camera work and short clips of events, some of C-SPAN's programming is about as exciting as watching paint dry.

Over the years, C-SPAN has expanded its coverage of public affairs to international events such as Question Time from the British House of Commons and sessions of foreign parliaments. Domestically, C-SPAN pioneered viewer call-in programs and long form interviews with public officials, journalists, and authors. Even C-SPAN's interviewing technique stands out. Eschewing the headline-making "gotcha" questions, C-SPAN interviewers intentionally gravitate toward the basic "who? what? when? where? and why?" inquiries. The C-SPAN philosophy encourages its 260 staff members to retain a passionate interest in the public policy process, but reinforces the expectation that employees remain entirely objective. As Brian Lamb puts it, "anyone with too much interest in the outcome of any political battle probably does not belong here."

Giving politicians and authors a national platform without intervention raises the question as to whether C-SPAN is simply being "used" by those with a political agenda. C-SPAN places a great deal of faith in its audience, assuming in Brian Lamb's words, "if we give them enough information they will figure out who the heros and who the zeros are." C-SPAN's commitment to balance forces them to seek out spokespersons for a wide variety of views. Going beyond the "regular suspects" who dominate network television, C-SPAN makes a point to cover third parties and spokespersons for fringe groups. While there might not be perfect balance on any one program, over time a natural or planned balance emerges. As Susan Swain, C-SPAN's senior vice president, sees it, "the good news is that both sides have figured out how to use us. For every Newt Gingrich there is an Al Gore."

Philosophically, C-SPAN staff and regular viewers would find it odd to

have their network of choice included in a book which equates contemporary media with "Show Time." For C-SPAN, the "show" is the unadorned event without the embellishments that "putting on a show" implies.

Who Is Looking in the Window?

In one sense, the commercial networks have little to fear from C-SPAN. Its audience is relatively small. Relieved of the need to establish audience size to garner advertising revenue, C-SPAN takes pride in not gathering ratings information. Its programming decisions are based on what needs to be shown rather than what will pull in an audience. C-SPAN is clearly a niche network, siphoning off a small, but extremely interested portion of the national television audience. "Deadly as it may seem, C-SPAN has an intoxication all of its own. It has created, across the country hundreds of thousands of C-SPAN junkies—hard-core loyalists who savor a good congressional floor fight the way true baseball fans love a pitchers' duel" (Warshaw, 1988). While only about 10% of the national viewing audience tunes into C-SPAN any week, that audience includes some of the most politically aware and politically active citizens. Regular C-SPAN viewers exceed national averages in voting, contributing to campaigns and contacting public officials. Politicians realize that if you want to reach the political "movers and shakers," C-SPAN is the media vehicle of choice (Frantzich and Sullivan, 1996). During intense political battles, such as the debates over the impeachment and removal of President Clinton, C-SPAN's appeal increases for individuals who want to "see the events for themselves" without typical commercial network filtering and analysis.

C-SPAN's ability to directly inform the public is augmented by the fact that both policy-makers and members of the media rely on its coverage on a day-to-day basis. From the White House and the legions of lobbyists' offices along Washington's K Street, to the congressional offices on Capitol Hill and the national newsrooms around the country, political practitioners monitor politics through C-SPAN coverage. Journalists outside of Washington now have access to many events only the "inside the beltway crowd" could once cover. Additionally, C-SPAN "transports" Washington-based reporters to events which even the most liberal expense accounts and free time schedules would not permit. News stories on the networks rely heavily on C-SPAN video clips to enhance their typical 90 second stories since for many public

affairs events, only C-SPAN was there. C-SPAN archives all its coverage, creating a historical video record of contemporary events available to scholars and journalists.

As a number of politicians have found out, it is now less possible to sluff off damaging comments by saying, "Oh, I was misquoted." The C-SPAN cameras capture and retain in undeniable format a much wider sample of political events than ever was the case before.

What Difference Does the Window Make?

C-SPAN has affected both the political practitioners it covers and the audience who watches it. Assessing the impact of any medium is constrained by the fact that the injection of a new medium into an environment is not an isolated event. With a wide variety of changes occurring, sorting out cause and effect is difficult. The most easily countable changes, such as the number of speeches given, probably have less importance than factors that are more difficult to capture, such as the quality of policy-making.

The View from Inside

Politicians, like all good strategists, assess the context and attempt to use it to their advantage. With a new vehicle for pursuing their political goals and spreading their message, members of Congress began to make more short speeches and use more visual props. In the words of one veteran lawmaker, "The stakes are higher now. We have an audience . . . we want to score with potentially millions of voters" (quoted in Ornstein, 1987, p. 5). The arrival of C-SPAN coincided with a long-term trend of increasing partisanship in congressional debate and voting. While C-SPAN was not the only cause, it certainly reemphasized the importance of such a conflict.

Heightened transparency of the political process affects what *did not happen* because the cameras were there as well as what did happen. While C-SPAN cameras have become a largely ubiquitous presence pushed to the back of the practitioner's consciousness, vague awareness of the cameras' proximity tempers some behaviors.

C-SPAN coverage increases the abilities of various stakeholders to monitor the political process. Members of Congress and their staffs watch

C-SPAN's congressional floor coverage to determine what is happening on the floor and how to schedule their time more effectively. As the voting clock winds down, members glance at the TV screen in their offices to determine what the vote is about and how much time they have to dash to the floor. Lobbyists monitor floor sessions, committee meetings, call-in programs, and public policy forums to keep up-to-date. The White House and other executive branch staff keep tabs on public policy discussions and prepare their responses. Journalists use C-SPAN to expand their beat. With the public policy window more open, less is done in politics by stealth today. The line between Washington political insiders and outsiders is far less clear since the arrival of C-SPAN.

On the individual level, C-SPAN represents a double-edged sword. A generation of political leaders such as Bill Clinton, Al Gore, Ross Perot, Newt Gingrich (former R-GA and House Speaker) and Dick Armey (R-TX and House Majority Leader) all used C-SPAN to establish their national careers. They recognized that being able to speak directly to some of the most active citizens and members of the media would create the legitimacy and recognition necessary for developing support among the larger population. Other public officials such as former House Speakers Tip O'Neill (D-MA) and Jim Wright (D-TX) suffered career damage because of C-SPAN's presence. In recent presidential contests, C-SPAN's capturing of an off-color joke by Senator Bob Kerry (D-NE) and misrepresentations by Senator Joe Biden (D-DE) cut short their candidacies. C-SPAN serves as a subtle career maker or breaker as congressional colleagues take into account potential leaders' ability to project well under continuous television scrutiny of the type C-SPAN provides (see Frantzich and Sullivan, 1996).

The View from Outside

Optimistic hope that opening the political process would expand public awareness and political participation in general has not been borne out. Overall levels of political awareness and political participation continue to decline. For the much smaller group of regular viewers, the situation stands out in stark contrast. C-SPAN junkies gravitate to the network based on their inherent interest in public affairs, while the information they receive often gives the wheel another spin, encouraging them to contact their public officials, engage in "talk show democracy," and involve themselves in other

forms of political activity. Elected officials and talk show hosts have become accustomed to having arguments begin, "As I saw on C-SPAN. . . ." Since American politics works on the dictum, "you can't win if you don't play," C-SPAN's influence lies in stimulating players to enter the fray and provides them timely and detailed information that increases their likelihood of affecting public policy. While the C-SPAN audience is not a random sample of the population in terms of demographics or opinions, politicians increasingly assume that it represents what most people would think *if they were informed and activated.* In the meantime, political leaders respond to those they hear from, and the C-SPAN audience stands out among those whose voice is likely to be heard.

Congress opened its door to C-SPAN coverage assuming that "to know us is to love us." With an increasingly cynical population, it was hoped that viewing the policy process live and in its entirety would build public support. A cursory look at the data might lead to the conclusion that in actuality "familiarity breeds contempt." Regular C-SPAN viewers are more negative about key elements of the policy process than the population as a whole. More careful analysis of the data indicates that C-SPAN viewers are "vehemently anti-Washington, yet at the same time . . . strikingly non-cynical and deeply convinced of the importance of one individual's participation in the American democratic process despite a deep discontent with the status quo" ("Profile," 1995). C-SPAN viewers strongly supported the "throwing the rascals out" perspective which led to the Republican takeover of Congress in 1994, and continue to have grave reservations about current position holders of both parties.

Keeping the Window Open

C-SPAN will never challenge either the broadcast networks or the major cable networks such as CNN or MTV for a significant portion of their individual audiences. It represents a niche-market cable channel, which combined with numerous other niche channels, has driven the broadcast networks below a 50% audience share. It shows that targeted programming has significant appeal for a segment of the population and provides a model for the coming information age with hundreds of channels and converging delivery technologies. While there is some danger in creating a fragmented society with specialized viewers choosing unique sets of information, C-

SPAN offers a breadth of programming that should have broader utility than the Home Shopping Network or the Country Dance Channel.

In the short term, the availability of the C-SPAN signal remains tenuous. While the cable industry has been relatively generous with its financial support, current limited channel capacity and the pressure to include new networks forces cable systems to pick and choose what they will include in their service. As a non-revenue-producing channel, C-SPAN inclusion is based solely on cable operators' commitment to public service. In one of the ironies of American politics, Congress has legislated various "must-carry" provisions requiring cable systems to broadcast specific local channels and formats (high definition television), potentially forcing C-SPAN off many cable systems. C-SPAN's primary role in bringing Congress to the people faces a continuing threat from the Congress itself. In the long run, technology will make channel capacity a moot issue. As cable capacity moves to 300 or even 500 channels, there will be plenty of room for niche networks like C-SPAN. In the mid term C-SPAN must survive media regulations which, while not directly targeting C-SPAN, could cause significant collateral damage to its functioning.

C-SPAN's commitment to increasing public knowledge of public affairs goes beyond the capabilities of any particular medium. Television was chosen in 1979 because it was becoming the dominant information medium for most Americans. As the Internet grew in popularity, C-SPAN jumped in with its own Web page (www.c-span.org), pioneering the distribution of text, audio, and video coverage of public affairs. Its recent presence on the radio makes its message more transportable for mobile Americans. As technologies change and converge, expect C-SPAN to remain in the forefront of providing interested citizens an alternative.

C-SPAN proudly proclaims itself as an alternative to typical broadcast and cable television, providing long-form coverage of public affairs events without enhancement or adornment. When the other networks cut away from congressional hearings, special events in the House or Senate, political party conventions, or news conferences, the C-SPAN cameras just keep on rolling. The C-SPAN window makes the goal of government in sunshine a reality, providing average citizens and political practitioners alike the ability to press their noses to the pane and see what is going on inside.

Note

1. For more detailed information and discussion of methodology, see Stephen Frantzich and John Sullivan, *The C-SPAN Revolution*, Norman: University of Oklahoma Press, 1996.

References

Baker, Howard. 1984. "We're Losing Political and Historical Treasures." *TV Guide*, July 21, p. 33.

Carmody, John. 1992. "The TV Column." *Washington Post*, November 18, p. 66.

Duff, Marilyn. 1994. "C-SPAN: The Way TV News Should Be." *Human Events*, November, p. 5.

Ely, Caroline. 1985. "The Meeting of Congress and Cable." *C-SPAN UPDATE*, December 9, p. 3.

Frantzich Stephen and John Sullivan. 1996. *The C-SPAN Revolution.* Norman: University of Oklahoma Press.

Metcalf, Senator Lee (D-MT). 1974. Joint Committee on Congressional Operations. *Congress and Mass Communications*, 93rd Congress, 2nd session, Hearings, p. 2.

Ornstein, Norman J. 1987. "Yes, Television Has Made Congress Better." *TV Guide*, July 25, p. 5-8.

"Profile of the Regular C-SPAN Viewer." 1992. press release, Times Mirror Center for the People and the Press.

Shales, Tom. 1981. "The Floor Show." *Washington Post*, December 1, p. B1.

Television and Radio Coverage of Proceedings in the Senate Chamber. 97th Congress, 1st Session. hearings on S.Res 20, Washington, D.C.: Government Printing Office, pp. 4-5.

U.S. Congress, Senate, Committee on Rules and Administration. 1981.

Warshaw, Robin.1988. " The Real Drama of All-Natural TV." *The Philadelphia Inquirer Magazine*, August 14.

Chapter 12
Democracy's Rebirth or Demise?
The Influence of the Internet
on Political Attitudes

Thomas J. Johnson
Barbara K. Kaye

The explosive growth of the Internet has sparked debate about its potential impact on the political process.

Supporters proclaim that the Internet may usher in a more democratic system by increasing the public's access to, and influence on, public officials. The Internet could also transform the election process away from television soundbites to substance as voters can readily compare candidates' stances on issues. Others go further, claiming that because the Internet allows citizens from all over the world to communicate, national governments will evaporate and we will become one global community. However, critics contend that the Internet will likely reinforce the existing political system by giving entrenched special interests a more powerful tool to influence government or pose a threat to democracy by making political officials too responsive to the will of the people.

But while many scholars have debated the influence of the Internet on democracy, only a few have examined the effect of the Internet on political attitudes and behaviors, and these studies have produced conflicting results.

This chapter will review the claims of Internet supporters that the Web will reinvigorate the democratic system and the arguments of critics that it poses a threat to democracy. The authors will also review studies that have examined the effect of the Internet on political attitudes and behaviors. This chapter will employ a survey of its own to examine politically interested Internet users online to discover the extent to which the Internet influences political interest, campaign interest, and the likelihood of voting after accounting for demographics, political attitudes and use of traditional media. After examining the arguments of others as well as the results of our own survey, we conclude that the Internet will not transform democracy as its supporters claim or destroy democracy as its critics fear. The Internet is likely to reinforce the existing political structure rather than change it.

Democracy's Rebirth

Those who advance a utopian view of the power of the Internet to transform the democratic process argue that the Net creates a new electronic public square that allows citizens to connect directly to government officials and with each other. The Internet also increases access to political information which should create a better informed citizenry who participate more in political life and have a greater influence on the political process.

While citizens have long been able to contact individual lawmakers through telephone and traditionally delivered mail, e-mail reduces both the cost and the time to communicate with lawmakers, which may encourage individuals to attempt to influence the political process. Greater access to lawmakers, coupled with the increased information available on the Internet, will shift the locus of power away from the well-heeled lobbyists and other powerful interest groups toward the "little guy" (Bimber 1996, 1998d, 1998e; Browning 1996; Carveth and Metz 1996; Corrado 1996; Schwartz 1996).

Before the Internet, only the rich could afford to broadcast a message to the public. But the low cost of creating Web pages and sending out e-mail messages across the globe enables grassroots activists to better recruit, organize, and mobilize individuals on behalf of a cause. The Internet, therefore, allows individuals and grassroots organizations to more effectively compete with lobbyists and interest groups to influence legislation (Bonchek 1995; Browning 1996; Selnow 1998; Schwartz 1996). For instance, when Congress debated restricting free speech on the Internet, more than 30 organizations and 100,000 individuals formed an online coalition to combat the Communications Decency Act (Berman and Weitzer 1997). Similarly, third-party candidates, who are traditionally ignored by the mainstream press and cannot afford costly television advertising, can create Web pages to inform voters about their stands on issues as well as to solicit money and volunteers. Analysts attribute Jesse Ventura's upset victory for the governorship of Minnesota in 1998 in part to his ability to recruit volunteers through his Web site and to employ his 3,000 member e-mail list to round up supporters to rallies in order to make his campaign more visible (Raney 1998). The Internet, therefore, may help create more competitive elections that may, in turn, boost interest in the political process (Corrado 1996).

While the Internet allows citizens to better communicate with elected officials, it also enables policymakers to better tap the views of their

constituents. Public officials can poll voters to see how they stand on important issues or hold electronic town meetings to hear their concerns as well as to update constituents on government activities (Slaton and Becker 1998; Toffler and Toffler 1995). Eventually voting could be done over the Internet, as was done by The Reform Party during the 1992 and 1996 campaigns, which would reduce the time and costs of voting and potentially increase voter turnout, particularly among the young and among those who have difficulty reaching the voting booth (Snider 1994; Van Dongen 1998).

The Internet not only improves discussion between government officials and the public, but it also allows citizens from across the globe to communicate with each other, increasing social connectedness and creating the sense of community needed to revitalize democracy (Jones 1995; Rheingold 1993; Schwartz 1995). The Internet serves as an ideal forum for individuals to express their ideas and opinions on anything from global warming to the new Smashing Pumpkins CD. Those who post messages to bulletin boards, Usenet groups or chat rooms are not subject to commercial or political pressures; they reside in a place that is essentially owned and policed by its participants, rather than controlled by a government agency, and where barriers to entry are low (Bryan, Tsagarousianou, and Tambini 1998; Schneider 1996). Internet advocates, in fact, tout several advantages of virtual rather than face-to-face discussions: People can come together without being close in either space or time; discussions can involve those who are home-bound; online discussion forums can accommodate more individuals than most physical spaces would allow; and people are anonymous so that physical appearance and offline identities do not matter and so views can be expressed more freely (Etzioni and Etzioni 1997).

While Internet supporters concede the quality of public debate may not always be high, Internet discussions are lively and spirited. As one political observer noted, "Discussion on the Internet is frontier speech: free, sometimes pointed, often blunt, and frequently rebellious. Our Founding Fathers would love it" (Whillock 1997, 1211). Internet utopians contend, then, that people will express their views more fully and openly in cyberspace so that more diverse viewpoints can be aired and true deliberation can take place. A simple scan of newsgroup sites (e.g., alt.politics.white-power,-alt.fan.rush-limbaugh,alt.anarchism,alt.conspiracy, misc.activism.militia, alt.politics.radical.left) reveals that the Internet plays host to a galaxy of groups who feel their views are ignored by the government and the mainstream media. Studies of Web content reveal that 22 percent of Web pages were posted by groups and individuals who would be placed on the far right

or left fringes of the country's political spectrum. Additionally, the number of anti-government messages outnumber pro-government ones about 20-1, with anti-government messages highest among residents of repressive regimes such as China and Cuba. The Web, then, is a place where people of all ideologies and nationalities can find a comfortable home to express their views (Hill and Hughes 1998).

Furthermore, political observers contend that the sheer volume of campaign information available on the Net through candidate Web sites, nonpartisan sites such as PoliticsNow, and online versions of traditional media should lead to a better informed public that will more readily participate in the political process (Bimber 1998e). In particular, the Internet may energize the young to participate more in the political process.

Analysts suggest that one reason people do not actively participate in politics is that they lack sufficient information to make decisions and therefore tune politics out (Hill and Hughes 1998). While television serves up its news in 22–minute segments, at specific times and through the filter of the reporter or anchor, the Internet provides the public a theoretically limitless newshole of up–to–date information available when the public wants it—much of it raw form that has not been digested by journalists. As *Washington Post* media writer Howard Kurtz notes, "The new ventures will give ordinary folks the ability to search voting records, election returns, exit polls, speeches and position papers, enabling them to cut through the political fog by downloading the facts for themselves" (Kurtz 1995). The Internet also allows voters to hold candidates more accountable by comparing their statements on the stump or their Web sites to more politically neutral sites such as the League of Women Voters or Rock the Vote (Kern 1997).

Democracy's Demise

Critics question whether the Internet can achieve the lofty democratic goals predicted of it. Rather than increase the public's influence on the democratic process, the Internet may simply reinforce the current political system or pose a threat to democracy by making lawmakers too responsive to the public will.

For the Internet to be truly democratic, it must enjoy universal access. While the democratic profile of the Internet is becoming increasingly

mainstream, (45 million 1998; EOverview 1998; GVU's Ninth 1998; Latest Intelliquest 1998) frequent Internet users tend to be well educated and politically interested individuals who already have influence over the political process (Bimber 1998a, 1998e). Therefore, rather than making the nation more democratic, the Net may actually increase the gulf between the have and have nots (Browning 1996; Carter 1997; Graber 1996; McChesney 1996; Bonchek, Hurwitz and Mallery 1996).

While the Internet does reduce the cost and time to gather political information, information availability alone does not guarantee increased participation in the political process. Studies suggest that people do not feel they lack sufficient information to make political decisions, but rather they feel they have little influence on the political process, and thus little desire to actively participate (Hacker 1996; Harwood 1991). Similarly, increased information does little to combat a lack of interest in the issues or candidates in a campaign or the belief that voting simply is not a priority in an individual's life and does nothing to eliminate barriers to voting such as voter registration requirements, elections being held on workdays and at times that may not be convenient for people to vote (Bimber 1998d; Whillock 1997). Observers note that while the Internet is indeed packed with information, it is not always easy for citizens to navigate the Web in order to find it, and not all of the information will be truthful. The Internet has spawned a host of online rumors and hoaxes, from the claim that African-Americans' voting rights will expire in 2007 to the promise that two 18-year-old virgin honor roll students would share their "first time" online (Why Hoaxes 1996; Navigating Fact and Fiction 1996). The proliferation of misinformation and pranks pervading the Internet has caused some to call the Internet's credibility into question, (Calabrese and Borchert 1996; Selnow 1998; Shenk 1997; Starobin 1996; Whillock 1997), and information that is false and misleading can only hinder the democratic process (Shenk 1997). Finally, political observers warn of information overload; voters may become so overwhelmed by the information available that they participate less, not more, in the political process (Collins 1999).

E-mail may reduce the costs and the time for individuals to contact government officials, but this does not necessarily mean that frequent Internet users will be more motivated to do so. Indeed, researchers have discovered few substantive differences in levels of political participation between those who rely on the Internet and those who rely on more traditional means like the post office and the telephone (Bimber 1998b). Worse, frequent Internet users are less likely to contact public officials than average

citizens using traditional means (Bimber 1998e, Kaye and Medoff 1999).

Similarly, while the Internet makes it easier for third-party candidates to reach voters and for grassroots organizations to mobilize individuals, this does not necessarily mean the common person will have more influence on the political process. Republican and Democratic candidates also post Web pages and they may have more resources to produce slicker Web sites. E-mail not only makes it easier for grassroots groups to get the ear of government, it also enables those lobbyists and special interests groups who already have access to government officials to more effectively mobilize individuals to their cause. Therefore, the Internet is not likely to tip the balance of power toward the "little guy" (Graber 1996; Starobin 1996).

Few argue the claim that the Internet serves as a freewheeling, unfettered forum for individuals of all beliefs to express their views, but it does not necessarily follow that the Net will promote a fuller and more deliberate political discussion. There is little evidence that political discussions on the Web approach the Lincoln-Douglas debates, or even what passes for debate on the Sunday morning television talk shows. Discussion forums such as bulletin boards, Usenet groups and chat rooms attract like-minded individuals who have already made up their minds on issues rather than groups of people with diverse views. Thus, "political debates" on the Internet typically involve people venting their opinions in short bursts rather than engaging in serious dialogue (Starobin 1996). The cloak of anonymity the Internet provides means that discussants cannot be held directly accountable for their views and thus are more likely to hurl insults and engage in name-calling rather than serious debate (Etzioni and Etzioni 1997; Starobin 1996; Whillock 1997). Indeed a content analysis of political discussions on the Net found that most messages were too brief or strange to be considered serious dialogue (Franke 1996). Most of the messages reflected users' "pre-established partisan views" rather than an open-minded discussion between those of differing beliefs, and a majority of the messages were significantly sarcastic in tone. Similarly, most political conversations in both Usenet groups and chat rooms are short; the average number of "threads" in the conversation of Usenet discussions was two. About two-thirds of messages in both Usenet groups and chat rooms reflected consensus among like-minded individuals rather than debate among those with substantially different views. Also, about 20% to30% of all messages involved "flaming"—hurling insults at other participants—and flaming was most common during actual debates (Hill and Hughes 1998). Finally, much of what is debated in discussion groups does not involve politics at all, but rather

"issues" ranging from the pros and cons of getting your nipples pierced (soc.culture.bondage.bdsm), to whether it would be better to marry Gillian Anderson or her onscreen alter ego Dana Scully (alt.tv.x-files) or whether rocker Marilyn Manson is secretly a Power Rangers fan (alt.fan.power--rangers).

Critics question whether electronic town meetings and other forms of electronic democracy such as online polling and voting would improve democracy. Electronic townhalls do not encourage thoughtful deliberations but snap judgments from people who may be uninterested and intentionally uninformed about the political process (Shenk 1997). Indeed, critics fear that such forms of electronic democracy could create a 'hyperdemocracy" where elected officials would base their votes on the quick judgments of citizens rather than through careful deliberation (Epstein 1996; Grossman 1995; Ornstein and Schenkenberg 1996; Schudson 1992; Starobin 1996). Worse, electronic townhalls and online polls would likely be dominated by the educated and politically interested who already influence the political system. The views of the poor and other marginalized voices would likely get "lost in a digital cacophony" (Pavlik 1996).

Finally, observers contend that they have heard the siren's call before. Enthusiasts invariably tout the potential benefits of new communication technologies on the democratic system, but these prophesies rarely come to pass. For instance, radio and then television may have transformed how candidates campaign and how the public receives information, but there is little evidence that they have helped to engage people in the political process. Studies offer no evidence that the public has become increasingly knowledge-able or that it participates more in politics since the advent of these two communication technologies (Bimber 1998d). Similarly, cable television was heralded as a two-way communication network that would allow people to voice their concerns to their legislators. In fact, Warner Cable established the QUBE system in Columbus Ohio in 1978 to allow voters to register their views in public opinion polls by punching buttons in their homes. Warner cable pulled the plug on the QUBE system six years later (Emery and Emery 1996; Smith 1982). If earlier communication technologies failed to alter the democratic landscape, why should the Internet be any different?

The Internet and Political
Attitudes and Behaviors

Several recent studies have exploded the myth that the Internet is "a haven for isolated geeks" who emerge from their "cavelike bedrooms" only to express an interest in politics when freedom on the Internet is threatened (Katz 1997). The Netizen does not appear to be disconnected and apathetic. Rather, studies indicate that in many ways Web users appear to be model citizens. Internet users are more politically knowledgeable than the average citizen (Bonchek 1997; Hill and Hughes 1998). For instance, they are twice as likely to be able to name William Rehnquist as the chief justice of the United States than nonInternet users (Katz 1997). In addition, Web users are politically interested and active, report high levels of political efficacy, are more likely to vote and more likely to seek out information from the media than the general public (Bimber 1998c; Bucy, D'Angelo and Newhagen 1997; Johnson and Kaye 1998; Bonchek 1997; Bonchek, Hurwitz and Mallery 1996). Politically active Internet users score higher on these measures than general users (Hill and Hughes 1998). Furthermore, a *Wired* magazine poll suggests that Netizens have more confidence in democracy and the free-market system, have more faith in the future, are more politically knowledgeable and vote in greater numbers than technologically disconnected individuals. As Wired political analyst Jon Katz noted, "Digital Citizens appear startlingly close to the Jeffersonian ideal—they are informed, outspoken, participatory, passionate about freedom, proud of their culture, and committed to the free nation in which it has evolved" (Katz 1997, 72).

But while Internet users may appear to be politically engaged citizens who believe they have the power to influence government, they do not necessarily trust the government to carry policies out. Internet users report high levels of political distrust (Bonchek 1997; Johnson and Kaye 1998; Katz 1997).

Furthermore, not all studies have found that Internet use predicts political attitudes and behaviors. While Internet use for political information may be linked to political interest, several studies suggest it is not related to intent to vote (Brady 1996; GVU's seventh 1997; Johnson, Braima and Sothirajah, in press) or to political knowledge (Tewksbury, Cox, Nixon, and Proctor 1997).

Examining Political Attitudes
and Behaviors of Internet Users

This study is based on an online survey of 308 individuals designed to attract politically interested Web users. The survey was posted on the World Wide Web from October 23 to November 20, which was the two weeks before and the two weeks after the 1996 presidential election. Links were established to the survey from other politically oriented Web sites and notices were sent to media and politically oriented discussion groups, forums, Usenet newsgroups, and listservs informing them of the survey. The intent was to attract politically interested Web users who would be more likely to use online media sources rather than drawing a random sample who may not be interested in politics.

The survey assessed the respondents' levels of interest in politics in general and in the 1996 presidential election in particular. Those who completed the survey before the election were asked about the likelihood that they would vote, while those who answered after the election were asked whether they did vote. This study also employs three measures of Internet use: how much people rely on the Web for political information, the number of hours per week they spend on the Web for political information and the total number of times they have been on the Web.

Hierarchical regression was conducted to examine the extent to which Internet use predicts political interest, campaign interest, and likelihood of voting after controlling for demographics (age, income, gender, education), political attitudes (strength of party support, political trust, and political efficacy) and amount of television and newspaper use. Hierarchical regression allows us to determine how well Internet use can predict political and campaign interest as well as voting behaviors after accounting for other explanations.

The predictors were entered as blocks. Demographic variables (gender, age, income, and education) were entered first, followed by the block consisting of strength of party support, trust in the government and feelings of efficacy. Next, traditional media use measures were entered, and lastly, Internet use measures. Statistical tests were conducted to ascertain significance.

Profile of Politically
Interested Internet Users

Internet use was measured by how much the respondents rely on the Web for political information, the number of hours they spend on the Web for political information and the number of times they have accessed the Web. Slightly more than one half (51%) of the respondents say they rely on or heavily rely on the Web to keep politically up-to-date. Only 3.9% of those surveyed do not rely on the Web for political information. Respondents spend an average of three hours per week seeking political information online and about another 10.2 hours on the Web in general. They are also experienced Web users who average 1,723 times online.

One purpose of the study is to assess the Internet user's interest in politics in general and in the 1996 presidential campaign in particular. Almost 9 out of 10 of those surveyed are politically interested and 91.5% indicated they were interested or highly interested in the presidential campaign. High interest in politics relates to voting intention as 95.5% of those who completed the survey prior to the election said they were likely to vote. Further, 86% of those who responded to the survey after the presidential election reported that they had cast their ballot.

Trust in politics and in politicians has long been on the wane. Internet supporters tout the medium as a means of increasing trust in the government while others claim that those who distrust the government to begin with are more likely to use the Web. This latter scenario is supported as almost nine out of ten respondents reported low to moderate levels of trust in the government.

Feelings of powerlessness and the belief that government does not respond to the public's concerns translates into low levels of efficacy. By using the Internet many argue that citizens can more easily become involved in the political process, thus increasing feelings of efficacy. In this study, slightly more than nine out of ten Web users reported moderate to high levels of internal efficacy, the belief that each individual has the power to bring about change.

Profile of College Age Internet Users

Political observers lament that college age Generation Xers are more

interested in piercing their body than participating in the body politic. Since they were given the right to vote in 1971, electoral turnout for the 18 and 24 year-old crowd has lagged behind all other age groups and has been declining with each election. Generation X has been portrayed by the media and scholars as self-absorbed and uncaring about society, cynical and distrustful of government, and largely ignorant and apathetic about politics (Bennett and Rademacher 1997; Hays 1998). On the other hand, Internet studies suggest that young people dominate the Internet and for some, cruising the Net may serve as a form of political participation (72 Million Online 1998). While it is recognized that the respondents to the online political survey are already a politically interested group, this study sought to examine whether respondents between the ages of 18 and 24 were more or less favorable towards politics than older respondents (25 years and over).

This study found that college age students were just as interested in politics as older individuals, although the college-age group was significantly less interested in the 1996 presidential campaign. However, analysts suggest that the media ignored youth issues in their coverage of the 1996 campaign and the candidates did not actively reach out to the young voter. This is a turnaround from 1992 when Bill Clinton actively courted the young through his appearances on MTV and late night talk shows (Chideya 1997).

College age Internet users also matched their older counterparts on other political attitudes and behaviors. The younger group of respondents reports similar levels of efficacy, trust in the government, and strength of party affiliation as older voters. Additionally, college age respondents are just as likely to report that they plan on voting and they are as actively involved with the voting process as older respondents.

The Internet as a
Predictor of Political Interest

Regression analysis reveals the Net predicted interest in politics in general. Even after controlling for other variables, reliance on the Web for political information and hours spent on political sites significantly predict higher levels of interest in politics. Additionally, trust in government and age are also significant predictors of general political interest.

The more individuals rely on the Web for political information and the more hours they spend seeking out political information the higher their

interest is in politics. Indeed, hours per week on the Web searching out political information was the strongest predictor of political interest. Also, those who spent more hours on the Web for political information tended to be more interested in the 1996 presidential campaign, although the relationship just missed being significant.

Reliance on the Web is the only significant media predictor of political interest. Indeed, reliance on television news tends to be negatively related to political interest while reliance on papers has little relation to political interest.

Internet users tend to display moderate to low levels of trust in the government and these levels of trust predict political interest and interest in the 1996 presidential campaign. Age also predicts political interest. Although many researchers and Internet analysts contend that the Web attracts younger people who tend to feel alienated from Washington, this study suggests that it is the older Web users who visit politically oriented sites and who tend to be more interested in politics. Finally, strength of party affiliation does not predict general political interest. However, Internet users who felt a strong sense of commitment to their political party reported more interest in the 1996 presidential campaign.

Internet Use and Voting

Using the Web for political information did not predict either intent to vote or actual voting behavior. However, few other measures influenced voting.

None of the six Internet use measures predict voting. Indeed, number of times accessing the Web tends to be negatively related to intent to vote and actual voting behavior. However, reliance on TV news and newspapers for political information does not predict voting either.

Those who are highly educated report they are more likely to vote. No other measure significantly predicts intent to vote. Younger individuals were significantly less likely to have actually voted as were the highly partisan.

Conclusion: Will the Internet Be Democracy's Rebirth or Demise?

The Internet has been transformed within the last five years from a device virtually unknown by anyone outside a small cadre of academics and military officials to a communication tool viewed as one of life's necessities by half of online users (*San Jose Mercury News* 1998). The explosive growth of the Internet has led to rampant speculations about its effects on the political system with opinions ranging from claims that it will usher in a new democratic revolution to apocalyptic predictions that it will undermine democracy and increase the gap between the haves and the have nots.

This study does not directly examine what influence the Internet will have on the political process, but it does provide insight into the type of person who resides there. This study supports several earlier ones (Bimber 1998c, 1998e; Bonchek 1997; Bonchek et al 1996; Bucy et al. 1997; Hill and Hughes 1998; Johnson and Kaye 1998) that demonstrate that in many ways the Netizen is a model citizen. Nearly nine in ten reported they were highly interested in politics and more than 80% closely followed the 1996 presidential campaign. Nearly all those before the election said they would vote and 86% after the election stated that they did indeed vote. Not only were Internet users interested in politics, but also more than nine of 10 either strongly or moderately believed they have the power to influence the political process. Furthermore, while political scientists have lambasted Generation X for opting out of the political process, college age Internet users match their older counterparts in political interest, efficacy, and political participation.

More importantly, hours per week using the Internet for political information and relying on the Web for political information remained significant predictors of political interest even after accounting for demographics, political variables, and traditional media use. Indeed, using the Web for political information was the strongest predictor of political interest and was also a moderate (though not significant) predictor of campaign interest. Internet use did not predict voting intention or behavior, however.

At first blush that only two of twelve Internet measures remain as significant predictors of political interest and voting may not sound terribly impressive. However, neither television nor newspapers predicted interest or voting and none of the political or demographic variables were consistent predictors either.

The significant link between Internet use and political interest does not mean that the Web is transforming people from apathetic to engaged citizens. As past studies indicate, those who surf the Web for political information are already political junkies (Cybercampaigns preach 1996; Katz 1997). The rich cache of political information amplifies their interest in the politics, but does not create it. Similarly, just because Internet use did not increase Web users' likelihood to vote does not mean that citizens who use the Net are opting out of the most basic expression of democracy. On the contrary, the frequencies indicate nearly all Internet users intended to vote in the first place and more than 85 percent did (as compared with less than 50 percent of the total U.S. adult population). Internet use did nothing to sway that intention. However, it is encouraging that college-age respondents, who traditionally vote in lower numbers than other age groups, were just as politically interested and as likely to vote as older citizens. Perhaps the Internet can boost political interest and activity among this often politically lethargic group.

The authors can only speculate on what influence the Internet will have on the political process. We believe that the Internet will probably not achieve the lofty goals that Internet utopians have set for it, nor wreak the damage to the system that its critics contend. The Internet will undoubtedly continue as a platform where those of various ideologies can come to air their views, although claims that the Internet will act as forums of thoughtful deliberation and debate reminiscent of Jacksonian democracy in the 1830s seem like wishful thinking. However the Internet lacks the face-to-face give and take of the Jacksonian democratic forums, and the Internet's cloak of anonymity makes it difficult to hold people responsible for their views, making it more likely that people "flame" those they disagree with. The Internet is better suited for blunt, rebellious frontier speech than careful, well-reasoned political debate.

The Internet does allow grassroots leaders to organize and mobilize citizens on behalf of a cause as well as allowing third-party candidates the opportunity to reach voters more effectively and efficiently. But the Internet is also a tool that can be wielded just as effectively (or more so) by the political interest groups and lobbyists who already exert undue influence on government. Also, Republican and Democratic candidates will continue to have more resources than third-party candidates to be able to use the Internet to attract voters. Therefore, the Internet is not likely to alter the balance of power between political insiders and outsiders, but rather merely speed up the time it takes to send information to government officials and the public.

The Internet could pose a danger to the current political system if, as some Internet utopians advocate, government decisions were based solely on the results of a cyberpoll or a gathering of citizens in an electronic townhall. This would short-circuit the process of deliberation on issues and likely lead to legislation based on the public's snap judgments. Also, because the Internet is dominated by those who already have a voice in the system, cybervoting could mean that the voice of the poor and of minorities would become even more muted. As political researchers note, (Ornstein and Schenkenberg 1996), the founding fathers rejected a pure democracy in which people gather and voice their opinions in favor of a republican system where the public select legislators to make and execute the law because of a fear that a direct democracy would lead to a tyranny of the majority. However, it appears unlikely that those in power would ever give that power up in favor of a direct democracy. Rather, legislators would probably use cyberpolls much as they currently use townhall meetings or opinions mailed or phoned in by constituents. The cyberpolls would be a rough indicator of public opinion that legislators take into account when they decide how to vote.

The Internet may provide a slick, high-tech avenue for politicians to campaign to voters as well as a gold mine of information for voters. The Internet may also speed up communication between politicians and citizens. However, like radio and television before it, there is little evidence that the Web will engage more people in the political process or fundamentally alter the balance of power between the government and the public. Rather, the Internet is likely to reinforce the existing political structure than to change it. However, because the Internet serves as an unregulated forum for anyone to express what is on his or her mind, cyberspace could act as a new form of democratic participation. The Internet may prove to be a particularly important vehicle for college students who tend to shy away from more traditional venues of political activity.

All of this is just speculation. As a leading Internet researcher noted, the Internet of today is much like television of the early 1950s. Television did not significantly influence the political process until the 1960s and 1970s, so it may take another decade or longer to truly gauge its impact (Bimber 1998e). Political observers writing 20 years from now may look back at this period just before the new millennium and marvel at all the changes the Internet wrought on the political system. On the other hand, they may also look back at the heated debates between Internet supporters and detractors and wonder what the fuss was all about.

References

Bennett, Stephen Earl, and Eric W. Rademacher. 1997. "The 'Age of Indifference' Revisited: Patterns of Political Interest, Media Exposure and Knowledge among Generation X." In *After the Boom: The Politics of Generation X*, ed. Stephen C. Craig and Stephen Earl Bennett. Lanham, MD: Rowman & Littlefield Publishers.

Berman, Jerry, and Daniel J. Weitzer. 1997. "Technology and Democracy." *Social Research* 64 (Fall): 1313-19.

Bimber, Bruce. 1996. "Politics on the Net: Is There a Theoretical Foundation for the Speculation?" WWW: http://www.sscf.-ucsb.edu/~survey1, available December 1996.

————. 1998a. "The Gender Gap in Electronic Democracy." WWW: http://www.lwv.org/JuneJuly98/gender_gap_in_electronic_democra.htm.

————. 1998b. "The Internet and Citizen Communication with Government: Does the Medium Matter?" (Paper presented at the annual meeting of the American Political Science Association, Boston, September).

————. 1998c. "The Internet and Political Communication in the 1996 Election Season: A Research Note." WWW: http://www.-polsci.ucsb.edu/~bimber/research/notemobilize.html.

————. 1998d. "The Internet and Political Transformation: Populism, Community, and Accelerated Pluralism." *Polity* 31 (Fall): 133-60.

————. 1998e. "Toward an Empirical Map of Political Participation on the Internet." (Paper presented at the annual meeting of the American Political Science Association, Boston, September.)

Bonchek, Mark S. 1995. "Grassroots in Cyberspace: Using Computer Networks to Facilitate Political Participation." (Paper presented at the annual meeting of the Midwest Political Science Association, Chicago, IL).

————. 1997. From Broadcast to Netcast: The Internet and the Flow of Political Information. Ph.D. diss., Harvard University.

Bonchek, Mark S., Roger Hurwitz, and John Mallery. 1996. "Will the Web Democratize or Polarize the Political Process? A White House Electronic Publications Survey." *World Wide Web Journal* 3 (Summer). WWW: http://www.w3j.com/3/s3.bonchek.html.

Brady, Dwight J. 1996. "Cyberdemocracy and Perceptions of Politics: An Experimental Analysis of Political Communication on the World Wide Web." (Paper presented at the annual meeting of the Midwest Associa-

tion for Public Opinion Research, Chicago, November.)

Bryan, Cathy, Roza Tsagarousianou, and Damian Tambini. 1998. "Electronic Democracy and the Civic Networking Movement in Context." In *Cyberdemocracy: Technology, Cities and Civic Networks*, ed. Roza Tsagarousianou, Damian Tambini, and Cathy Bryan. London: Routledge.

Browning, Graeme. 1996. *Electronic Democracy: Using the Internet to Influence American Politics*. Wilton, CT: Pemberton Press.

Bucy, Erik P., Paul D'Angelo, and John E. Newhagen. 1997. "New Media Use and Political Participation." (Paper presented at the annual meeting of the Association for Education in Journalism and Mass Communication, Chicago, August.)

Calabrese, Andrew, and Mark Borchert. 1996. "Prospects for Electronic Democracy in the United States: Rethinking Communication and Social Policy." *Media, Culture and Society* 18: 249-68.

Carter, Dave. 1997. "'Digital Democracy' or 'Information Aristocracy?': Economic Regeneration and the Information Economy," In *The Governance of Cyberspace: Politics, Technology and Global Restructuring*, ed. Brian D. Loader.. London: Routledge.

Carveth, Rod, and J. Metz. 1996. "Frederick Jackson Turner and the Democratization of the Electronic Frontier." *The American Sociologist* 27 (Spring): 72-90.

Chideya, Farai. 1997. "The Election: Recipe for Apathy." *Media Studies Journal* 11 (Winter): 83-87.

Collins, Kathleen. 1999. "Information Overload Could Make Voters Tune Out, Scholar Says." *The Freedom Forum Online*. WWW: http:// www. freedomforum.org/technology/1999/1/22noam.asp.

Corrado, Anthony. 1996. "Elections in Cyberspace: Prospects and Problems." In *Elections in Cyberspace: Toward a New Era in American Politics*, ed. A. Corrado and Charles M. Firestone, p. 16. Washington, D.C.: The Aspen Institute.

"Cybercampaigns Preach to Choir." 1996. *The Media & Campaign '96*. Media Studies Center, Briefing No. 1, 8-9.

Emery, Michael, and Edwin Emery with Nancy L. Roberts. 1996. *The Press and America: An Interpretive History of the Mass Media*. 8th ed. Boston: Allyn and Bacon.

"EOverview Report Indicates: Only 37 Million Currently Online in U.S." 1998. *Business Wire*. 8 July, 1-3.

Epstein, Edward. 1996. "Election '96 Internet Style." *PC World*, May,

174-80.

Etzioni, Amitai, and Oren Etzioni. 1997. "Communities: Virtual vs. Real. " *Science* 277 (July 18): 295.

"45 Million U.S. PCs access the Internet Regularly." 1998. WWW: http://www.zdintelligence.com/news. 29 October.

Franke, Gordon. 1996. "Participatory Political Discussion on the Internet." *Votes and Opinions* 2 (July/August): 22-25.

Graber, Doris. 1996. "The 'New Media and Politics: What Does the Future Hold?" *PS: Political Science and Politics* 29: 33-36.

Grossman, Lawrence K. 1995. *The Electronic Republic: Reshaping Democracy in the Information Age*. New York: Viking.

"GVU's 7th WWW User Survey." 1997. GVU homepage. WWW: http://www.gvu.gatech.edu/user_surveys/survey-1997-04/#exec.

"GVU's Ninth WWW User Survey." 1998. GVU homepage. WWW: http://cc.gatech.edu/gvu/user_surveys/survey-1998-04/.

Hacker, Kenneth L. 1996. "Missing Links in the Evolution of Electronic Democratization." *Media, Culture, and Society* 18: 213-32.

Harwood, Richard C. 1991. *Citizens and Politics: A View from Main Street America*. Washington, D.C.: Kettering Foundation.

Hays, Carol E. 1998. "Alienation, Engagement, and the College Student: A Focus Group Study." In *Engaging the Public: How Government and the Media Can Reinvigorate American Democracy*, ed. Thomas J. Johnson, Carol E. Hays, and Scott P. Hays, pp. 41-55. Lanham, MD: Rowman & Littlefield.

Hill, Kevin A., and John E. Hughes. 1998. *Cyberpolitics: Citizen Activism in the Age of the Internet*. Lanham, MD: Rowman and Littlefield.

Johnson, Thomas J., Mahmoud A. M. Braima, and Jayanthi Sothirajah. In press. "Doing the Traditional Media Sidestep: Comparing the Effects of the Internet and Other Nontraditional Media with Traditional Media in the 1996 Presidential Election." *Journalism & Mass Communication Quarterly.*

Johnson, Thomas J., and Barbara K. Kaye. 1998. "A Vehicle for Engagement or a Haven for the Disaffected? Internet Use, Political Alienation, and Voter Participation." In *Engaging the Public: How Government and the Media Can Reinvigorate American Democracy*, ed. Thomas J. Johnson, Carol E. Hays and Scott P. Hays. Lanham, MD: Rowman & Littlefield.

Jones, Steven G, ed. 1995. *CyberSociety: Computer-Mediated Communication and Community*. Thousand Oaks, CA: Sage Publications.

Katz, Jon. 1997. "The Digital Citizen." *Wired,* December, 68-82, 274-75.

Kaye, Barbara K., and Norman J. Medoff. 1999. *The World Wide Web: A Mass Communication Perspective.* Mountain View: Mayfield Publishing Company.

Kern, Montague. 1997. "Social Capital and Citizen Interpretation of Political Ads, News, and Website Information in the 1996 Presidential Election." *American Behavioral Scientist* 40 (August): 1238-49. Kurtz, Howard. 1995. "Webs of Political Intrigue: Candidates, Media Looking for Internet Constituents." *The Washington Post,* 13 November, sec. B, p. 1, col. 4.

"Latest Intelliquest Survey Reports 62 Million American Adults Access Internet/Online Services." 5 February 1998. *Intelliquest homepage.* WWW: http://www.intelliquest.com/press

McChesney, Robert W. 1996. "The Internet and U.S. Communication Policy-Making in Historical and Critical Perspective." *Journal of Communication* 46 (Winter): 98-124.

"Navigating Fact and Fiction: How Journalists Are Using the Internet." 7 December 1996. GomdaWeb. WWW: http://www.-stanford.-edu/class/comm217/reliability/usage

Ornstein, Norman, and Amy Schenkenberg. 1996. "The Promises and Perils of Cyberdemocracy." *The American Enterprise* (March/April): 53-54.

Pavlik, John V. 1996. *New Media Technology: Cultural and Commercial Perspectives.* Boston: Allyn and Bacon.

Raney, Rebecca Fairley. 15 November 1998. "E-Mail Was Key in Successful Internet Campaign Strategies." *Cybertimes.* WWW: http://www.-nytimes.com/library/tech/98/11/cyber/articles/15campaign.html.

Rheingold, Howard. 1993. *The Virtual Community: Homesteading on the Electronic Frontier.* Reading, MA: Addison-Wesley.

"San Jose Mercury News: 50 Percent Consider Internet a Necessity." 7 December 1998. *NUA homepage.* WWW: http://www.nua.ie/surveys.

Schneider, Steven M. 1996. "Creating a Democratic Public Sphere Through Political Discussion: A Case Study of Abortion Conversation on the Internet." *Social Science Computer Review* 14 (Winter): 373-93.

Schudson, Michael. 1992. "The Limits of Teledemocracy." The *American Prospect* 11: 41-45.

Schwartz, Evan. 1995. "Looking for Community on the Internet." *National Civic Review* 84 (Winter): 37-41.

Schwartz, Edward A. 1996. *NetActivism: How Citizens Use the Internet.* Sebastopol, CA: Songline Studios, Inc.

Selnow, Gary W. 1998. *Electronic Whistle-stops: The Impact of the Internet on American Politics*. Westport, CN: Praeger.

"72 Million Online in the US in August 1998." 1998. *MediaMark Research, Inc*. WWW: http://www.mediamark.com.

Shenk, David. 1997. *Data Smog: Surviving the Information Glut*. New York: HarperCollins.

Slaton, Christa Daryl, and Theodore L. Becker. 1998. "Increasing the Quality and Quantity of Citizen Participation: New Technologies and New Techniques." In *Engaging the Public: How Government and the Media can Reinvigorate American Democracy*, ed. Thomas J. Johnson, Carol E. Hays, and Scott P. Hays, pp. 207-16. Lanham, MD: Rowman & Littlefield.

Smith, Ralph Lee. 1982. "The Birth of a Wired Nation." *Channels*, (April-May).

Snider, James H. 1994. "Democracy On-line." *The Futurist*, (September/October): 15-19.

Starobin, Paul. 1996. "On the Square." *National Journal*, 25 May, 1145-1149.

Tewksbury, David, Heather Cox, Matthew Nixon, and Shannon Proctor. 1997. "Political Uses of the Internet: A Study of Political Participation on the World Wide Web." (Paper presented at the annual meeting of the Midwest Association for Public Opinion Researchers, Chicago, November.)

Toffler, Alvin, and Heidi Toffler. 1995. *Creating a New Civilization: The Politics of the Third Wave*. Atlanta: Turner Publishing.

Van Dongen, Rachel. "2000 Election Will Be First of Digital Era, New Study Predicts." WWW: http://207.87.8.69/election/cyberpolitics.html.

Whillock, Rita Kirk. 1997. "Cyber-Politics: The Online Strategies of '96." *American Behavioral Scientist* 40 (August): 1208-25.

"Why Hoaxes Are a Concern." 10 December 1996. GomdaWeb . WWW: http://www.stanford.edu/class/comm217/reliability/hoaxes.

Chapter 13
The Incendiary Internet:
Hate Speech and the Public Good

Donna Bertazzoni
Janis Judson

In the film *You've Got Mail*, actress Meg Ryan describes with innocent delight and anticipation how she experiences that phrase when it chimes from her computer—the potential for mystery, new relationships, intellectual dialogue, and perhaps even a romance to brighten an otherwise tedious day. Yet the Tom Hanks–Meg Ryan comedy bears little resemblance to the reality some Internet users face when they discover an e-mail of hate and fear rather than an endearing expression from the heart.

In 1997, several University of California at Irvine students opened their e-mail to find this message (the typos are part of the original message):

> From: Mother Fucker (Hates _____)<mfucker@uci.edu>
> Subject: FUck You _____ Shit
> Hey Stupid fucker
> As you can see in the name, I hate _____ including you. If it weren't for _____ at UCI, it would be a much more popular campus. You are responsible for ALL the crimes that occur on campus. YOU are responsible for the campus being all dirty. YOU ARE RESPONSIBLE. That's why I want you and your stupidass comrades to get the fuck out of UCI. IF you don't I will hunt all of you down and Kill your stupid asses. Do you hear me? I personally will make it my life career to find and kill everyone of you personally. OK?????? That's how determined I am.
> Get the fuck out,
> MOther FUcker (_____ hater). (Ingall 1998, 136)

We have deleted the offending ethnic designation to give our readers an opportunity to understand the profoundly powerful message these students received. Before you move on with this chapter, fill in your own ethnic, racial or religious identity (e.g., Catholic, Latino, Jewish, African-American, Asian, Mormon, Islamic, Caucasian) in the blank spaces and read the e-mail once again. How do you personally experience the message this time? Do you consider it a prank, not to be taken seriously, or are you fearful, angry, or disgusted? Do you believe this message should be protected by the First Amendment, or should it be limited as it reinforces racist stereotypes? Whose

rights do you believe are more important, those of the individual to say what he or she believes, or those of the community's to ensure a society in which everyone's rights are guaranteed? These are questions to consider as you delve into the subject of this chapter—hate speech on the Internet.

Before we address the controversy about whether hate speech on the Internet can or should be limited, we first have to define it, discuss some of the ways constitutional scholars have viewed the First Amendment, and examine what court decisions govern the hate speech debate.

Hate speech denigrates someone because of an immutable characteristic of that person—such as his or her race, gender, or ethnicity. It may also be directed at individuals because of a changeable aspect such as their religion or their sexual orientation (although some people consider sexual orientation immutable). Many of the sites that can be classified as hate web sites, for example, denigrate Jews, Muslims, or other non-Christians. Congress legally defined a hate crime in the Violent Crime Control and Law Enforcement Act of 1994 as "a crime in which the defendant intentionally selects a victim, or in the case of a property crime, the property that is the object of the crime, because of the actual or perceived race, color, national origin, ethnicity, gender, disability, or sexual orientation of any person." In 1993, the Supreme Court upheld the constitutionality of Wisconsin's hate crimes statute which enhances the sentence of crimes in which the perpetrator "intentionally selects" the victim "because of" his or her characteristics (*Wisconsin v. Mitchell* 1993).

How do we analyze hate speech in a First Amendment context? Throughout most of the twentieth century, constitutional scholars have viewed free speech in the United States through the lens of the "marketplace of ideas." This metaphor was devised by Justice Oliver Wendell Holmes in his 1919 dissenting opinion in *Abrams v. United States*, and it has become a richly prevailing viewpoint among First Amendment scholars. In the case, Holmes argued that "the ultimate good desired is better reached by free trade in ideas—that the best test of truth is the power of the thought to get itself accepted in the competition of the market" (*Abrams v. United States* 1919). Hate speech is now being dramatically tested in the Internet marketplace.

In addition to the marketplace rationale for free speech, other reasons—such as self-governance, individual self-worth, discovery of the truth, and promotion of democratic ideals—have also been advanced as justifications for free speech (Fraleigh and Tuman 1997, 6). However the marketplace metaphor, where individuals are free to buy and sell products and ideas, seems most fitting for a capitalist culture in which the power of

an idea to be accepted leads to its success or failure.

Underlying this philosophy of the marketplace is a belief that truth will prevail. John Milton expressed that view in *Areopagitica* in 1644, when he wrote, "And though all the windes of doctrin were let loose to play upon the earth, so Truth be in the field, we do injuriously by licencing and prohibiting to misdoubt her strength. Let her and Falsehood grapple; who ever knew Truth put to the wors, in a free and open encounter" (Patrick 1968, 327). As Milton points out, to get to "truth," one must grapple with falsehood. John Stuart Mill echoed Milton's sentiment in his own seminal work, *On Liberty*, by writing "Ages are no more infallible than individuals; every age having held many opinions which subsequent ages have deemed not only false, but absurd" (Mill 1975, 19). The marketplace leaves it up to individuals to decide for themselves what they consider worthwhile, what they want to buy, and ultimately, what is the truth.

Recently, though, a school of thought called Critical Legal Studies has questioned the applicability of the marketplace metaphor for legal analysis. Scholars who subscribe to this philosophy believe the First Amendment should not stand as a barrier to limiting hate speech. They argue that hate speech is not truly "speech"; it is not designed to examine ideas or to advance a common good. Instead, hate speech is more like action. By hurling an invective against a member of a targeted minority, the speaker wants to stop speech. The goal is to deliver a rhetorical sucker punch that leaves the victim so devastated that he or she is unable to respond.

The incendiary e-mail sent at UC Irvine was actually addressed to Asian students. How do you imagine they felt after receiving that e-mail? Students who testified at the trial of the man who sent the e-mail gave evidence of feeling threatened. Sabina Lin, one of the recipients, said "getting the message shattered her sense of safety." "I started carrying Mace. I had two friends walk me to class and pick me up after class" (Ingall 1998, 147). Other students who testified said they grew afraid and refused to go out alone at night. "Others were simply angry and shrugged it off as a bad joke" (Hernandez 1998, n.p.).

Without a response from the victim, the marketplace metaphor cannot function properly. Those of us who are not affected directly by hate speech cannot decide which speech is "true" because we do not have access to all the wares in the marketplace. In addition to questioning the efficacy of the marketplace model, CLS advocates also challenge the First Amendment preoccupation with rights. As Mary Glendon suggests, our society suffers both from "the exaggerated absoluteness of American rights rhetoric" and

from "a near silence concerning responsibility" (1991, 45).

Hate speech traces its constitutional roots to the 1942 case *Chaplinsky v. New Hampshire*, in which the U.S. Supreme Court first defined "fighting words." Chaplinsky had been charged with a violation of the breach of public order for calling a local politician "a god-damned racketeer" and a "fascist" in front of an already unruly crowd. Chaplinsky was convicted, and on appeal, the Supreme Court ruled that the First Amendment did not guarantee protection for speakers using certain categories of words, including fighting words, and lewd, libelous, and obscene language.

Writing for the Court majority, Justice Murphy ruled that fighting words were words "that by their very utterance inflict injury or tend to incite an immediate breach of the peace" (*Chaplinsky v. New Hampshire* 1942). Murphy further argued that "utterances that have no essential part of any exposition of ideas" cannot expect protection from the First Amendment (*Chaplinsky v. New Hampshire* 1942). It was not clear in the opinion what type of injury the Court intended to prevent, but one can surmise the Court may have meant both physical and psychological harm. This interpretation may be helpful when we discuss the Critical Legal Studies perspective in more depth later.

In succeeding fighting words cases, the Court backed away from the *Chaplinsky* ruling. In *Terminiello v. Chicago* (1949), the Court invalidated the conviction of a Catholic priest who had verbally denigrated African-Americans and Jews at a veterans' rally. The Court ruled that although speech that provoked a breach of communal interest could still be restricted, the "injurious" element of the *Chaplinsky* doctrine could not be defended. The *Terminiello* case reasserted the view that free speech, even a provocative incendiary speech such as the one given by the Rev. Terminiello, was an essential ingredient of democracy.

In *Cohen v. California*, in 1971, the Court tackled a contemporary dispute over the nature of so-called fighting words. During the height of the Vietnam conflict, Cohen was arrested after wearing a jacket inscribed with the phrase "Fuck the Draft" into a Los Angeles courtroom. On appeal to the Supreme Court, the justices invalidated Cohen's "fighting words" conviction on the grounds that speech may have an emotive quality that also deserves constitutional protection. Speech has not only a cognitive element, but an emotional one as well (Fraleigh and Tuman 1997, 152). The Court also ruled that the recipients of Cohen's speech (the other people in the courtroom) could have shielded their eyes from the offending phrase.

A 1972 case, *Gooding v. Wilson*, involved Wilson's conviction for

calling a police officer "a white son of a bitch," and telling the officer "I'll kill you" after he had been arrested and handcuffed during a political protest. Wilson was convicted under a state statute that punished a person for using "opprobrious words or abusive language tending to cause a breach of the peace" (*Gooding v. Wilson* 1972). The Supreme Court invalidated the conviction and argued that the state statute was overbroad in proscribing certain types of speech. Justice Brennan also noted in the majority opinion that it was highly unlikely that the police officer would have been provoked by the threat. Brennan's reference to the "person addressed" by the fighting words suggested the Court was now beginning to pay attention not only to the speaker, but to the recipient of speech as well.

With the Court's decision in *R.A.V. v. City of St. Paul* in 1992, the justices made their most dramatic contemporary statement about fighting words. The doctrine was now being evaluated in the context of codes supported by state initiatives to put an end to hate-motivated crimes. The defendant in the *R.A.V.* case, a minor at the time of his arrest, had burned a cross inside the yard of an African-American family's residence. He was arrested for violating St. Paul's ordinance making it a crime for a person to use symbols that might "cause anger, alarm or resentment based on race, ethnicity, religion, or gender" (*R.A.V. v. City of St. Paul* 1992).

In a decision that shocked many observers, the Court invalidated *R.A.V.*'s conviction on the grounds that the ordinance was underinclusive, meaning it did not take into account all the possible classifications of people who might be offended by incidents of hate speech. The ordinance, for example, did not prohibit incendiary speech that might "arouse someone to anger" based on other characteristics. Justice Scalia wrote, "Those who wish to use fighting words in connection with other ideas to express hostility, for example, on the basis of political affiliation, union membership, or homosexuality are not covered. The First Amendment does not permit St. Paul to impose special prohibitions on those speakers who express views on disfavored subjects" (1992). Consequently, since the statute did not eliminate *all* types of hateful language, *no* hateful speech could be censored. Justice Scalia went on to argue, as the Court had done in Cohen, that such hateful speech might also have true communicative value.

For all intents and purposes, the fighting words classification that had been used to modulate the impact of hate speech was now a legal doctrine of the past. It is clear from these cases the Court has created a paradox regarding fighting words and hate speech. The Court has argued theoretically that there is a fighting words "categorical exception" to the First Amend-

ment. But as observers have pointed out, the justices have "consistently [failed] to allow any state or local attempt at bringing this doctrine to legislation" (Fraleigh and Tuman 1997, 167).

A final Supreme Court case requiring consideration in the discussion of banning hate speech from the Internet is *Reno v. ACLU*, decided in 1997. That case arose after Congress passed the *Communications Decency Act* (CDA) as a part of the *Telecommunications Act of 1996*. Congress passed the *CDA* because of concerns about the easy availability of pornography on the Internet. The *CDA* was designed to limit access to "indecent" material by minors, but it was challenged because it had the potential effect of limiting adult access to protected speech. In the decision, Justice Stevens, writing for the majority, struck down the *CDA*, saying it "threatens to torch a large segment of the Internet community." He also recognized that the Internet deserved full First Amendment protection.

> This dynamic multifaceted category of communication includes not only traditional print and news services, but also audio, video and still images, as well as interactive, real time dialogue. Through the use of chat rooms, any person with a phone line can become a town crier with a voice that resonates farther than it could from any soapbox. Through the use of Web pages, mail exploders, and newsgroups, the same individual can become a pamphleteer. (*Reno v. ACLU* 1997)

Yet in all of the discussions of the CDA and the Reno case, there has been very little commentary on what effect hate speech could have on children and society. We find it interesting that the focus of the CDA was pornography, while hate speech was virtually ignored. We believe a minor's access to hate speech may be more damaging to a civil society than his or her access to pornographic images. And minors are accessing these sites. Many signers of the Knights of the White Kamellia, Realm of Texas' guestbook, for example, include their age in their message. A typical posting reads: " i'm only 15 now but when i get older i plan to join the Klan To support the master race. ~~WHITE Power~~WHITE PRIDE~~ (Knights of the White Kamellia 1997, n. p.). The film *American History X* illustrates just how intoxicating hate speech and action can be for receptive adolescents.

Matt Hale, creator of the web site for the World Church of the Creator, a decidedly anti-Semitic organization, has set up pages on the site specifically for children (Hale *WCOTC* 1999, n.p.). These pages include on-line crossword puzzles, a list of the World Church's Sixteen Commandments, and coloring pages "all serving as a primer on the white preservationist movement." In response to criticism of his site, Hale says, "Why should we

not? Sesame Street goes after young kids with their agenda about race and tolerance. I see no reason why we shouldn't bring a message like this" (McCafferty 1999, 6–7).

Can we properly analyze the problem of Internet hate speech in the absence of jurisprudential leadership from the Supreme Court? How, for example, would the Court review the hate speech e-mail that its author sent to Asian students at UC Irvine? Using its own precedents, would it reiterate that fighting words are not afforded First Amendment protection (*Chaplinsky*); that there is no proof of actually injury (*Terminiello*); that the emotive quality of the e-mail is legitimate (*Cohen*)? Does it further mean that the communicative, although heinous, value of the hate mail necessitates its protection (*R.A.V.*); and finally, that fighting words can't be banned because Internet speech is protected (*Reno*)? How has the Court arrived at such circular legal reasoning—theoretically permitting a doctrine to limit language but practically allowing that speech to flourish? The Supreme Court probably would not have ruled against Machado if the case had been appealed. It might, however, as it did in the *R.A.V.* case, suggest that other statutes be used to limit such virulent messages. As Justice Scalia pointed out in *R.A.V.*, St. Paul already had an ordinance that could be used to prosecute the young man, "without adding the First Amendment to the fire" (1992). Consequently, *R.A.V.* was later convicted of criminal trespass.

Few Internet hate speech cases have actually been prosecuted. In 1995, a University of Michigan student, Jake Baker, was charged with transmitting a threat to kidnap or injure a person after posting a fantasy about raping and killing a named female student to an Internet usegroup. However Baker's case was dismissed by U.S. District Judge Avern Cohn, who ruled that the story was protected by the First Amendment. In his ruling, Cohn called the posting, "only a rather savage and tasteless piece of fiction" (Yuhn 1995, n.p.) and wrote, "musings, considerations of what it would be like to kidnap or injure someone, or desires to kidnap or injure someone" do not violate the constitution unless some intent to commit the acts is expressed" (Yuhn 1995, n.p.). A federal appeals court later upheld the dismissal of the charges.

Unlike Jake Baker, Richard Machado was convicted. Machado has been billed as "the first person convicted of a hate crime on the Internet (Hernandez 1998, n.p.). But the law he was charged under did not specifically address the Internet. Ironically, he was charged under a 1960s civil rights statute that was aimed at segregationists who tried to prevent African-American students from attending public schools in the South. The law criminalized the behavior of those who "by force or threat of force attempts

to injure, intimidate or interfere with . . .any person because of his race, color or national origin and because he is or has been enrolling in or attending any public school or public college" (Ingall 1998, 138). Prosecutors were able to charge Machado because he included a threat of violence in his e-mail. After a first jury was unable to reach a verdict in the case, Machado was tried again and found guilty. However he had already spent more time in jail than the recommended sentence for the crime, so he was released. Instead, the judge sentenced him to an additional year of supervised probation that was to include psychiatric counseling and training in racial sensitivity and tolerance (ZDNet 1998, n.p.).

E-mail and usegroups are just two of the places where hate speech can be found on the Internet. The World Wide Web has become an especially fertile area for hate groups to spread their messages. The Anti-Defamation League (ADL), in its 1997 publication *High Tech Hate: Extremist Use of the Internet* contends that these groups are using the Internet as a recruitment tool as well as a propaganda tool. Unlike e-mail, these sites have to be accessed deliberately. If you want to find out about the Ku Klux Klan or another white supremacist group, you deliberately search for it. E-mail is more frightening because it is unsolicited, and it can be anonymous. The ADL publication cites a number of examples in which targeted individuals received hateful messages, but the perpetrators were never found or prosecuted (ADL 1997).

As you recall from the free speech metaphor discussed earlier, the marketplace of ideas offers valuable products as well as questionable ones. Depending on your point of view, hate speech is either worthless or valuable. According to Professor Matsuda, "human experience teaches us that certain ideas are wrong. Presumably we would all agree that slavery, the Holocaust, and apartheid are evil. On issues such as these . . .opposing viewpoints do not need a hearing in the marketplace of ideas" (Fraleigh and Tuman 1997, 187). For groups that consider hate a valuable product, the Internet has given them a new outlet to propagate their message. Don Black, a white supremacist and former Ku Klux Klan member, was one of the first to recognize the power and scope of the Internet. He started the Stormfront bulletin board in 1990 with three subscribers. He opened it to the public in 1994, and he started the Stormfront web site in 1995 (Black 1999, n.p.).

The Stormfront site opens with a Celtic Cross surrounded by the words White Pride World Wide, followed by an explanation of its purpose. "Stormfront is a resource for those courageous men and women fighting to preserve their White Western culture, ideals, and freedom of speech and

association—a forum for planning strategies and forming political and social groups to ensure victory" (Black, *Stormfront* 1999, n.p.). Stormfront compiles sites that advocate white supremacy. Black writes that when he first started Stormfront, he could find only three sites worth linking to. Now, he runs an extensive website that offers several pages of links to such categories as White Rights and Racially Conscious Conservatism, Eugenics, the Ku Klux Klan, Skinheads, White Power Music, and even "The Other Side." In his description of "The Other Side," Black writes, "these are sites opposing our use of the 'Net to promote our point of view. Some openly support censorship (though they don't call it that) while others claim that they only want to 'expose' us for 'what we really are'" (Black, *Stormfront* 1999, n.p.). In that section, he links to such organizations as Hatewatch, Nizkor, the Simon Wiesenthal Center, The Anti-Defamation League, and the Jewish Defense Organization.

Stormfront also offers white singles a chance to meet, a chat group, a list of recent news articles that both advocate separation and criticize white supremacist groups (to give advocates a chance to read what the mainstream media have to say about them), and a link to his own homepage (Black, *Stormfront* 1999, n.p.). Black does not specifically advocate any of the groups he offers links to, just the message that they post.

Black is particularly media savvy. He has been willing to be interviewed by ABC's Ted Koppel in an appearance on *Nightline*; he has been quoted on ABC News, CBS News, in the *Birmingham News,* and newspapers in Florida, where he resides (Black, *Homepage* 1999, n.p.). He recognizes that many people are unhappy about the information that he gathers, but he argues that he has a First Amendment right to disseminate his point of view. He has started a Stormfront Legal Defense Fund "to pay legal expenses for selected First Amendment-related cases" and he uses his web site to solicit contributions to the fund. In his appeal, he compares the United States, with its "strong First Amendment tradition guaranteeing freedom of speech," with such countries as Germany where, he says, "a website operator was arrested for merely including a link to Stormfront on his page" (Black, *Stormfront* 1999, n.p.).

Black has a point. Much as we may abhor his web site, the marketplace of ideas allows unpopular material to be heard and it relies on "the other side," as Black calls it, to counter his message. Countries without a First Amendment guarantee of free speech have limited what information their citizens can read and write on the Internet. Human Rights Watch's World Report 1999 on Freedom of Expression on the Internet is replete with

examples.

> —Saudi Arabia expected to get local access to the Internet by the end of
> 1998. "In anticipation of the new service, Council of Ministers Decision 163
> required parties using the Internet to refrain from 'any activities violating the
> social, cultural, political, media, economic and religious values of the Kingdom'"
> (Human Rights 1999).
> —In July 1998, "China arrested and charged a software engineer with
> subversion for supplying e-mail addresses to a U.S.-based pro-democracy
> magazine and the Web site known as 'Big Reference'" (Human Rights 1999).
> —In June 1998, "a Turkish court sentenced a teenager, Emre Ersoz, to ten
> months suspended jail time for making comments about the police while
> participating in a daily on-line forum . . . He reportedly criticized rough police
> treatment of a group of blind people who were protesting against potholes in
> pavement in the nation's capital, Ankara" (Human Rights 1999).
> —Restrictions on Internet access were not confined to countries with a
> shaky history of democracy. "A Bavarian court convicted Felix Somm, the former
> head of the German division of the U.S. on-line provider Compuserve, in May
> 1998, for spreading child pornography and other illegal material by providing
> access to such information on the Internet" (Human Rights 1999).

The issue of hate speech was not mentioned in the Human Rights Watch report. However, an article about the report, which appeared in the *CyberLaw Journal*, pointed out that "countries with more democratic traditions, such as the United States and members of the European Union, are considering policies that, in an effort to control problems like racism and pornography, could end up restricting legitimate speech on the global network" (Mendels 1998, n.p.). The article stated that the Canadian government may extend its ban on hate speech to the Internet, and that the European Union "is examining proposals that would require Internet service providers to block 'harmful speech' like sites promoting racism, or hold them accountable by law when they make such information available" (Mendels 1998, n.p.). Do the United States and other democratic nations want to be grouped with China, Russia, Malaysia, and Saudi Arabia as countries that block access to information on the World Wide Web? There may be a legitimate concern about children's access to such information, but there are means far short of censorship to reach that goal.

It is not just white supremacists who offer links to hate groups. The Hate Directory, for example, not only links to web sites that denigrate women, minorities, gays, and religious groups, it also offers links to anti-hate sites such as Hate Watch, the Southern Poverty Law Center, and the Anti-Defamation League. Besides web sites, it offers links to bulletin boards and chat rooms that focus on hate. This site, compiled by Raymond Franklin,

disavows any endorsement of the links it offers. Instead, Franklin calls his site a historical reference. In an e-mail interview, he wrote that the site was developed as part of a law enforcement seminar on hate crimes he organized in Maryland in 1996. Franklin has continued to present information about the proliferation of hate sites on the Internet to law enforcement and human relations groups. He has maintained the site "to support an understanding of how new technology is being exploited by organizations of this kind" (Franklin 1999, n.p.).

By offering both hate and anti-hate links, Franklin fulfills the goals of the marketplace of ideas. Peruse both; see which type you prefer; decide which truth you want to believe. But he believes there's another advantage to allowing these groups to freely spread their messages. ". . . [T]he Internet brings these groups out of the shadows, informs us of their intentions, allows us to confront their views. It is the freedom of expression that provides the best defense against these groups; it is the solution and not the problem" (Franklin 1999, n.p.).

The Hate Directory offers in one easy-to-find package a compilation of what many consider the worst of the web. Are these sites truly hurtful, hateful, and horrifying? Check it out at http://www.-bcpl.net/-~rfrankli/hatedir.htm, examine some of the links, and decide for yourself. While at the directory, you will notice that racist and virulent speech is not limited to white supremacists. Other groups and web sites that are listed include Louis Farrakhan's Nation of Islam, the Black Panthers Coloring Book, "God Hates Fags," and a number of Christian Identity Churches.

This explosion of hate speech on the Internet leaves some hoping there is an equally powerful counter-argument to unfettered free speech. For many, the arguments advanced by Critical Legal Studies (CLS) scholars resonate. First and foremost, CLS scholars argue that hate speech deserves little, if any, constitutional protection. Assaultive speech usually targets outsiders—the traditionally disenfranchised such as women and people of color. In their book *Words That Wound*, Professors Charles Lawrence and Mari Matsuda write about the ways in which such speech causes severe and irreparable harm. Hate speech, based on a person's immutable characteristics (things they cannot change) causes self-hatred and diminished self-esteem for the victim. "Victims of vicious hate propaganda experience physiological symptoms and emotional distress ranging from fear in the gut to rapid pulse rate and difficulty in breathing, nightmares, post-traumatic stress disorder, hypertension, psychosis, and suicide. Patricia Williams has called the blow of racist messages 'spirit murder' in recognition of the

psychic destruction victims experience" (Matsuda 1993, 24). This is an extraordinary price, CLS scholars argue, to pay for society's tolerance of virulent speech. Hate speech should not be evaluated according to sterile legal formalism or constitutional doctrine; rather it must be examined in the context of human experience and emotion. Columbia University Law Professor Patricia J. Williams describes the pain of being on the receiving end of a kind of hate diatribe in her memoirs, *the Alchemy of Race and Rights: diary of a law professor* (sic). After a difficult semester with her students Williams writes,

> . . . my personal concern is with identifying the specifics of my pain. What causes it, what sustains it, what interferes with my ability to be most fully and most productively myself. My unhappiness, whether alone or among many, makes me inefficient. It makes me hide myself (Williams 1991, 94)

> In the margins of their notebooks they deface me: to them I look like a stereotype of a black person, not an academic. They see my brown face and they draw lines enlarging the lips and coloring in the black frizzy hair. They add red eyes, to give a demonic look. . . . In the margins of their notebooks, I am obliterated. (Williams 1991, 115)

Although Williams is not writing about an Internet hate speech encounter, her eloquent description is at the heart of the Critical Legal Studies critique of free speech. Language does cause harm, perhaps not in the way Justice Murphy meant in his *Chaplinsky* opinion, but in ways many legal analysts could not have predicted. CLS scholars further contend that it is easy to lurk behind such constitutional defenses of free speech as the marketplace model and wholly forget the impact that language has on self and identity. Although the injury to the recipient may be silent and invisible, it is no less abhorrent. And even with the possibility of recovering damages in a tort action for severe emotional distress, the impact of injury from hate speech can be profound and indelible. Finally, CLS writers are concerned with "the paradoxical pitting of the First Amendment against speaking about other forms of injury" and how this analysis results in the "specter of legal censorship blocking further discussion of moral censure" (Williams 1991, 112). Critical legal analysts such as Matsuda and Williams want desperately to add a moral texture to the complex discussion of hate speech. Their analysis should prove informative as society tackles the problem of hate speech and its ability to co-exist alongside harmony and civic community.

What does hate on the Internet reveal to us about our prevailing national character and values? To many it reveals a culture in decline, a nation that

has lost respect for difference and diversity, or even worse, a nation never able to acknowledge the beauty or attribute of difference. To others, Internet hate messages and sites are just isolated examples of rampant individualism. To some, however, they mirror the very ugliest our society has to offer. As we put the final touches on this essay, a Texas court has convicted a white supremacist "for one of the grisliest racial crimes in the United States since the civil rights era." John William King's brutal murder of James Byrd Jr. prompted NAACP President Kweisi Mfume to say "this case clearly shouts across the world for the urgent need of this Congress to move quickly to strengthen and to pass anti-hate legislation" (Associated Press 1999, A-3). No doubt King's viciousness may have found a fruitful haven in some of the Internet hate sites described in this paper. In any case, hate speech may prove to have long-term effects by reinforcing prejudice and inferiority and contributing to a social pattern of dominance and inequality (Greenawalt 1995). It may also prove to weaken the already shaky fabric of a national community. By national community, we refer to the important notions of respect, trust, civic virtue, and the common or public good.

Ironically, in a recent discussion of web chat rooms, a young entrepreneur spoke of the new "communities" (including hate communities) being created everyday in our cyberspace network. Community, solidarity, and commonality are terms used most frequently to describe the new online experiences. Feelings of isolationism and powerlessness diminish in the camaraderie of Internet relationships. Thus, web communities such as Stormfront and the Knights of the White Kamellia, defined and strengthened by their bond of hate, provide a sense of fellowship and identity for those threatened by our growing ethnic and cultural diversity. These sites allow the community of racists to feel safe in an insular and protected sort of way, even if it is at the expense of their victims. Is this the type of community that Alexis de Tocqueville saw in *Democracy in America* or the type of intimate loving community that Robert Bellah et al. envisioned in *Habits of the Heart*—a contemporary analysis of Tocqueville's communitarianism? Will our definition of the traditional community, as the common good, be so altered that it will now require a transformation of its historical meaning? Consider these questions as you reflect on the reality and presence of Internet hate communities.

Tocqueville actually provides us with another important framework for the analysis of hate speech on the Internet. An astute historian of cultural mores and values, Tocqueville advanced a central theme in the study of our American character—the inherent tension between the conflict of "fierce

individualism" and the urgent need for community (Bellah 1985). It is a debate that posits individual autonomy and the primacy of rights against social cohesiveness and a vision of the collective good.

In January 1999, hate on the Internet gave us another example of this tension between individualism and community. A court in Oregon fined the developers of *The Nuremberg Files*, a web site devoted to collecting and maintaining dossiers on physicians who perform abortions. This coalition of concerned citizens, as the site developers describe themselves, solicits and records physicians' addresses, pictures, license plate numbers, and other related information for visitor dissemination. Murdered abortion providers were listed on the site with a line through their name; injured providers were listed in gray (Horsley, *The Nuremberg Files* 1999). According to reports in *The Washington Post* in February 1999, during the trial, doctors testified that they lived in fear: They disguised themselves when they went out; they drove different routes to work; and they instructed their children to hide if they heard gunshots. After the decision was reached, attorneys for the doctors said in interviews on national television that they planned to seek an injunction against the site. However the Associated Press reported that before they were able to request the injunction, the Internet Service Provider that hosted *The Nuremberg Files* pulled it off the World Wide Web. Can we really expect to reconcile the competing demands of the individual freedom to construct this heinous site, with the opposing need of the community to protect itself and reside in harmony? Can *The Nuremberg Files*, a testimony to the very limits of free speech, co-exist with the simultaneous reality of young children hiding in terror for fear of being gunned down along with their parents? Is the Nuremberg Internet controversy an example of free speech violated, or of violence prevented?

The Internet will continue to grow as a viable resource for information and progress. Yet, as we have argued, it is also a place where intolerance, hatred, and venom are available for those who seek it out and even for those who do not willingly wish to broach its messages. In the final analysis, we can only hope that the excesses of Internet hate will be checked by the national community's greater desire to bank the flames of dissension and acrimony with a moral discourse truly deserving of the best in our national character.

References

Abrams v. United States, 250 U.S. 616 (1919).

ACLU v. Reno, 117 S.Ct. 2329 (1997).

American History X. 1999. Screenplay by David McKenna. Dir. Tony Kaye. Perf. Edward Norton, Avery Brooks, Edward Furlong, Elliot Gould, and Stacy Keach. New Line Cinema.

Anti-Defamation League. 1998. *High Tech Hate: Extremist Use of the Internet.* New York: Author.

Bellah, Robert, Richard Madsen, William M. Sullivan, Ann Swidler, Steven M. Tipton. 1985. *Habits of the Heart Individualism and Commitment in American Life.* New York: Harper & Row.

Black, Don. 1999. "Don Black's Homepage." <http://www.stormfront.org/-dblack>. January.

————. 1999. "Stormfront." <http://www.stormfront.org>. January.

Chaplinsky v. New Hampshire, 315 US 568 (1942).

Cohen v. California, 493 US 13 (1971).

Fraleigh, Douglas, and Joseph S. Tuman. 1997. *Freedom of Speech in the Marketplace of Ideas.* New York: St. Martin's Press.

Franklin, Ray. 1999. <franklra@nsl.dpscs.state.md.us> "*Hate Directory* discussion." Private e-mail message to Donna Bertazzoni. 17 February.

Glendon, Mary Ann. 1991. *Rights Talk,* 45. New York: Free Press.

Gooding v. Wilson, 405 US 518 (1972).

Greenawalt, Kent. 1995. *Fighting Words: Individuals, Communities, and Liberties of Speech.* Princeton: Princeton University Press.

Hale, Matt. 1999. "World Church of the Creator Children's Page." <http://www.wcotc.com/kids> April.

Hate Crimes Prevention Center of the Leadership Conference Education Fund of civilrights.org. 1999. "Cause for Concern: Hate Crimes in America." <http://www.civilrights.org/lcef/hcpc/concern.html>. January.

Hernandez, Greg. 1998. "Man Convicted of E-Mail Hate Crime Released." *Los Angeles Times,* 14 February. <http://www.elibrary.com/s/edumark-/getdoc...docid=1322458@library> March 1998.

Horsley, Neil. 1999. "The Nuremberg Files." <http://www.christiangallery.-com/atrocity>. February.

Human Rights Watch World Report. 1999. "Special Issues and Campaigns: Freedom of Expression on the Internet." http://www.hwr.org/-

hwr/worldreport99/special/internet.html>.January.

Ingall, Marjorie. 1998. "i will hunt all of you down & kill you" *Mademoiselle*, September, 136–47.

"Jury to Decide Sentence/Racist Guilty in Dragging Death." 1999. *The Frederick Post,* 24 February, A-3.

Knights of the White Kamellia, Realm of Texas. 1997. "Guestbook." <http://members.aol.com/ralmoftex>. November.

Matsuda, Mari J. 1993. "Public Response to Racist Speech: Considering the Victim's Story." In *Words That Wound: Critical Race Theory, Assaultive Speech and the First Amendment*, edited by Mari J. Matsuda, Charles R. Lawrence III, Richard Delgado, Kimberle W. Crenshaw. Boulder, CO: Westview Press. (First published in *Michigan Law Review* 87 [August 1989)].

Matsuda, Mari J., Charles R. Lawrence III, Richard Delgado, Kimberle W. Crenshaw. 1993. *Words That Wound: Critical Race Theory, Assaultive Speech and the First Amendment.* Boulder, CO: Westview Press.

Mendels, Pamela. 1998. "Governments Expand Restrictions on Internet, Report Says." *Cyberlaw Journal* <www.nytimes.com/library/-tech/98/12/cyberlaw/18law.html>. February 1999.

McCafferty, Dennis. 1999. "www.hate.com comes to your home." *USA Weekend,* 26–28 March, 6–7.

Mill, John Stuart. 1975. *On Liberty: Annotated Text Sources and Background Criticism.* Ed. David Spitz, 19. New York: W. W. Norton.

Patrick, J. Max. 1968. *The Prose of John Milton.* New York: New York University Press.

R.A.V. v. City of St. Paul, 505 US 377 (1992).

Terminiello v. Chicago, 337 US 1 (1949).

Williams, Patricia. 1991. *The Alchemy of Race and Rights: Diary of a Law Professor.* Cambridge: Harvard University Press.

Wisconsin v. Mitchell, 113 S.Ct. 2194 (1993).

You've Got Mail. 1998. Screenplay by Nora Ephron and Delia Ephron. Dir. Nora Ephron. Perf. Tom Hanks, Meg Ryan, Jean Stapleton, Greg Kinnear. Warner Brothers.

Yuhn, Amy. 1995. "Judge Dismisses Charges in Internet Fantasy Case." Associated Press Report, 23 June 1995.

ZDNet/UK. 1998. "US Report: Hate E-mailer Sentenced to a Year." <wysiwyg://5/http://www.zdnet.co.uk/news/news1/ns-4324.html> 5 May.

Chapter 14
Going Online:
The Future of the News Media

John E. Hughes

Quite often college professors require students to read a daily newspaper or a weekly magazine. Many professors seem to feel that students today are more likely to read *Sports Illustrated* or *Cosmopolitan* than *Newsweek*, or to read the sports section instead of the front page. Perhaps even worse, a lot of faculty fear that students are not *reading* anything and are instead watching *Friends*, *Dawson's Creek*, or the newest hit twenty-something dramas and sitcoms. In fact, the concerns of these faculty have been proven true by the dwindling numbers of regular newspaper readers and the sinking ratings of the network news shows. Yet, with more than 4900 newspapers online (www.newslink.org), there appears to be a trend towards more news being provided and, hopefully, consumed. Does this mean that people are abandoning traditional news sources such as television news and newspapers in favor of online news sources? Or is the growth of Internet news just a result of traditional news seekers expanding their range of sources? In essence we wonder whether Internet news reaches a new audience or attracts those who already follow the news.

This chapters tries to address this issue. The chapter is divided into two main parts, each focusing on a different aspect of new consumption. The first part examines who gets the news, whether by reading newspapers, watching television news programs, or going online. The second part discusses the competition between traditional news sources such as newspapers and television news programs and online news outlets. We try to understand whether the increasing availability of online news poses a threat to traditional forms of news delivery.

Data and Methods

Before we find out who uses the news, we should say a bit about our data and methodology. The data for this chapter come from a survey

provided by the Pew Research Center for the People and the Press (1998).[1] They surveyed 3,002 adults from April 24th to May 11th of 1998. Clearly the results may be somewhat dated but the survey still provides an excellent sample of Internet-news-related questions. More details about the survey and its questions are provided in the appendix.

The majority of the methods used to analyze these data are purposefully simple. In most cases we present the percentage of people who fall into particular categories. When comparing percentages across categories we will note whether or not the differences are statistically significant. In a few cases we also correlate two behaviors. A correlation means that these two behavior move together—a person who does one thing is more or less likely to do other. For example, we will want to know if a person who goes online for news is more or less likely to read a newspaper. Again, we will note whenever the findings are statistically significant.

Statistical significance is sometimes a confusing concept. All it really means is that we have probably found a true difference or relationship between two groups. Non-significance means that whatever the difference appears to be, it is probably due to random error and so it is not real. For example, if 55% of brown eyed people go online for news but only 50% of blue eyed people do, have we found a *real* difference? That is answered by calculating the statistical significance which tells us if the differences are real or are the artifact of error. The simple shorthand is: *if a relationship is significant there is a real difference and if it is non-significant then there is no real difference.*

Who Gets the News?

Our first step is try and understand who uses the news. News seeking, sometimes called surveillance, is an activity regularly engaged in by only a (depressingly small) portion of the public. What we want to know is whether the characteristics of online news users are the same as those of traditional news consumers. If they are, then it would suggest that online news is not attracting new consumers but instead appealing to the people who already use traditional news sources.

We start with an overview of news consumption–a basic demographic profile of news consumers. "Demographics" refers to personal characteristics, as opposed to attitudes or beliefs. For example, age is a demographic

characteristic while favorite news anchor is an attitude. Three demographic characteristics commonly used to understand news consumption are age, education, and gender (Barwise and Ehrenberg 1988; Davis 1996; Price and Zaller 1993; Robinson and Levy 1996). These characteristics are also related to the use of the Internet as a news gathering tool (Davis and Owen 1998). Income is often included as well but since it is closely tied to education (and the chart looks the same) to save space only education is presented here. How are these characteristics related to the use of different types of news? What groups are the most or least likely to follow the news? Figures 1 through 3 show the percentage of people in each group that claim to regularly read the newspaper, watch television news, or go online for news related information. In the case of using online news, only people with access to a computer are included in the analysis.[2]

In general, we expect that as people age they consume more news (Bogart 1992; Chaffee and Frank 1996; Robinson and Levy 1996). This finding should not be surprising as people who are older typically have more time to devote to surveillance, a greater interest in the news, and they are more familiar with the topics. Figure 1 proves this point for both television news and newspaper reading. As age rises, the percentage of people watching network news or reading a daily paper increases. Of course, most people claim to follow the news regularly, even when they don't, but that claim is highest amongst those over the age of 65. By contrast, online news seeking is inversely related to age. Younger people are more likely to go online for news while older people are less likely. This pattern is especially striking given that *we included only people who have access to a computer.* This is not just a matter of older people being less likely to have a computer. Even among computer users younger people are more likely to get news online. In fact, the 18-24 age group is about as likely to get news online as they are to get it from television. For this age group Internet news use may be expanding the number of news consumers . If based on no other evidence than Figure 1, we can expect to see online news grow in popularity as older generations are replaced by younger ones.

Figure 2 depicts the relationship between education and news surveillance. As with age, education should be positively related to news seeking (Davis 1996; Robinson and Levy 1996). People with more education are typically more interested in not only politics but general news subjects, are more socially involved, and are better able to follow and understand current events. The results, however, are somewhat mixed. In the case of television, the use of the news has a relatively small but significant relationship to edu-

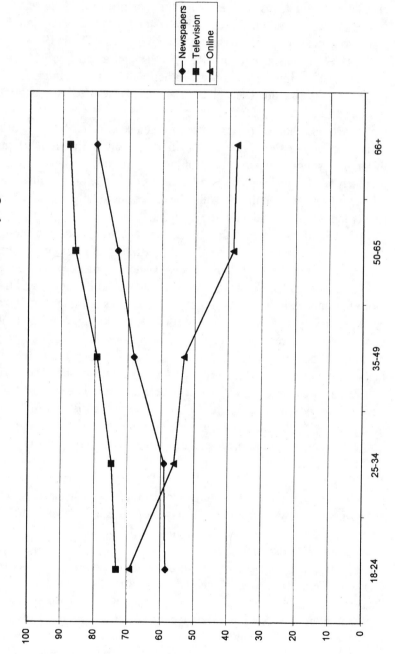

Figure 1.
Percentage of People Using News Sources by Age

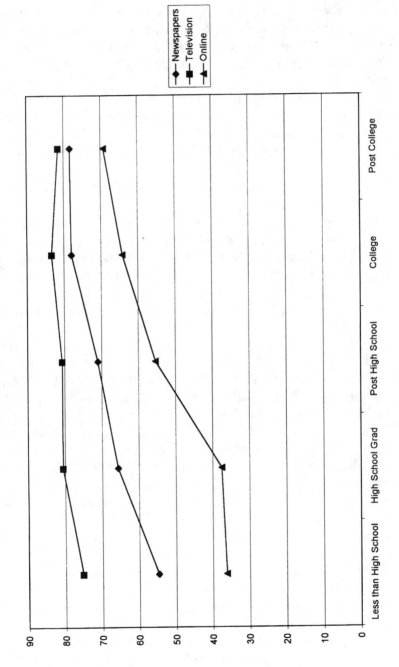

Figure 2.
Percentage of People Using News Sources by Education

cation. The percentage of people who watch nightly news shows is only slightly greater at the high end of the educational spectrum.[3] For newspaper reading the relationship is much stronger. From a low of 55% to a high of 78%, higher education leads to considerably higher rates of newspaper readership.

Does the same hold true for online news seeking? With a slight dip for high school graduates, yes. In general, education is positively related to online news seeking. The trend is especially pronounced for education past high school. College students and those with post college experience are the most likely to go online for news. The one break in the pattern, for high school graduates, is caused by surveying 18-year-olds who are currently in high school. These students currently have less than a high school education but they are more likely to go online. Moreover, they are clearly different from adults who never completed high school which is what this category was intended to measure. Thus, when 18-year-olds are removed from the analysis, 36% of those with less than a high school education go online for news as compared to 38% for those with a high school degree. In short, education increases the use of online news sources, especially at higher levels of education.

Figure 3 examines the connection between gender and media use. Past research has found that women and men sometimes use media sources differently. That is, they seek different gratifications from the media. Our interest, however, is whether women and men choose different types of media. For example, Davis and Owen (1988) found that men were more attracted to talk radio while women were more interested in day-time talk shows. Our question is whether such gender differences exist for news surveillance in general and online news in particular. As Figure 3 shows, men and women are equally likely to read newspapers and watch television news. But that is not true for online news. About 60% of men go online for news as compared to 47% of women, a difference that is statistically significant.[4] The reasons for this are unknown for now, though it may be that men have embraced recreational computer uses, i.e. video games, more quickly. This in turn has increased computer use among men, especially for pleasure purposes. In addition, some of the difference may be attributable to a slightly higher political interest among men (Davis and Owen 1998) though this would be a small effect.[5]

Several times now we have referred to interest as a reason for getting the news. Interest is an attitudinal variable that tries to measure a person's desire to learn about certain topics. In our case we are concerned with education

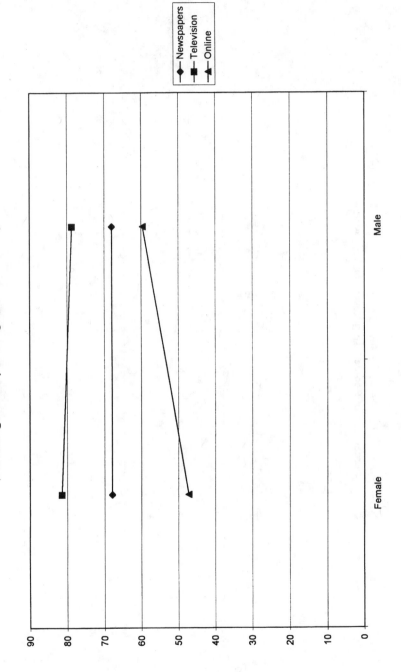

Figure 3.
Percentage of People Using News Sources by Gender

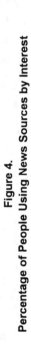

Figure 4.
Percentage of People Using News Sources by Interest

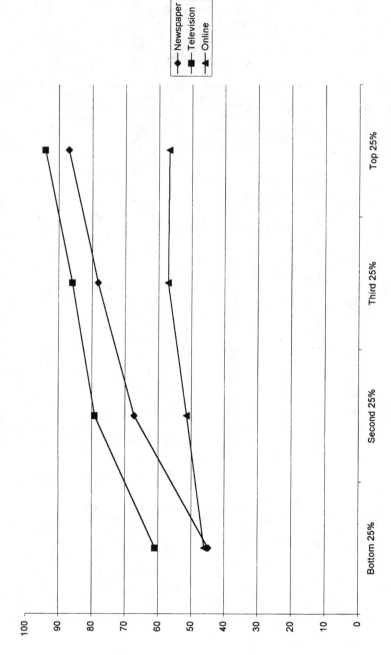

general news interest–how strongly does a person feel about following the news and how much do they wish to know about it? Clearly such a variable should be related to news seeking. But how strong is the relationship and is it the same for each type of news source? To answer these questions we divided the sample into four groups based upon their level of interest in politics. We would expect the least interested to be less likely to follow the news and vice versa. Figure 4 shows the results of our analysis. For television news and newspaper reading the pattern is exactly as expected and is statistically significant. The greater a person's level of interest, the more likely he or she is to use these two sources. For online news seeking the pattern holds but it is somewhat less pronounced. Amongst the least interested, about 46% go online for news as compared to 57% for the most interested – about an 11% difference that is statistically significant. By contrast, the difference between the top and bottom groups is 33% for television news watching and for newspaper reading it is 42%. So while interest is clearly related to news seeking, the relationship is much weaker for online news.

Taken together, what can we learn from these four figures? First, we see that younger people and men appear to be either more comfortable with or drawn to online news sources. This may indicate a new audience being drawn to the news, especially for younger news consumers. It also means that we can reasonably expect that as today's youth age the overall comfort level will increase and online news seeking will increase as well. In the case of gender, if the differences between the sexes in online news use are caused by things such as comfort or experience, then we can expect this difference to disappear over time as well. If the difference is caused by different levels of interest then we expect men to continue to make more use of this new medium. However, since women and men differ only for online news seeking, it is probably not interest related. If interest were the culprit differences in new use would show up for newspapers and television news as well. The more likely cause is gender differences in the use of computers.

Our second finding is that online news seeking mirrors traditional news seeking with regard to education and interest. The same groups who read the paper and watch the nightly news are also going online for news. Online news is, for most people, just another source of information. Below we try to find out if this new source of information threatens the established traditional media.

Of course, we can still wonder which of the four characteristics have the most effect on someone's likelihood of going online for news. To answer this

question we test the effect of age, education, gender, and interest in a combined logistic regression model. In this way we control for, or take into account, the effect of each variable. In other words, we are able to isolate the effect of one variable while holding constant each of the other variables. The results tell us how strongly each variable is related to online news use.

While all four variables are statistically significant, some are more important than others. In particular, age has the biggest effect on one's likelihood of going online while education is a close second. Interest has the least effect, though it is still statistically significant.[6] Given the strong connection between age and online news seeking we would expect that online news use will grow as the population ages. Further, since the number of people educated beyond high school is growing, this too will expand the online news market. Thus, while most people prefer to get their news from papers or television, that may not last beyond the current generation. At the very least we expect to see online news becoming as commonplace as newspapers in the very near future.

Aside from general interest, why else would someone choose to get their news online? The 1998 Pew Center survey did not include items that would help us address that question. However, they did include a question concerning this topic in a 1996 survey. They asked respondents why they go online to get news and gave them four possible responses. The two most common responses were that more information was available online and because it was more convenient. Finding information not available elsewhere or getting information that matched personal values was far less common (Hill and Hughes 1998). If these results hold today, online news represents not so much an alternative source of news but an extended one. People go online to get more information, not different information. If this is indeed the case then we should find below that online news outlets are not replacing traditional sources. That is the next topic to be addressed.

Do Online News Sources Supplant Traditional News Outlets?

What happens to the traditional news sources when people can get news online? Do people abandon traditional methods of news delivery? And what kinds of news do they seek online? To answer these questions we examine the relationship between online news use and the use of traditional media. There

are three possible relationships between traditional and online media. First, they could compete with each other. This would mean that people who use one type of media use the other types less (they would be negatively correlated). In this case, online news seekers would make less use of traditional news sources. Second, they could complement each other. People who go online could make greater use of other media news sources (they would be positively correlated). Finally, they might simply be unrelated to each other-being online might have no effect on the use of traditional media.

We test the relationship between online and traditional news sources by correlating online news seeking with the use of traditional media. The results show that getting information online is positively related to newspaper reading but unrelated to television news viewing. This held true while controlling for age, education, gender, and interest. The correlation between newspaper reading and online news seeking is very small, .07, but still statistically significant. The correlation between online news surveillance and television news watching is even smaller, -.02, and is non-significant.[7] In other words, there is a small, but complementary, relationship between going online for news and reading the newspaper. People who go online for news are somewhat more likely to read the paper. However, no relationship exists between online news seeking and watching television news.

How is such a result possible? Doesn't it stand to reason that one media must supplant another? Recall from above that getting more information is amongst the most common reasons for getting news online. If that is the case, then many people will make use of any source available to them. Recall also that our studies of education and interest showed that those who use traditional sources are those most likely to go online. This indicates that more highly educated and more interested people seek the news from multiple sources-both traditional and online. Once the effect of education and interest are controlled for, we find that there is little, if any, connection between going online and getting the news from other sources. Going online for news, by itself, is unrelated to television news viewing and only slightly related to reading the newspaper.

What does all this really mean? It tells us that as more people go online for news the traditional media need not fear abandonment. Newspapers may actually receive a small boost in sales and television news seems unlikely to be affected. The number of readers and watchers of traditional media may still decline in the near future. Reading the papers and watching the news will decline, for example, if interest declines. But such a decline will not be caused by the growth of online news services. These analyses also tell us that

as more people go online, they will not be drawn away from traditional sources. Interest and education drive the interest in news and gender and age drive the choice of type of news delivery. Over time age will change to a more equal distribution and the gender effect will also likely disappear. Of course, all of this assumes that the new online users will be generally similar to original online news seekers, that their motivations will be the same. That may not be the case, but it is something we are unable to test here. So based on this analysis, we conclude that online news sources pose no direct threat to traditional media. In the future, online news sources will probably exist right alongside traditional ones with little, if any, direction competition.

So far we have discussed online "news" in general terms. There are, however, many types of news. A daily paper provides tangible evidence of this fact with its multiple sections arranged by topic. Is it possible that online news sources are more or less popular depending on the type of news sought? Figure 5 provides clear evidence that some types of news are more commonly sought online. Technology news is both popular and obvious. People who go online clearly have some computer and technology experience. Moreover, many will have job duties that require they keep informed of technology advances. Similarly, scientific news is very specialized and often tied to work requirements. Thus, the convenience and flexibility of going online make it a good way to gather scientific news. By contrast, local news stands out as the least common type of news sought online. Given the smaller audience for a given geographic area, this is probably because there have been fewer web sites devoted to local content, though this is rapidly changing.

Since some types of news are more popular online, it is possible that the relationship between traditional and online media depends upon the type of news being consumed. For example, people may see online technology news sources as good substitutes for traditional sources but find traditional sources better suited for delivering local news. We test this idea by Figure 5 here correlating online and traditional news use for each type of news depicted. The analyses are just like the one conducted earlier for general online news reading, the only difference being we are correlating going online for each specialized news type with the use of traditional media. The results are presented in Table 1. We find that, in general, there simply is not much of a relationship between types of online news use and the use of traditional media. That said, there are a couple interesting patterns. Starting with the column for newspaper reading we see that the people who get politics and sports-related news online are somewhat more likely to also read the newspaper. For these two types of news, online sources and newspapers

Figure 5.
Percentage of People Who Get News Online by Type of News

complement each other. For the other news, types there are no statistically significant relationships. Turning to the second column we see that only one type of news is statistically related to television news viewing. Local news is positively correlated with going online for local news. This might describe a person who avidly watches the local news and goes online to get more information, probably from the local channel's web site.

In all, Table 1 shows us two things. First, the relationship between online news and traditional news is a weak one. Even the three statistically significant coefficients are very, very small. That said, we can see that some types of news appear to connect online and traditional sources. Specifically, people who go online for political and sports news are more likely to also read the newspaper while people who get local news online are more likely to watch television news. Most notable, though, is that going online for science and technology has no effect on traditional news sources. Given the large percentage of online news seeker who get science and technology news we might have expected that they would change their use of traditional news. In each case, however, the relationship is non-significant. This is good news for traditional media. If the most popular online subjects neither increase nor decrease the use of newspapers and television news, then we have further conformation that online news does not threaten traditional news outlets. In fact, what few relationships we did uncover are uniformly positive thus indicating greater online news seeking is related to more traditional news use.

Summary and Conclusion

Before discussing the future of the news media, we should recap the findings of this chapter. We find that education and interest drive the consumption of news in general and online news sources specifically. People who are better educated or more interested in current events are more likely to go online for news. In addition, age is positively related to news surveillance via newspaper or television but is negatively related to online news seeking. In terms of gender, men are more likely to go online for news but women and men are otherwise quite similar in their use of traditional news sources. We also found that the correlation between the use of online news sources and traditional ones is either very small or nonexistent. Even for the most popular types of online news–science and technology, there is no indication that people substitute one medium for another. Traditional and

Table 1.

The Relationship between Types of Online News Use and the use of Traditional Media

Online News Type	Newspaper Reading	Television News
Politics	0.097**	-0.036
Sports	0.13**	-0.01
Technology	-0.055	0.02
Science	-0.054	-0.046
Weather	0.015	0.017
Entertainment	0.056	-0.022
International	0.017	-0.038
Local	0.028	.102**

Note: Coefficients are partial correlations controling for age, education, gender, and interest,
$* = p < .05$; $** = p < .01$

online media currently are able to peacefully coexist.

Predicting the future should probably be left to the "Psychic Friends Network," but based on what we have learned in this chapter we can make some educated guesses. For instance, it seems safe to conclude the media's future is a digital one. Such a statement, however, is as clear as it is ambiguous. We know that print and television are moving into the digital age as computers, cable, and wireless communications begin to converge. But we don't know what form(s) future media will take. Certainly the World Wide Web offers a possible glimpse of the future, but only of one future. But if that future comes to pass, if traditional media and the public all embrace the web, what will happen?

The near, and long-term prospect for the growth of online news is good. In the near future women will probably start getting news online almost as often as men. This speculation is based upon the fact that both genders make equal use of traditional news sources. To the extent that online content supplements or enhances traditional outlets we can expect both sexes to get an equal portion of their news online. In the more distant future today's youth will replace the older generations. Today's youth are already computer savvy and tomorrow's youth will be even more computer literate. As they age they will find online outlets a natural and convenient source of news content. In addition, educational levels continue to rise and this too will drive an increase in online news consumption. Taken together these three findings confirm and explain that common-sense idea that there will be a dramatic increase in online news consumers.

A more controversial finding is that this increase will probably not come at the cost of traditional media. News consumers will happily gather this information from multiple sources, including both traditional and computer-based ones. In fact, there is some evidence that online news seeking and the use of traditional media reinforce each other. Whether in terms of general or specific news seeking these data offer no indication that today's online news seekers are abandoning traditional media sources.

Finally, one topic not addressed thus far is convergence. Traditional media are making use of online media when they provide some or all of their news online. In such a case, it may seem that online and traditional media merge and become one and the same. But we should note that so far the traditional media continue to provide the bulk of the revenue. So it is of vital importance to know whether the revenue producing outlet will suffer when online content is provided. Clearly the marketing and management aspects of maintaining a newspaper or TV studio are outside the scope of this

chapter. But all the evidence in the present study suggest that going online will not threaten, and may enhance, the revenue arm of a media company. In short, the results of our study suggest that the future of the news media will include both traditional and online delivery services.

Notes

1. I gratefully acknowledge the Pew Center for providing these data. The author is solely responsible for all interpretations and errors.

2. Including only people with computer access eliminates the effects of not owning a computer. This effect is most striking for older people and people with lower incomes. If people without access are included the overall pattern remains the same but it is greatly exaggerated.

3. The exact difference is from 75% for those with less than a high school education to 82% for those with post-graduate education.

4. $x^2 = 58.1$, $p < .001$.

5. The mean level of political interest is higher among men than among women ($F = 5.3$, $p = .02$).

6. The R for age is -.19, for education .16, for gender .075, and for interest .073.

7. The results were obtained by conducting a partial correlation test using age, education, gender, and interest as control variables.

Appendix

Survey Information

Survey conducted by the Pew Center for the People and the Press, April 24-May 11, 1998. Survey sampled 3,0002 adults by phone via random digit

dialing. The survey results are weighted to match census demographic data. For full details see the report's web site at http://www.people-press.org/med98que.htm

Variables Used in the Analyses

Age: Coded as actual age in years.
Gender: 1= female, 2= male.
Education: 1 = Less than High School, 2 = High School graduate, 3 = Some College, 4 = College graduate, 5 = post-graduate.
Political interest: A scaled variable consisting of six interest related questions. The reliability coefficient for the scale is .73. When sample is divided by interest it is divided in groups of approximately 25% each.
Read Newspaper?: "Do you happen to read any daily newspapers regularly, or not?" Coded 1 = no, 2 = yes.
Watch TV News?: "Do you happen to *watch* any *TV news programs* regularly, or not?" Coded 1 = no, 2 = yes.
Online News Use: "How frequently do you go online to get news..." Coded 1 = never 2 = does go online for news sometimes.
Specialty News Online: Several questions each worded as "Do you sometimes go online to get... political news, sports news, international news, technology news, weather news, science news, entertainment news, local news?" Coded 1 = no, 2 = yes.

References

Barwise, Patrick, and Andrew Ehrenberg. 1988. *Television and Its Audi-ence*. Newbury Park, CA: Sage Publications.

Bogart, Leo. 1992. The State of the Industry. In *The Future of the News,* ed. Philip S. Cook, Douglas Gomery, and Lawrence W. Lichty. Baltimore: Johns Hopkins Press.

Chaffee, Steven, and Stacey Frank. 1996. How Americans Get Political Information: Print Versus Broadcast News. *Annals of the American Academy of Political and Social Science* 546: 48-58.

Davis, Richard. 1996. *The Press and American Politics: The New Mediator*

2nd Ed. Upper Saddle River, NJ: Prentice Hall.

Davis, Richard, and Diana Owen. 1998. *New Media and American Politics.* New York: Oxford University Press.

Hill, Kevin H., and John E. Hughes. 1998. *Cyberpolitics: Citizen Activism in the Age of the Internet.* Lanham, MD: Rowman and Littlefield.

Pew Center for the People and the Press. 1998. *Internet News Takes Off.* http://www.people-press.org/med98rpt.htm.

Price, Vincent, and John Zaller. 1993. Who Gets the News: Alternative Measures of News Reception and the Implications for Research. *Public Opinion Quarterly* 57:133-64.

Robinson, John P., and Mark R. Levy. 1996. News Media Use and the Informed Public. *Journal of Communication.* 46: 129-35.

About the Authors

Donna Bertazzoni is an Associate Professor of Journalism and acting director of the Communications Arts Program at Hood College. She has been a recipient of the James H. Ottaway Fellowship from the American Press Institute, and before joining the Hood faculty she worked for many years as a reporter and editor for newspapers in Massachusetts and Maryland. Her primary area of research is the Internet and the law, and she has written and presented papers on the topic. With Dr. Judson, she received a Teagle Foundation Grant to study issues of technology and the First Amendment.

Rex Brynen is Associate Professor of Political Science at McGill University in Montréal. He is author of *Sanctuary and Survival: the PLO in Lebanon* (1990) and *A Very Political Economy: Peacebuilding and Foreign Aid in Palestine* (2000); editor of *Echoes of the Intifada* (1991); and cooeditor of the *Many Faces of National Security in the Arab World* (1993) and *Political Liberalization and Democratization in the Arab World* (2 volumes, 1995, 1998). In addition to his primary research on peacebuilding and Middle East politics, he is inordinately fond of science fiction television.

John M. Bublic is Assistant Professor of Political Science at Kent State University. His research interests focus on the political economy of the news media. He has published several articles concerning the role that journalistic values play in shaping national and international labor-management disputes.

William Elliott is Dean of the College of Communication and Professor of Journalism at Marquette University. He has a BS in Mathematics (Oregon, 1964) and a Ph.D. in Journalism and Mass Communication (UW-Madison, 1972). His research in public opinion and political communication has appeared in *Journalism Quarterly*, the *Quarterly Journal of Speech*, *Communication Research*, and the *Western Journal of Speech Communication*. He has co-authored two books on presidential campaign debates: *News verdicts, the debates, and presidential campaigns* (Praeger, 1991) and *The politics of disenchantment: Bush, Clinton, Perot, and the press* (Hampton, 1996).

Steve E. Frantzich is Professor and Chair of the Department of Political Science at the U.S. Naval Academy. After graduating from Hamline University, he received his Ph.D from the University of Minnesota. He won one of the first all-campus teaching awards at the Academy and has been active in promoting the use of television and computers in teaching. He serves as a consultant to the U.S. Congress, C-SPAN and the Dirksen Center on technology and politics. Among his more than a dozen books are the *C-SPAN Revolution* (University of Oklahoma Press) and *Making a Difference: Citizen Activists in a Cynical Age* (Rowman and Littlefield) which profiles average citizens who changed national public policy.

Amy Fried (Ph.D., University of Minnesota, 1991) teaches political science at the University of Maine. Professor Fried has published work on political culture, public opinion, the media, gender, the political values of heroism and patriotism, and environmental politics. In 1997, Professor Fried published *Muffled Echoes: Oliver North and the Politics of Public Opinion* with Columbia University Press. She is now writing about elites' strategic efforts to increase public distrust of government.

Tracey L. Gladstone-Sovell (Ph.D. Purdue University, 1981) has been a Professor of Political Science at the University of Wisconsin-River Falls since 1986. She teaches courses in Political Philosophy and American Politics including a course entitled "The Media and American Politics." She has been especially interested in studying the interactions between the entertainment media and politics since attending an NEH Summer Seminar on "Symbolism and Politics" under the direction of Professor Murray Edelman, in 1987.

John E. Hughes received his Ph.D. from the University of Florida. He is currently an Assistant Professor of Political Science at Monmouth University. His research interests include political behavior and political communication with a special emphasis on new technologies. Along with Kevin Hill, he is the co-author of *Cyberpolitics: Citizen Activism in the Age of the Internet.*

Thomas J. Johnson (Ph.D., School of Communications, University of Washington, 1989) is an Associate Professor in the School of Journalism at Southern Illinois University at Carbondale. His fields of specialization are public opinion and political communication research, particularly the role of

the media in presidential elections. He has published one book, *The Rehabilitation of Richard Nixon: The Media's Effect on Collective Memory* (New York: Garland Publishing, 1995) and is co-editor of *Engaging the Public: How Government and the Media Can Reinvigorate American Democracy* (Lanham, MD: Rowman & Littlefield, 1998). His work has appeared in *Journalism & Mass Communication Quarterly, Political Communication, Mass Comm Review, Communication and Journal of Media Economics*.

Dr. Janis Judson is the Director of the Law and Society Program at Hood College. She teaches in the areas of Judicial Process, Constitutional Law, Civil Liberties, and Gender Discrimination. Dr. Judson has been the recipient of law and politics fellowships from Harvard Law School, Stanford Law School and Johns Hopkins University. She has presented many papers on agenda-setting and non decisionmaking on the US Supreme Court. Dr. Judson is a contributor of constitutional essays on the Court and Congress and will be contributing to the forthcoming *Encyclopedia of the US Independent Counsel* which addresses constitutional issues surrounding the Clinton impeachment. As a recipient of a Teagle Foundation Grant from Hood, Dr. Judson has engaged in extensive research with Professor Bertazzoni on issues of technology, law, and the First Amendment.

Barbara K. Kaye (Ph.D., Florida State University, 1994) is an Assistant Professor in the Department of Communication Arts, Valdosta State University, Valdosta, GA. Dr. Kaye is co-author of the text book *The World Wide Web: A Mass Communication Perspective*. Her research interests include the World Wide Web and media effects. Her published research has appeared in *Journalism & Mass Communication Quarterly, Journal of Broadcasting and Electronic Media, Social Science Computer Review, Journal of Promotion Management*, and the *New Jersey Journal of Communication*. Additionally, she has presented numerous papers at the annual conventions of the Broadcast Education Association, National Communication Association, International Communication Association, and the Association for Education in Journalism and Mass Communication.

James D. Kelly is Associate Professor in the School of Journalism at Southern Illinois University, Carbondale where he teaches photojournalism, graphics, and new media technology. A former news photographer involved with documentary film making, his research examines the impact of new

imaging technology on newsroom routines and the believability of photo-
graphs, as well as the effect visual imagery has on audience understanding
of events. He is the editor of *Visual Communication Quarterly* and recently
published a book on the use of the Internet in Sri Lanka. He received his
Ph.D. in Mass Communication from Indiana University in 1989.

Stephanie Greco Larson (Ph.D., Florida State University, 1987) is an
Associate Professor of Political Science at Dickinson College in Carlisle,
Pennsylvania. She is author of *Creating Consent of the Governed: A
Member of Congress and the Local Media* and several journal articles on the
content and consequences of political news and the socio-political messages
in popular culture (specifically soap operas and detective fiction).

Martha F. Lee is an Associate Professor of Political Science at the
University of Windsor, Ontario, Canada. Her publications include: *Earth
First! Environmental Apocalypse* and *The Nation of Islam, An American
Millenarian Movement*. She is currently engaged in a major research project
on the British conspiracy theorist, Nesta Webster, and her influence on the
"New World Order" conspiracy theory.

Dr. Douglas M. McLeod is an Associate Professor of Communication at the
University of Delaware. His research focuses on media coverage of protest
groups, the role of the media in social conflicts, and mass-mediated messages
as forms of social control. He teaches courses on mass media and politics,
advertising and society, mass communication theory and research methods.
He received an M.A. and Ph.D. in Mass Communication from the University
of Minnesota and a B.A. in Journalism and Psychology from the University
of Wisconsin.

Cynthia Nantis completed her Master's degree at the University of Windsor
in 1996.Her major research interest is women in the American military. She
is currently completing her law degree at the University of Windsor.

David Schultz is a Professor in graduate school of Public Administration
and Management at Hamline University, St. Paul, Minnesota and the
coordinator of the doctoral program in public administration. He is also an
attorney and an adjunct professor of law at the University of Minnesota. He
is the author and editor of numerous books and articles on American politics
and law.His most recent books include *Leveraging the Law: Using the*

Courts to Achieve Social Change (Peter Lang, 1998) and *Inventors of Ideas: An Introduction to Western Political Philosophy* (with Donald Tannenbaum, St. Martin's Press, 1997), and *The Politics of Civil Service Reform* (with Robert Maranto, Peter Lang, 1998).

Gregory W. Streich received his Ph.D. from the University of Wisconsin at Madison in 1997. He has taught at the University of Wisconsin, Ohio University, and is currently an Assistant Professor of Political Science at Central Missouri State University. His teaching and research interests are in the fields of contemporary political theory, race and ethnic politics, and the politics of mass media, with special interests in democratic theory and theories of civil society.

Index

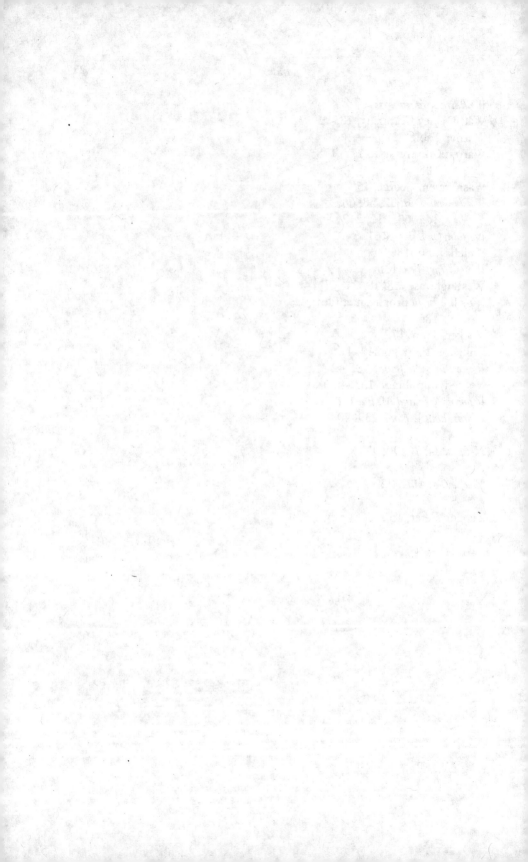

Politics
Media &
Popular Culture

David A. Schultz, *General Editor*

This series is devoted to both scholarly and teaching materials that examine the ways politics, the media, and popular culture interact and influence social and political behavior. Subject matters to be addressed in this series include, but will not be limited to: media and politics; political communication; television, politics, and mass culture; mass media and political behavior; and politics and alternative media and telecommunications such as computers. Submission of single-author and collaborative studies, as well as collections of essays are invited.

Authors wishing to have works considered for this series should contact:

Peter Lang Publishing
Acquisitions Department
275 Seventh Avenue, 28th floor
New York, New York 10001

To order other books in this series, please contact our Customer Service Department at:

800-770-LANG (within the U.S.)
(212) 647-7706 (outside the U.S.)
(212) 647-7707 FAX

or browse online by series at:

WWW.PETERLANG.COM